The Darkroom Cookbook

Second Edition

The Darkroom Cookbook

Second Edition

Stephen G. Anchell

Focal Press

Boston Oxford Auckland Johannesburg Melbourne New Delhi

Focal Press is an imprint of Butterworth–Heinemann.

Copyright © 2000 by Butterworth–Heinemann
ℛ A member of the Reed Elsevier group
All rights reserved.

 Recognizing the importance of preserving what has been written, Butterworth–Heinemann prints its books on acid-free paper whenever possible.

 Butterworth–Heinemann supports the efforts of American Forests and the Global ReLeaf program in its campaign for the betterment of trees, forests, and our environment.

Library of Congress Cataloging-in-Publication Data

Anchell, Stephen G.
 The darkroom cookbook / Stephen G. Anchell.—2nd ed.
 p. cm.
 Includes bibliographical references and index.
 ISBN 0-240-80423-6 (pbk. : alk. paper)
 1. Photography—Processing. 2. Photography—Developing and developers.
 3. Photography—Equipment and supplies. I. Title.
 TR287 .A63 2000
 771′.4—dc21
 00-025753

British Library Cataloguing-in-Publication Data

A catalogue record for this book is available from the British Library.

The publisher offers special discounts on bulk orders of this book.
For information, please contact:
Manager of Special Sales
Butterworth–Heinemann
225 Wildwood Avenue
Woburn, MA 01801-2041
Tel: 781-904-2500
Fax: 781-904-2620

For information on all Focal Press publications available, contact our
World Wide Web home page at: http://www.focalpress.com

10 9 8 7 6 5 4 3 2 1

Printed in the United States of America

Many products are claimed as trademarks. Where this occurs, and Butterworth–Heinemann is aware of a trademark claim, the trademark is acknowledged with initial capital letters (e.g., Kodak Elite).

This book is dedicated to all the selfless photographers who have shared their experience and darkroom discoveries. To these photographers, known and unknown, we owe a debt of gratitude.

Contents

CHAPTERS

APPENDIXES

Preface to the Second Edition

When I first set out to write *The Darkroom Cookbook* in 1992, it was my intent to share little-known photographic facts and formulas that I had gathered over the years. Many of these were on scraps of paper in my darkroom, some were merely stored in my head. Although I felt there was a need for this information to be shared, the number of photographers who were thirsting for this information came as a great surprise.

As a result of the success of *The Darkroom Cookbook*, I found myself serving as a clearinghouse for even more formulas and obscure techniques. Enough new information has since come my way to justify the publication of a Second Edition.

After writing *The Darkroom Cookbook* I also became even more aware of what photographers need to make a book of this nature useful. Much of the new information presented in this Second Edition was selected to fill what I perceived to be gaps in the First Edition, especially in the areas of warm-tone paper developers and toners, amidol film development, monobaths, and archival processing of films and papers.

In addition to the new formulas and updated information, I have endeavored to correct a number of minor errors found in the First Edition of *The Darkroom Cookbook*. None was of great significance, nonetheless they needed to be addressed.

Further, while I am not now, nor have I ever claimed to be, a photographic chemist (I was kicked out of high school chemistry with a "D+" just so I could graduate), in the process of writing *The Film Developing Cookbook* with real-life photo chemist Bill Troop, I added substantially to my knowledge of the process. This has enabled me to improve the quality of the information in this book.

Still in all, *The Darkroom Cookbook* is meant to be a point of departure for creative photographers to discover and explore new techniques and formulas in order to create a unique signature of their own. It is also meant to be a potpourri for photographers who just want to play with their craft. As I like to

tell my students, when photography ceases to be fun, it's time to find a different outlet for your creativity.

Finally, I would like to share the following insight. Despite its seeming complexity and daunting technicality, *photography ain't rocket science.* You have to be pretty far off to fail completely. For example, if a formula calls for sodium carbonate anhydrous and you accidentally use monohydrate, what's going to happen? Well, for one, it's not like being on the NYPD bomb squad and cutting the wrong wire. The worst that will happen is that the batch of negatives will probably be slightly underdeveloped and you will have to print on grade 3 instead of your usual grade 2 paper. It's far worse to be off on exposure than it is to be slightly off on your formula.

Preface to the First Edition

To paraphrase Frank Rogers, the photographer from whom I learned the most, "There are no secrets, just photographers who like to think there are." There is nothing new under the sun, and certainly, there is nothing new in *The Darkroom Cookbook*. Even the two most recent formulas, Gordon Hutchings's PMK Formula and Maxim Muir's Blue-Black Developer, have both been previously published. What is new about *The Darkroom Cookbook* is the gathering together of formulas so that they do not have to be continually rediscovered.

As such, it would be more correct to say I am the editor of *The Darkroom Cookbook* rather than its author. Even though I have written much background text, only one of the 140 formulas is mine, and that's a warm-tone paper developer. The rest belong to photographers who have gone before, such as J. Ghislain Lootens, Bürki, Edward and Brett Weston, Ansel Adams, and many others who are still working today.

The Darkroom Cookbook is based upon a series of articles originally appearing in *Camera & Darkroom* magazine. The articles were inspired by a brief encounter at a camera store.

I was browsing the chemical section searching for potassium bromide. When I found it, a young woman inquired what it was used for. I pointed to the paper developer she was holding and said, "An ounce of 10% bromide solution in that developer will improve the highlights in your prints."

"Oh my goodness! That sounds too technical to me!"

This made me realize that one photographer's basic craft is another photographer's "oh my goodness!" Yet, I have never considered myself to be technical. Even though I learned the Zone System in 1976, half the time I do not use light meters, and certainly have no use for a densitometer. To me, adding bromide or carbonate to a developer is about as technical as exposing for the shadows. Every photographer should know that!

Since the first columns appeared in *Camera & Darkroom* magazine, *The Darkroom Cookbook* has taken on another significance. As a photographer,

educator, and writer, I put great importance on the future of the silver-based process. I have a strong desire to keep the flame alive, to pass on experiences and technique to new generations of photographers. This desire is not entirely altruistic. I am in love with the process and want it to be around for at least as long as I am!

At the turn of the last century, platinum/palladium printing was the most popular printing process among professionals. It was not until well into the twenties that silver printing became widely accepted. When it did, platinum/palladium all but disappeared.

Today platinum/palladium is enjoying a resurgence of interest among fine art photographers. Unfortunately, though there have continued to be a number of practitioners through the years, the wealth of information and techniques developed by thousands of platinum/palladium printers has mostly been lost. The publishing and, specifically, how-to book industry was not what it is in our own time, and most photographers either abandoned the process or simply took their skills with them to the grave. Today's practitioners are in a position of having to rediscover, or reinvent, techniques that were often considered standard practice.

The demise of the silver process may sound unlikely now, but consider that platinum/palladium papers were available commercially until the mid-twenties. I wasn't there, but am certain that longtime platinum/palladium printers never thought there would come a time when they couldn't purchase at least *one* brand of paper off the shelf.

The purpose of this book, then, is twofold. The first is to enable photographers to create images in the darkroom that reflect their emotional state and response to their subject. The second is to preserve and share the knowledge and techniques that have been so arduously developed by creators in silver.

Further, *The Darkroom Cookbook* serves as a reference for many older formulas. These formulas are being lost, not because they are necessarily outdated, but because they are no longer manufactured. Sometimes because the company who owned the rights to the formula is no longer in business—sometimes because the chemicals have poor keeping properties and must be mixed immediately before use.

It is an interesting aside that, at least until the 1930s, the standard developer sold by Eastman Kodak for home darkroom workers was a pyro-based formula. This was replaced by D-76, which is easier to manufacture, package, and does not have the side effects often associated with pyro, such as staining.

We have recently passed the 150th anniversary of photography and are approaching the turn of the century. Photography is going through remarkable changes. With the advent of computer and video technology, silver-based imaging is becoming just one component in the larger world of photo imaging.

Before long, silver-based imaging may be considered an alternative process, like platinum/palladium printing. It is ironic that as we watch the changes taking place, silver-based imaging has reached a peak in the history of the process. Technological advances in film manufacture, long dormant, are happening so fast that they can hardly be kept up with. Premium papers like Zone VI Brilliant, Oriental Seagull, Kodak Elite, Agfa Insignia, and Ilford Galerie are unquestionably the finest ever made.

For the present, we record using a still camera and create in the darkroom. In the not so distant future, moments may be recorded using a video camera

and created in a computer. The technique we use, video to computer, still camera to darkroom, is not important. What is important is the creation of images as a means of communicating our thoughts, ideas, and vision to others. In either method, the creation is in the second, not the first, step.

When manufacturers cease to make premium-quality papers, when Kodak, Fuji, and Ilford diversify and follow more lucrative markets in magnetic imaging, when Nikon puts their efforts into still video cameras, photographers working with the old techniques of silver-imaging will become an elite. Their skill and knowledge will become special, simply because of its rarity. If a few happen to have clear vision and continue to create beautiful images in silver, so much the better.

Today, it is possible to take negatives to a lab for processing and printing . . . tomorrow?

Acknowledgments

There are two husband-and-wife photography teams who influenced and encouraged me in my formative years. They are Frank and Daughtee Rogers, and Cornelia and Rodger Davidson.

Frank and Daughtee gave me a solid grounding in basic photography and darkroom techniques, unselfishly sharing their knowledge. They taught me to respect the craft and made me aware that it was more than a livelihood I was learning; it was a tradition. Daughtee was a master printer and retoucher. Frank did most of the photography.

Cornelia and Rodger taught me basic color technique. Their specialty was color transparency, specifically Ektachrome E-3, which they processed by hand every evening in their West Los Angeles home for commercial, architectural, scientific, and fine art photographers.

It is safe to say that without Frank, Daughtee, Cornelia, and Rodger's patient guidance and teaching, I would not have survived the first difficult years of my photographic career.

Pertaining directly to *The Darkroom Cookbook,* the hero I want to acknowledge is Samy Kamienowicz, owner of Samy's Camera in Los Angeles. In the early 1980s, Samy made a present to me of three Morgan and Lester Photo-Lab-Indexes from the 1930s and 40s. This generous gift sparked my interest in older formulas and darkroom techniques and made it possible for me, at a later date, to share them with other photographers. Without Samy there would be no *Darkroom Cookbook.*

There are several others to whom *The Darkroom Cookbook* owes special thanks:

Thom Harrop who, as former editor of *Camera & Darkroom* magazine, encouraged me to begin writing about photography in 1990. It was also Thom who suggested that I write a column on darkroom techniques.

Ana Jones, also a former editor of *Camera & Darkroom,* for her strong support, encouragement, and permission to publish *The Darkroom Cookbook* as a book.

Gordon Hutchings, the leading authority on pyro, contributed extensively to the pyro sections, much of it in his own writing. Gordon also corrected many misconceptions I have long held regarding pyro.

Maxim Muir, formerly of the Gamma .55 Group in North Carolina, provided a number of invaluable tips and suggestions. In addition, Maxim tested and corrected several formulas, updating them for current emulsions and papers. His Blue-Black paper developer, has become one of my favorites.

Fine art portrait and landscape photographer Marshall Noice, an expert on reduction and intensification techniques, helped refine the appropriate sections of *The Darkroom Cookbook.*

Ira Katz, of Tri-Ess Sciences in Burbank, California, freely shared his vast knowledge and experience of chemistry. Ira's knowledge is not limited to photo chemistry, and his insights and suggestions for storage, mixing, and safety are an indispensable part of this work.

A special thanks is due to Bill Troop for his many suggestions and final technical editing of the formulas. Bill possesses the most complete knowledge of photographic formulas of anyone I know. He has the remarkable ability to spontaneously "invent" workable formulas.

I would especially like to thank Donna Conrad for her invaluable editing. Donna is a photographer and writer who works with 35mm color transparency and Ilfochrome prints. When she was younger, she exposed a roll or two of black-and-white film, even printed an image she made at Point Lobos. Donna edited the manuscript so *she* could understand it. If you, too, are able to make sense out of this book, it's mostly thanks to her.

The Second Edition would be incomplete without the careful scrutiny of Paul Lewis of Winnipeg. Paul has managed to provide the knowledge of chemistry, which I am happily lacking.

In addition, I have recently come to rely upon the gracious assistance of Dr. Marty Jones, chairman of the Adams State College Chemistry Department in Alamosa, Colorado. Dr. Marty has taken his personal time to aid and abet my tedious research efforts.

My brother, Dr. James Anchell, also assisted in the research for this edition. James earned his Ph.D. in theoretical chemistry proving that chemical illiteracy is not endemic in the Anchell family and at least someone in our family is able to go the distance. My father, Melvin, reminds me that he, too, excelled in chemistry and earned his Ph.D.

Prior to embarking upon the Second Edition, I had the good fortune to reconnect with Paul Van Gelder. Paul introduced me to both pyro and amidol in the early 70s, and quite possibly set the course, which allowed me to write this book. I lost track of Paul in the late 70s, and was pleased to find out that he was still quietly crafting fine images, still using pyro and amidol. A letter sent to me by Paul in 1976 is reproduced in chapter 8.

List of Formulas

FILM DEVELOPERS

Divided and Water-Bath Developers
1. Amidol Water-Bath Developer
2. D2D Divided Developer
3. D-23 Divided Developer
4. D-76H Divided Developer
5. General Purpose Divided Developer
6. Reichner's Divided Developer
7. H. Stoeckler's Fine-Grain Divided Developer

Extreme Compensating Developers
8. D175 Tanning Developer
9. Maxim Muir's Pyrocatechin Compensating Developer
10. Windisch Extreme Compensating Developer

Fine-Grain Developers—Grain Reduction
11. Kodak D-23
12. Kodak D-25
13. Kodak Balanced Alkali Replenisher for D-23 and D-25

General Purpose Developers
14. Ansco 17
15. Ansco 17a
16. Ansco 47
17. Ansco 47a
18. Crawley's FX 37
19. D-76H
20. Ilford ID-68

PAPER DEVELOPERS

FIXERS

TONERS

Blue Toners

Brown Toners

Dye Toners

Green Toners

INSPECTION FORMULAS

MISCELLANEOUS

PRINTING-OUT PAPER FORMULAS

Introduction

Why invest the time and money necessary to develop and print your own photographs? After all, today there are many good full-service and specialty labs that will both develop and print your work, possibly even doing a better job than you could.

Besides, there are many photographers, especially in the field of photojournalism and commercial photography, who never print their own images, and for good reason. For the photojournalist pursuing one fast-breaking story after another in far-flung corners of the world, there is no time for developing and printing. For commercial photographers time is money. Even if they maintain a lab on their studio premises, it is usually more cost-effective to hire an assistant to do the processing.

In both cases, there is no faulting their vision. Some of the most memorable photographs have been taken by professionals working in one or the other manner.

But consider that the camera only records what we see. The moments recorded by photojournalists have become images only after they have been developed by a lab, chosen from proof sheets by an editor, and printed in a way that they can be presented and shared with others: in magazines, newspapers, books, and exhibits.

The successful tabletops, fashion layouts, and architectural views are only the creation of the photographer as far as he or she is able to see, compose, and light. Snapping the camera's shutter doesn't create the image, it only freezes a moment in time. The fulfillment of the photographer's inner vision is not realized until the film has been processed and reproduced.

If your interest in photography does not go beyond recording moments in time, or completing commercial assignments, there is no reason to practice darkroom techniques. The question is, do you wish to become a creator of images? If you do, then you must learn to develop and print your own work.

Brett Weston, one of the greatest practitioners of the "West Coast School of Photography," pioneered by his father, Edward Weston, as well as Ansel

Adams and Imogen Cunningham, destroyed almost seventy years' worth of negatives on his eightieth birthday because he refused to allow anyone else to print his work. Why? To paraphrase Brett, there may be someone who could print his work better, but then it wouldn't be his. Brett believed an image is recorded in the camera, but created in the darkroom.

There was a time when all photographers were proud of their skills and expertise in the darkroom. Each had his or her own version of a particular formula and knew several others that enabled them to achieve specific results. In the field, the photographer could concentrate on composing images and achieving the best possible exposure, aware that anything was possible in the dark.

The Darkroom Cookbook will teach you methods to alter and improve published formulas. Through the use of chemicals and additives you can fine-tune over-the-counter or published formulas to increase or decrease contrast and enhance tonality.

If you take the title of this book literally, you can think of yourself as either a cook or a chef. A cook follows a formula as it is given, a chef creates formulas by adding or subtracting ingredients according to taste.

Some of the greatest practitioners have been cooks. Edward Weston learned the simple formulas he used throughout his long and prolific career in photography school. On the other hand, Paul Caponigro mixes and matches formulas to suit his taste at any given time, with any given image. Edward could be considered a cook, Paul a chef.

Cook or chef? It is not important which, only that you are able to obtain the results you desire. To what end? To give life and expression to your work—life and expression that is not always possible and, at the very least, may be seriously curtailed by dependency on packaged formulas.

But even packaged formulas can be used by a chef to great advantage. Mixing soft-working, warm-toned Kodak Selectol-soft with varying amounts of cold-toned Kodak Dektol will open entire new worlds in print color and tonal scale. The manufacturers do not suggest this in their literature, but then the manufacturers are not artists. They're probably not even photographers.

The formulas and techniques in this book, while not exhaustive, have been chosen to aid the photographer attempting to express a personal vision. Beginning with the choice of film developer to emphasize speed, graininess, or acutance, and continuing with the choice of paper developer for color and gradation, this book will provide the necessary background.

The Darkroom Cookbook begins with chapters on subjects that are usually reserved for an appendix: equipment, chemicals, weights, and measures. The knowledge and use of these are vital to understanding the formulas that follow. That doesn't mean you need to memorize them, but you should examine them. They have intentionally been placed where they will not seem an afterthought.

All the formulas are given in full at the back of the book where they can easily be found and used. If you want to learn more about a formula, read the appropriate chapter. If you already know what you need, go directly to the back and begin cooking.

There are many film-developing formulas listed. Some photographers may be surprised to learn there are so many. I assure you these only scratch the surface. Why are so many developing formulas necessary? After all, if you get

to know one or two formulas—Rodinal and Kodak D-76—and stick with them, what else do you need, right? In the early stages of learning the craft, this is a good idea. But notice the headings for each set of developers: high-definition, low-contrast, fine-grain, high-energy, tropical, and so on. There is a developing formula to create almost any effect you can imagine: sharp, clean edges, or superfine grain; low-contrast, long tonal scales, or high-contrast and short tonal scales. There are developers that will allow you to process film in the Brazilian rain forest, at temperatures near 100°F, and some that permit you to develop in Antarctica at below 0°! Complete knowledge of one or two developers is important, but knowing what else is available and how to make use of it to create the image you want is vital.

Paper developers also abound in *The Darkroom Cookbook*. While printing techniques such as dodging and burning affect the emotional impact of a print, the choice of paper developer can enhance, or detract, from the image's main message. Each developer formula varies slightly in its rendition of blacks. Select a warm-toned paper and a cold-toned paper you particularly like and, over a period of time, test each of the print developers which interest you. Keep a book of the resulting prints, which you can refer to when a given tonality is desired.

When you decide which developer/paper combinations are applicable to your style, try several—or all—of the different toning formulas to discover which ones please you the most. Keep a book of these also. These reference sources will greatly enhance your ability to communicate through your images.

Under miscellaneous formulas you will find a number of useful items. Kodak S-6 Stain Remover, for example, will remove both oxidation and developer stains from film. I hope you will never need to use it, but I've included it just in case! Also included are two formulas for sensitizing paper. There are others, but these are a start. If it should ever come to pass that silver papers are no longer available, this may be one way to continue. On the other hand, coating your own paper may be well worth experimenting with for the special results that can be obtained.

Intensification and reduction techniques are also of special value to photographers. Even Ansel Adams required the technique of local negative intensification to save his most famous photograph "Moonrise Over Hernandez." The negative was exposed for the moon's luminance, at 250 c/ft^2. As a result, the foreground was badly underexposed and very difficult to print. Without the necessary darkroom skills the image might not have survived.

Throughout *The Darkroom Cookbook*, formulas are given in metric and U.S. customary (avoirdupois) units. However, within the text, only metric units are used. You do not need to know anything about the metric system. It's only numbers. Once you get used to it, you will find it easier to calculate changes in measurements. For example, which is easier to add: 5 grams to 10 grams, or 73 grains to 145 grains? Not convinced? Okay, try liquid measures. You need to make a 15% solution: 15% of 1000 ml is 150 ml.; 15% of 32 ounces is, uh . . . let's see . . . 10% of 32 is 3.2 ounces, half of 3.2 is 1.6. Then 1.6 plus 3.2 is 4.8! That's it! Fifteen percent of 32 ounces is 4.8 ounces . . . uh, how much is ".8" of an ounce? I suggest you get used to working with metric measurements.

1 Equipment

A list of basic equipment needed for a darkroom can be found in appendix III, Planning a Darkroom. If you already own a darkroom, you probably have most of the equipment needed to "get cookin'." The extra equipment you need to mix your own formulas is minimal.

Basic Equipment

- Beaker(s)
- Coffee filters (optional)
- Funnel
- Graduate(s)
- Measuring spoons
- Mixing container(s)
- Mortar and pestle
- Photograde storage bottles
- Scales or balance beam (optional)
- Weighing cups

Balance Beam and Scales

The formulas in *The Darkroom Cookbook* are given in conventional metric and U.S. customary units. The easiest way to use *The Darkroom Cookbook* is to invest in a scale. The scale does not have to be state-of-the-art, but it should have readability to 0.1 grams and contain a counterbalance system, or tare, to compensate for the weight of the measuring container.

Scales are available in either mechanical or electronic models. An inexpensive mechanical scale, the Pelouze R-47, is available through camera

stores in either metric or U.S. customary models. It is accurate enough for quantities to 100 grams and has a good counterbalance system.

The next step up in a mechanical balance is the Ohaus Triple Beam Balance. The model 760 will weigh up to 610 grams in 0.1-gram increments, which is more than enough for a small darkroom.

The scale that I use is the Acculab VI-400 electronic digital scale. Compared to the Ohaus 760, the Acculab takes up less than a third of the counter space and, being electronic, is more accurate and easier to use. The capacity of the Acculab is 400 grams in 0.1-gram increments. It can weigh in either grams or ounces. Ohaus also makes an electronic digital scale, the Scout SC4010, which can weigh up to 400 grams in 0.1-gram increments.

If you will often be weighing small amounts of chemicals such as Phenidone, you will need a scale with readability to 0.01 grams. However, going from 0.1 grams to 0.01 grams readability almost doubles the price of the scale. A suitable model is Acculab's VI-200 or VI-350 with 200 gram and 350 gram capacity, respectively. If you ever have a need to measure in milligrams, down to 0.001, I recommend the Acculab VI-3mg.

A standard-issue postage scale found in most stationery stores is also handy to have. This can be used for quick weighing of large amounts where accuracy is not critical—for example, weighing one pound of sodium thiosulfate for a standard hypo bath. I have a two-pound Pelouze postage scale for just this purpose. The best part is you don't have to worry if the postage rates go up!

Teaspoon Measurement

Many photographers claim to achieve a reasonable degree of accuracy using teaspoons to make volume measurements rather than weighing with scales. This is because as chemicals age they absorb or lose water molecules. This can cause a change in weight, but not volume. As teaspoon measurement deals with volume, not weight, it is arguably more accurate than weighing.

There is no reason not to use the teaspoon method if you prefer. Unfortunately, an accurate conversion of weight to volume is not possible. This is for the very reason given above: the weight of any given chemical changes with age due to water absorption. If you were to measure a level teaspoon of fresh sodium carbonate today, and again in a month or two from the same bottle, the second teaspoonful would weigh more, due to water absorption. Therefore, any conversion chart from grams to teaspoon is limited in accuracy to the time it is made.

However, the convenience of spoon measurements cannot be overlooked. If you are consistent in your work habits, there is no reason this method should not prove to be as reliable as using a scale, especially since the change in weight due to water absorption (or loss) affects the potency of chemicals measured by weight, as well. The real key is: be consistent, *it ain't rocket science!*

A teaspoon conversion table can be found in the Conversion Tables at the end of the book.

Storage Bottles

Maintain a good selection of photograde storage bottles. Starting with 250 ml, double the size and have several containers that are 500 ml, 1 liter, 2 liter, and 4 liter. Photo storage bottles can be purchased at most photography stores and any chemical outlet. A list of chemical outlets is found in appendix II, Sources.

Developers should be kept in brown amber glass bottles, particularly if kept for more than a few weeks. This is because developers easily oxidize and lose their potency when exposed to air and/or light. Plastic bottles breathe and will speed the rate of oxidation. An exception is the 32-ounce (slightly less than 1 liter) Barrier-Tainer made by Delta 1, which is nonosmotic (doesn't breath.) High-density polyethylene storage bottles are suitable for solutions of fixer, stop bath, bromide, carbonate, and just about anything except developers.

Beakers, Mixing Containers, and Graduates

In addition to bottles, you will find it convenient to have a selection of measuring graduates, beakers, and mixing containers. A graduate is a tall cylinder with markings on the side used for measuring liquids. A beaker is wider and sometimes has a handle; it may or may not have units of measurement on it. Graduates are primarily used for measuring liquids; beakers can be used for measuring but are more useful for mixing and pouring.

For the utmost convenience you should eventually obtain three graduates—25 ml, 100 ml, and 1 liter. The 1-liter graduate can be used in place of a 1-liter beaker for mixing. In addition to a 1-liter beaker or graduate, a 4-liter beaker is indispensable. A good source for lab-grade graduates is Tri-Ess Sciences (see appendix II, Sources).

Additional Equipment

Make sure to have a large funnel and stirring rod. On occasion you might need to filter the sludge out of a solution. While lab-grade filters are expensive and unnecessary, untreated coffee filters, such as those found at health food stores, are a good thing to have around.

A mortar and pestle is sometimes handy for breaking up chemicals that are not already in powder form—especially, but not exclusively, if you are measuring with teaspoons. This is because if there are lumps in the powdered chemical it is hard to get a consistent teaspoon measurement. Use only a glass, porcelain, or dense plastic mortar. Wood, stone, and marble absorb chemicals and can contaminate the next chemical you pulverize.

2 Chemicals

Most of the chemicals used in black-and-white processes are safe and biodegradable. A few, such as pyrogallol, mercuric chloride, and hydrochloric acid, require careful handling and disposal. Throughout *The Darkroom Cookbook* specific warnings and instructions will be given where appropriate.

This chapter is a general overview for those not familiar with handling chemicals. Chapter 3, Pharmacopoeia, contains descriptions of chemicals, including most of those used in this book. Knowledge of these chemicals and their use will be of great advantage in manipulating formulas.

Obtaining Chemicals

Many of the chemicals used here can be obtained from photo suppliers. Less common chemicals, such as amidol and pyrogallol, can be obtained from various chemical suppliers. A few suppliers even specialize in photographic chemicals. Not all chemical suppliers will sell directly to the public. Appendix II, Sources, lists some that do.

Nomenclature

Manufacturers often give their own trade name to the same chemical. For example, the developing agent monomethyl-*p*-aminophenol sulfate is commonly known as either Kodak Elon or Agfa Metol. Throughout *The Darkroom Cookbook,* this widely used chemical will be referred to by its most common name, metol.

Spelling also varies between the U.S. and Great Britain. The British spelling of *sodium sulfite* is *sodium sulphite,* and *sodium sulfate* is spelled *sodium sulphate. The Darkroom Cookbook* will use the U.S. spelling.

Chemical Classification

Chemicals come in different grades or classifications: analytical reagent (AR); pharmaceutical or practical; and technical or commercial.

- *AR*—Chemicals of AR quality are used primarily for analytical and testing purposes. Such chemicals meet the highest standard for purity and uniformity. Though they may be used for photographic work, they are the most expensive and not generally required. In the United States, AR-quality chemicals are labeled ACS (American Chemical Specification) and in the United Kingdom ANALAR™ (Analytical Analyzed Reagents).
 Note: ANALAR is a trademark of ANALAR Standards, Ltd., a subsidiary of British Drug House Chemicals, Ltd., a leading authority on international chemical standards.
- *Pharmaceutical or Practical*—These chemicals meet the specifications of the U.S. Pharmacopeia (USP) or the National Formulary (NF). USP/NF-quality chemicals are approximately 97% pure and can be used for almost all photographic work. In Great Britain, they are labeled either BP (British Pharmacopeia) or BPC (British Pharmaceutical Codex).
- *Technical or Commercial*—These chemicals are primarily intended for use in manufacturing processes (e.g., making laundry detergents). In a few instances it may prove economical to use such chemicals, but, generally speaking, they cannot be recommended for photographic work.

Anhydrous (Desiccated), Monohydrate, and Crystalline

The terms anhydrous, desiccated, monohydrate, and crystalline are often a source of confusion. They refer to the various hydrate forms of some chemicals. Anhydrous, and the older name desiccated, means "without water." Monohydrate means that one water molecule is attached to the chemical's molecule. Crystalline means that as many water molecules as possible are attached to the chemical's molecule. The water bonded to the chemical makes the molecule weigh more. The extra weight is only water. In practice, this means that if a formula calls for an anhydrous chemical, you will need more monohydrate or crystalline chemical to make the same working concentration. You can convert the weight needed, using the Conversion Tables at the end of the book, if you have a different hydrate form than called for in the formula.

Monohydrate chemicals are generally the most stable. Anhydrous chemicals will try to absorb water from the air to become monohydrate. Crystalline chemicals will try to release their water to the air to become monohydrate. Due to these tendencies it is important to store anhydrous and crystalline chemicals in airtight bottles to maintain their hydrate state.

Weights and Measures

Formulas are given in both U.S. customary and metric units. The figures are not directly interchangeable, because 1 liter of water does not exactly equal 32 ounces. Therefore, they must be specially compounded to be equivalent. At the end of this book you will find a compound conversion chart with many of the most commonly used amounts listed for your convenience.

Preparing Formulas

Before attempting to mix any formula, read and follow all handling and safety instructions listed for the chemicals. Always wear protective equipment such as safety glasses, a plastic apron, rubber gloves, and a mask to avoid allergic reactions, burns, and irritation to the skin or lungs.

Refer to appendix I, Safety in Handling Photographic Chemicals, for explicit safety instructions and for a list of 24-hour poison center hotlines.

Dos and Don'ts

- Never place raw chemicals directly on the scale. Chemicals can be weighed by placing a piece of filter paper on top of the pan, or a non-pleated paper cup, such as a Dixie cup. The second method is preferred, as there is a tendency, when using paper, for the chemical to spill over the sides and make a mess. Instead of a paper cup, reusable plastic weighing cups can also be purchased from chemical suppliers.
- When mixing an acid, *always pour the acid into the water.* Do not pour water into the acid, as splattering can occur, causing dangerous burns. Be sure to wear eye protection.
- Use a funnel when pouring solutions into bottles. Tightly secure the top and label the bottle with the solution's name and date. Most developers keep for only a few months. The life of the developer can be extended by displacing the oxygen with nitrogen or Falcon Dust-Off Plus, which is more readily available from photo dealers. A less expensive method is to obtain a few bags of glass marbles. As the developer is used, add sufficient marbles to raise the volume until it is even with the neck of the container. However, *do not* use marbles with strong acids (e.g., sulfuric or hydrochloric) or strong alkalies (e.g., sodium hydroxide). Marbles are made of soda glass and will react or decompose.
- Do not prepare formulas in the containers or tanks in which they are to be used. Glass or porcelain jars, wide-mouthed glass bottles, plastic beakers, or graduates are suitable for mixing.
- Never use metal other than stainless steel. In particular, do not use iron, copper, aluminum, and tin.
- Although solutions may be shaken to dissolve the ingredients, stirring is preferred, as shaking causes oxidation. When adding water, do so slowly and, whenever possible, indirectly (i.e., allow the water to run down the wall of the mixing container rather than directly into the liquid). This will help to slow the rate of oxidation.
- Keep a record of what you do so you can adjust and customize the formulas.

Weighing Chemicals

A set of plastic or stainless steel measuring spoons will facilitate transferring chemicals from the bottle to the scales. They will help to prevent wasteful spills, which can cause contamination. Do not overfill the spoon; transfer a little at a time to prevent spilling.

Begin by placing the scale on a level, protected (e.g., newspaper-covered) surface and zeroing it. Place a weighing cup in the middle of the balance pan. If you are using a triple-beam balance without a tare, such as the Ohaus 700, weigh the cup first and subtract its weight from that of the chemical. When using a double-pan scale, such as the Pelouze R-47, place the same size cup in both pans so their weights will cancel each other.

Have all the chemicals to be used at hand and in the order of use. Use a clean cup and spoon for each chemical to prevent contamination. Immediately recap the bottles to avoid confusion, spills, or contaminating one chemical with another.

A convenient method for weighing small amounts of chemicals is to place them on precut pieces of paper. Write the name and weight of each chemical on the paper, and arrange the chemicals on the mixing bench in the order of use. For amounts over 20 grams, use a small plastic or Dixie Cup instead. Polystyrene weighing dishes are also convenient. They can be washed and reused and are available from Tri-Ess Sciences (see appendix II, Sources).

Order of Dissolving

Unless otherwise specified, *always dissolve the ingredients in the order given.* In developers, the sulfite is usually dissolved first because most developing agents are easily oxidized in water without this preservative.

An exception is metol, which is only soluble with difficulty when mixed in sulfite solutions. Therefore, when mixing developers that contain metol, you should dissolve the metol before the sulfite. This has a minimal effect on the keeping properties of the developer as metol is not easily oxidized. Even so, many workers prefer to dissolve a pinch of sulfite before dissolving the metol, to ensure against oxidation. The small amount of sulfite is usually ignored in the overall total as it is insufficient to upset the balance in the finished developer.

A good rule to follow in preparing developers is to make certain that each ingredient is completely dissolved before the next is added. Always begin with at least a quarter, or even a half, less water. When all the chemicals have been dissolved, add cold water to make the required volume.

Water

Unless a formula specifically calls for distilled water, tap water can be used. Even when distilled water is indicated, good quality, filtered tap water will usually suffice.

In areas where the water is very hard, it can be treated with sodium hexametaphosphate, or Calgon. Three g/L should be added before the other developing agents. EDTA, ethylenediaminetetraacetic acid, can also be used, but it may speed up the rate of aerial oxidation of the developing agents, possibly causing dichroic fog.

If neither Calgon nor EDTA is available, an alternative method is to allow the water to settle overnight then decant the clear liquid, preferably through filter paper. This procedure, while inconvenient, is sufficient for most developers.

Percentage Solutions

For convenience, and when the amount of a chemical may be too small to be weighed accurately, the amount is often given as a percentage solution. This can be simply stated as how many grams of a chemical are dissolved in 100 ml of water. For example, a 10% solution has 10 grams of a chemical dissolved in 100 ml of water.

Regardless of the amount used in the formula, the percentage is always the same. That means that every 10 ml of a 10% solution contains 1 gram of the chemical. If a formula requires 2 grams of chemical, use 20 ml of the percentage solution.

The following is an example of the use of percentage solutions. Suppose the formula calls for

Potassium ferricyanide	5 grams
Potassium bromide	1.5 grams
Water to make	1 liter (1 liter = 1000 ml)

If we start with stock solutions of 10% potassium ferricyanide and 10% potassium bromide, we can quickly make our solution by multiplying the dry amount by 10 and taking

Potassium ferricyanide, 10% solution	50 ml
Potassium bromide, 10% solution	15 ml
Water to make	1 liter

It is easy to see the advantage of this method, especially for chemicals that are often used in small amounts (e.g., Phenidone, potassium bromide, benzotriazole).

When mixing percentage solutions, start with less than the total volume of water. After the chemical is fully dissolved, add the remaining water to make the required volume.

The Crisscross Method for Diluting Solutions

An easy method for figuring dilutions is by the crisscross method. Place at A the percentage strength of the solution to be diluted and at B the percentage strength of the solution you wish to dilute with (in the case of water, this will be 0). Place at W the percentage strength desired. Now subtract W from A and place at Y. Also subtract B from W and place at X. If you take X parts of A, and Y parts of B and mix, you will have a solution of the desired strength W.

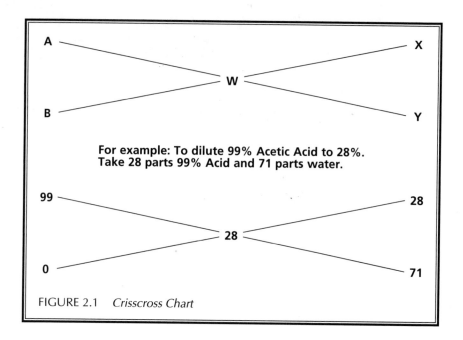

FIGURE 2.1 *Crisscross Chart*

Formulas in Parts

Many formulas, especially older ones, are given in parts. Parts can be converted into the equivalent number of grams and milliliters. For example, a formula calling for "1 part A to 1 part B to 1000 parts water" can be translated as "1 gram of A, 1 gram of B, to 1000 ml of water."

Often formulas in parts, such as this one, will be written as "1:1:1000" or "1:1 to 1000 ml of water." Whichever way it is written, it comes out the same. The important point is to make sure that all the units are in the same system of measurement, either metric or U.S. customary units; in other words, grams with grams, ounces with ounces. This is also important when both liquid and solids are indicated in "parts." Be certain that solid ounces go with liquid fluid ounces and that solid grams go with liquid milliliters.

3 Pharmacopoeia

The chemicals listed here represent those used in the formulas in this book. Familiarizing yourself with the properties and uses of these chemicals will greatly enhance your darkroom skills.

In a few cases the chemical will be found under its common name. The reason is that if you ask a clerk at the local photo supply for a pound of mono-methyl-*p*-aminophenol sulfate you probably won't get too far. Ask for a pound of metol, and you *may* fare somewhat better.

Information such as common grades and uses will be given where applicable. In a few instances substitutions will be given. Finally, remember what I've mentioned before, *this ain't rocket science.*

Chemical Terms

- An **acid** is a compound usually having a sour taste and capable of neutralizing alkalies (most developers are alkaline). Solutions with a pH less than 7 are considered acid.
- An **alkali**, the opposite of an acid, is a compound, or salt (e.g., sodium metaborate, sodium carbonate), used as an accelerator in photographic developers. Solutions with a pH greater than 7 are considered alkaline.
- An **anhydrous** chemical is one with all water removed; it is free from water, or dry (see chapter 2, Chemicals).
- A **deliquescent** chemical is able to absorb moisture from the air.
- A **denaturant** is used to render alcohol unfit for drinking.
- **Decahydrate** means having ten molecules of water.
- **Desiccated** is an older word meaning the same as anhydrous.
- **Dihydrate** means having two molecules of water.
- **Dodecahydrate** means having twelve molecules of water.
- **Effervescence** means giving off bubbles of gas.

- **Efflorescent** means the crystals have broken down and become covered with powder.
- **Hygroscopic** is the property of a liquid or solid that attracts moisture from the air.
- **Inflammable** means being capable of being set on fire.
- **Monohydrate** (monohydrous) means having one molecule of water (see chapter 2, Chemicals).
- **Octahydrate** means having eight molecules of water.
- **Pentahydrate** means having five molecules of water.
- **Viscid** indicates having a thick, sticky consistency.

CAUTION: Treat every chemical as if it were a poison. Wear gloves and other appropriate safety equipment when handling, either in powder or solution. Do not swallow and, most importantly, keep all chemicals away from your eyes. Finally, carefully read appendix I, Safety in Handling Photographic Chemicals.

Photographic Chemicals

ACETIC ACID See Acid, Acetic.

ACETONE

Synonyms: Dimethyl ketone, Propanone.
Appearance: Colorless liquid.
Uses: As a solvent of most resinous substances. Used in some developer formulas as a source of alkali by reaction with sulfite; useful as a drier and as an ingredient in toning formulas.
Cautions: Highly volatile and inflammable.

ACETONE SODIUM BISULFITE

Synonyms: Acetone sulfite.
Appearance: White crystals, fatty feel, almost odorless, slight sulfur odor.
Uses: Accelerator in Amidol developers.

ACID, ACETIC

Synonyms: Acid methanecarboxylic, Ethanoic acid, Purified pyroligneous acid, Vinegar.
Appearance: Clear, colorless liquid; strong pungent odor.
Common Grades: Glacial USP, 99½%; USP, 36%; photo, 28%. To prepare 28% photograde from glacial grade, dilute 3 parts acid with 8 parts of water (e.g., 150 ml of glacial acetic acid to 400 ml of water). Glacial grade solidifies at about 60°F/15°C. It is easily melted by standing in warm water.
Uses: Hardening and acid fixing baths; stop baths; as a clearing bath after ferrous oxalate development of bromide paper. Glacial acetic acid can be used as a solvent of gelatin, celluloid, and pyroxylin.

Cautions: Glacial acetic acid should not be added to sodium sulfite without dilution. It may cause decomposition of the sulfite with resulting formation of sulfur dioxide. A 28% acetic acid is the preferred concentration for photographic uses. It should never be added to hypo unless sulfite is present. Sulfurization of the hypo will result.

High concentrations of acetic acid can cause bad burns on contact with skin. However, working strength stop bath is usually only 1% to 2%, less than ordinary household vinegar.

DO NOT MIX ACETIC ACID WITH HOUSEHOLD BLEACH. Acetic acid reacts with household bleach, often used for cleaning darkroom utensils, including trays and drying racks, to form a highly toxic gas.

To prepare lower-strength acids from glacial acetic acid (USP $99\frac{1}{2}$%) use the following table:

Diluting Glacial Acetic Acid		
Strength Acetic Acid Required	Parts by Weight Water	Parts by Weight $99\frac{1}{2}$% Acid
28%	71	28
36%	63	36
56%	43	56
80%	19	80

Substitutions: White vinegar is a weak form of acetic acid, varying in strength from 3% to 15%, generally expressed in "grain" content, 10 grain being equivalent to 1%. The usual vinegar sold in grocery stores is 45-grain or $4\frac{1}{2}$% acetic acid.

Distilled vinegar of 40 to 150 grain (4% to 15%) may be purchased from vinegar manufacturers or wholesalers. A working-strength stop bath is usually in the 1% to 2% range; mixing 1 part 40-grain vinegar with 2.5 parts water will make a working-strength solution.

Acid, ascorbic

Synonyms: L-Ascorbic acid, 3-oxo-L-gulofuranolactone (enol form), Vitamin C.

Appearance: White crystals.

Uses: As a developing agent and as a preservative. As a developing agent it acts more vigorously at higher alkalinities. It is slow to get started but gives images with low fog. At low alkalinities, in combination with metol or Phenidone, ascorbic acid is an active, long-lasting developing agent.

Substitutions: The pure vitamin C powder, available from health food stores, can be used. Or you can use the tablet form and crush it to a powder with a mortar and pestle before adding. Do not weigh the tablets as insoluble starch binder adds weight. Just add up the vitamin C contents (i.e., a 500 mg tablet = 0.5 grams of vitamin C, a 1000 mg tablet = 1.0 gram). To remove the starch binder, filter the developer solution through a coffee filter (do not use the filter for coffee afterwards!).

Sodium ascorbate or sodium isoascorbate can also be substituted. Use 1.125 times the weight of vitamin C (11.25 grams of either is equivalent to 10 grams of ascorbic acid).

Hydroquinone can also be replaced by vitamin C.

See Hydroquinone; Sodium ascorbate; and Sodium isoascorbate.

ACID, BENZOIC

Synonyms: Flowers of benzoin, Phenylformic acid, Phenylmethanoic acid, Benzenecarboxylic acid.

Appearance: White crystalline needles or scales.

Uses: Preservative in emulsions; toning baths; preparing photographic paper. Restrainer in developers; has delaying action or affect upon the swelling of gelatin.

ACID, BORIC

Synonyms: Boracic acid, Hydrogen borate, Orthoboric acid.

Appearance: Colorless, odorless, transparent crystals, fine white globules, or a white amorphous powder.

Uses: As a buffer with borax, to maintain a stable pH, even when the developer is greatly diluted.

Minimizes sludging tendency and improves the hardening properties of fixing baths containing potassium alum and acetic acid. Can also be used as a stop bath (use 3% to 5% in water).

Notes: Crystalline boric acid should be used. Powdered boric acid dissolves only with great difficulty, and its use should be avoided. Boric acid is also used in roach poisons, and should not be taken internally.

ACID, CITRIC

Appearance: Colorless, odorless crystals or granules efflorescent in dry air, deliquescent in moist. Very soluble in water; freely soluble in alcohol.

Uses: Preservative; in clearing baths, emulsions, etc. As a sequestering agent and as a stop bath.

Common forms: Citric acid can be purchased in powder form from many drug and health food stores.

ACID, HYDROCHLORIC

Synonyms: Chlorhydric acid, HCL, Marine acid, Muriatic acid, Spirit of salt, Spirit of sea salt.

Appearance: Clear, colorless, or slightly yellow, fuming liquid.

Uses: Clearing pyro stains; vanadium, iron, and copper toning processes. Excellent for cleaning trays.

Substitution: A satisfactory substitute for HCL is a mixture of sodium bisulfate and sodium chloride. Mix twice as much sodium bisulfate to sodium chloride to make the substitute. Use four times as much of the substitute as hydrochloric acid required in a formula.

Concentrated (35% to 37%) HCL is expensive. Considerably less expensive muriatic acid, available from pool suppliers and hardware stores, can be

substituted by multiplying the formula amount by 1.17. For example, if the formula calls for 10 ml of HCL, multiply by 1.17 and use 11.7 ml of muriatic acid.

Cautions: Poisonous; irritating vapor; corrosive. *Always add the hydrochloric acid to the water slowly*, stirring constantly. *Never* add the water to the acid; otherwise, the solution may boil and spatter the acid on the hands or face, causing serious burns. Always use a face mask and eye protection.

ACID, NITRIC

Synonyms: Acid axotic, Aqua fortis, Hydrogen nitrate.
Appearance: Heavy, transparent, colorless or yellow, fuming, corrosive liquid.
Uses: Preservative for pyro solutions.
Cautions: Intensely poisonous; causes very painful burns. Extremely corrosive. Use proper ventilation and neoprene gloves when working with the concentrated acid. The fumes from concentrated nitric acid are harmful.
Add the acid *slowly* to the water; *never* add the water to the acid.

ACID, OXALIC

Synonyms: Ethanedioic acid.
Appearance: Transparent, colorless and odorless crystals. Freely soluble in water and alcohol; slightly soluble in ether.
Uses: Preservative for pyro solutions; sensitizer of platinotype paper; acts as a restrainer with some developers. Removes ink and some developer stains; used in toning and mordanting formulas.

ACID, SULFAMIC

Appearance: White or colorless, nonhygroscopic crystals.
Uses: As an acidifier in ammonium thiosulfate fixing baths.

ACID, SULFURIC

Synonyms: Battery acid, Chamber acid, Contact acid, Dipping acid, Fortifying acid, Hydrogen sulfate, Oil of vitriol, Tower acid, Vitriolic acid.
Appearance: A heavy, oily, colorless liquid.
Uses: Preservative for pyro solutions; in acid fixing baths and bleaching solutions; in chrome alum fixing baths.
Cautions: Poisonous and very corrosive. *Always add the sulfuric acid to the water slowly*, stirring constantly, and *never* add the water to the acid; otherwise, the solution may boil and spatter the acid on the hands or face, causing serious burns. Always wear a face mask and eye protection.

ACID, TARTARIC

Appearance: Colorless transparent crystals or granules.
Uses: Preservative for sensitized paper and emulsions.

Aerosol OT (docusate sodium)

Appearance: A waxy, solid pellet.

Uses: As a wetting agent before drying films.

Notes: Aerosol OT is the dioctyl ester of sodium sulfosuccinic acid. The standard working solution to make a wetting agent is 0.1%, but the exact strength is not critical.

Agar

Synonyms: Agar-agar, Japan Agar; Bengal, Ceylon, Chinese or Japan Isinglass or Gelatin; Layor Carang.

Appearance: Long, transparent, odorless, tasteless strips or coarse or fine powder.

Uses: Making photographic emulsions.

Notes: Insoluble in cold water; slowly soluble in hot water to a viscid solution. A 1% solution forms a stiff jelly upon cooling.

Alcohol, ethyl

Synonyms: Alcohol, Cologne spirits, Ethanol, Ethyl hydrate, Fermentation alcohol, Grain alcohol, Rectified spirits, Spirits of wine.

Appearance: Transparent, colorless, mobile, and volatile liquid, with a slight characteristic color.

Uses: As a preservative in photographic emulsions; concentrated developers; rapid drying and cleaning.

Cautions: Inflammable.

Notes: 40% alcohol is the equivalent of 40% by volume or 80 proof alcohol.

Alcohol, isopropyl

Synonyms: Dimethylcarbinol, Isopropanol, Secondary propyl alcohol.

Appearance: Colorless liquid; weak alcoholic odor resembling that of acetone.

Uses: In developing formulas for its high solvent properties. To replace alcohol wherever it is called for. To control the diffusion of solutions into emulsions.

Cautions: Inflammable.

Alcohol, methyl

Synonyms: Carbinol, Colonial spirit, Columbian spirits, Methyl hydrate, Methylic alcohol, Methanol, Pyroligneous spirit, Pyroxylic spirit, Wood alcohol, Wood naphtha.

Appearance: Clear, colorless, mobile liquid.

Uses: For denaturing ethyl alcohol; solvent; in preparing very concentrated solutions of developers; cleaning prints and negatives; to control diffusion of solutions into emulsions; the making of film cement.

Cautions: Burns with a nonilluminating flame. The presence of excessive amounts of methyl alcohol may cause softening of the film base.

ALCOHOL, TERTIARY BUTYL

Synonyms: Trimethylcarbinol, Tertiary isobutyl alcohol, Tertiary butyl alcohol.

Appearance: Colorless crystals, camphor color. Melts at 78°F/26°C to a colorless, viscid liquid.

Uses: Film cleaner.

ALUM

See Alum, ammonia; Alum, chrome, potassium; Alum, potassium; and Aluminum sulfate.

ALUM, AMMONIA

Synonyms: Alum, Aluminum-ammonia sulfate, Ammonium alum.

Appearance: Colorless crystals or white powder; styptic taste.

Uses: In fixing baths; hypo-alum (sulfide) toning; hardener for gelatin.

ALUM, CHROME, POTASSIUM

Synonyms: Chrome alum, Chromium and potassium sulfate, Potassium chromium sulfate.

Appearance: Dark violet-red crystals (ruby red by transmitted light); or light violet powder.

Uses: Preparation of chrome alum fixing bath; as hardening agent for gelatin.

ALUM, IRON

Synonyms: Ammonio-ferric alum, Ammonio-ferric sulfate, Ammonium sulfate, Ferric ammonium alum, Ferric ammonium sulfate, Ferric alum, Iron ammonia sulfate, Iron ammonium alum, Iron sulfate.

Appearance: Violet efflorescent crystals.

Uses: In reducer formulas; toning solutions; sensitizing solutions.

ALUM, POTASSIUM

Synonyms: Alum, Alum flour, Alum meal, Aluminite, Aluminum and potassium sulfate, Common alum, Cube alum, Double sulfate of aluminum and potassium, Octohedral alum salt, Potash alum, Potassic-aluminic sulfate, Potassium-aluminum sulfate, Roman alum, Sulfate of aluminum and potassium.

Appearance: Large, colorless, hard, transparent crystals or white crystalline powder.

Uses: Hardening solutions for fixing baths; ingredient of the hypo-alum toning bath; clearing bath.

Substitutions: Cake alum, found in grocery stores can be substituted for potassium alum.

ALUMINUM CHLORIDE HEXAHYDRATE

(Not to be confused with Anhydrous Aluminum Chloride.)

Appearance: White or yellowish white, deliquescent, crystalline powder. It is nearly odorless and has a sweetish, very astringent taste.

Uses: In photography as a hardener in acid fixing baths that use ammonium thiosulfate as the solvent for silver halides.

Cautions: Incompatible with alkalies.

Notes: 1 gram is soluble in 0.5 ml of water at 77°F/25°C.

ALUMINUM SULFATE

Synonyms: Concentrated alum, Papermaker's alum, Sulfate of alumina.

Appearance: White, lustrous crystals, granules, or powder.

Uses: Can be used as a substitute for alum as a hardener (ratio = 2 parts aluminum sulfate as a substitute for 3 parts alum).

See Alum, ammonium; Alum, chrome; and Alum, potassium.

AMIDOL

Formulas: Diaminophenol, 2,4 Diaminophenol dihydrochloride.

Trade Names: Acrol, Dianol.

Appearance: Fine white or bluish gray crystals.

Uses: A rapidly working developer requiring only sulfite as an accelerator. Primarily used for printing, but occasionally for negatives. Oxidizes rapidly and keeps poorly.

Amidol is one of the finest developing agents for blue-black tones on soft-emulsion bromide paper. It is also capable of creating neutral-blacks with a fine scale and transparency in the shadows.

Notes: Amidol is very soluble in water or sulfite though it deteriorates rapidly in solution. The keeping properties of amidol in solution can be improved by the addition of a weak acid, such as lactic acid. Amidol is energized by sodium sulfite alone, without the necessity of adding any alkali.

AMMONIUM ALUM See Alum, Ammonium.

AMMONIUM BROMIDE

Appearance: White crystalline powder.

Uses: As a restrainer.

Cautions: Should not be used with caustic alkalies or carbonates as ammonium is liberated.

AMMONIUM CARBONATE

Synonyms: Ammonium carbaminate, Harthorn, Rock ammonia (a mixture of ammonium carbonate and ammonium bicarbonate).

Appearance: White, hard, translucent lumps or cubes.

Uses: Replaces potassium and sodium carbonate as an accelerator; replaces ammonia water in some solutions.

Notes: Converts to bicarbonate upon exposure to air.

AMMONIUM CHLORIDE

Synonyms: Ammonium hydrochloride, Chloride of ammonia, Hydrochloride of ammonia, Muriate of ammonia, Sal ammoniac.

Appearance: White, odorless granules or powder.
Uses: To make rapid fixing baths, as an accelerator in sodium thiosulfate-based fixing baths; also used in chloride and salted albumen papers. Mild silver halide solvent.

AMMONIUM HYDROXIDE

Synonyms: Ammonia water, Strong solution of ammonia.
Appearance: Colorless liquid; intense, pungent, suffocating odor.
Uses: Accelerator of developing solutions; caustic, tending to enlarge grain structure of negatives; hypersensitizing films. An emulsion softener; causes fog on fast films.
Cautions: Keep cool in strong, glass-stoppered bottles not completely filled.

AMMONIUM PERSULFATE

Synonyms: Persulfate of ammonia.
Appearance: Colorless crystals or white crystalline powder.
Uses: Flattening reducer (i.e., reduces highlight detail more than shadows); removes developer stains.

AMMONIUM THIOCYANATE

Synonyms: Ammonium rhodanate, Ammonium rhodanide, Ammonium sulfocyanide, Ammonium sulfocyanate, Ammonium thiocyanide.
Appearance: Colorless, deliquescent crystals.
Uses: For gold toning printing-out paper.
Cautions: Keep well stoppered.

AMMONIUM THIOSULFATE

Synonyms: Ammonium hyposulfite.
Appearance: Colorless anhydrous crystals; sold in 60% solution.
Uses: Sometimes substituted for the sodium salt in rapid fixing baths. A 15% to 20% solution of ammonium thiosulfate is capable of more rapid fixation than a 35% to 40% solution of sodium thiosulfate.

ANTIFOG NO. 1 See Benzotriazole.

ANTIFOG NO. 2 (6-NITROBENZIMIDAZOLE NITRATE)

Appearance: Colorless crystals or white powder.
Uses: Antifoggant and density depressant in developers.

BAKING SODA See Sodium bicarbonate.

BALANCED ALKALI (KODALK)

Appearance: White crystals.
Uses: An alkali used as an accelerator in developers of intermediate activity between that of carbonate and borax. Developers containing Balanced Alkali usually have a pH range of 9.0 to 10.0, and the concentration varies from 2 to 50 g/L.

An advantage of this alkali is the almost proportionate change in developer activity with varying alkali concentration, permitting precise adjustments of the activity of a moderately alkaline developer.

A second advantage is that Balanced Alkali does not release a gas when added to an acid rinse or an acid fixing bath; hence it minimizes "blistering."

Substitutions: Although Balanced Alkali is a proprietary formula of the Eastman Kodak Company, the composition is known to be sodium metaborate, octahydrate. Sodium metaborate is commonly sold in the octahydrate state, as it is the most stable. Therefore, weight-for-weight substitution can be made.

Sodium carbonate can also be used as a substitute for Balanced Alkali, or vice versa. Two parts by weight of Balanced Alkali is approximately equivalent to 1 part by weight of sodium carbonate monohydrate in normal developers. A more precise substitution is to use 5.9 grams of sodium carbonate monohydrate, for each 10 grams of Balanced Alkali.

Yet another substitution is to use 4 parts sodium carbonate monohydrated and 1 part borax to equal the same weight of Balanced Alkali (e.g., 10 grams of Balanced Alkali equals 8 grams of carbonate and 2 grams of borax).

Notes: A sludge of basic aluminum sulfite is occasionally formed when a developer containing sodium carbonate reacts with a partially exhausted acid-hardening fixing bath. This sludging tendency of certain fixing baths is minimized when developers containing Balanced Alkali are used.

BENZOIC ACID See Acid, Benzoic.

BENZOTRIAZOLE

Synonyms: Aziminobenzene, Benzisotriazole.

Trade Names: Edwal's Liquid Orthazite, which contains approximately a 3% solution of benzotriazole with sodium sulfite. Kodak Anti-Fog #1 (no longer manufactured).

Appearance: Colorless crystals or white powder.

Uses: Organic antifoggant and density depressant in developers. Benzotriazole acts as a restrainer without affecting other properties of the developer. It can also be used as a fog restrainer when processing outdated paper.

When blue-black or cold-black image tones are desired with bromide papers, benzotriazole should be used in addition to, or substituted for, potassium bromide. Make a 0.2% solution of benzotriazole (2 grams benzotriazole in water at 125°F/52°C to make 1 liter) then reduce the bromide to 1/10 or 1/6 strength and use just enough benzotriazole solution to prevent developer stain or fog. A little experimentation will be required.

The same treatment can be applied to chloride and chlorobromide papers to eliminate any greenish black tendencies and/or achieve a blue-black tone.

Notes: Benzotriazole does not dissolve readily in cold water. Use hot water—125°F/52°C or higher.

BORAX

Synonyms: Biborate of soda, Biborate of sodium, Borate of soda, Borate of sodium, Purified borax, Pyroborate of soda, Sodium biborate, Sodium borate, Sodium pyroborate, Sodium tetraborate, Tetraborate of soda.

Trade Names: 20 Mule Team Borax.

Appearance: Pure white crystalline powder.

Uses: As a mild alkali accelerator in fine-grain developers and those of low activity; in certain hardening fixing baths and in some acid hardeners, especially those intended for prints that are to be dried through heated belt driers; and in gold toning baths to render them alkaline and to increase the rate of deposition of gold.

Notes: Borax is available as borax, pentahydrate, but most commonly as borax, decahydrate, the form used in photographic formulas. The old term for decahydrate is crystalline. Borax, decahydrate, and 20 Mule Team Borax are one and the same.

BORIC ACID See Acid, Boric.

BROMCRESOL PURPLE

Synonyms: Dibromo-ortho-cresol sulfonphthalein.

Appearance: Light pink, crystalline powder.

Uses: As an indicator to test the acidity of rinse and stop baths. At pH 5.2 it is yellow, and at pH 6.8 it is purple.

Note: Practically insoluble in water, but soluble in alcohol and dilute alkalies. Mix it in a little alcohol or a small volume of dilute sodium hydroxide, then add to the water.

See Indicator for Stop Baths.

BROMIDE See Potassium bromide.

CALCIUM CARBONATE, PRECIPITATED

Synonyms: Aeromatt, Albacar, Purecal, Precipitated chalk.

Appearance: White, odorless, tasteless powder.

Uses: In gold toning.

Notes: Insoluble in water, slightly soluble in water saturated with CO_2, with increased solubility in water containing ammonium salts. Dissolves in dilute acids with effervescence.

CALGON

Synonyms: Graham's salt, Sodium hexametaphosphate, Sodium polymetaphosphate.

Appearance: White flaky crystals or granules; small, broken, glass-like particles.

Uses: Water softener. Calgon has the property of holding calcium and magnesium salts in solution, even when boiling.

Notes: This chemical is packaged as Calgon Water Softener.

CARBONATE See Sodium carbonate.

CATECHOL See Pyrocatechin.

CAUSTIC ALKALI See Sodium hydroxide.

CHLORAMINE

Synonyms: Chloramine-T, Chlorazene, Chlorazone, Sodium para-Toluenesulfonchloramide, Tochloride.

Appearance: White or faintly yellow crystalline powder with a slight chlorine odor.

Uses: As an efficient hypo eliminator for negatives and prints. Used in very dilute solution (0.2%).

Notes: Slowly decomposes on exposure to air. Should be kept dry and tightly closed. Fairly soluble in water, decomposed by alcohol.

CHLORHYDROQUINONE

Formulas: 2 Chloro-1,4 dihydroxybenzene; 2-Chloro-1,4-benzenediol.
Trade Names: Adurol, Chlorquinol, C.H.Q. (Edwal).
Appearance: Fine white needles or leaflets.
Uses: For warm tones on papers, when restrained with bromide.

Notes: A derivative of hydroquinone, chlorhydroquinone was once a mainstay for warm-tone prints. Unfortunately, it is becoming increasingly hard to find, not because it is not useful as a warm-tone developing agent, but because it is both expensive and dangerous to manufacture. There is no current manufacturer of this developing agent. Any contemporary source should be considered suspect.

As a negative developer it has no advantage over metol-hydroquinone, although it does have a minimum tendency to give aerial or formalin fog.

Substitutions: Its developing properties roughly correspond to those of a mixture of hydroquinone with 5% of metol.

See Hydroquinone.

CHLORINATED LIME

Synonyms: Bleaching powder, "Calcium Hypochlorite."
Appearance: White or grayish white powder with strong odor of chlorine.
Uses: As a hypo eliminator; in reducing and clearing negatives; stain remover.

Cautions: Wear gloves and a mask when working with the powder, and use ventilation.

Notes: Composition somewhat variable. Usually contains about 35% active chlorine. Becomes moist and rapidly decomposes on exposure to air. Must be kept dry and tightly closed.

CHROME ALUM See Alum, Chrome.

CITRIC ACID See Acid, Citric.

DIAMINOPHENOL HYDROCHLORIDE See Amidol.

ELON See Metol.

ETHYL ALCOHOL See Alcohol, Ethyl.

Ferric ammonium citrate

Synonyms: Ammoniocitrate of iron, Ammonium citrate, Iron citrate, Soluble ferric citrate.

Appearance: Clear green crystals.

Uses: In iron-toning solutions.

Notes: Occurs also as brown scales, but green scales are preferred for photographic purposes. Both brown and green salts are light-sensitive. Keep well closed and protected from light.

Fresh ferric ammonium citrate tends to form a layer of mold after a few days. This can be filtered or lifted off. After the first time the mold rarely returns.

Ferric chloride

Synonyms: Chloride of iron, Ferric trichloride, Flores martis, Iron chloride, Iron perchloride, Iron sesquichloride, Iron trichloride, Sesquichloride of iron.

Appearance: Orange-yellow opaque masses or lumps.

Uses: Reduction; blue-toning.

Notes: Keep well closed.

Ferric oxalate

Synonyms: Iron Oxalate, Iron sesquioxalate.

Appearance: Greenish crystalline scales or pearls.

Uses: In iron-toning solutions.

Notes: Light-sensitive.

Ferricyanide See Potassium Ferricyanide.

Formaldehyde See Formalin.

Formalin

Synonyms: Formaldehyde Solution, Formol, Morbicid, Veracur.

Appearance: Clear, colorless liquid; suffocating odor.

Uses: Hardening bath (10% solution). In connection with hydroquinone developer, yields negatives of great contrast; useful for developing litho film. A small amount prevents swelling of gelatin in warm solutions. Also useful as a preservative.

Cautions: Poisonous; vapors attack mucous membrane of the eyes, nose, throat, causing intense irritation. Use in a well-ventilated area and exercise all handling precautions. Unless your mixing area has an effective fume hood, it is highly recommended that you mix formaldehyde outdoors, and even then an appropriately rated fume mask should be used. These masks are available from chemical supply houses such as Tri-Ess Sciences, see appendix II, Sources.

Note: Formalin is an aqueous solution of formaldehyde, 37% by weight or 40% by volume.

See Formaldehyde.

GELATIN

Synonyms: Glutin.
Appearance: Colorless or light yellow, transparent, brittle, practically odorless sheets, flakes, or coarse powder.
Uses: Preparation of emulsions, sizing paper, adhesives, light filters.
Notes: Swells up and absorbs five to ten times its weight of cold water.

GLYCERIN

Synonyms: Glycerine, Glycerol, Glyceryl hydroxide, Glycl alcohol.
Appearance: Clear, colorless, syrupy liquid.
Uses: Prevents too rapid drying; keeps gelatin emulsions of paper and films flexible.

GLYCIN

Formulas: para-Hydroxyphenyl glycine; para-Hydroxyphenylamino acetic acid.
Trade Names: Athenon (Kodak), Glyconol, Iconyl, Kodurol, Monazol (Edwal).
Appearance: Glistening white or gray powder.
Uses: Nonstaining, clear-working developer; gives fine-grained negatives of a gray-black color. Commonly used with para-phenylenediamine in fine-grain formulas; also used in paper developing formulas.
Notes: Glycin is almost insoluble in water, but it dissolves readily in alkaline solutions, thus it should be added last to any developer formula. It oxidizes very slowly and is very clean working.

Until the advent of 35mm film, with the resulting emphasis on fine-grain developers, glycin was used mainly in paper developers. Now it is sometimes used in combination with other developing agents for fine-grain film development.

Glycin is very sensitive to bromide and also to low temperature. With alkali carbonates it makes slow-working developers, which have good keeping properties and give low contrast.

Must not be confused with glycocoll medicinal, sometimes called glycine.

GOLD CHLORIDE

Synonyms: Aurochlorohydric acid, Chlorauric acid, Gold trichloride (acid).
Appearance: Bright golden yellow crystalline compound.
Uses: Gold toning.
Notes: Contains approximately 50% of gold. Keep in a tightly closed bottle and protected from light.
Caution: Gold chloride can blister the skin and then on exposure to light will leave violet-brown spots. Wear gloves when working with the powder or solution.

HYDROGEN PEROXIDE

Synonyms: Hydrogen dioxide.
Appearance: Colorless, unstable liquid.

Uses: Hypo eliminators, push-processing film.

Caution: Highly concentrated hydrogen peroxide is very caustic, but the 3% solution available from drugstores is not considered harmful.

See "Hydrogen Peroxide Technique," chapter 7.

HYDROCHLORIC ACID See Acid, Hydrochloric.

HYDROQUINONE

Formulas: 1,4 Dihydroxybenzene; para-Dihydroxybenzene.

Trade Names: Hydrochinon, Hydroquinol, Quinol, Tecquinol, Hydroquinol.

Appearance: Lustrous, silky, white needles.

Uses: Developer; builds density in combination with other developers.

Hydroquinone is generally a clean-working and nonstaining developer. It oxidizes easily both in solution and as crystals.

At temperatures below 50°F/10°C hydroquinone developers are inactive. It is extremely susceptible to the action of bromide. When compounded with alkali carbonates it gives a slow-working but contrasty developer. With caustic alkalies (e.g., sodium hydroxide) its action is very rapid, with the highest possible contrast. For this reason, it is the most widely used developer for technical applications, especially in process work where the highest attainable contrast is essential. In the presence of caustic alkali (i.e., high pH) it is not temperature-sensitive and can be used for low-temperature developing. Hydroquinone developers keep well and are slowly exhausted.

Hydroquinone alone is not largely used, but in combination with metol (MQ) or Phenidone (PQ), it is among the most popular developers. By varying the relative quantities of metol and hydroquinone and adjusting the quantities of sulfite and carbonate, almost any desired contrast or rate of development can be obtained.

Substitutions: Vitamin C can be used as a substitute for hydroquinone. Start by using 1.6 times the weight of hydroquinone, and increase the alkali (i.e., borax, carbonate, etc.) by 1.6 times to compensate for the acidity of the vitamin C.

HYPO See Sodium Thiosulfate.

IODINE

Appearance: Violet gray scales.

Uses: For bleaching bromide prints in sulfide toning; with potassium cyanide as a print reducer; for removing silver stains. Iodine stains on fingers disappear in hypo or sulfite.

IRON ALUM See Alum, Iron.

ISOPROPYL ALCOHOL See Alcohol, Isopropyl.

KODALK See Balanced Alkali.

LIQUID ORTHAZITE See Benzotriazole.

MERCURIC CHLORIDE

Appearance: White powder or heavy colorless crystals; unstable in solution when exposed to light.

Uses: Bleaching agent in mercury intensification; preparation of mercuric chloride intensifier.

Cautions: Extremely poisonous and dangerous to use. Mercuric chloride is a poisonous material and may be fatal if swallowed. Mercury salts and solutions must never be used except in adequately ventilated areas.

Mercuric chloride *must not be allowed* to contact the skin. Use impervious rubber gloves, such as Bench Mark or Bluettes, while handling these chemicals or their solutions. The outer surface of the gloves and the hands should be washed thoroughly after each use.

Containers of mercury intensifier solutions should be adequately labeled as poisonous. If they are used in the home, they should be stored in a locked cabinet out of the reach of children. Read carefully any directions on the manufacturer's label for these substances. Follow regulations of local health authorities regarding disposal of waste solutions.

METHYL ALCOHOL See Alcohol, Methyl.

METOL

Formulas: Monomethyl para-aminophenol sulfate; para-Methylaminophenyl sulfate.

Trade Names: Claritol (Defender; half-strength metol), Elon (Kodak), Enol, Genol, Graphol, Metol (Agfa and others), Pictol (Mallinckrodt), Photol (Merck), Planetol, Rhodol (DuPont), Veritol (Defender).

Appearance: White to slightly yellowish powder.

Uses: As a developing agent, usually with hydroquinone, but sometimes by itself, as in Kodak D-23.

Although metol is easily soluble in water, it is not soluble in a strong sodium sulfite solution. It does dissolve readily in a weak solution of sulfite. Metol builds image detail rapidly, and it keeps well in solution.

Metol has low-fogging tendencies and responds well to the addition of bromide, giving a very clean-working developer without any staining of either film or fingers. The energy of the developer is only slightly affected by low temperature and is only slightly reduced by the addition of bromide.

Metol alone with either sodium or potassium carbonates gives a rapid-working developer when the alkalies are in high concentration, but the speed of development can easily be controlled by dilution.

The use of caustic alkali (e.g., sodium hydroxide) is not recommended with metol as there is a tendency to excessive fog. When used with sulfite alone, without additional alkali (Kodak D-23), metol provides a slow-working, fine-grain developer. This type of film developer often works well with a mild alkali, such as borax, which accelerates the rate of development without increasing the grain size appreciably (Kodak D-25).

Developers containing metol as the sole developing agent are not widely used, but metol with hydroquinone provides the most widely used developer combination.

Substitution: Phenidone can be substituted for metol. Start by using approximately 10% of the quantity of metol.

Cautions: Metol has a reputation for causing skin poisoning (a painful rash that looks and feels like poison oak). It includes severe itching, red rash, and peeling skin. This poisoning usually occurs after being exposed to the substance over a period of years but in some cases can happen even sooner.

It is believed that metol poisoning results from trace contamination of para-phenylenediamine in the metol, not from the metol itself. Knowledge of this has changed the manufacturing process, and as a result, metol poisoning is less common than it once was.

Good-quality metol does not usually cause a rash. However, some people are still sensitive to even the purest grade of metol. It is possible to avoid metol poisoning either by wearing protective gloves or by substituting Phenidone.

See "Superadditivity" in chapter 4, Developers.

Monomethyl para-aminophenol sulfate See Metol.

Nitric acid See Acid, Nitric.

6-Nitrobenzimidazole nitrate See Antifog No. 2.

Ortho-phenylenediamine

Formulas: 1,2-Benzenediamine, ortho-Diaminobenzene, para-aminophenol hydrochloride.

Appearance: White to brownish-yellow crystals.

Uses: As a fine-grain silver solvent; a substitute for p-phenylenediamine; or very weak developing agent. Usually used in combination with metol.

See para-phenylenediamine.

Para-aminophenol hydrochloride

Formulas: 4-Amino-1hydroxy-benzene hydrochloride; para-Hydroxyaniline.

Trade Names: Activol, Azol, Kodelon (Kodak), Para, Rhodinal.

Appearance: White, crystalline substance.

Uses: As a developing agent used in conjunction with sodium or potassium carbonates or with caustic alkalies. The sodium salt of this is the developing agent in the concentrated solution of prepared developer. It is marketed under the trade name of Rodinal by Agfa.

At one time this was a very popular developing agent. In 1931 the Eighth International Congress of Photography adopted as a standard developer for scientific sensitometric work the following formula:

para-Aminophenol hydrochloride	7.25 grams
Sodium sulfite, anhydrous	50.0 grams
Sodium carbonate, anhydrous	50.0 grams
Water to make	1.0 liter

p-Aminophenol hydrochloride is very soluble in cold water. Its principal use is in the preparation of very concentrated developers with caustic alkalies

that could be diluted from 20 to 100 times. Concentrates keep well and should not be diluted until immediately before use.

These developers work rapidly, are free from fogging properties, and do not stain. They are not sensitive to temperature variations, nor do high temperatures affect their clean working. Tropical Process Developer, Kodak D-13, is an example. (D-13 is not given in *The Darkroom Cookbook*; instead DK-15 and DK-15a are given.)

Carbonate should not be used with this substance as it precipitates out the base and prevents the preparation of any but very dilute solutions.

PARA-AMINOPHENOL SULFATE See Metol.

PARAFORMALDEHYDE

Synonyms: Paraform, Polymerized formic aldehyde.
Appearance: White, crystalline powder.
Uses: Produces formalin when dissolved in water. It is also an emulsion hardener and reacts with sodium sulfite to form sodium hydroxide.
See Cautions under Formalin before using.

PARA-HYDROXYPHENYL GLYCIN See Glycin.

PARA-PHENYLENEDIAMINE

Formulas: para-Diaminobenzene; 1,4-Diaminobenzene.
Trade Names: Diamine, Diamine P, Paramine Metacarbol (free base), and Para D.
Appearance: White to slightly reddish crystals in photogrades.
Uses: Very low energy developer; produces negatives of minimum graininess. Often used in combination with glycin and/or metol.

p-Phenylenediamine is the classic superfine-grain developer. Besides the cautions that follow, it requires strong overexposure of the film and a very long developing time, often twenty minutes or more, and even then the contrast of the resulting negatives is rather low.

As a result, there have been efforts to replace p-phenylenediamine with other agents. One of the more successful is the Windisch Superfine-Grain Developer that uses o-phenylenediamine. This agent also has weak developing properties, but it works as a good solvent for silver halide.

Cautions: Toxic and stains hands, clothing, and other things on prolonged contact. The free base of para-phenylenediamine and its water soluble salts may cause eczema or other skin irritations. Always wear a good dust mask when working with the powder and gloves when working with the powder or the solutions.
Notes: Only slightly soluble in water.
See ortho-Phenylenediamine and para-Phenylenediamine Hydrochloride.

PARA-PHENYLENEDIAMINE HYDROCHLORIDE

Trade Names: Diamine H, P.D.H.
Appearance: White or grayish white to slightly reddish crystalline powder.

Uses: As a developing agent for fine-grain images; used in combination with other developing agents. para-Phenylenediamine hydrochloride has the same general characteristics as its base (para-Phenylenediamine), except that an alkali is required to make it function as a developer. It is preferable to the base on account of better solubility and keeping properties. Unfortunately, much larger quantities are required and therefore all standard formulas use the base.

Cautions: Toxic and stains hands, clothing, and other things on prolonged contact. Can cause eczema and other skin irritations. Always wear a good dust mask when working with the powder and gloves when working with the powder or solutions.

Notes: Only slightly soluble in water, but much more soluble as the hydrochloride.

PHENIDONE

Formulas: 1-Phenyl-3-pyrazolidone; 1-Phenyl-3-pyrazilidinone.
Trade Names: Fotodone (Mallinckrodt), Graphidone.
Appearance: White or slightly yellow powder; colorless crystals.
Uses: As a hypoallergenic developing agent (this means it is unlikely to cause dermatitis) that can be substituted for metol. Sufferers of metol poisoning can often use Phenidone-based developers without ill effects.

Notes: Phenidone is sparingly soluble in cold water and moderately in hot and can require temperatures of 175°F/80°C to dissolve. It is readily soluble in both aqueous acids and alkalies, including solutions of alkali bisulfites and carbonates, so that it can easily be incorporated into a developer solution.

Used alone in sodium carbonate/sulfite solutions, it is very fast but extremely soft working and is only capable of producing negatives of low contrast. In combination with hydroquinone it produces developers with superadditivity that are even more efficient than MQ developers.

Phenidone-based developers keep better than those based on metol. The reason is the oxidation product of Phenidone is more efficiently regenerated by hydroquinone than is metol.

Additionally, while the first oxidation product of hydroquinone, mono-sulphonate, forms an almost inert system with metol, it has a superadditive effect with Phenidone, increasing developing power.

Because very small amounts of Phenidone are required, it is often desirable to use a percentage solution. A concentrate of Phenidone, containing a preservative, can be made as follows:

Water (125°F/52°C)	24 oz	750 ml
Sodium bisulfite	90 grains	6 grams
Phenidone	30 grains	2 grams
Cold water to make	32 oz	1 liter

For use, 100 ml of the concentrate contains 0.2 grams of Phenidone. The preservative will have no appreciable effect on any developing formula.

Alternately, a 5% concentration can be made using methyl hydrate instead of water, but it does not keep. Use immediately.

Substitution: Phenidone can be substituted for metol. There is evidence that as a substitute for metol it causes a true increase in film speed. However, Phenidone should not be used as a substitute in developers in which metol is the sole developing agent, such as Kodak D-23 and D-25. Try substituting approximately 10% of the amount of Phenidone for the amount of metol required.

See "Superadditivity" in chapter 4, Developers.

PINAKRYPTOL GREEN

Appearance: Small, granular crystals.
Uses: Used as a desensitizer for ordinary orthochromatic or panchromatic films. May be used as a forebath or mixed with the developer.
Notes: Soluble in water, giving a green solution that does not stain gelatin.

PINAKRYPTOL YELLOW

Notes: More powerful than pinakryptol green at the same concentration and more active in reducing the color sensitivity of films. It *cannot* be added to the developer as it is destroyed by sodium sulfite; use as a prebath only.

POTASSA SULFURATED

Synonyms: Hepar sulfuris, Liver of sulfur, Potassium trisulfide.
Appearance: Yellowish brown lumps; slight odor.
Uses: To precipitate silver from photographic waste. Used in toning formulas.
Notes: Decomposes upon exposure to air. Potassa sulfurated often becomes coated with a hard crust having no value. This crust should be broken away as much as possible before weighing out the inner part.

POTASSIUM ALUM See Alum, Potassium.

POTASSIUM BICHROMATE

Synonyms: Bichromate of potash, Bichromate of potassa, Potassium dichromate, Red chromate of potash, Red chromate of potassa.
Appearance: Bright, orange-red crystals.
Uses: Bleaching ingredient in tray cleaners and chromium intensifiers.

POTASSIUM BROMIDE

Synonyms: Bromide, Bromide of potash, Bromide of potassium.
Appearance: White crystalline granules or powder.
Uses: Fog preventer and restrainer in developing solutions.
Potassium bromide is the most commonly used restrainer in developing formulas, especially those using hydroquinone, pyrocatechin, or pyrogallol. The addition of potassium bromide usually results in a reduction of contrast and can have a warming effect on image tone when used in paper developers. It is also used as an ingredient in intensifying, reducing, toning, and many other photographic solutions.

POTASSIUM CARBONATE

Synonyms: Carbonate of potash, Pearl ash, Potash, Salt of tartar, Salt of wormwood, Subcarbonate of potash.

Appearance: White, deliquescent, granular powder.

Uses: Since potassium carbonate is more soluble than sodium carbonate, it is used in concentrated solutions where an alkali is needed.

Potassium carbonate can be substituted for sodium carbonate as an alkali accelerator in developers. As its solubility is much greater, developers with greater concentration can be formulated. Thirteen parts by weight are equal to 10 parts by weight of sodium carbonate. Substituting potassium carbonate for sodium carbonate will help to obtain warmer tones in paper development.

Substitution: To substitute potassium carbonate anhydrous, multiply the amount of sodium carbonate monohydrate by 0.90.

See Sodium carbonate.

POTASSIUM CHLORIDE

Synonyms: Chloride of potash, Muriate of potash.

Appearance: Colorless or white crystals or powder.

Uses: In special developing formulas.

POTASSIUM CITRATE

Synonyms: Tribasic citrate of potash.

Appearance: White granular powder.

Uses: As a restrainer in alkaline development; used in several copper toning baths.

POTASSIUM CYANIDE

Synonyms: Cyanide of potash, "cyanide."

Appearance: White, granular salt.

Uses: Monckhoven's Intensifier.

Substitutions: Sodium cyanide.

Caution: DEADLY POISON; DANGEROUS TO HANDLE. Potassium cyanide reacts with acids (e.g., acetic acid) to form the poisonous gas, hydrogen cyanide. Cyanide salts and solutions must never be used except in adequately ventilated areas. Potassium cyanide *must not be allowed* to contact the skin. Use impervious rubber gloves, such as Bench Mark or Bluettes, while handling these chemicals or their solutions. The outer surface of the gloves and the hands should be washed thoroughly after each use.

POTASSIUM FERRICYANIDE

Synonyms: Ferricyanide, Ferricyanide of potash, Red praised of potash.

Appearance: Ruby red, lustrous crystals.

Uses: Principal use is in conjunction with hypo, forming Farmer's Reducer; used in iron printing processes and as a bleach before sulfide toning; also in dye-toning formulas.

Notes: Keep protected from light.

POTASSIUM FERROCYANIDE

Synonyms: Ferrocyanide of potash, Yellow prussiate of potash.
Appearance: Lemon yellow crystals or powder.
Uses: A small amount in pyro and hydroquinone developers tends to lower fog and give greater density.
Notes: It is light-sensitive in solution.

POTASSIUM HYDROXIDE

Synonyms: Caustic potash, Caustic potassa, Hydrate of potassa, Potassium hydrate.
Appearance: White, deliquescent lumps or sticks.
Uses: Caustic alkali accelerator in development.
Cautions: Poisonous; attacks the skin, inflicting severe burns. Extremely corrosive. Keep in a tightly sealed bottle and wear gloves.

POTASSIUM IODIDE

Synonyms: Iodide of potash.
Appearance: White crystals, granules, or powder.
Uses: In preparation of mercuric chloride intensifier; has the property of reducing emulsion fog, dissolving iodine.

POTASSIUM METABISULFITE

Synonyms: Metabisulfite of potash, Potassium pyrosulfite.
Appearance: Transparent needle crystals or crystalline powder.
Uses: As a preservative in developers; used in place of sodium sulfite in some developers. Also used for acidifying fixing baths.
Notes: Replaces sodium bisulfite weight for weight. Deteriorates rapidly in air.

POTASSIUM PERMANGANATE

Synonyms: Permanganate of potash.
Appearance: Purple-black crystals of metallic luster.
Uses: As a reducer (acid solution); test for hypo; hypo eliminator; stain remover and bleacher in redevelopment.
Cautions: Powerful oxidizing agent; its stain can be removed with a solution of potassium metabisulfite or sodium bisulfite.

POTASSIUM PERSULFATE

Synonyms: Anthion
Appearance: Colorless or white odorless crystals.
Uses: As a hypo eliminator.
Notes: Keep well closed in a cool place.
Cautions: A powerful oxidizing agent.

POTASSIUM SULFIDE

Appearance: Yellow to yellowish red crystals.
Uses: Toning baths.

POTASSIUM THIOCYANATE

Synonyms: Potassium rhodanide, Potassium sulfocyanate, Potassium sulfocyanide, Sulfocyanate, Rhodamide.
Appearance: Colorless, deliquescent crystals.
Uses: Thiocyanate toning baths; silver halide solvent.

Potassium thiocyanate can produce actual reduction in the size of individual silver halide grains by virtue of its dissolving action. As a result of physical development, it produces a more homogeneous deposition of silver. It is used in concentrations of 1.0 to 1.5 g/L in certain developers, such as Kodak DK-20 (DK-20 is not included in the formulas found in this edition).
Notes: Because of its deliquescent nature, thiocyanate should be used in percentage solutions.

PYROCATECHIN

Formulas: 1,2-Dihydroxybenzene; ortho-Dihydroxybenzene.
Synonyms: Catechol, Pyrocatechol.
Appearance: Colorless crystalline needles or scales.
Uses: Developing agent for film or paper; gives warm black images; with caustic soda, gives rapid development with high contrast.

Pyrocatechin is easily soluble in warm water. It is chemically akin to hydroquinone but with special properties, notably the fact that it oxidizes readily and its oxidation products have a tanning effect upon gelatin.

When used without sulfite, or a very low sulfite content, it gives a heavily stained image and tans the gelatin in proportion to the density of the image. This property has led to its use for high-definition and tanning developers (Windisch Extreme Compensating Developer). Used with caustic alkali it is one of the best compensating developers (Maxim Muir's Pyrocatechin Compensating Developer).
Notes: All developers containing pyrocatechin should be mixed with distilled water, whether or not the formula calls for it.
Caution: Poisonous; wear a dust mask and gloves when working with the powder, use adequate ventilation, and wear gloves when using the working solutions. Clean up any powder or spilled solutions, and dispose of the residue safely.

PYROGALLOL

Formulas: 1,2,3 Trihydroxy-benzene; 1,2,3-Benzenetriol.
Trade Names: Piral, Pyro, Pyrogallic acid, Trihydroxybenzene.
Appearance: Fine white powdery crystals (sublimed) or heavy, prismatic crystals; properties of the two forms are the same.
Uses: Active agent in pyro developers.

At one time, pyro was a universally used developer. It was even available in prepackaged formulas from companies such as Eastman Kodak. Unfortunately, it has been almost entirely replaced by metol-hydroquinone- and Phenidone-hydroquinone-type developers. The main reasons are that pyro stains, it must be handled carefully, and it does not keep well in solution. In other words, it is not as commercially viable as other forms of developers.

When used correctly, pyro creates a stained image of unprecedented tonal scale, especially in the high values. In combination with either metol or Phenidone, it exhibits superadditive characteristics. It produces an overall stain on the negative, which adds to the contrast of the silver image. The stain is a desirable part of a properly developed pyro image.

Pyro tends to oxidize very rapidly in solution and cannot be kept without the aid of preservatives such as sulfuric or other acids, sulfites, etc. Pyro should be added *after* these preservatives have been mixed with the water. Pyro oxidation products act as strong antifogging agents.

Caution: Poisonous; wear a dust mask and gloves when working with the powder, use adequate ventilation, and wear gloves when using the working solutions. Clean up any powder or spilled solutions, and dispose of the residue safely.

See "Superadditivity" in chapter 4, Developers; see chapter 8, Pyro Developers.

SILVER NITRATE

Synonyms: Lapis caustic, Luna caustic, Lunar caustic, Nitrate of silver.
Appearance: Colorless, flat crystals.
Uses: Most important silver salt used in photography; emulsion making; intensification; etc.
Cautions: Stains on fingers can be removed by rubbing with tincture of iodine followed by a strong solution of hypo. Wear a dust mask when working with the powder and gloves when working with either the powder or solutions.

SODA See Sodium carbonate.

SODIUM ACETATE

Synonyms: Acetate of soda.
Appearance: Colorless, transparent, efflorescent crystals.
Uses: Toning baths; retarder in hydroquinone developer; used to buffer acidity of acid solutions.
Notes: Keep in a tightly sealed bottle in a cool place.

SODIUM ASCORBATE

Synonyms: Soda ascorbate, Sodium Isoascorbate, Vitamin C sodium.
Appearance: White crystals.
Uses: As an ecologically friendly developing agent, usually in combination with metol or Phenidone. May be used as a substitute for ascorbic acid in film developers (see Acid, ascorbic). May also be used as a substitute for hydroquinone. Try using 1.8 times the weight of the hydroquinone. The alkali does not have to be increased because sodium ascorbate is not acidic.
Substitutions: Sodium ascorbate is available in health food stores and the canning goods department of some grocery stores. Ten grams of sodium

ascorbate can be substituted with 8.89 grams of ascorbic acid. Sodium ascorbate can be replaced with sodium isoascorbate, weight for weight.

See Acid, ascorbic; Hydroquinone; and Sodium isoascorbate.

SODIUM BICARBONATE

Synonyms: Acid sodium carbonate, Baking soda, Bicarbonate of soda, Monosodic carbonate, Sodium hydrocarbonate, Sodium hydrogen carbonate.

Appearance: Fine, white powder.

Uses: In hypo baths for fixing self-toning papers; in gold toning baths; in developers to inhibit fog.

SODIUM BISULFATE

Synonyms: Sodium acid sulfate, Sodium hydrogen sulfate.

Appearance: White, crystalline powder.

Uses: Acid rinse and stop baths. In combination with sodium acetate, used as a substitute for acetic acid.

Sodium bisulfate can be used in conjunction with sodium chloride to make a substitute for hydrochloric acid.

SODIUM BISULFITE

Synonyms: Acid sulfite of soda, Leucogen.

Appearance: White, crystalline powder.

Uses: In acidulating and preserving fixing baths; as a preservative for pyro developer; for removing silver stains from printing-out paper.

Notes: Can be substituted weight for weight with sodium metabisulfite.

SODIUM BROMIDE

Synonyms: Bromide of soda.

Appearance: White or colorless granules or granular powder.

Uses: As a restrainer in developers.

SODIUM CARBONATE

Synonyms: Carbonate, Carbonate of soda, Sal soda, Soda, Soda ash, Washing soda.

Appearance: White or colorless, granules or granular powder.

Uses: One of the principal alkalies (accelerators) used in development.

Cautions: Sodium carbonate releases a gas when added to an acid stop bath or an acid fixing bath; this gas may cause pinholes, or "blistering," to develop in film emulsions.

Substitutions: Balanced Alkali (Kodalk) can be used as a substitute for carbonate or vice versa.

Sodium carbonate is commonly available in anhydrous and monohydrous forms. The crystalline form is available as Arm & Hammer Washing Soda, which is sodium carbonate decahydrate (use the yellow, unscented box). This can be safely substituted in almost all formulas calling for carbonate.

See "Alkali Substitutions" in Conversion Tables.

SODIUM CHLORIDE

Synonyms: Carbonate of soda, Common salt, Kosher salt, Muriate of soda, Rock salt, Salt, Sea salt.

Appearance: Colorless, transparent crystals or white crystalline powder.

Uses: In preparation of chloride emulsions; salting papers before sensitizing and before toning; in hypo alum toning formulas, also acts as a weak restrainer.

Substitutions: Sodium chloride is simply common table salt. However, in the United States, it is almost always mixed with iodine and the iodine is variable in nature and amount. Therefore, if you wish to buy your sodium chloride from your grocer rather than support a struggling chemical supplier, use Kosher salt, which is not iodized.

Notes: Can be used in conjunction with sodium bisulfate to make a substitute for hydrochloric acid.

See Acid, hydrochloric.

SODIUM CYANIDE

Appearance: White, deliquescent granules or lumps.

Uses: Monckhoven's Intensifier.

Substitutions: Potassium cyanide.

Caution: DEADLY POISON; DANGEROUS TO HANDLE. Sodium cyanide reacts with acids (e.g., acetic acid) to form the poisonous gas, hydrogen cyanide. Cyanide salts and solutions must never be used except in adequately ventilated areas. Sodium cyanide *must not be allowed* to contact the skin. Use impervious rubber gloves, such as Bench Mark or Bluettes, while handling these chemicals or their solutions. The outer surface of the gloves and the hands should be washed thoroughly after each use.

SODIUM HEXAMETAPHOSPHATE See Calgon.

SODIUM HYDROXIDE

Synonyms: Caustic alkali, Caustic soda, Hydrate of soda, Hydrated oxide of sodium, Mineral alkali, Soda lye, Sodic hydrate, Sodium hydrate.

Trade Names: Red Devil Lye.

Appearance: White, deliquescent lumps or sticks.

Uses: High-energy accelerator or alkali sometimes used to activate low-energy developing agents (e.g., hydroquinone).

Caustic alkalies are most often used where a powerful and quick-acting developer is required. Developers compounded with caustic alkali have poor keeping properties and are soon exhausted.

Substitutions: Red Devil Lye, available in hardware and grocery stores, can be substituted in almost all formulas for sodium hydroxide.

Notes: Store in a well-sealed bottle. Weigh it rapidly as it can pick up moisture from the air and change its weight.

Cautions: Of all the chemicals commonly used in the black and white darkroom, this is perhaps the most caustic. It is the same chemical used in many commercial drain cleaners.

Cold water should always be used when dissolving sodium hydroxide because considerable heat is generated. If hot water is used, the solution will boil with explosive violence and may result in serious burns. If the water is not cold enough, the solution may start to steam. If this should occur, add some ice to cool the solution. DO NOT BREATHE THE VAPOR. If it starts to steam and you cannot get it to cool, leave the room until it is cool.

The best method to mix a solution of sodium hydroxide is to measure out the amount to be used, place it in a dry glass or plastic mixing container, and slowly add cold water.

It is a good practice to dissolve sodium hydroxide separately in a small amount of cold water, then add the solution after the developing agent has been dissolved, stirring vigorously.

Wear a face mask, gloves, and eye protection when working with the powder and solutions.

SODIUM ISOASCORBATE

Synonyms: Isovitamin C sodium.
Appearance: White Crystals.
Uses: As an ecologically friendly developing agent, usually in combination with metol or Phenidone. It can also be used as a substitute for hydroquinone. Start with 1.8 times the weight of the hydroquinone. Sodium isoascorbate is not acidic so the alkali does not have to be increased.
Substitutions: As with sodium ascorbate, 10 grams of sodium isoascorbate can be substituted with 8.89 grams of ascorbic acid. Sodium isoascorbate can be replaced with sodium ascorbate, weight for weight.
Notes: Sodium isoascorbate is made up of the same chemicals as sodium ascorbate, but they are combined in a different pattern. This matters to our bodies, but not to an emulsion!
See Acid, ascorbic, and Sodium ascorbate.

SODIUM METABISULFITE

Synonyms: Sodium pyrosulfite.
Appearance: Colorless crystals or white powder.
Uses: As a preservative in developers; used in place of sodium sulfite in some developers, particularly in two-solution formulas where the increased acidity of the metabisulfite inhibits oxidation. For acidifying fixing baths.
Notes: Can be substituted weight for weight with sodium bisulfite.

SODIUM METABORATE

Trade Names: Kodak Balanced Alkali, Kodalk.
Appearance: White crystals.
Uses: As a mild alkali accelerator in developers of moderate to high alkalinity. Used to avoid the creation of gas when it comes in contact with an acid. For this reason the possibility of blister formation is minimized.
Substitutions: Sodium metaborate, octahydrate ($8H_2O$), and Balanced Alkali (Kodalk) are, for all practical purposes, the same. Substitution can be made weight for weight.

A substitution for sodium metaborate octahydrate is to use 9.5 grams of sodium hydroxide and 45.4 grams of borax decahydrated in water to make 1 liter. This is equivalent to a 10% solution of sodium metaborate octahydrate. This can be made from Red Devil Lye and 20 Mule Team Borax and safely used in formulas as a substitute (20 ml of a 10% solution = 2 grams; 25 ml = 2.5 grams; etc.).

SODIUM PHOSPHATE (DIBASIC)

Synonyms: Disodium orthophosphate, Disodium phosphate, DSP, Secondary sodium phosphate.
Appearance: Colorless, transparent crystals.
Uses: Gold toning; silver chloride emulsions.

SODIUM PHOSPHATE (TRIBASIC)

Synonyms: Normal sodium ortho-phosphate, Tribasic, Trisodium orthophosphate, Trisodium phosphate, TSP, Tribasic sodium phosphate.
Appearance: Colorless, needle crystals; smaller than the dibasic crystals.
Uses: An alkali used as a substitute for caustic and carbonate alkalies in negative development. Used as a water softener. Good for cleaning and detoxifying vessels and trays that contained fixer.

SODIUM SULFANTIMONIATE

Synonyms: Sodium thioantimoniate, Schlippe's salt.
Appearance: Large colorless or yellow crystals.
Uses: Toning bromides; negative intensification.

SODIUM SULFATE

Synonyms: Dried sodium sulfate, Glauber's salt, Sulfate of soda, Vitriolated soda.
Appearance: White powder.
Notes: In nonswelling acid rinse baths for roll film and in tropical developers for use at high temperatures.
Store in a tightly sealed bottle and store in a cool place.

SODIUM SULFIDE

Synonyms: Sulfide of soda.
Appearance: Colorless, or slightly yellow deliquescent crystals.
Uses: Sulfide toning; silver recovery.
Cautions: Should not be kept near light-sensitive materials as it tends to bring about their deterioration. Has the odor of rotten eggs or a high school chemistry experiment.
Store in a tightly sealed bottle and store in a cool place. Do not handle with bare hands.

SODIUM SULFITE

Synonyms: Sulfite, Sulfite of soda.
Appearance: White crystals or powder.

Uses: As a preservative of developing agents; constituent of the acid fixing bath; blackener in negative intensification; active energizer in amidol development.

Sodium sulfite is the most widely used preservative in developers. It also plays an important part in the process itself. By using a sufficient quantity of sulfite, you can prevent the formation of many undesirable by-products during development.

Sulfite is also an important solvent for silver halide. It can therefore have a noticeable effect on the graininess of the silver image at concentrations over 50 g/L.

SODIUM TETRABORATE See Borax.

SODIUM THIOCYANATE

Synonyms: Potassium rhodanide, Sodium sulfocyanate, Rhodanide.
Appearance: Colorless or white deliquescent crystals.
Uses: Substitute for potassium thiocyanate weight for weight.
Notes: When sodium thiocyanate is dissolved, the temperature of the water is considerably lowered.

Also, because of its deliquescent nature, thiocyanate should be used in percentage solutions.

SODIUM THIOSULFATE

Synonyms: Antichlor, Hypo, Hyposulfite of soda, Sodium hyposulfite, Sodium subsulfite.
Appearance: Large, white, transparent crystals and powder.
Uses: In preparation of fixing baths; ingredient in various reducers.

Sodium thiosulfate is one of a few known substances that will dissolve silver bromide. As such it is universally used in modern photographic procedures. In this process, which is known as "fixation," the unexposed silver bromide is dissolved in the sodium thiosulfate by combining with it to form soluble complex thiosulfates of silver and sodium.

Notes: Hypo is available in two forms: anhydrous and, more commonly, crystalline. Crystalline hypo, when dissolved, lowers the temperature of the water considerably, whereas anhydrous does not. Always begin with water of at least 90°F/32°C when mixing the crystalline form. Use 64% of the anhydrous salt as a substitute for crystalline hypo.

See "Fixers" in chapter 10, Stop Baths and Fixers.

STARCH

Uses: For sizing papers and in preparing pastes and adhesives.
Notes: Insoluble in cold water; soluble in hot water, forming a jelly on cooling.

SULFAMIC ACID See Acid, Sulfamic.

SULFOCYANATE See Potassium thiocyanate.

Sulfurated potash See Potassa sulfurated.

Sulfuric acid See Acid, Sulfuric.

Tartaric acid See Acid, Tartaric.

Tertiary butyl alcohol See Alcohol, Tertiary Butyl.

Thiocarbamide See Thiourea.

Thiourea

 Synonyms: Sulfocarbamide, Sulfourea, Thiocarbamide.
 Appearance: White, prismatic crystals.
 Uses: In gold toning baths; clearing yellow stains from prints; in mordant solutions for dye toning.

Trisodium phosphate See Sodium Phosphate (Tribasic).

4 Developers

Developers are made up of four basic components:

- Developing agent.
- Preservative, which slows the rate of developer oxidation.
- Accelerator (or alkali), which energizes the developer.
- Restrainer, which restricts the formation of excessive fog and/or slows the rate of development.

All four of these components are necessary for the development process to be successful. Often, however, one chemical will serve more than one function. For example, sodium sulfite is usually used as a preservative to prevent oxidation. In the film developing formula Kodak D-23 the large amount of sodium sulfite (100 grams) serves to create an environment sufficiently alkaline that the developing agent, metol, can reduce the silver halide without an additional accelerator. As development progresses, soluble bromide is precipitated out of the film, acting as an effective restrainer. D-23 has only two chemicals—metol and sodium sulfite—yet as a developer it has all four of the required components!

Developing Agents

For the non-chemist, development is a reduction process. Silver halide[1] crystals are selectively reduced, through the action of a developer, to metallic silver. In order to be reduced, the silver halide must first be exposed to light.

[1]Silver halide is a group that includes silver bromide, silver chloride, and silver iodide. Film emulsions consist of silver bromide with small amounts of silver iodide. Paper emulsions can be either silver bromide, silver chloride, or a combination of the two, usually with small amounts of silver iodide. As silver bromide is the most common of the three, it is often used when referring to film and developing processes.

Exposure to light changes its electrical charge and makes it sensitive to the action of the developer.

When light is sharply focused by a lens, on film or paper, certain areas receive more exposure than others. The more light an area receives, the more silver halide is affected and subsequently reduced to metallic silver. The more metallic silver in an area of the film or paper, the darker it appears.

There are many chemical agents that will reduce silver halide to metallic silver, but developing agents are a special kind of reducing agent because they act only on silver halide that has been exposed to light.

The following are the four most common developing agents in use today:

- Hydroquinone
- Metol
- Phenidone
- Ascorbic Acid

Other agents more commonly used in the past are as follows:

- Pyrogallic Acid (pyro)
- Amidol
- Glycin
- para-Aminophenol hydrochloride
- Chlorhydroquinone
- Pyrocatechin (Catechol)
- para-Phenylenediamine (ppd)

All of the above developing agents have unique characteristics, and some have a special purpose. The shortening of the list of modern developing agents has more to do with ease of manufacture, storage, and shipping than it does with their usefulness. The superadditive effects of hydroquinone, metol, Phenidone, and ascorbic acid (see discussion later in this chapter) has also added to their popularity with manufacturers.

Developing agents for film can be used for paper and vice versa. In practical terms, some developing agents are more advantageous to use in one process or the other. For example, ppd is better suited for film development than for paper development, while chlorhydroquinone is better with paper than with film. Hydroquinone, metol, ascorbic acid, and Phenidone are well suited for either film or paper. This is an additional reason they are preferred by manufacturers. It is worthwhile to familiarize yourself with the brief description of each developing agent in chapter 3, Pharmacopoeia.

Superadditivity

The phenomenon known as superadditivity plays an important role in many film developers. Superadditivity occurs when the combined result of two developing agents is greater than either one of them working alone.

As a developing agent, metol provides good low-contrast shadow detail but produces weak highlight density. It is also fast acting. Hydroquinone, on the other hand, is a slow-acting developer, which, when used alone, is capable of creating strong highlights and high-contrast images.

Combining metol with hydroquinone results in a developer that is faster than metol alone and produces contrast equal to, or greater than, that of hydroquinone alone. Developers of this kind are known as MQ (metol and Quinol, Kodak's trade name for hydroquinone). The optimum quantity of metol to hydroquinone is said to be 28% metol to the total amount of hydroquinone in the formula.

The phenomenon of superadditivity is even more pronounced when Phenidone and hydroquinone are combined (PQ). Phenidone on its own is almost useless as a developing agent, one exception being the low-contrast developer, POTA, as Phenidone is fast acting but produces extremely low contrast negatives. By adding a comparatively small quantity to a hydroquinone developer, Phenidone retains its high activity and combines with it the higher contrast of hydroquinone. The optimum amount of Phenidone to hydroquinone is said to be 7%.

Under most conditions, Phenidone is about 18 times more efficient than metol. An optimized PQ developer is 50% faster than a comparable MQ developer. However, this increased efficiency has its downside. PQ developers often have a tendency to produce more fog. Fortunately, this can be controlled by the addition of benzotriazole in the amount of 0.1 to 0.2 g/L (because of the difficulty of measuring small amounts it is easier to use 5 to 10 ml of a 2% benzotriazole solution).

Finally, the higher the proportion of either metol or Phenidone, the lower the contrast of the negative or print. Conversely, the higher the proportion of hydroquinone, the higher the contrast.

Other superadditive combinations are pyro-metol, metol-ascorbic acid, Phenidone-ascorbic acid, and Phenidone-glycin. The superadditive effects are similar, while the resulting negatives exhibit their own unique qualities.

Trouble in Paradise

From the above it would seem that the best developers to use are those that exhibit superadditive characteristics. Most general-purpose developers fall into this category, as do many other formulas. However, there is a flip side. Most developers that utilize this effect tend to yield greater high-value density than those that rely on one developing agent. A developer of the semi-compensating type using either metol or pyro alone in a solution of relatively low pH, is capable of producing brilliant high values, full-scale midtones, and shadows (e.g., Kodak D-23 and Kodak D-1, ABC Pyro, especially Edward Weston's variation).

With the average MQ or PQ developer, by the time the required shadow density is reached, the high-value densities may be too severe. On the other hand, development to the desired high values may produce insufficient shadow densities! For this reason, many photographers who use general purpose MQ or PQ developers use them as one-shot developers, diluted 1:1 or more. This provides additional highlight compensation without greatly increasing the development time and without causing loss of emulsion speed.

Because superadditive formulas result in shorter development times, usually 5 to 10 minutes, the advantage of prolonged development times, 15 to 30 minutes, is often not appreciated by photographers accustomed to using superadditive developers. However, extended development in a semi-compensating developer, or developers of low pH or alkalinity, will often

produce negatives of incomparable scale if photographers are willing to take the additional time.

Preservatives

Excessive exposure to air will oxidize any developer rendering it useless. During the development process the developing agent is always oxidized. However, developers will oxidize even without the development process. To prevent this, or at least inhibit the rate of oxidation, a preservative is added to the developer.

By far the most commonly used preservative is sodium sulfite. Potassium sulfite is only occasionally used in highly concentrated formulas such as Rodinal.

Sodium bisulfite is often preferred in pyro developers and in Phenidone concentrates (see the description of Phenidone in chapter 3, Pharmacopoeia, for a concentrate solution). Sodium bisulfite is often used in formulas that are divided into two solutions, as its weak acidity helps to inhibit the oxidation of the concentrated developing agent. When carbonate, contained in the "B" solution, is added to make a working solution, the bisulfite is immediately broken down into sulfite and bicarbonate, producing a useful buffering effect.

NOTE: Sodium bisulfite and sodium metabisulfite are for all practical purposes identical and are often the same chemical.

Potassium metabisulfite will sometimes be encountered in formulas. For photographic purposes, there is no practical difference between potassium and sodium metabisulfite except that the potassium salt is more expensive. They can be exchanged weight for weight in most formulas.

Accelerators (Alkali)

As a rule, developing agents have very weak developing powers and require the presence of an accelerator (alkali) to make them practical for use. Without some form of accelerator, most developing agents would require several hours to reduce the silver halide. Even then, the results would be low contrast with excessive fog buildup. Adding an accelerator greatly reduces development time and increases the contrast.

There are three general categories of accelerator:

- *Mild alkali*—pH value around 8 to 10 (Balanced Alkali, borax, sodium metaborate, and sodium sulfite)
- *Moderate alkali*—pH value around 10 to 11 (sodium carbonate, potassium carbonate, and trisodium phosphate)
- *Caustic alkali*—pH value around 12 (potassium hydroxide, sodium hydroxide)

Increasing the amount of accelerator in a developer will increase the contrast. This is because it creates a more active environment in which the developing agent can reduce additional silver halide in the exposed areas. However, too much accelerator will increase fog levels, necessitating the addition of bromide or some other form of restrainer. While paper developers

should always contain some restrainer, when formulating a film developer it is better to decrease the accelerator rather than add more restrainer.

pH

The pH of a developer plays a major role in how fast the developing agents will cause an image to be formed on film or paper. The higher the pH, the more active the developer.

Also, the higher the pH, the faster a developer will oxidize. To prevent oxidation, developers often are stored in separate A and B solutions that are mixed just prior to use. Developers using caustic alkali should always be formulated in this manner. Developers containing easily oxidized developing agents, such as pyro, should also be stored this way, regardless of which accelerator is used.

pH Scale

The pH scale has a range from 1 to 14, the neutral point being pH 7. Any solution with a pH higher than 7 is an alkali; a pH lower than 7 indicates an acid. Mild acids and alkalies fall close to 7 on the scale; stronger acids or alkalies are found at either end of the scale.

Although the differences between the pH values may seem small, remember that the pH figures are logarithmic values. This means that a solution of pH 10 is 10 times more alkaline than a solution of pH 9. Thus a small change in pH indicates a sizeable variation in alkalinity. An inexpensive meter that will enable you to monitor pH levels is the pHep® made by Hanna Instruments. It is available from Tri-Ess Sciences.

Here are some examples of the pH value of chemicals used in developing:

14.0 –	5.2 – Boric acid 0.5%
13.0 – Sodium hydroxide 0.4%	5.0 –
12.0 –	4.3 – Sodium bisulfite
11.5 – Sodium carbonate 5%	4.2 – Fresh acid fixers
11.3 – Trisodium phosphate 1%	4.0 –
11.0 –	3.0 –
10.5 – Sodium metaborate	2.9 – Acetic acid stop bath
10.0 –	2.2 – Citric acid 2%
9.9 – Balanced Alkali 0.2%	2.0 –
9.5 – Borax 0.1%	1.2 – Sulfuric acid 1%
9.0 – Alkaline Fixer (8.5–9.5)	1.1 – Hydrochloric acid 3 to 4%
8.0 – Sodium sulfite 5%	1.0 –
7.0 – Water; Potassium bromide	0.0 –
6.0 –	

Buffering

A buffer acts to keep the pH of the solution fairly constant. A buffered developer will maintain a constant pH whether it is diluted 1:1 or 1:3. A non-buffered developer may change its pH as it is diluted. Most alkalies used in developers have some buffering ability.

Carbonate and Balanced Alkali are the most stable alkalies. Borax does not buffer well against a rise in pH, and hydroxide loses its alkalinity rapidly as the solution is diluted.

Mild Alkalies

Mild alkalies produce less contrast and take longer to work, but they remain stable for a longer period of time in a working solution, especially in large concentrations.

Balanced Alkali is a proprietary chemical of Eastman Kodak, and until recently it was known as Kodalk. Balanced Alkali is more alkaline than borax and more easily soluble, but less alkaline than carbonate. As Balanced Alkali contains no free carbonate, there is no danger of carbonic gas bubbles being formed when an acid stop bath is used (see "Moderate Alkalies," below). Balanced Alkali can be substituted for carbonate (see "Alkali Substitutions," Conversion Tables), and for most practical purposes it is identical to sodium metaborate.

A substitution for Balanced Alkali can be made by mixing sodium hydroxide with borax, decahydrate. See chapter 3, "Pharmacopoeia," under the Balanced Alkali entry.

Borax is the mildest common alkali. It finds it's widest use in low-contrast and fine-grain developers. Decahydrated is the most preferred form. Sodium sulfite, though most often used as a preservative in formulas, can also be used as a mild alkali. In Kodak D-23 it serves both purposes.

Moderate Alkalies

Sodium carbonate, generally referred to as "carbonate," is available in three forms: crystal, anhydrous (also known as desiccated), and monohydrous. The difference between the three concerns the number of water molecules attached to each molecule of sodium carbonate. Anhydrous[2] has no water molecules attached, monohydrous[3] has one, and crystal has ten.

The more water molecules there are, the greater the weight of chemical necessary to provide the same activity in solution. For example, the equivalent of 35 grams anhydrous would be 40.95 grams of monohydrate (see "Sodium Carbonate Conversion Table," Conversion Tables).

With it's single molecule, the monohydrous form is the most stable of the three forms and for this reason the most desirable. Anhydrous, having no water, is quicker to absorb moisture from the air and must be stored in an airtight container to prevent deterioration. The crystalline form, which tends to lose its water molecules rather rapidly, is rarely seen in current photographic practice.

Carbonate has one drawback that is important to remember. When a large amount is used, carbonic gas bubbles can form in the emulsion of either film or paper when transferred to an acetic stop bath, resulting in pinholes and/or reticulation. Using a less acid stop bath, such as Kodak SB-1 Nonhardening Stop Bath or a running water bath, should prevent this problem.

[2]The prefixes a- or an- are both from Greek and mean "without." Hydrous is an adjective that means "containing water." Therefore, anhydrous literally means "without containing water."

[3]The prefix mono- means "one." Therefore, monohydrous (or monohydrate) refers to substances containing one molecule of water.

Potassium carbonate is available in both anhydrous and crystalline forms. The crystalline contains 1.5 molecules of water and a small amount of bicarbonate buffer, depending on the grade. The potassium salt readily absorbs water from the air and must be kept in airtight containers.

Potassium carbonate is far more soluble than sodium carbonate, hence its use in highly concentrated solutions. The two should not be interchanged.

Trisodium phosphate (TSP) can often be used as a moderate alkali.

Caustic Alkalies

Potassium and sodium hydroxide are far more energetic than the alkali carbonates and are used only when a powerful, fast-acting developer is required. Developers compounded with caustic alkalies have poor keeping properties and are soon exhausted.

NOTE: The only practical difference between potassium and sodium hydroxide, as far as photography is concerned, is that 10 parts by weight of sodium are the equivalent of 14 parts by weight of potassium. Also, potassium hydroxide is more soluble, meaning more will go into solution than sodium hydroxide. The limit of sodium hydroxide in water is 50%; the limit for potassium hydroxide is somewhat higher.

Phosphates

Sodium and potassium phosphate approach the pH of the hydroxides without being as dangerous to handle. Although technically speaking phosphates are not true alkalies, they can be considered as replacements for hydroxides when high alkalinity is desired.

One reason phosphates have been little used is that they can cause a scum if the film is plunged directly into a fixer that contains alum hardeners. Since the use of alum hardeners is waning, this may no longer be a major concern. In powder form the phosphates appear to be less stable than the other alkalies.

Restrainers

Restrainers are necessary to prevent excess fog. With film developers this means primarily chemical fog. With paper developers restrainers are used to retard both chemical and safelight fog.

Restrainers should be used sparingly in film developers. Some photo chemists recommend that they not be used at all. According to photo chemist Bill Troop, "A film developer should not need to use a restrainer—if it does then the alkali is too strong." Even so, most film-developing formulas rely on restrainers, partly to prevent fog and partly as "insurance" against errors in formulation.

Whereas a degree of base fog is permissible in a negative, no amount of fog, which would show up as gray highlights, is acceptable in paper. For this reason, paper developers always require restrainer, often in significant amounts.

Potassium Bromide

Potassium bromide, usually referred to as "bromide," is the primary restrainer found in most developers. Bromide has the adverse effect of holding back the overall action of the developer, reducing the effective sensitivity of the film, and diminishing the amount of useful density created in the shadow areas. By inhibiting the reduction of silver halide, bromide also acts to increase contrast. This action varies with different developers.

As film is developed, soluble bromide is produced and passes into the developer solution. This buildup of bromide adds to the already existing restrainer. If too much bromide is initially present, the combined amounts can considerably affect the contrast and effective sensitivity of the film.

Another consequence of this reaction is "bromide drag," which occurs when either too much bromide builds up or agitation is unidirectional, causing streaks across the negative. This can be prevented by sufficient agitation, altering the direction of agitation, and the use of "one-shot" developers or the proper replenishment of developers before use.

Bromide is generally used in paper developers when a warm or neutral tone is desired. The more bromide, the warmer the tone, though too much bromide will inhibit development in the shadow areas and fogging may occur.

Benzotriazole (BZT)

The antifogging effects of BZT are greater than bromide, especially in developers of high pH. As a result, BZT is especially useful for salvaging outdated papers or when blue-black tones in prints are desired.

For salvaging outdated papers, mix a 0.2% solution (2 grams in water at 125°F/52°C to make 1 liter). Add 15 ml of this solution to every liter of developer. If 15 ml does not do the trick, keep adding 15 ml at a time and make tests until you get a clear paper without fog.

NOTE: To test, develop a small piece of unexposed paper for the full time; after fixing, when the paper is held up to a white surface, such as the back of another piece of paper, it should show no signs of gray.

It is advisable with *all* old paper, even those not exhibiting fog, to keep development times between 45 seconds and 1.5 minutes (the longer paper develops, the more likely it will exhibit fog).

Benzotriazole is often used in PQ formulas, especially those of medium to high alkalinity. Bromide is a superior restrainer in PQ formulas of low alkalinity. As a substitute for bromide, BZT is generally used at $\frac{1}{10}$ the solution concentration of the bromide in most formulas.

Potassium Iodide

Although it is recommended by no less an authority than Geoffrey Crawley, former editor of the *British Journal of Photography* and formulator of FX and Paterson developers, potassium iodide has not been thoroughly investigated for its use as a restrainer. However, what little research has been done indicates that it is superior to potassium bromide. As a substitute, it is usually

recommended to use $\frac{1}{10}$ to $\frac{1}{100}$ the weight of bromide. Iodide can also be used in combination with bromide.

Other Additions to Developers

Water Softener

When hard water is used for mixing developers, a milkiness is sometimes produced. This is caused by the action of alkali and sulfite on the lime salts in the water. If the lime is excessive, a precipitate of calcium carbonate and sulfite may be deposited on film.

In areas of hard-water concentration, it is best to compound developers using distilled, deionized, or demineralized water. However, if none of these is available, a water softener can be added directly to the developer. Do not add a water softener unless it is absolutely necessary as it will change the pH balance of the developer.

If a water softener is required, use a small amount of sodium hexameta-phosphate, available as the proprietary compound Calgon. One part per 1000 (1 g/L) should be sufficient, except for very hard water, in which case the amount can be increased up to 3 g/L. Always dissolve the water softener before adding the developing ingredients.

Other Considerations for Developers

All developers will oxidize when exposed to air. MQ and PQ developers that contain high concentrations of sodium sulfite are slow to oxidize. High-energy developers containing caustic alkali, developers containing pyrogallol, pyro-catechin, catechol, amidol, and many others, oxidize quickly. These should be used immediately upon diluting to a working solution.

Dark brown or amber glass bottles are best for storing developers. Always fill the bottle to the top in order to prevent oxidation. This can be achieved through the addition of glass marbles that take up any extra space. However, do not use glass marbles with developers with high acid or alkali content (see "Dos and Don'ts" in chapter 2, Chemicals).

Creating Your Own Formula

The Darkroom Cookbook is meant to be a point of departure for photographers desiring to take full control of their craft. At any time, you should feel empowered to "interpret" any formula, design a new one, or adapt an existing one to a new purpose. In doing so, keep these six aspects of the process in mind:

1. The developing agent—its nature, concentration, and, in cases where several are used, the ratio between them.

2. The alkali or accelerator—its nature and concentration. Also, keep in mind with film that if you have too much fog, you have too much alkali. Reduce the alkali content before adding restrainer.
3. The preservative can greatly affect the graininess and compensating effect of the developer.
4. The restrainer—its type and quantity.
5. The percentage of each component in the formula.
6. Never compare stock solutions of formulas. Compare working dilutions only.

The following is a good way to teach yourself how to manipulate developing formulas and the effect of different chemicals. Start with a general-purpose paper developer, such as Kodak D-72, and dilute as you would for a normal print. Choose a full-scale negative that prints well on grade 2 paper. Make a good print and mark the back "test" or "control." Make thirteen more identical prints and put them in a light-tight box without developing them.

NOTE: The prints don't have to be large; 4 × 5″ or 5 × 7″ will suffice.

Mix a fresh batch of developer using only the metol and sulfite in 1 liter of water, then dilute and develop the first print for the same time as the test print. Add the carbonate and develop the second print. Add the bromide and develop the third print. Be sure to mark the back of each successive print with a number, such as "1," "2," and so on.

Repeat the test, this time using only the hydroquinone and sulfite in 1 liter of water, diluting as before, and then adding the other chemicals in succession. Be sure to mark the back of each print.

Next, mix a fresh solution of D-72, only this time use half the amount of carbonate (40 grams), and develop another print. Then add enough carbonate to bring the amount to half again more than normal (total carbonate = 120 grams). Add enough carbonate to double the normal amount (total carbonate = 160 grams).

Repeat this exact test, only this time use the normal amount of carbonate (80 grams), and manipulate the bromide. The only difference is that you should use no bromide for the first print. Then add bromide to bring the total to 1 gram, 2.5 grams, and, finally, 4 grams.

Compare each print to the test print and become familiar with the results. You can repeat this test with any paper developer. Doing this test in its entirety will familiarize you with the full range of effects and controls possible with any developer. It will also help you learn how to create your own formulas.

5 Film Development

The choice of which film developer to use is perhaps the single most important decision a photographer can make. Film developers directly affect the sharpness (acutance), graininess, tonal scale, and contrast of the image. All are interdependent. For example, film developers that maximize sharpness do so at the cost of increased graininess. High-energy film developers shorten the tonal scale of a negative, and soft-working developers, while extending the scale, lower the contrast.

For landscape and architectural work a developer rendering maximum acutance is generally preferred. Portraits often require a softer look, with finer, more rounded grain.

Enlarging equipment must also be taken into account. Condenser enlargers emphasize contrast and crispness. A photographer using a condenser system may prefer a softer negative with lower grain acutance. Diffusion enlargers generally work best with negatives that exhibit maximum sharpness. With diffusion systems, graininess is not usually as important because diffused light has a tendency to mask it. In the following sections, developers will be discussed according to their specializations or unique qualities.

Divided Development

Divided development allows a photographer to expose roll or sheet film under many different and difficult situations and still create printable negatives because of the compensating action inherent in the process.

Divided, or two-bath, development has a number of secondary advantages:

- It produces even, consistent development.
- Development takes place primarily on the surface of the film so there is less halation and irradiation, resulting in the best possible sharpness.
- Depending on the developing agents, there can be little or no loss in emulsion sensitivity; often sensitivity is increased.
- Temperature variations have little effect on contrast and density.

Another advantage is that the cost per roll of film is much less than with single-solution developers. A safe number of rolls of film to develop using 1 liter of the first bath is 20 as long as it is not contaminated or does not oxidize. The second bath, which contains the less expensive chemicals, should be discarded after processing 10 rolls of film.

Divided development can be used for all films except document films (e.g., Kodak Technical Pan).

NOTE: The addition of sodium bisulfite to the first bath will help prevent oxidation. The rule is to make the preservative approximately 20% bisulfite (e.g., D-23 Divided Developer requires 100 grams of sodium sulfite; instead use 80 grams of sulfite and 20 grams of bisulfite).

Technique of Divided Development

In divided development, two separate baths are used. The first bath contains the developing agents, restrainer, and preservative. The second bath contains the accelerator. The second bath is used to activate the developer. Borax is the least active accelerator. Metaborate is about double the strength of borax; carbonate is about double the strength of metaborate. Hydroxide is the most active of the alkalies and the least controllable.

Film is placed into the first bath where the emulsion absorbs the developing agent. Because the pH is low, little or no developing takes place. The film is then transferred directly to the second bath *without rinsing.*

Development takes place in the second bath until the developing agent, absorbed by the emulsion in the first bath, is exhausted. The shadow areas, where less exposure to light has been received, continue to develop even after the developer has been exhausted in the highlight areas. The result is the compensating action mentioned earlier.

Do not use a presoak and *do not rinse* between solutions. After the second bath, use a water rinse or go directly into the fixer.

Although agitation is not as critical as with single solutions, it should always be gentle. In the first bath, agitation may be either continuous or intermittent. If intermittent, it should be continuous for at least the first 30 to 60 seconds. After that, follow your standard agitation procedure. As a general rule, agitation should be continuous in the second bath.

NOTE: Divided development usually works very well with continuous agitation in both baths. This is an excellent technique to use with a JOBO processor, making certain that the tank changes direction during the development cycle.

The temperature of development is not as critical for divided development as single-solution processing, but for best results, keep the temperature of all solutions the same, between 68°F/20°C and 80°F/27°C.

Water Bath Development

Water bath development is similar to divided development. Both methods are useful for reducing overall contrast while maintaining useful density in the key shadow areas.

There are two major differences between divided and water bath development. The first is agitation. In divided development, agitation takes place in both the first and second baths. In water bath development, the film is gently placed into the second bath and left without motion for 2 to 3 minutes.

The second difference is that divided development is a once-in, once-out process: once in A, once in B, rinse, then fix. Water bath development, like intermittent development (see D-23 Divided Developer, Method #2), is meant to be a repeatable cycle. After immersion in the second bath, the film is returned to A, and the process repeated as many times as necessary to achieve the desired contrast or density. For this reason, water bath development is often used in conjunction with development by inspection.

A problem experienced with water bath development and modern emulsions is streaking, which can ruin the film. It may be possible to eliminate the problem of streaking by using a 3% sodium sulfite solution (30 grams sulfite to 1 liter of water) in place of plain water in the second bath. This will create somewhat less compensation, but it is better than ruining the negative.

Additionally, water bath methods usually result in a loss of film speed. Should you chose to use this method, plan to overexpose by at least one stop, possibly more.

The overall method for water bath development is to immerse the film in the developer for 2 to 3 minutes with normal agitation. The film is then moved as quickly as possible to the plain water (or 3% sodium sulfite) bath in order to prevent aerial oxidation. It should be completely immersed in the water bath and left motionless for 2 to 3 minutes then moved quickly back to the developer. The entire procedure is repeated as many times as necessary.

It is recommended to use a one-minute running water bath in place of a stop bath with this method.

While water bath development can reduce overall contrast, there are other methods for attaining similar results, such as using a soft, compensating, fine-grain developer (e.g., Windisch Extreme Compensating Developer).

Extreme Compensating Developers

Strictly speaking, compensating developers are those that give proportionally full development to the shadow and middle values while limiting the degree of development in the high values. Extreme compensating developers, such as those included here, are used to arrest the development of the highlights in

order to record extremely high-contrast subjects while maintaining separation throughout the high subject values.

Two formulas—D175 Tanning Developer and Maxim Muir's Pyrocatechin Compensating Developer—are also tanning developers. They work by tanning the gelatin of the emulsion, a process that is enhanced by a low concentration of sulfite or its complete absence. Tanning takes place in proportion to the amount of silver reduced. Therefore, the tanning is greatest in areas that have achieved the most exposure. Since tanning developers allow development only on the surface of the film, they minimize halation and the scattering of light within the emulsion. Images exhibit an extremely high degree of acutance. With the exception of glycin, most developing agents will produce a tanned image when used in a formula similar to D175, but pyrocatechin and pyrogallol are the most powerful tanning agents.

The distinction between this group of developers and low-contrast developers for high-contrast films is somewhat arbitrary. The primary difference is that the three

in this group are designed to work with full-range panchromatic films. The three formulas under "Low-Contrast Developers—For High-Contrast Films" are primarily used with high-contrast document films such as Kodak Technical Pan.

Fine-Grain Developers

All films have a grain structure predetermined by the manufacturing process. Faster films have larger grain than slower films. The type of developer used will make some difference in grain size, but it is impossible to produce the same fine grain in fast films as in slow films.

There are several factors that may cause some grain particles to "clump," forming larger single grains. The visual effect is referred to as "graininess" (see appendix IV, The Anatomy of Film). Some of the factors causing graininess are excessive or overly vigorous agitation (not as important with modern T-grain films); prolonged development at normal dilutions (long development times with highly dilute developers creates a smoother, finer-grained image); and transference of the developed film to solutions of different temperatures.

The tendency to clump can be retarded through the use of fine-grain developers. This was considered especially important when negatives were becoming smaller and grain was staying the same size. Today, with the advent of fine-grain manufacturing techniques, including T-grain structures, fine grain is not as important to achieve as high acutance (high definition).

A good fine-grain developer is one that gives low contrast without any serious loss of speed and without "clumping" the grain. The developer may or may not actually improve the definition. Finally, fine-grain developers should be compensating, that is, they should prevent the formation of heavy, unprintable deposits in the highlight areas.

As can be seen from the preceding, to take full advantage of fine-grain developers, you must choose a fine-grain film of low or medium speed. Fast, medium-to-coarse-grain, low-contrast films (e.g., Tri-X) do not benefit from fine-grain development.

General-Purpose Developers

Most general-purpose developers in use today are metol-hydroquinone-based (MQ) rather than Phenidone-hydroquinone-based (PQ). This is due in part because Phenidone has not been around that long as a developing agent, and also because the initial investment in Phenidone is high. However, because of the allergic reaction many photographers have to metol (see the Metol entry in chapter 3, Pharmacopoeia), it is sometimes desirable to substitute Phenidone.

To substitute Phenidone for metol, start with 10% of the amount of metol, by weight, of Phenidone. Develop a test roll, inspect the results, and then add more or less as needed until your formula produces the results you want.

The most popular developer in the world, Kodak D-76, falls under this category of general-purpose developers. D-76 was formulated in 1927 by Capstaff of Kodak as a black-and-white movie film developer. However, not long afterwards better formulas were introduced and D-76 found use as a still-film developer. Eventually, it became the standard by which all other developers were to be judged. It's not that D-76 was the best developer ever formulated. It was more that a standard was needed, and D-76 had the best all-around compromise of sharpness to grain with a full tonal range from black to white.

Not long after Capstaff formulated D-76 it was discovered that the pH of the developer actually increased with storage. Not a good sign for a standard! A number of solutions were proposed over the next thirty years but the simplest and most elegant was proposed by Grant Haist, also of Kodak. Haist suggested removing hydroquinone from the formula and increasing the metol to 2.5 grams. The resulting developer, D76H, is indistinguishable from D-76 without the tendency to change pH. Not only that, but without hydroquinone it is less expensive to make and more environmentally friendly.

Ilford ID-11 is an exact duplicate of D-76. However, the published formula for D-76 is not the same as the Kodak packaged formula. While Ilford has remained true to the original formula, Kodak has altered it in many undisclosed ways to make it more commercially viable. If D-76 is your formula of choice, you will improve overall image quality by mixing it yourself as D-76H, or at least by using the Ilford packaged formula.

NOTE: Four of the film developers included in this book have companion replenishers whose formulas are also given. However, I do not recommend the use of replenishment unless you are operating a high-volume lab. There is no advantage or savings in replenishing for most small-volume, home darkrooms, and there are numerous disadvantages. Among them are the possibility of bromide buildup, resulting in bromide drag, developer oxidation, and inconsistent results.

High-Contrast Developers

In general, these developers are used most often for scientific and fine art applications where a high degree of contrast is required, such as with lithographic films or to make title slides. With the introduction of high-quality graded and variable contrast printing papers, the need for high-contrast developers to expand low-contrast subjects, such as landscapes under subdued light, is not as important as it once was.

Hydroquinone in a low solution, or in combination with a small amount of metol or Phenidone, makes an ideal high-contrast developer. However, in a full tonal scale photograph there are other variables to maintain: sharpness, fine grain, and speed. To maintain these qualities, additional chemicals must be included, such as bromide restrainer, and an alkali.

High-Definition Developers

In the section on fine-grain developers it was mentioned that fine grain is not as important as acutance. This is in part because modern films are so fine-grained that there is little need for further improvement.

A high-definition developer (also known as high-acutance) is one that enhances negative acutance and leads to prints of good image sharpness. To get the optimum quality out of modern films, a high-definition developer should be both soft-working and compensating. The developers listed here have a relatively low concentration of developing agent so they exhaust rapidly in the highlights. At the same time, they contain a relatively high alkali content to fully develop the shadows.

A high-definition developer, therefore, is one that gives increased definition to photographic images by enhancing the contrast of edges and fine detail in the negative, although the resolving power of the emulsion may not be any higher than usual. This is usually achieved through the use of a formula containing low concentrations of developing agent, sulfite, and bromide, and a high pH.

In addition to using a high-definition developer, edge effects can be further enhanced through reduced agitation. To obtain the highest acutance possible from a given film and developer combination, agitate continuously for the first 30 to 60 seconds, and then for 10 seconds each minute thereafter.

For even higher acutance, agitate for 10 seconds every third minute thereafter. This second method requires at least a 50% increase in development time, whereas the first does not. The gain in acutance, with the second method, is slight.

For additional high-acutance developing formulas see "Extreme Compensating Developers" above.

Low-Contrast Developers for High-Contrast Films

These developers are similar to extreme compensating developers in their ability to record scenes of extreme contrast. The main difference is that the low-contrast developers listed here are favored for developing films such as Kodak Technical Pan Film. Tech Pan, as it is commonly known, is an ultra-fine-grain film of high contrast, which, when properly handled, is capable of producing full-scale images of exceptional resolution.

Another application of low-contrast developers for high-contrast film is their value in making low-contrast masks for contrast control and other purposes. Most low-contrast developers are based on a single developing agent and are very simple formulas.

Low-Contrast Developers for Panchromatic Film

Low-contrast developers for conventional films are often known as soft-working developers to distinguish them from low-contrast developers for high-contrast films. These are designed to give lower than normal contrast with full-range panchromatic films. Used with slow-speed, thin-emulsion films, they are capable of creating an image with smooth grain, full gradation, and low contrast that is ideal for portraiture.

At one time these were considered a cornerstone of the Zone System. However, as with high-contrast developers, they are less useful today due to the introduction of high-quality graded and variable contrast photo papers.

Low-Temperature Developers

Many developing agents become inactive or extremely sluggish at low temperatures, especially below 65°F/18°C. Although development should be avoided at such low temperatures, there may be times when it is not possible to do so.

The main problem that must be overcome is the loss of developer activity. Therefore, it is a good idea to start with a developer that is normally very active, for example, a caustic hydroquinone developer (Kodak D-8) or a still more alkaline variation of a caustic MQ developer (Kodak D-82 + Caustic). For very low temperature processing, a caustic solution of two powerful developing agents, such as amidol and pyrocatechin, may be required (Kodak SD-22 Amidol-Pyrocatechin).

D-8 is usually preferred over D-82 + Caustic since it gives less base fog, though this can be adjusted somewhat during printing. SD-22 gives very good speed, and curves with long straight lines, but oxidizes rapidly.

Film also takes longer to fix at low temperatures. When temperatures begin to drop below 65°F/18°C fixing time will need to be extended. Observe how long the milkiness takes to disappear from the surface of the film and multiply that time by three. At extremely low temperatures, below freezing, a thiocyanate fixer should be used (see Defender 9-F Rapid Thiocyanate Fixer).

Superfine-Grain Developers

When exposed silver halides are reduced to metallic silver via the development process, there is always a degree of extraneous, unexposed silver halide that remains attached. Fine-grain and superfine-grain developers make use of solvents to dissolve as much of the extraneous silver halide as possible. The more efficient the solvent action of the developer, the finer the grain.

The classic superfine-grain developing agent is para-phenylenediamine (ppd), which is capable of giving an exceedingly fine grain but requires strong overexposure and a long developing time. Even then the contrast of the negatives is low. Additionally, ppd is poisonous and has a strong tendency to stain, causing brown spots that are very difficult to remove. It stains film,

clothes, fingers, and work surfaces. Always use gloves, cover the work surface with newsprint, wear an impervious apron, and try not to spill any!

These disadvantages have led to attempts at discovering developing agents, and combinations of other agents with ppd, that would give superfine-grain results and shorter development times without the troublesome properties. Three such agents are glycin, o-phenylenediamine, and diethyl-p-phenylene-diamine bisulfite.

Glycin, used in combination with ppd (Sease No. 3 Superfine-Grain Developer), gives a fine-grain developer with improved properties as far as emulsion speed and rate of development. Unfortunately, because of the presence of ppd, it still suffers from the unpleasant side effects: high toxicity and staining.

o-phenylenediamine is one of the more successful replacements for ppd. It has weak developing properties but is a good solvent for silver halide. In the Windisch Superfine-Grain Developer, metol acts as the primary developing agent for the silver halide. The o-phenylenediamine works on the silver being developed, dissolving any extraneous unexposed halide and resulting in superfine grain.

Geoffrey Crawley's FX 10 makes use of a ppd derivative, Kodak CD-2, commonly found in modern color developers. As a developing agent, CD-2 works faster with less tendency to stain than ppd but is not capable of producing as fine a grain.

As far as the general composition of superfine-grain developers, nearly all of them make use of a high sodium sulfite content (sodium sulfite is an effective silver solvent). For an alkali they use small quantities of either carbonate or borax in order to minimize the energy of the developer and produce a finer grain. FX 10 uses a buffer mixture of borax and boric acid, while Windisch Superfine-Grain Developer uses sodium metabisulfite to reduce the pH of the sodium sulfite.

NOTE: At one time, 35mm negatives were simply smaller versions of large format emulsions. Film manufacturers had not perfected the "small-grain, thin emulsion" techniques available today, including thin emulsions and T-grain technologies. Largely for those reasons, photographers choosing to use small formats became obsessed with fine grain and fine-grain developers.

Fine grain and acutance are not always compatible. Specifically, superfine-grain developers, such as those that utilize ppd derivatives, tend to destroy acutance. This is because they effectively etch each grain particle into individual "islands." These islands don't connect with each other, as do less fine, clumped grains. The result is that lines running through the negative that should be continuous, are instead broken into small bits and pieces as they jump from small grain to grain. This effect is often useful, as in portraits, where the opposite effect (high acutance) would tend to accentuate wrinkles and other physical defects often thought to be unflattering.

Tropical Developers

With most developers an increase in temperature means an increased rate of development, increased danger of fogging, and excessive swelling of the gelatin emulsion that could result in its melting away. The faster the film

(e.g., Tri-X), the more susceptible it is to increased fogging at high temperatures (as a general rule, Tri-X should not be processed above 72°F/22°C).

However, there may be a time when it is not possible to cool the solutions to the required temperature. This includes photographers working in noninsulated darkrooms during the summer where a water-cooling system is not available.

Generally, any time black-and-white film processing temperatures rise above 75°F/24°C, steps should be taken to protect the emulsion and prevent excessive fog. (One notable exception would be T-Max film, which is recommended to be processed at 75°F/24°C.)

Fortunately, there are some special developers known as "tropical developers," and some modifications that can be made to other developers for extreme heat conditions. In general, the more alkaline the developer, the more the gelatin swells and the more rapidly development takes place. When processing at high temperatures, a mildly alkaline, buffered borax developer is recommended. Alkali-free developers of the amidol type or one of the mildly alkaline fine-grain developers (Kodak D-23) are preferable to those with normal alkali content. Additionally, a prehardening bath (Kodak SB-4 Tropical Hardener Bath) or a specially formulated tropical developer may be used.

Tropical developer formulas prevent excessive swelling of the gelatin, either by the addition of a substance that reduces swelling or by balancing the ingredients, eliminating those that cause excessive swelling. Tropical developers often include sodium sulfate and extra antifoggant.

Modifying Developers for Tropical Development

Most developers can be made suitable for use at high temperatures—up to 95°F/35°C—through the addition of 105 grams of sodium sulfate, anhydrous, to each liter of the working solution. This addition prevents the gelatin in the emulsion from excessive swelling.

NOTE: The addition of sulfate will alter the development time. The required adjustment can be found in the following table:

Normal Development Time (minutes) in nonsulphated developer at: 68°F/20°C	Development time (minutes) in sulphated developer:			
	75°F/24°C	80°F/27°C	85°F/29°C	90°F/32°C
3¼	4	3	2	1½
4	5	3½	2½	1¾
4¾	6	4½	3	2¼
6½	8	6	4	3
8	10	7	5	3½
9½	12	8½	6	4½
12	15	11	8	5½
16	20	14	10	7
20	25	18	13	9

Using Sodium Sulfate with D-72 or D-76

By adding sodium sulfate anhydrous to Kodak D-72 or Kodak D-76, as in the following table, the normal development time recommended at 68°F/20°C can be maintained through the range of temperatures shown. After adding the sulfate to the developer solution, stir until dissolved completely.

Developer	Temperature	Sodium Sulfate	
		per 32 ounces	anhyd. per liter
D-76	75°F/24°C to 80°F/27°C	1 oz 290 grains	50 grams
	80°F/27°C to 85°F/29°C	2½ oz	75 grams
	85°F/29°C to 90°F/32°C	3 oz 145 grains	100 grams
D-72 (1:1)	75°F/24°C to 80°F/26°C	3 oz 145 grains	100 grams
	80°F/27°C to 85°F/29°C	4 oz 75 grains	125 grams
	85°F/29°C to 90°F/32°C	5 oz	150 grams

Stop Bath for Tropical Development

Films should be immersed for about 3 minutes in either Kodak SB-4 Tropical Hardener Bath or Kodak SB-5 Nonswelling Acid Rinse Bath after development and before fixation. Agitate the negative in the stop bath frequently.

Between 68°F/20°C and 80°F/26°C use SB-5. Between 80°F/26°C and 95°F/35°C use SB-4.

6　Monobath Film Developing

The ability to develop and fix film in one operation is appealing. It eliminates the need for separate stop and fixing baths, and for hardening solutions. Moreover, it does not require precise timing of development and decreases the effect of variations in agitation, temperature, and other processing conditions. A monobath is a single solution that combines the actions of development and fixation in this manner.

Solutions of this type were first proposed in 1889, but only relatively recently have the difficulties associated with their formulation been overcome. The main problem has been the loss of emulsion speed that results when the exposed silver halide is dissolved by the fixation process before development can take place. For this reason films intended for monobath processing often need to be overexposed by at least one stop.

For a monobath to work it must combine a developer that acts so quickly that development is finished before fixation starts. But even after fixing has begun, development can be further assisted by a process of physical development that takes place concurrently.

Additional problems of the monobath method have included unsatisfactory gradation and maximum density, and a tendency to produce unacceptable levels of base fog. Storage and exhaustion properties have also tended to be poorer than with conventional developers that produce similar results.

To prevent the above drawbacks, developing agents of high activity and short induction periods are required. Phenidone and hydroquinone are suitable monobath developing agents. A combination of these two generally leads to higher speed, improved contrast, and maximum density. In the 1950s several Phenidone-hydroquinone (PQ) formulas were devised that are capable of producing results practically identical with those obtainable through conventional processing.

In devising a monobath, several points must be considered. The first is the concentration of the monobath developer. For acceptable results the devel-

oper concentration has to be increased an average of five times. At the same time, the pH has to be raised to pH 11-12, while the hypo content must be reduced.

To increase the stability and exhaustion rates until they are equal to conventional developers, an appropriate buffer must be used. In H. S. Keelan's monobath potassium alum has been added. The alum also helps prevent excessive swelling of the gelatin, which could otherwise result in reticulation at higher processing temperatures.

The target point of development is determined by the composition of the monobath and cannot be varied by change in dilution, time, or temperature of development. However, it is possible to obtain a wide gamma range without loss of film speed by simply varying the hypo (or salt) content. In G. W. Crawley's monobath the use of 70 to 125 grams of hypo is recommended to increase or decrease the contrast of the film. The more hypo, the softer the results. Less hypo results in higher contrast. Similar variations in the amount of hypo can be made to the other formulas. The rate of fixation is also influenced by the amount of hypo.

The speed of development can usually be controlled by the alkali content. Sodium hydroxide is used in all the monobath formulas given in the Formulas section.

Working with these two variables, hypo and accelerator, monobath formulas can be modified for different films. In fact, Grant Haist, in *Monobath Manual*, has concluded that no monobath can be formulated that will work equally well with all films. However, it is possible to design a monobath for individual films that will produce results comparable to normal processing. You may want to experiment and create a specially balanced formula for each group of similar emulsions (i.e., T-grain, conventional films of similar speed, etc.).

The following variations in monobath formulation and processing conditions, summarized by Haist, may be used to modify the results.

To increase contrast and emulsion speed:

1. Raise the pH.
2. Increase the concentration of the developing agent.
3. Reduce the concentration of the fixing agent.
4. Raise the processing temperature.
5. For more contrast, increase the concentration of hydroquinone.
6. For more speed, increase the concentration of Phenidone.

To reduce contrast or emulsion speed:

1. Lower the pH.
2. Increase the concentration of the fixing agent.
3. Increase the salt content or viscosity.
4. Use more vigorous agitation, increasing the rate of fixation (this may not be possible with in-cassette processing).

Four monobath formulas are given in the Formulas section. Unfortunately, the sources for these formulas do not give the film type or development times and temperatures. If you wish to experiment with monobaths, you will have

to test various films and find your own times. I suggest starting with 6 to 8 minutes at 75°F/24°C with medium speed films.

Grant Haist's out-of-print book, *The Monobath Manual,* is the best source for additional information on this process.

In-Cassette Processing

Processing 35mm film inside the metal cassette it comes in is an interesting way to develop film. The technique is simple and was originally described by Eastman Kodak. It should only be used with a 20- to 24-exposure roll, or smaller, as a 36-exposure roll does not have enough room for the solution to flow evenly.

Other than the film, all that is needed is a glass or beaker for the monobath and washing, latex or rubber gloves, and an agitation rod. The agitation rod is easy. Pick up a ⅜″ wooden dowel from a hardware store. Cut off about 6 inches and notch one end with a penknife or a hand saw. The notch should fit over the notch in the film spool.

When exposing the film it is important to leave two blank exposures at the beginning, and two more at the end. This means that a 24-exposure roll will yield 20 exposures. After the 20 exposures have been made, be careful not to rewind the film leader into the cassette. If your camera automatically rewinds the film, try taping the leader to the take-up spool when loading the camera. This may not work on all cameras, but give it a try. Otherwise, pick up a Brandess/Kalt leader-retriever for a few bucks at a camera store.

Developing

To process the film, use the following procedure:

1. Cut the leader from the film, leaving approximately 1 inch protruding from the cassette.
2. Wrap the protruding film backwards around the cassette and secure it with a rubber band.
3. Insert the ⅜″ agitation rod into the cassette and rotate gently clockwise to tighten the film.
4. Slowly unwind the film by rotating the agitation rod counterclockwise, counting the number of turns until resistance is felt.
5. Presoak the film in a glass or beaker containing sufficient water, preferably with a drop of wetting agent (i.e., Edwal LFN), to cover the cassette. While slowly lowering the film into the water, wind and unwind the film by the number of turns counted in step 4. Hold the cassette with the fingers of one gloved hand to keep it from turning.
6. Remove the film from the presoak water, drain, then immerse in the monobath solution following the same wind and unwind procedure described in Step 5. Do this twice for the initial agitation.

 NOTE: Both hands should be protected with gloves, as sodium hydroxide, also known as caustic alkali, is not safe for skin contact.

7. When the cassette is fully immersed in the monobath, wind the film by half the number of turns determined in Step 4. For the rest of the recommended processing time, rotate the rod back and forth through about one and a half turns. It is normal for air bubbles to be released during processing.
8. When processing is complete, lift the cassette and allow the monobath solution to drain, discard the remaining monobath solution, and immerse the cassette in water of the same temperature. If the correct time and temperature have been used the film will be fully developed and fixed, though it will still require washing.

The key to success is in the winding and unwinding operations. These should be carried out gently, making certain the film is not wound too tightly on the spool; otherwise scratches may result. Generally, too much rotation of the agitation rod during processing causes dark bands to be formed across the width of the film, while light bands across the width are caused by insufficient agitation during processing.

Before trying to develop good images with this technique, expose a few rolls of the front of your house or similar subject. Practice developing each roll one at a time. By the third or fourth roll you will be an expert.

Although the monobath method can be used in a tray or conventional processing tank, combined with in-cassette processing the photographer does not require a darkroom, changing bag, or developing tank.

Washing

If you are using in-cassette processing at home you can remove the film from the cassette and wash and dry in the normal manner. If you happen to be traveling and staying in a motel or campground—and you don't happen to have an "Archival" Film Washer with you—try using a method recommended by Ilford.

Remove the film from the cassette and place it loosely in the beaker or glass it was developed in. Fill the vessel with fresh water. Cover the top with your hand, a small plate, or another appropriate item; turn it over five times, then dump the water out and fill it again. Let the film set in the fresh water for about 3 to 5 minutes, then invert the tank ten times, dump and fill again. Let the film set in the fresh water for about 3 to 5 minutes and then, for the final time, invert the tank twenty times, dump, refill, add a wetting agent, let soak for a minute, then dry.

Tips on Drying

Assuming you are in the field without access to a drying cabinet, you can hang the film in the bathroom where you are staying. Remove all towels and cloth materials, which will act as dust magnets and static generators. Run the hot water in the shower for a few minutes to create steam. This will settle any

remaining dust. Hang the film from a clothes hanger using a clothes pin. Restrict the use of the bathroom until the film is dry, which will prevent the dust from being stirred up again.

If you don't have access to a place to hang the film, say you are in a campground or on assignment in the middle of the Olympic National Rain Forest, you can rapidly dry film by using a Rapid Film Dryer, such as the one suggested by Paul Lewis (formula #201). When you return home, thoroughly wash and dry the film in a normal manner to ensure long-term preservation.

Monobaths, or in-cassette processing, may never replace standard development practices. However, they are both techniques well worth knowing and fun to play with.

7 Push-Processing Film

One of my early influences in photography, Roger Davidson, told me, "You can't push film! All you're doing is underexposing and attempting to compensate in the development! Don't you know, if it's not on the film you can't develop it?"

Technically, Roger was right—you can't push film. But in the field, when it's necessary to squeeze the last *nth* of shutter speed and maintain as much depth of field as possible, forget about shadow detail. Get an image and do whatever has to be done in the darkroom.

The technique of pushing film requires ignoring the manufacturer's ISO rating and creating your own Exposure Index (EI) by setting your ISO dial at a higher number. Typically, instead of using Kodak Tri-X at its factory rating of ISO 400, you would set the dial at EI 1600, EI 3200, or even EI 6400. (ISO is the speed rating of the film as per factory specifications, determined through controlled testing; EI is any speed other than the factory spec ISO that you choose to use.)

To be successful requires a developer that will reduce the maximum amount of silver possible. Crawley's FX 11 and Diafine-type are designed to do that. However, using high energy developers such as these usually results in increased fog levels and graininess, sometimes a desirable aesthetic result. An alternative is to use D-76 or Kodak XTOL. Both developers produce maximum film speed better than many so-called pushing developers, while maintaining image quality.

Push-processing is an experimental technique, and there are never any guarantees. However, with testing and experience, you should be able to capture almost any event on film, regardless of how dim the light. If your negatives are still thin, intensify them with one of the formulas in chapter 13, Intensification.

Increasing Film Speed

A number of methods for increasing the speed of panchromatic negative emulsions are known. Today many are considered hazardous, such as using mercury vapor fumes or formic acid, a form of formaldehyde. Either of these

two methods can knock you dead or cause permanent brain damage. Their use is not advised!

Two methods that have proven to be safe and effective are given below. The Hydrogen Peroxide Technique is based on sensitizing the film after development but before fixing. The Acid Vapor Method is a latensification technique used after exposure but before development. These are both older methods for increasing film speed. Neither of them works equally well with all films. Before committing valuable images to either of these techniques, develop one or more test rolls exposed under working conditions.

Hydrogen Peroxide Technique

The Hydrogen Peroxide Technique helps to reduce barely exposed silver in the shadow areas. This method of pushing film will create an apparent 3- to 4-stop increase in film sensitivity, with excellent shadow detail, moderate graininess, and increased exposure latitude. I have used it successfully with Kodak Tri-X film, rated at EI 3200, for many years. The result is a gutsy grain pattern not possible with other films. My tests indicate that T-grain films do not respond to this technique.

Recommended EIs

*Pan F+	ISO 320
*Plus-X, FP4+	ISO 800 to 1600
Tri-X, HP5+	ISO 3200 to 6400

*There is ordinarily no advantage in pushing these films. However, this process may help if the film has been inadvertently underexposed.

Procedure

Kodak D-76 and XTOL both work well with this technique.

Just after development, the film is "steamed" in pressurized hydrogen peroxide fumes. To prevent reticulation try not to allow the temperatures to go much over 108°F/42°C.

1. Place either two 35mm reels or one 120mm reel, as a spacer, and eight ounces of hydrogen peroxide in a *metal* tank of at least 1 liter. With the lid on, place the tank in a water bath of 105°F/40°C. Bring the peroxide to this temperature.
2. Develop the film at normal temperatures, 68°F/20°C to 75°F/24°C. Use an extended development time. For example, for a 1-stop push, develop for 30% to 40% more; for two stops, develop 100% more.
 NOTE: Kodak publishes a comprehensive list of development times for most films at a variety of EIs with XTOL.
3. After development, rinse with plain water at the same temperature as the developer. *Do not use acid stop bath at any time during this process.*
4. In total darkness, transfer the film to the tank holding the peroxide and the spacer reels. Never allow the peroxide to touch the film. Place the lid on firmly—the tank must be airtight so that pressure can build up.

Leave the film to "steam" for 10 minutes, maintaining a water bath temperature of 105°F/40°C. During this period, it is safe to turn on the lights, as long as the lid is not removed. Once every minute the tank should be gently swirled (not inverted!) for 10 seconds, being careful not to splash peroxide onto the film.

5. At the end of 10 minutes, turn the lights off. Carefully remove the lid. Transfer the film to a dry tank (metal or plastic). Cap the lid tightly. Let stand for 5 minutes.
6. Rinse the film in plain water at the original processing temperature by filling and emptying the tank at least five times. Fix and wash as usual.

The emulsion will be extremely delicate until dry.

Latensification of Films with Acid Vapors

This method consists of treatment of the film *after exposure* but before development with the vapors of acetic acid. The speed increase obtainable, especially with high-speed emulsions, has been reported to be as high as 200% to 300%, with only slight increases in fog. Low-speed emulsions appear to gain little or no additional speed.

NOTE: It is important to carry out this treatment after exposure; if unexposed film is treated with this method the result is a sharp *loss* of film speed.

Procedure

1. In a container with a close-fitting lid, insert an empty film reel as a spacer, and a tuft of cotton on which a few drops of glacial acetic acid have been placed.
2. In total darkness, place the exposed film in the container, making sure that the acid does not come in contact with the film at any point. Fasten the lid securely.
3. With a high concentration of acid vapor, the treatment is complete within 1 to 2 hours.
4. After the vapor treatment, the film should be removed and given normal development as soon as possible.

Factors affecting the amount of speed increase with acid vapors are as follows:

1. The speed of the film. High-speed films gain more in proportion than lower-speed films.
2. The age of the film. Fresh films gain more speed than old ones. After 1 year to 18 months, no perceptible increase in speed can be obtained.
3. The development of the film. More speed is gained in low-contrast borax developers, such as Ansco 17. The more energetic developers tend to increase the speed of the film somewhat by extended development, hence the proportionate gain in film speed by the acid treatment is less. It should be noted, however, that increased speed resulting from forced development is usually accompanied by an increase in fog and contrast.

8 Pyro Developers

There is nothing that can compare to a full tonal scale black-and-white nega-
tive developed in pyro. Negatives developed in pyro exhibit exceptionally
sharp edges and unbelievably delicate highlight detail. That does not mean
you cannot get superior results using conventional formulas, it simply means
that a properly developed pyro negative is as good as it gets.

There was a time when pyro was the developer universally used by pho-
tographers. But the advantages of pyro were often offset by the disadvantages.
Besides being subject to rapid oxidization, pyro can cause inconsistent stain-
ing and streaking during development. With the advent of packaged develop-
ers, and the relative ease of using MQ and PQ as primary developing agents,
pyro became all but forgotten. Thanks largely to the work of John Wimberly
and Gordon Hutchings, pyro as a developing agent is gaining renewed popu-
larity among photographers.

In *The Book of Pyro*, Gordon Hutchings writes,

> Pyro can provide a definite increase in both the printing quality of the
> negative and its capacity to record subtle nuances of light. Sharpness,
> acutance, highlight separation and, in the case of pyro staining formu-
> las, the masking of the inherent grain are properties of the pyro devel-
> oped negative.
>
> Pyro produces stronger and more consistent edge effects than any
> other known developer. A print from a pyro negative will show greater
> acutance (subjective visual sharpness) than a print from a convention-
> ally developed negative.
>
> Edge effects in prints are most noticeable in very light areas adjacent
> to smooth middle-gray tones. These light areas in the prints will be
> edge-etched with fine dark lines that separate them from the gray areas.
> These lines are most apparent around clouds, white clothing or other
> bright areas.

Pyro excels in separating and preserving highlight values. This effect is often the first change noticed when one begins to print pyro negatives. Negatives exposed under very difficult light conditions illustrate the superiority of pyro. Strongly backlit subjects, such as summer grass and glacial polish, or overall white subjects that exhibit very little internal contrast, all separate remarkably well.

NOTE: If you plan to use pyro, read the additional notes under Kodak D-1, ABC Pyro, especially pertaining to aerial oxidation. If you are interested in learning more, the most complete text is *The Book of Pyro* by Gordon Hutchings, quoted above (with permission). Much of the practical information on pyro included in *The Darkroom Cookbook* is from that text.

Pyro Stain

While all pyro developers will produce some degree of yellowish green stain, with many the stain is minimal. However, emphasizing the stain has two benefits. It fills in the spaces between the silver grains, becoming an inherent part of the image density, and masks, to some degree, the film grain. Film speed and negative printing quality are improved. A stained pyro negative shows both acute sharpness and reduced visible grain effect (graininess).

Enlarging paper reacts to this stain as density. Thus the total density of a stained pyro negative consists of the silver density plus the stain density. With all stained negatives, the printing density is much greater than the apparent density. This means that a properly developed pyro negative will appear thinner than negatives developed in MQ-type developers. Because of the yellowish green stain, black-and-white densitometers will not give an accurate reading. A color densitometer in the blue filter channel is required to properly read a pyro-stained negative. For more on this, consult page 63 of *The Book of Pyro* (see Bibliography).

If the maximum degree of pyro stain is desired, use a fixer that contains a minimum amount or no sodium sulfite. Sodium sulfite is a salt and salt inhibits image stain. However, sodium sulfite is used in fixers as a preservative. Fixers without some form of sulfite will not last beyond a single day's use. Plain Hypo is an example of a fixer with no sulfite.

After fixing, and before rinsing or washing, immerse it directly into the used pyro developer for 2 minutes with 30 seconds of agitation every minute. Then wash and dry in the normal manner. Avoid using hypo clearing agents (HCA), as the sulfite in them will remove the stain.

Pyro and JOBO Processors

Many users of JOBO continuous-agitation processors have attempted to use pyro with various degrees of success. The problem is that aerial stain tends to form as the developer is oxidized and as the film is rotated in and out of solution while the drum rotates. Several techniques have been proposed to solve the problem. The simplest technique of all is proposed in *The Film Developing Cookbook*: use Gordong Hutchings' PMK but add 30% more of Stock Solution A in the working solution.

A second solution is to use a formula known as Rollo Pyro. The "Rollo" stands for rotary processing. Another name, used by those who think "Rollo Pyro" is too clever by half, is AB C+ Pyro. Adherents to Rollo Pyro claim that, due to the use of ascorbic acid (vitamin C), and a large quantity of pyro, it does not oxidize like traditional pyro formulas and can safely be used with JOBO rotary processing. However, I suggest first trying PMK with additional Stock Solution A, as suggested in the paragraph above. If that doesn't work, try Rollo Pyro.

Paul Van Gelder on Pyro

I was introduced to pyro by photographer Paul Van Gelder in the early 1970s. Paul is what I consider a photographer's photographer. He has quietly and consistently created quality images for at least the last thirty years. His work is among the finest I have ever seen, yet he is relatively unknown, doing nothing in the way of promoting himself. Rather, he prefers to support himself as a woodworker so as not to compromise his photographic vision by creating images for mass consumption.

In 1976 Paul wrote a handwritten letter to me, detailing what he then knew of pyro, including his specific directions for using ABC Pyro. Much of what he had to say is as valid today as it was then. It also serves as an example of the way film development technique has been unselfishly passed down from photographer to photographer, as well as how information has come to me over the years. Here are some excerpts. (I have capitalized, underlined, abbreviated, and used "&" as in the original letter.)

When sold "Pyro" is usually called <u>Pyrogallic Acid</u> or <u>Pyrogallol</u>. The grade I get from Bryant Labs is an analytic reagent quality which is a very pure grade. Don't confuse "Pyro" with <u>Pyrocatechol</u> a totally different chemical, it does not work the same as "Pyro."

The following is from Ansel Adams' "Making of a Photo" 1939.

[Author's note: Here Paul gives Adams' variation of Kodak D-1, ABC Pyro, followed by the following instructions. Adams' variation can be found attached to formula #54.]

When mixing stock solutions do not mix over 80°F. Get a good stainless steel container with at least an 8"–10" wide opening to allow you to easily see when each chemical is dissolved. Be sure to mix in order given. I would mix up only ½ to ⅓ those (ABC Pyro) stock solutions at first being as that is a lot of "Pyro" (60 grams–over 2 oz.) to lose if it went bad. You could mix all the stock solutions except the "A" & mix up just enough of the "A" for each developing session. Sod. sulphite solutions keep very long but I'm not sure of Carbonate solutions, at any rate they should be in full containers for protection from oxidation.

I almost always mix up all my chemicals at each developing session to insure total freshness of chemicals, higher consistency, it gears me to shooting less negatives & getting more into each one.

I digressed a little, you could write volumes on Pyro & unfortunately no one has, as far as I know.

[Author's note: This letter was written before *The Book of Pyro*.]

This is the conclusion of the <u>Pyro ABC Directions</u>.

Tray Development–Constant Agitation

Mix <u>1 part each of A.B.& C. to 7 parts</u> of water. Do not let mixed solutions sit more than a couple of minutes, otherwise a lot of the developer activity has been burned up. Consistency in procedure is most important with Pyro with time & temperature intervals between mixing & developing most critical for maximum consistency & prediction of results.

Also it is important to presoak film before immersion in developer about 20–30 seconds in H_2O with agitation, a quick drain 3 or 4 secs. & into developer.

Slide film in from one end & flip through developer 3 or 4 times to dislodge any clinging air bubbles & then continue remainder of agitation by rocking tray method. This is important because you can't use the leaf method where film is leaved in & out of developer because of oxidation of Pyro–Actually you can use it but it's more inconsistent. Not leafing the film means of course developing one sheet at a time pretty much unless you are tank developing 4 × 5 in which case you should use: <u>1 part each of A.B.C.</u> with <u>11 parts</u> H_2O.

Also you could agitate every 30 sec. for about 8–10 minutes with Plus-X or Ilford FP4. This is of course assuming you are using condenser enlarger for most.

With the tray development about 5–7 minutes is usually good with Super XX or Super Pan Press (now discontinued).

If you are using Plus-X or Ilford be careful they are hot films but work beautiful on compressed scale subjects. i.e. cloudy days, flat lit subjects, dead flat sun (non angular) etc.

Continuation of developing instructions for <u>A.B.C. Pyro</u>.

After development is complete it is very important to go to a water rinse for 4–5 sec. (a couple of swooshes thru a tray of plain H_2O) then to an Acetic acid (standard) stop bath 15-20 sec. constant agitation, then to fixer, 5-10 minutes. The reason is the switch from alkaline developing state right to the Acid (Stop or Fixer) is too severe, it causes a lot of little explosions or Bubble like spots on the negative (most distressing).

You can set your own TEMP. std. anywhere from 65°F–70°F is good—not too high though or Pyro might be too active. But for some instances you might want to experiment.

Normally you only vary your developing times about 20–30%. Pushing or reducing developing times greatly, as with metol etc. is not advantageous with Pyro. Much better results are obtained by varying the carbonate. i.e. 1A; 1B; ½ C.

Something of that order will produce a lower C.I. (contrast index) also very fine translucent hi values. This is perhaps it's finest qualities unmatched by any other developer. Other qualities of Pyro are surface acting, very hi acutance, semi-compensating. Although another pyro developing formula is entirely different & much more compensating, but also much more staining & inconsistent. The A.B.C. is a light stain & thus more controllable & consistent.

[Author's note: Here Paul gives the formula for Kodak SD-1 Pyro Stain Developer followed by the following instructions.]

Develop 4–5 minutes @ 68. When mixed appears very orange. Use right away.

This is for long scale film & contact printing densities. Can be used with beautiful results with roll film but must be modified for condenser enlarging. Try cutting carbonate in $\frac{1}{2}$. Too much dilution of Pyro isn't good it loses its activity & you lose your neg.

Keep me in mind if you see any lenses for 8 × 10. Such as convertibles or longer focal lengths. Thanks. A vicious storm blew in last night (high winds, driving rain) good time to write.

9 **Paper Development**

Photographic papers are made from three light-sensitive materials: silver chloride, silver bromide, and silver iodide. There are currently three combinations available for photographic printing: chloride, bromide, and chlorobromide. Papers with a higher percentage of chloride are slower and usually warmer in tone. Papers with a higher percentage of bromide are faster and colder in tone. As a general rule, whichever component comes first in the name is the major ingredient (e.g., chlorobromide has a higher percentage of chloride than bromide). Varying amounts of the third material, silver iodide, are also found in most papers.

Chloride papers, also known as contact printing papers, are rarely used today. Kodak Azo and Bregger Art Contact may be the last in a list that once included Convira, Apex, Velox, and others. Chloride papers are usually very slow. With chloride papers, projection prints made with an enlarger, though possible, could take 5 to 10 minutes, even longer. Contact prints with the same paper, using a direct light source, such as a bare bulb or contact printer, may require printing times of only 30 seconds to 3 minutes.

Bromide papers are generally the most sensitive to light and almost always give neutral or cold (blue-black) tones. They are the best papers with which to achieve cold tones through direct development, as opposed to toning, after development. Examples of bromide papers are Agfa Brovira Speed and Luminos Flexicon.

Chlorobromide papers are probably the most commonly used today. As the name implies, they are a compromise between the fast bromide and the slow chloride papers. Chlorobromide papers are usually slower than bromides. The percentage of bromide to chloride can allow manufacturers to create either warm- or cold-toned papers with a variety of sensitivities. Currently available chlorobromide papers include Agfa Portriga-Rapid, Bergger Prestige papers, Cachet Multibrom Plus, Ilford Galerie, and Luminos Charcoal R and Tapestry X. All current Kodak papers, except for Azo, are chlorobromide.

Chlorobromide papers tone better than bromide papers. This includes blue-black toning with gold toner. In fact, bromide papers hardly respond to blue-black toning at all. Therefore, if a slight cold tone is desired through direct

development, as with Maxim Muir's Blue-Black Developer, use a bromide paper. If colder tones are desired through toning, use a chlorobromide paper.

Image Color: Print Tone vs. Tint

The color of a print, though it may be subtle, strongly affects the viewer's response to an image. Warm tones tend to engage the viewer emotionally, drawing them into the image. Neutral and cold tones tend to create an emotional distance, a sense of looking at the image from the outside. Although there are no rules but your own (which should not be etched in stone), portraits, still lifes, and nostalgic images (e.g., old barns, dusty highways) often look best with warm tones. Landscapes, abstracts, and modern architecture often lend themselves to neutral and cold tones, or at least this is the way in which we have become accustomed to viewing them. Learning to manipulate and control the tone of a print opens new vistas and ways to communicate a photographer's vision.

When discussing the color/tone of paper, it is important to note the difference between tone and tint. The tone of a paper is determined by varying the amounts of chloride and bromide; the more chloride in the mix, the warmer the tone and the slower the paper speed.

The tint of a paper is determined entirely by the color of its paper base. A paper may have a base color which is brilliant white, cream, ivory, or some other variation of off-white. Although warmtone papers can be coated on a brilliant white base, most warmtone papers made today have a tint to their base. This allows the manufacture to use less chloride, thereby increasing paper speed, and still claim to have a warmtone paper, even though it is the tint, and not the tone which we see.

Whereas tint is most easily seen in the highlights, the tone of a print is most obvious in the shadows. Changes and variations in print tone may not always be glaringly apparent. Often the difference on any given paper is subtle, so much so that someone viewing a print might not even be aware that it is neutral, color, or warm, unless the fact is drawn to their attention, or they see samples of each, side-by-side. The simplest test to determine whether or not a paper is cold, warm, or neutral toned, is to develop it for 2 minutes in Kodak D-72 and compare it in daylight to other papers developed similarly.

Manipulating Paper Tones

Paper, like film, has grain. The larger the grain, though invisible to the eye, the blacker it appears. Paper grains start out very small but become larger as development proceeds. When the grain first starts to develop, it is yellow in color, then turns reddish, then brown, and finally, after full development, becomes black.

This information can be quite useful. For example, giving a print more than the usual exposure and developing it for less than the normal time, say 45 seconds to 1 minute, will enhance warm tones. Using a warm-tone paper and developer combination will further heighten this effect.

Also, when a developer nears exhaustion it is unable to fully reduce the silver halides in the emulsion. As a result, the print may appear to be red or brown, as it cannot develop all the way to black. By adding a proportion, up

to 1:1, of used developer to fresh developer, beautiful warm tones can be achieved. This is because the used developer prevents the silver halides from being fully developed, while the fresh developer ensures that development takes place. This technique is especially effective if the used developer contains glycin (Ansco 130 and Dassonville D-3).

The three most important components in a developer for influencing tone are the developing agent, bromide restrainer, and organic antifoggant. Developing agents such as glycin or pyrocatechin give a warm image tone in the absence of an organic antifoggant (e.g., benzotriazole). Organic antifoggants, such as benzotriazole, tend to cause a cold or bluish image. Also, as the bromide content is increased the image tends to become warmer in tone.

Paper Base

The primary source of print color, in the highlights, is the paper base tint. Depending on the tint, the highlights might remain brilliantly white or off-white, regardless of the developer used. Cachet Multibrom Plus paper, which is coated on a bright white baryta base, will retain white highlights, only slightly affected by the developer. Another paper by the same company, Cachet Multibrom WA Warm Tone, will exhibit both warm shadows and highlights as it is coated on an ivory-tinted base.

Cold Tones

While arresting development is an easy way to achieve warm tones, and developing to completion will result in more neutral tones, there is nothing beyond arresting development or development to completion. As a result, cold tones are usually either very subtle or glaringly obvious and are harder to achieve.

There are three recognized ways to achieve cold tones. The first is through direct development of bromide papers. The results are usually very subtle. The second is through the gold toning of normally warm, chlorobromide papers. This is generally considered the most pleasing and satisfactory method. The third method is immersion in a blue-toning bath (Ansco 241 Iron Blue Toner). This method turns the entire print blue. This is not a true cold tone, rather it is overall "blue toning."

The classic developing agent for creating cold tones on bromide papers is amidol. However, PQ developers using organic antifoggants, such as benzotriazole, will also increase the amount of blue tone in a print (Maxim Muir's Blue-Black Developer). Increasing the amount of benzotriazole and decreasing, or eliminating altogether, the bromide content will help to achieve blue-black tones in a print. This is because bromide restrains development, favoring a warm or neutral tone, while benzotriazole acts as an antifoggant without inhibiting the reduction of the silver halides.

To obtain blue-blacks using benzotriazole, reduce the potassium bromide to $\frac{1}{10}$ or $\frac{1}{6}$ strength and add just enough 0.2% benzotriazole solution (2 grams in water to make 1 liter) to prevent developer stain or fog. For best results use a bromide paper. The blue-blacks obtained by this method are not as strong as those obtained through gold toning of warm-tone chlorobromide papers.

However, as bromide papers do not readily achieve blue-black with gold toning, it is better to reduce the potassium bromide and add or increase the benzotriazole.

A final tip for increasing blue-black tones, which can be used in conjunction with any of the techniques just mentioned, is to decrease exposure and prolong development to 5 or 6 minutes. With some, though not all papers, the print will exhibit stronger blacks, tending toward the bluish part of the spectrum.

Neutral Tones

Neutral tone developers produce images with the least amount of bias toward either warm or cold tones. This does not mean that some bias may not exist, depending on the paper, only that it will be less than if a warm- or cold-tone developer is used.

Some papers will have a slight greenish cast when developed in a neutral-tone developer. If this occurs, substitute either Edwal's Liquid Orthazite or benzotriazole for the potassium bromide. This can be done by eliminating the bromide altogether or lessening the amount and adding a small amount of benzotriazole (see the discussion on cold tones above). Selenium toning, after fixing, will also eliminate any green cast.

Warm Tones

Although some papers produce warmer tones, the prevailing trend has been for manufacturers to modify emulsions to create neutral tones. To create warm tones a photographer usually has to resort to modified development and/or toning.

There are many ways in which to achieve warm tones with most papers, although the results will differ according to the type of paper used. As a general rule, print developers using only hydroquinone produce a warm tone, and those using only glycin produce a brown tone. Some methods to create warm tones are as follows:

- The less carbonate used, the warmer the tone (the use of too little carbonate, however, will result in a flat, muddy print).
- Substituting potassium carbonate for sodium carbonate will create warmer tones. Although sodium carbonate is the standard accelerator used in most developers, some printers prefer to use potassium carbonate. Besides creating browner tones it can be used in stronger concentrations for increased contrast.
- Increasing the amount of bromide in most formulas will also increase the warm tone. If the tones are not warm enough, add between 30 and 125 ml of a 10% bromide solution. After that, increase by 30 ml until the tones suit you or fogging occurs (see "Bromide and Carbonate," below).
- Generally, though not always, increased exposure, resulting in shorter development times, yields warmer tones.
- Choosing a warm-tone developer will enhance warm tones inherent in the paper.

- Diluting fresh developer with up to 50% used developer will increase warm tones. If you like warm tones in your images, keep a bottle of used developer on the shelf for just this purpose. Glycin-based developers work well.
- Tone after processing is complete.

Redevelopment Method

The halide type and composition of any given paper has some effect on the image tone. However, as manufacturers don't typically release this information, except in a general context (i.e., bromide, chlorobromide, chloride), it is impossible to know beforehand what the composition is. The technique of redevelopment eliminates the need to know, as it reduces all halide in the emulsion to silver bromide, which can then be redeveloped and toned.

To use this method expose, develop in a neutral tone developer, fix, and wash a print in the usual manner. Next, use Print Rehalogenating Bleach to convert all silver metal to silver bromide with no mixed halides. Then rinse for 5 minutes and redevelop using any toning developer of your choice (this includes cold-tone developers).

Amidol Developer

There are very few photographers working today who remember how rich a print developed in amidol can be. There is no other paper-developing agent capable of creating the depth of black and subtle range of tones that can be achieved with amidol.

However, do not rush out and buy a pound of amidol and try to achieve spectacular results on your current batch of paper. First, you would either have to mortgage your home or sell your firstborn. This is because amidol, a petroleum distillate, has only one known purpose in the world today: as a developing agent for black-and-white negatives and prints. Because it has been known to go bad on the shelf before the manufacturer, much less the distributor, can sell it (primarily because there are relatively few photographers who use it so it sits for a long time in adverse storage conditions), the cost of manufacture and distribution is prohibitively high.

Second, and even more important, amidol works best with only two types of paper. Either old-style, soft emulsion papers, or long-scale chloride papers, such as Kodak Azo and Bergger Art Contact. With any other paper, which is to say all modern prehardened papers, amidol works just as well, though not necessarily better, than most other developing agents, or combination of developing agents. Even so, when used with a premium paper like Cachet Multibrom Plus, it is still capable of producing the greatest depth of black the paper is able to achieve.

To understand and use amidol to its greatest advantage, one must know the history of paper. Before the widespread use of machine processors for commercial black-and-white printing—in other words, pre-1950s—paper emulsions were "soft" and easily damaged. This was because they contained a minimal amount of hardener in their emulsion.

Printers handled them with "kid gloves" or used hardener in their fixer, after development, to prevent damage. As a result, it was nearly impossible to machine process black-and-white papers without damage to their emulsion. However, machine processing turns out to be far more profitable, both for commercial labs and the manufacturers who make, sell, and service the machines. In response to this, paper manufacturers began formulating papers with prehardened emulsions. Unfortunately, when the surface of the paper has been significantly hardened, as with nearly all modern papers, amidol behaves the same as any other developing agent.

While all papers must have some hardener to prevent the emulsion from sluffing off, most modern papers have too much. Amidol requires an old-style, soft emulsion paper to really perform as it was intended. There are only a few photographic papers, of which I am aware, at least in the United States and Canada, that work with amidol to produce the stunning results formerly possible: Kodak Azo, Bergger Art Contact & Prestige papers, David Lewis' Photographic Bromoil Paper, and Cachet Expo R.

The problem with Kodak Azo is fourfold. The first is that it is a slow chloride contact printing paper. This means it is not practical for projection printing with an enlarger. Most printers using Azo work with large format negatives, generally 8 × 10" or greater. A typical print exposure with Azo, or contact printing papers in general, is 30 seconds to 3 minutes using a 150-watt bulb suspended approximately 3 feet above the contact printing frame. Printing times with an enlarger and lens are impractically long.

Second, Azo is hard to get. Due to limited interest in large-format contact printing, Azo almost always has to be special ordered and costs more than most projection papers. Currently, Freestyle Photo has the largest available selection of Kodak Azo in the world, see appendix II, Sources.

Third, Azo is only made in single weight, and fourth, due to lack of interest in the art of contact printing, Azo comes in a limited range of contrasts. The contrast availability is also dependent upon the size. For example, 8 × 10" Azo is available in grades 1, 2, and 3; 20 × 24" Azo is only available in grade 2.

Having said all this, if you happen to be a large-format photographer and have never used the Azo-amidol combination, I suggest you buy 10 grams of amidol and a box of Azo. Combined with highly dilute selenium toning (1:128), there is no finer combination for black-and-white printing.

NOTE: Unlike other papers, Azo has an optimum development time, in amidol, of 45 seconds to $1\frac{1}{2}$ minutes.

Some of the problems associated with Kodak Azo are overcome with Bergger Art Contact. Although it is a slow chloride contact printing paper, it is somewhat faster than Azo, and is coated on double-weight stock. It does share some of Azo's limitations though. Art Contact is only available in grade 2 and in sizes from 8 × 10" to 20 × 24". Art Contact can be obtained from Bergger Products and Freestyle Photo, see appendix II, Sources.

NOTE: The limitation in contrast grades experienced with both Azo and Art Contact can be overcome to a certain degree by using some of the variable contrast developing techniques found below under "Variable Contrast Print Developers."

David Lewis' Photographic Bromoil Paper is manufactured under the private label of Canadian photographer David Lewis. David is one of the world's

leading authorities on bromoil and the bromoil transfer process. His book, *The Art of Bromoil and Transfer,* is the best available reference source on this unique process.

To print bromoil properly requires an old-style soft emulsion projection-quality paper, just like those favored by amidol. There being none available, David contracted with a European paper manufacturer to make a soft-emulsion paper specifically for his process. As there is a minimum order, which far exceeds David's needs, he packages and sells the excess paper.

There are three drawbacks to David Lewis' paper. Like Azo it is not currently easy to obtain. In Canada, it is available directly from David; in the United States it is available from The Photographers' Formulary (see appendix II, Sources). The second drawback is that it is only available in two sizes, 8 × 10" and 12 × 16" (16 × 20" is available by special order).

The final drawback is that it is currently only available in one grade, approximately between grade 1½ and 2. This is because the bromoil process requires a contrasty negative (the opposite of platinum/palladium printing, which requires a flat, dense negative). If your negatives consistently print well between grades 1 or 2, follow my suggestion to large format photographers: pick up 10 grams of amidol and a package of David's paper. (David has informed me that if enough silver printers request it, he might be convinced to produce a higher contrast grade of paper.)

NOTE: If you do use David's paper, remember, it has minimal hardener in the emulsion and will easily scratch. Use wide, salon borders, at least 1 inch all around, and handle by the borders only; tongs of any kind will scratch the image area.

Finally, there is Cachet Expo and Bergger Prestige papers. These are both beautiful, silver-rich, graded papers. While Expo and Prestige papers are both chlorobromide-based, they contain less hardener than most papers, which means they react very well to amidol development.

Amidol and Oxidation

Much has been said about amidol's tendency to both oxidize rapidly and to stain paper. Regarding the first claim, amidol does not oxidize any faster than most other developers. I have used Amidol Paper Developer diluted 1:2, with as many as four students, for four-hour printing sessions. This means that many more prints were run through the developer than any photographer working alone is capable of producing in the same amount of time.

If anything, amidol should only be used for one session and then tossed, never saved for later. Even so, more than once I have mixed a working solution of amidol for personal use, been called away for several hours (once for an impromptu lunch with a client), only to return and find it still working. Whenever this occurs, I either cover the tray with an oversized piece of Plexiglas or pour the amidol into a storage container.

Regarding paper staining, there are three reasons amidol will stain. The first is that the amidol powder is old. Fresh amidol should look like fine gray powder or dust with a slightly green tint. If it looks like black or gray sand, it is old and will probably cause staining.

Second, the working solution is exhausted. All developers exhaust with time and use, and amidol does have its limits. Even so, I have read references to amidol formulas that caution that, once mixed the amidol will not last more than two days in a tray! Even so, I still recommend that amidol developers be mixed fresh and dumped at the end of a session.

The third reason amidol may cause stains is that an acetic acid stop bath has been used. Always use either citric acid or a running-water stop bath with amidol.

NOTE: Amidol stains skin, fingernails, clothing, and everything else. It is also toxic—*never put your hands into a solution of amidol*; either use tongs or rubber gloves. This is good advice for all developing agents, including MQ developers.

Bromide and Carbonate

To increase the flexibility of any developing formula keep a bottle of carbonate solution and a bottle of 10% bromide on your darkroom shelf.

Carbonate Solution

To make a carbonate solution, dissolve 60 grams of carbonate in 750 ml of water and add water to make 1 liter. If you are in a hurry, just dump the 60 grams into a liter of water. As long as you always do it the same way, the results will be the same.

Adding carbonate solution to paper developer will increase the speed of the developer and create the appearance of greater contrast through stronger and richer blacks. Start with 50 to 100 ml to each liter of paper developer. As much as 200 ml can be used per liter, but beyond that your highlights may fog.

NOTE: If you intend to gold-tone a print for blue tones, do not add too much carbonate solution as it will make it difficult to secure a brilliant blue with gold chloride toner.

10% Bromide

With paper developers, adding a solution of 10% bromide will help prevent fog and slow the speed of excessively fast papers (allowing longer printing times for dodging and burning). Additionally, it will give clearer highlights, slightly extending the contrast range of the paper. With shortened development times it will produce brownish to olive-brown tones. Finally, it will enhance or increase warm tones by restraining development.

Of the above effects, the most important is to keep the highlights clear and thereby yield a bit of extra contrast. Add 15 to 25 ml of 10% bromide to 1 liter of developer. (You can add more, but even though bromide helps to prevent fog, after a point it will actually cause fogging.)

To make a 10% bromide solution, add 100 grams of potassium bromide to water to make 1 liter. As you did with the carbonate solution, if you are in a hurry, pour the 100 grams into a liter of water and go.

A Perfect Balance

The combination of carbonate solution and 10% bromide perfectly balance each other to achieve the best possible results. The increase in speed gained from using carbonate balances the decrease in speed caused by bromide. At the same time, highlights are enhanced by the restraining properties of the bromide, while blacks become stronger and richer with the carbonate. When using them together add 1 part bromide to 3 parts carbonate.

NOTE: It is not a good idea to add bromide and/or carbonate from force of habit. It is better to begin with an unmanipulated developer, observe the results, and then determine if one, the other, or both are needed.

Test for Chemical Paper Fog

Throughout the text, and in several formulas, I have noted that restrainer can be increased or decreased to achieve certain effects. Both too much or too little restrainer may cause chemical fogging of the paper. This usually appears as a graying of the highlights. It can also be subtle and hard to detect.

A simple test for *chemical* fog is to take a piece of unexposed paper and cut it into four parts. Develop and fix the first, as a control, for the full normal time. Then, as you increase the amount of restrainer or antifoggant, develop additional pieces and compare them to the control print. As long as they are as white as the control, more restrainer may be added.

Additional Methods of Print Manipulation

Variable Contrast Print Developers

There are several methods for manipulating contrast either by using specially formulated developers, combining developers, or manipulating exposure and development. The simplest is to use a low contrast developer with a paper one grade higher. For example, if you need a contrast grade between 2 and 3, use grade 3 paper with Ansco 120 1:1, developing for 3 minutes. This will reduce contrast by about a half grade.

A specially formulated developer for variable contrast control is Roland F. Beers Two-Solution Variable Contrast Developer. Solution A, of "Beers" (as it is commonly known), contains metol, and Solution B contains hydroquinone. Mixing the two in various proportions gives a progressive range of contrasts with any grade of paper. Although Beers is usually thought of for graded paper, it works equally well with variable contrast papers for tweaking contrast in slight increments.

Combining two developers, one high/normal contrast, and one low contrast, is another method for obtaining variable contrast results similar to Beers. The advantage of combining different developers, over using Beers, is that a variety of image colors can be achieved through various combinations. For example, combining D-72 with Ansco 120 will produce one image color, while using Agfa 108 and 105 will usually produce a different color. The color may also vary with the amount of each developer used.

Typically, varying amounts of *stock solution* high/normal contrast developer are added to a tray of *working solution* low contrast developer. The more high/normal developer added, the higher the contrast. Start by adding 25 ml of *stock solution* high/normal contrast developer, such as D-72, to each liter of *working solution* low contrast developer, such as Ansco 120 1:1.

The disadvantage of combining developers is that the high/normal contrast developer, which usually contains hydroquinone, may exhaust before the low contrast developer. This is not a problem if only a few prints are to be made from one negative, which is often the case when using developers in this way. However, if consistency is important for a large number of prints, it is important to make certain there is sufficient high/normal contrast developer in solution.

The general rule is that at least 10 ml of high/normal contrast developer needs to be present for each 8 × 10" print. This may lead to doubling, or even tripling, the initial volume. For example, if you are using Ansco 120 1:1 with 25 ml of D-72 per liter, instead of starting with 2 liters in the tray, start with 4 liters (2 liters Ansco 120 and 2 liters of water). This will enable you to add 100 ml of D-72, which is good for 10, consistent, prints. If you are using 50 ml of D-72 per liter, this would equate to 200 ml per 4 liters of Ansco 120, or 20 prints. However, the amount of D-72 added is dependent on the contrast desired.

A variation of this technique is to use two separate developers, usually a low contrast formula, such as Ansco 120, and a high/normal contrast developer, such as Ansco 130 or Kodak D-72. Development is begun in the low contrast solution and completed in the high/normal contrast developer. For this application you may wish to dilute the Ansco 120 as much as 1:4.

The time in each can be varied, though the minimum time in the high/normal contrast developer is usually about 15 seconds. A good starting point would be to develop the print for 1 minute and 30 seconds in the low contrast developer, and 30 seconds in the high/normal developer, although as much as a 50/50 time split may be used. A 10 second drain between developers will help to prevent the second, high/normal contrast, solution from becoming too dilute.

Manipulating Exposure and Development

Subtle control over contrast can also be gained by manipulating the exposure, contrast grade, and development time. The paper contrast grade, or filter, has a greater effect on the shadow regions, while the time in the developer affects the highlights. Increasing the contrast grade or filter and shortening the development time will have the effect of maintaining a solid black while not allowing the highlights to overdevelop. The minimum time for developing a fiber-based print is about 1 minute and 15 seconds. For an RC print use a minimum time of 45 seconds.

A different effect can be gained by slightly underexposing the print (once a correct time has been determined for the highlights) and overdeveloping. In this case the contrast grade may not have to be altered. Most fiber-based papers have a useful range of 1½ minutes to 6 or 7 minutes in the developer. RC papers have a range of about 45 seconds to 3 minutes. Within this range slight increases in midtone separation can often be achieved, though the results are dependent upon the paper used.

10 Stop Baths and Fixers

Stop Baths

Whether or not to use an acid stop bath or a plain running-water bath has been a long-standing controversy among photographers. On the one hand, an acid stop bath immediately arrests the development process. On the other, when sodium carbonate, one of the most commonly used alkali in developers, comes into contact with acid, carbon dioxide gas is released, which can cause blistering in the emulsion of both film and paper. The problem is more critical in film, where it is exhibited as a pinhole, usually in dense areas of silver deposits such as the sky.

There are three methods to prevent pinholes from occurring. The first is to use developers compounded with mild alkalies, either Balanced Alkali or borax, which do not create carbon dioxide gas. The second is to use a 3% to 5% solution of sodium metabisulfite, a 3% solution of chrome alum, or a mildly acid stop bath, such as Kodak SB-1 Nonhardening Stop Bath. Another very gentle-acting stop bath, suggested by Jay Dusard, is a simple solution of 10 grams of sodium bisulfite in one liter of water.

NOTE: Stop baths made of 3% to 5% metabisulfite or 3% chrome alum may cause green stains on some enlarging papers.

The third is to use a plain-water rinse instead of an acid stop. A plain-water rinse does not stop development. In fact, development will continue in the emulsion layer until the film is in the fixer. However, the plain-water rinse will slow the rate of development considerably and prevent the developer from contaminating the fixer. Running water should be used whenever possible. If running water is not available, fill the tray or tank with fresh water, agitate for 20 to 30 seconds, dump, and repeat three times.

At least one of these three methods should always be used as a buffer between the developer and fixer. Otherwise the fixer will quickly lose acidity

and become exhausted. Stains in the emulsion are likely to occur if this happens.

If you prefer to use acid stop baths instead of plain or running water, they can be made from a variety of chemicals. The most widely used is acetic acid in a 1% to 2% working solution. The only other ingredient sometimes added is a pH indicator dye (Indicator for Stop Baths, formula #118).

Other chemicals that can be used to make stop baths are boric acid, citric acid, and sodium bisulfite. Chemicals that *should not* be used are potassium salts, such as potassium metabisulfite. The introduction of potassium salts into an ammonium or sodium thiosulfate fixing bath can convert the bath to potassium thiosulfate, which is nearly inactive as a fixing agent. Before WWII, German companies formulated many stop baths using potassium salts, as they were less expensive than sodium (Germany was in a depression, as was the rest of the world). Subsequent research revealed the problems associated with potassium salts in stop baths, and its use was discontinued. Unfortunately, there are still some old pre-WWII formulas floating around.

NOTE: Potassium alum, often found in fixers, does not have the same effect as potassium metabisulfite or potassium sulfite.

Fixers

Proper fixation is as important to the process as proper development. Fixing can make the difference between an image of lasting value and an image that doesn't last. As important as the process may be, it is not well understood by many photographers.

In brief, the fixing process is the removal, after exposure and development, of unused silver bromide from the paper or film. This is necessary because unused silver bromide particles will eventually turn black and ruin the image.

The fixing process is not a simple one. It involves a series of chemical reactions in which the silver bromide is converted into complex argentothiosulfates. Upon immersing an emulsion (film or paper unless otherwise noted) into fixer, the first reaction is the conversion of unused silver bromide into an insoluble, and not very stable, compound. This compound can be seen by looking at negatives (not prints) after only a few seconds in the fix. They will be milky in appearance. If fixation is not continued to completion, and the milky substance totally removed, the negatives will rapidly degenerate. Paper has a similar reaction, but there is no milky substance visible to the eye.

As fixing progresses, the intermediate complex compound reacts with fresh hypo to form a soluble compound of sodium argentothiosulfate that can be removed by washing. The actual rate of fixation is relatively fast. It is the breaking down of by-products (complex argentothiosulfates to soluble sodium argentothiosulfate) that takes so long. In other words, fixing creates by-products; more fixing eliminates them.

The fixing process for paper and film is similar, but film and paper have their own unique characteristics and requirements. Until the 1970s, the primary agent used for fixing was sodium thiosulfate (hypo). Other fixing agents, though not as common, include alkali thiocyanate, thiosinamine, cyanide,

sodium sulfite, ammonia, thiourea, and concentrated solution of potassium iodide. Except for special purposes (e.g., ammonium thiocyanate can be used to achieve fixing times of a few seconds, as in Defender 9-F Rapid Thiocyanate Fixer), only two fixing agents are of interest to the general darkroom worker today, sodium thiosulfate (hypo) and ammonium thiosulfate. Fixers using ammonium thiosulfate are commonly referred to as "rapid fixers."

For practical purposes the difference between the two thiosulfates is a matter of fixing time. Ammonium thiosulfate is 20% to 30% faster than sodium thiosulfate. That ammonium thiosulfate is faster than hypo was well known long before it was in common use. At some point, ammonium thiosulfate gained an unjust reputation for producing less permanent images. Also, it was not available in a stable form. Therefore, photographers desiring a more rapid rate of fixation would add ammonium chloride to their standard hypo solution just before use. This produced ammonium thiosulfate in the solution.

Today, a stable, pure form of ammonium thiosulfate is readily available in two forms. The preferred form is a 60% solution. However, when it is inconvenient to ship or store liquids, it is also available in photograde crystalline form. Although there are five published ammonium thiosulfate formulas, known as ATF-1 to ATF-5, the two most commonly used in contemporary photographic practice are ATF-1 and ATF-5.

Fixing Negatives

A rule of thumb for fixing negatives is to allow at least three times the time required for the clearing of all traces of milkiness from the film, with 3 minutes as the minimum (the film should not be exposed to light for examination until it has been in the fixer for at least 1 minute). In other words, if all traces of milkiness have disappeared upon examination after 1 minute in the fixer, it is safe to assume that total fixation will have taken place in 3. The use of hypo or ammonium thiosulfate makes no appreciable difference except for time.

NOTE: There are only two *accurate* methods to establish when a fixer is exhausted.

1. When the fixer is fresh and the first roll of film is observed to be clear (no milky deposits), a time is then established for subsequent rolls. As the fixer begins to exhaust, from the buildup of by-products in the solution, it takes longer for film to reach the initial clearing stage. When the clearing takes twice as long as when first observed, the fixer should be replaced.
2. Keep count of how many films have been fixed. When the manufacturers recommended limit has been reached, the fixer should be discarded. As a general rule, twenty rolls of film per liter is a safe limit, when the manufacturer's recommended limit is not known.

NOTE: Other methods of determining fixer exhaustion may be used but they are less reliable.

Fixing Paper

Fixing paper is a controversial procedure. The two "heavies," Ilford and Kodak, are at odds as to how the process should be handled. The time-honored method, established by Kodak, is the two-bath method. In the two-bath method, two fresh fixing baths are placed side by side. Paper is immersed in the first bath for a predetermined time, drained, and moved to the second, fresh bath for an identical time. Since the paper is completely fixed in the first bath, only a minimal amount of complex argentothiosulfates are carried into the second bath. There the action of fresh fixer breaks down the remaining complex argentothiosulfates to sodium argentothiosulfate, which is easy to remove.

The final step is the changing of the baths. After the first bath is exhausted, which is determined by one of the two methods detailed above, or by testing with a 5% solution of potassium iodide (Fixer Test Solution, formula #189), it is poured out, and the second bath becomes the first. A fresh bath is mixed to replace the second. After the third rotation, both baths are deep-sixed, and two fresh baths are mixed.

While not faulting this method, Ilford suggests an alternative, which they claim is better. According to Ilford, the use of a single, concentrated, rapid fixing bath for 1 minute prevents the buildup of complex argentothiosulfates in the emulsion. This method works because the paper is 90% to 100% fixed within the first 15 seconds. If this method is used, it is important to monitor the time *exactly*. The paper should be immersed for 60 seconds, drained for 15, and immediately transferred to a fresh water bath, preferably with running water. Excess time in the fixer allows complex compounds to form, negating any advantage of the method.

Both methods have their merits, and no one is certain which, if either, is the better for the longevity of paper. One advantage of the two-bath method is that whichever fixing agent you choose, hypo or ammonium thiosulfate, the fixing time is not as critical as in the single-bath method, although excessive fixing with acid fixers isn't a good idea under any circumstance.

Types of Fixer

There are three general types of fixing baths: plain (or neutral), acid, and alkali. A plain fixing bath is one consisting of hypo in water only. A plain bath can be easily mixed by adding 2 pounds of sodium thiosulfate crystals to 1 gallon of water. When using the crystalline form of sodium thiosulfate, begin with water of at least 90°F/32°C, as the temperature will drop considerably.

A plain hypo bath is often used prior to toning and sometimes as the second bath in the two-bath system. It has a short tray life and is not efficient at neutralizing alkali brought over from the developer. Used as the first bath with paper, or as the primary bath for film, a plain hypo bath may cause stains and other problems. For these reasons it is not considered suitable for general applications or as a first bath.

Except for plain hypo, most fixers are of the acid type. Acid fixers are made by adding acid to the solution. Not just any acid can be used, though,

as many would decompose the hypo and precipitate sulfur into the bath. Weak organic acids, like acetic acid, can be used, but only in combination with sodium sulfite to produce sulphurous acid in solution. Sulfurous acids can be used, but they are not stable in solution; sodium metabisulfite is more stable. Bisulfites can also be used and are safer for the fixer.

Alkali fixers are the most efficient and effective with modern emulsions, film or paper. Although they have been used for scientific purposes for quite some time, they have only recently become commercially available. TF-4, a proprietary formula from Photographers' Formulary, is an excellent, easy-to-use, alkaline fixer. A fixer having similar properties but a considerably shorter shelf life, TF-3 Alkaline Rapid Fixer, is given in the Formulas section of this book.

There are advantages to using alkaline fixers. One is that alkaline fixers are easier to wash out of paper fibers (paper fibers are akin to the fibers found in clothing; the reason laundry soaps are alkaline is because they will wash out more easily than a soap which is acid; there is no such thing as an "acid" laundry detergent or soap!).

Another advantage is that, unlike acid fixers, it is almost impossible to overfix with an alkaline fixer.

Hardener

The use of hardener is also controversial, though there is not as much disagreement. The purpose of hardener is to reduce the risk of injury to the emulsion of the film or paper *while it is wet*. This was of great importance when most photo papers were made with soft emulsions (see "Amidol Developer," chapter 9). After drying, hardener *serves no useful purpose*. On the down side, the use of hardener makes it more difficult for fresh fixer to penetrate the surface of the emulsion to perform its function. The two most noticeable results are that fixing time is extended, even doubled, and some toners may have an adverse reaction to hardener, resulting in stains or uneven toning.

Most agree that film fixing baths, especially for tray-processed sheet films, should include hardener (film on rolls is mainly at risk when being removed from the reel for drying). Unless you are a very careful worker, the advantages of protecting film from scratches outweigh the disadvantages of using hardener.

For tray processing of paper, it is not necessary to use hardener unless you experience scratches on the print emulsion from handling (machine processors should always use hardener). The reason is that papers are already pre-hardened to various degrees (see "Amidol Developer," chapter 9).

If scratches do occur, and with some of the less hardened papers this is still possible, hardener should be added to the solution. Start by adding one-third of the manufacturer's recommended amounts, and increase the amount in one-third increments until the problem is eliminated (i.e., if the directions call for $1\frac{1}{2}$ ounces of hardener start with $\frac{1}{2}$ ounce; if the problem persists, add another $\frac{1}{2}$ ounce).

Chrome and potassium alum are the two most common hardening agents. Chrome alum has the greater effect, but fixers using this agent have poorer keeping qualities. For this reason potassium alum is usually preferred.

Archival Print Process

Archival means different things to different people. To many manufacturers archival means increased sales and higher profits by labeling a product as "archival." To photographers, archival means negatives and prints that will last at least a century or more. To the best of our collective photographic knowledge, gained both through experience and advanced aging tests, the following procedure will help to produce prints that are archival by a photographer's definition.

1. Develop the print from 45 seconds to 6 minutes, depending on the developer, paper (RC or fiber-based), and density desired.
2. Place the print in acid stop bath, with agitation, or running water for at least 30 seconds.
3. Fix the print in fixer without hardener (it does not matter which brand of fixer you use, but follow the manufacturer's recommended time). Do not overuse the first fixer, generally you should be able to fix 100 8 × 10"s per 4 liters (20 8 × 10"s per liter), then toss. Use constant agitation.
4. Fix the print in a second, fresh fixer without hardener. Use this fixer to replace the first fixer when the first fixer reaches 100± prints. Use constant agitation.
5. Selenium tone for 3 to 5 minutes. Use either Berg Selenium Toner, Kodak Rapid Selenium Toner, or one of the formulas in the formula section, diluted from 1:9 to 1:30, depending on whether you want a color shift (the less dilute the more likely you will achieve a color shift).
6. Soak the print for 5 full minutes *with continuous agitation* in Berg Bath, mixed according to instructions for the archival dilution.
 NOTE: Selenium toning may leave a residue of unused selenium on the surface of the print. This residue is not visible to the eye, but in time may darken. Extended washing may eliminate some or all of this residue. However, Berg Bath, a proprietary washing aid of Berg Color-Tone, is specifically formulated to remove both residual selenium and fixer (see appendix II, Sources).
7. Prints can be held in a horizontal tray-type washer (e.g., the Zone VI horizontal print washer) with running water, until all prints are ready to be placed in a vertical washer (e.g., Cachet Eco Wash), or they can be placed directly into the vertical washer.
8. Wash the prints for 30 minutes. *Under no circumstances* should prints be allowed to wash for more than one hour; the prolonged immersion in water will weaken the fiber of the paper.
 NOTE: There is only one requirement to achieve a complete and thorough washing of prints (or negatives): a continuous flow of fresh water. The flow rate is not significant, as long as it is continuous. The purpose of a vertical washer is simply to keep the prints separated while the water flows over them. Even if one side of the print appears to stick to the vertical plastic dividers, the constant flow of water will leach out any chemicals in the paper.
 I recommend the Cachet Eco-Wash as it uses the least amount of water to achieve a thorough washing. The 16 × 20" Eco-Wash uses

approximately 24 to 32 oz of water per minute compared to at least 128 oz (1 gallon) per minute of the next most efficient washer currently on the market.

9. Move prints directly from the vertical washer to a solution of Agfa Sistan (975 ml water to 25 ml of Sistan; capacity = 100 80 × 10"s per liter). Agitate for 1 minute.

10. Squeegee the back and then the front of the print, and place it face down on a drying rack that has been cleaned with household bleach, diluted 1:4 with water, then fully rinsed to remove all traces of the bleach before placing the prints on it.

11 Toning Prints

There are two primary reasons to tone prints: one is to change the color of the image, the other is for print protection. While the two are not mutually exclusive—some formulas both change the color and protect the image—they are not always complementary. For example, prints treated with iron toners, while attaining a rich blue color, will not last more than a few years. Properly fixed and washed prints toned with selenium toner, whether or not a color change is detected, will last indefinitely.

Many substances will tone prints. In fact, a beautiful, and permanent, warm tone can be achieved on many fiber-based papers by using your morning coffee (fresh ground seems to work better than instant). After fixing and a brief rinse in running water, immerse the print in cold (or warm) coffee until the desired brown tone is reached. Finish by washing the print in the usual manner.

Not all papers tone equally well. Some papers do not take to toning at all. Others may respond well to one toner and not another. Also, the color of a toned print depends on the formula of the toner and its dilution; the paper type, surface, and paper base tint; and not least of all, the processing method. This last includes not only the print developer used, but often the choice of fixer.

Points to Remember for All Toning Processes

The following points apply to all toning processes.

- Development: Don't exceed the capacity of your developer. Contaminated or exhausted developer can cause image-color variations.

- Stop Bath: If you use an acid stop bath, do not use an exhausted or *over-concentrated* stop bath. A fresh stop bath will preserve the acidity and fixing properties of the fixer. Replace the stop bath frequently or use an indicator stop bath.

 Stop bath left in the tray overnight will evaporate and become overconcentrated. This can cause mottling in the base of a toned print.

 Insufficient agitation of prints, especially during the stop bath, can also cause mottling. The mottling will not be evident until the print is toned with a selenium or sulfide toner.

- Fixing: Improper fixing is probably the major cause of stains in toned prints. An exhausted fixing bath contains insoluble silver compounds that will be retained by prints and cannot be completely removed by washing. When these residual silver compounds come into contact with a toner, they form a yellow stain that is especially noticeable in the highlights and borders.

 Excessive fixing with acid fixers is almost as bad. Prolonged fixing expands the paper and allows the solution to penetrate the base. Acid fixer that is trapped in this way is difficult to wash out and will make prints toned in selenium or sulfide turn yellow. Alkaline fixers do not exhibit this characteristic.

 Proper agitation is also important. Purple stains can occur in both selenium and sepia toner when prints have previously stuck together in the fixer.

 Avoid the use of hardening fixers. Hardening fixers do just what the name implies: they harden the emulsion. This prevents toners from penetrating the emulsion and doing what they are supposed to do. Use Plain Hypo, Looten's Acid Hypo, Kodak F-24 Nonhardening Acid Fixer, TF-2 Alkaline Fixer, TF-3 Alkaline Rapid Fixer, or ATF-1 Nonhardening Rapid Fixer.

- Washing: Thorough washing is especially important. Residual silver salts and traces of hypo in the paper may cause stains, uneven tones, and fading. Hypo Clearing Agent (HCA) may be used to conserve water without adversely affecting toning.

 Other Considerations: Do not use metal trays or tanks. Use trays made of nonmetallic material such as glass, inert plastic, or hard rubber.

While it is perfectly acceptable to tone prints that are still wet, having just been fixed and washed, the most consistent results are obtained from toning dry prints that have been rewet. This is because the emulsion of freshly processed prints is still in a state of flux. This instability may cause minor variations between prints, even in the same batch. However, if you tone prints that have already been dried, soak them in water for at least 5 minutes before toning. If the prints are to be stored for extended periods prior to toning, use proper storage techniques, as you would for any fine print. Prints that have been stored incorrectly may show stains.

It is difficult to wash toner from the edges of a print. Therefore, when toning RC paper, keep toning times to a minimum to prevent the solution from

penetrating the edges of the paper. If extended toning times are anticipated, longer than 5 minutes, use salon borders of at least 1 inch around the image. The same is true for fiber-based prints meant to be toned for longer, about 10 to 12 minutes.

Prior to rewashing freshly toned prints, use HCA with *fiber-base* papers to save time and conserve water. Do not use HCA for RC prints, as it will serve no useful purpose except to extend wet time. Do not reuse HCA for *untoned* prints, as it will contain traces of toner.

Toned prints should be dried face up on clean drying racks, as many toners will transfer to the screen when placed face down. One exception is properly washed selenium toned prints, which may be safely dried, face down, on *clean* drying racks. Racks should be cleaned with a solution of household bleach diluted 1:4 with water (wear gloves and use proper ventilation when using bleach).

If you must dry toned prints with heat, use the lowest and coolest setting. Heat drying may cause a cool color shift in toned prints. You can often compensate by using a more dilute solution of toner and/or toning the prints to a warmer color.

Types of Toner

There are two basic methods for toning prints. The first is by direct toning, the second is by conversion, known as bleach-and-redeveloping.

There are three categories of direct toners:

1. Those which bond an inorganic compound directly to the silver in the image, in effect *coating* it (Kodak GP-1 Gold Protective Solution and Nelson Gold Toner).
2. Those that *convert* the silver image, through a series of chemical reactions, into a compound of some other metal. The compounds produced are usually either ferricyanide (Dassonville T-5 Copper Toner) or selenite (Dassonville T-55 Direct Selenium Toner). These are also known as replacement toners.
3. Organic toners that penetrate the emulsion and tint the white portions of the paper as well. Organic toners, although direct in nature, sometimes require an initial first step known as mordanting (see "Dye Toners" below).

Bleach-and-redevelopment toners bleach the silver to a pale color and then redevelop it to a new color. Most bleach and redevelop toners are of the warm-tone sepia/sulfide-type (Ansco 221 Sepia Toner). In some formulas a copper bleach may be used, but this should not be confused with direct copper toners.

CAUTION: Sulfide/sulfur based toners can cause damage to light sensitive materials, such as undeveloped negatives and papers. Do not use in a room where undeveloped materials are stored. Generally, these toners, which often smell like rotten eggs, can be used outdoors in daylight.

Cold Tones

One of the best ways to achieve blue-black tones is to use gold chloride. Not only does the gold chloride tone the shadow areas of the print to various shades of blue, it also serves to protect the silver from degenerating.

Gold chloride works in direct ratio to the amount of silver in the print. Where there is no metallic silver in the print, such as the clear highlights, the gold chloride will have no effect on the paper.

To get the best results remember the following:

- The most brilliant blue tones will be secured on glossy papers.
- Papers of the slow chlorobromide variety will be more successful for blue toning than fast chlorobromide or bromide papers.
- The paper developer affects the results. If you develop in glycin or pyrocatechin, the blue tones will be lighter. Any developer that produces a brownish color by direct development is good for blue toning.
- If a fixer with hardener has been used, refix in Plain Hypo, or use Dehardener before toning.
- Wash thoroughly before gold toning. Any appreciable hypo left in the print will create a yellow-brown stain, or the toning will take a long time and not be very good.
- After toning, if the emulsion feels soft to the touch, either reharden the print before drying or be extra careful that the surface does not stick to anything.
- The concentration of the gold chloride affects the brilliance of the blue. Make the formula stronger by using less water or more gold chloride to achieve the desired effect.
- The temperature of the solution can affect the color.
- Normally the temperature should be around 70°F/21°C, but when the action of the toner appears sluggish, it might help to heat the formula to 75°F/24°C or even as high as 95°F/35°C.
- The higher the contrast of graded paper, the harder it is to blue tone.
- A dry, untoned print that looks perfect might be too dark after toning because of the "intensification" effect of many blue toners. If in doubt, make a slightly lighter print with clear highlights.

Besides the use of gold chloride, blue tones can be achieved through the use of various iron-based toners. These toners often use some combination of ferric ammonium citrate (green is preferred) and potassium ferricyanide (the *ferric-* and *ferri-* in the two names denote iron). Iron toners can give a variety of pleasing blue tones. However, they do nothing to enhance image stability. In fact, some may even lead to early degradation.

Warm Tones

At one time, every portrait studio had its own signature warm-tone formula. Many times the tone was achieved by using more than one toner in succession. Often the formula and technique were a proprietary secret of the owner, who disproved the adage, "you can't take it with you," as many of them most certainly did.

The easiest method to achieve warm tones is to choose a paper that is susceptible through direct development or direct toning. Though there used to be many papers of this type, manufacturers have slowly moved away from making them in favor of neutral-tone papers. While this is a loss to fine art photographers, warm tones can still be achieved—and in great variety—through the use of toners.

Some warm-tone papers still available are Agfa Multigrade Classic, Bergger Prestige, Ilford Multigrade Warmtone, Kodak Azo, Luminos Classic Charcoal R, and Luminos Flexicon Premiere Warm Tone.

Warm-toners are usually divided into three groups according to the colors they produce.

Purple to Reddish-Brown Toners

Purplish to reddish-browns are usually the result of using some form of selenium. There are two that are currently commercially available: Berg Selenium Toner and Kodak Rapid Selenium Toner.

NOTE: Although I recommend the use of either Berg Selenium Toner or Kodak Rapid Selenium Toner, for those who wish to mix their own I have included Dassonville T-55 Direct Selenium Toner, Dassonville T-56 Bleach and Redevelop Selenium Toner, and Flemish Toner, the latter two are both bleach-and-redevelop selenium toners. The advantage to mixing your own is that it is possible to obtain colors not possible with either the Berg or Kodak products.

CAUTION: Selenium powder is highly toxic. IF YOU HAVE ANY DOUBTS, WHATSOEVER, ABOUT YOUR ABILITY TO SAFELY HANDLE TOXIC CHEMICALS, DO NOT USE SELENIUM POWDER.

If you do wish to mix your own, avoid inhaling any of the powder before or during mixing. Use ample darkroom ventilation, including a fume hood over the mixing area and a face mask. If a fume hood is not available, then the powder should be mixed and completely dissolved outdoors and an appropriate fume mask used. Also, use neoprene gloves when handling caustic chemicals such as selenium powder, whether in powder or solution. Read the additional cautions in appendix I, Safety in Handling Photographic Chemicals.

Deep-Brown Toners

Deep-browns are often created from single-solution, sulfur-reacting toners such as Kodak T-1a Hypo-Alum Sepia Toner and Kodak T-8 Polysulfide Toner for Sepia Tones.

Many, though not all, deep-brown toners are of the hypo-alum variety: that is, they use a combination of thiosulfate and potassium alum (chrome alum can also be used, but it is more hazardous to the environment; therefore potassium alum is preferred). The method in which hypo-alum toners work is very interesting and was discovered early on in photography. When an acid fixer containing any form of alum nears exhaustion, sulfur precipitates out and makes the solution milky. This precipitated sulfur can tone prints.

Sulfide/hypo-alum toners are reusable and often improve with age. They often contain a milky white deposit, the result of sulfurization: do not filter,

but stir well before use. While the toned print is still in water, wipe it with cotton to remove any surface scum.

To reduce toning times, use temperatures of around 110°F/43°C. At this temperature prints will still take from 15 to 45 minutes to tone. However, RC papers should not be toned at this temperature as they may delaminate.

Warm-Brown Toners

Varying degrees of warm browns are often produced by bleach-and-redevelopment sulfide toners such as Kodak T-7a Sulfide Sepia Toner. The bleach-and-redevelopment process converts the metallic silver in a print back into a halide by combining it with a halogen. This first step is the "bleaching" process during which the image on the paper seems to disappear. Don't panic. It will return upon redevelopment. The most common bleaching agents used today are copper sulfate, potassium permanganate, potassium ferricyanide, and potassium or ammonium dichromate.

Once the silver has been reconverted to a halide, the print is redeveloped with either a toner, a toning developer, or any number of solutions that will cause the transparent halide to take on a warm tone.

Partial bleaching, that is, stopping the process when some of the metallic silver is still visible, will often create a deeper color than bleaching to completion. However, it is less controllable, as the precise moment to pull the print may not be repeatable. Partial bleaching may also cause a split-toned effect that may, or may not, be desirable (see "Split-Toning" below).

As a general rule, always start with a darker print than usual as there will be a loss of density. However, this is not an iron-clad rule. Some bleaches, such as copper, will intensify the print. Only experience will tell which does what.

Dye Toners

Carbon-based (organic) dyes do not normally combine with inorganic compounds like silver. However, they will combine with certain silver salts.

Organic dye toners come in two types: mordant and straight. Mordant dye toners use a special bleach, called a mordant, to convert silver to either silver iodide or silver ferricyanide so that an organic dye will adhere to it (think of mordants as "glue"). The dye is deposited in direct proportion to the density of the mordant (bleached) image (see "Two-Solution Dye Toner"). In other words, the more silver that is mordanted, the stronger the color.

With straight dye toners, the silver is not converted, and the dye affects all areas equally. Although straight toning can produce vivid colors, the lack of difference in toner intensity between the highlight and shadow areas tends to create a flat color effect. This can either unify an image or make it visually dull. However, by masking off certain areas of the image with a paper frisket or liquid masking material, selected areas of an image can be toned, using a straight dye toner, while others remain untoned (see "Multiple Toning," below).

Protective Toners

Even a properly washed print will form silver sulfide as a result of atmospheric pollutants, such as sulfur dioxide. Unless controlled, these sulfide compounds will occur in a haphazard manner that will eventually degrade or destroy the print.

There are two methods to help prevent this from happening. The first is to *completely and uniformly* convert the metallic silver to either silver sulfide or selenite. Once this is done, further deterioration is no longer possible. In other words, converting the silver all at once will protect the image; allowing the silver to convert in a random manner, over time, will destroy it.

Sepia and sulfide toners, such as Ansco 221 Sepia Toner or Kodak T-7a Sulfide Sepia Toner can be used to completely and uniformly convert the metallic silver to silver sulfide. Selenium toners, such as Dassonville T-55, convert the silver to selenite (examples of commercial selenium toners are Berg Selenium toner and Kodak Rapid Selenium Toner).

Both types of conversion have their advantages. The sepia/sulfide toners are, to the best of current knowledge, the most stable. However, they cannot be used without changing the image color to a warm tone. This may not always be desirable.

Selenite is impervious to almost all environmental pollutants, with the added benefit that, at dilutions of 1:20 or greater,[1] it will not effect image tone. Not only that, but selenite has a deeper maximum black than metallic silver, enhancing the richness of the shadows.

The second method is to protect the silver by coating it (as opposed to converting it) with another metal, such as gold. The classic formula for this is Kodak GP-1 Gold Protective Solution. Like selenium toner, GP-1 not only protects the print but causes a minimum of color change. What shift there may be is toward a slight blue-black that some photographers find pleasing. With some papers, GP-1 will also improve separation in the highlights.

Red Toners

Red tones can be achieved through the use of a direct toner, such as GT-15, or by combining toners. Try a combination of Ansco 221 Sepia Toner and Blue Gold Toner. Follow the directions for Ansco 251 Green Toner for washing between processes.

Another combination is to use a sepia or brown toner first, then Kodak T-26 Blue Toner. To use this combination, wash the print thoroughly after using sepia or brown toning, then use T-26 as per directions. The red tone will appear after approximately 15 to 30 minutes in this solution at 90°F/32°C. This technique usually produces a density loss in the shadows. Start with a print that has higher-than-normal contrast. Cold-tone papers will yield a truer red; warm-tone papers will yield more of an orange hue.

[1] The dilution is paper dependent. Some papers can stand a much lower dilution, some require more.

DuPont 6-T Toning System

Until the early 1970s, one of the leading manufacturers of quality photo paper was the DuPont Company. In fact, more than one printer of that era would agree that DuPont papers such as Velour Black and Varigam were the *only* premium papers of their time. At least through the late 1990s Fred Picker, founder of Zone VI Studios and author of *The Zone VI Workshop*, one of the best books from which to learn the Zone System, was still hoarding 500 sheets of Varigam in his freezer!

In my opinion, until the introduction of Cachet Multibrom Plus, there has been no paper that has rivaled the lustrous quality of DuPont papers. Upon discovering Multibrom Plus, I inquired into its pedigree and found that Multibrom, and it's companion graded paper, Expo R, is based on DuPont technology! My personal experience printing on this paper leads me to believe Cachet's claims that these are updated versions of Velour Black and Varigam, and they are as good—or even better—today as they were in 1970 (in chapter 9 I recommend both of these papers for amidol printing).

This brings us to DuPont Toners (see DuPont 6-T Toning System). Known variously as Defender[2] or DuPont 6-T Varigam Toners, or Thiocarbamide Toners for Varigam, this "system" of toners was originally designed by Defender to work on Varigam paper. This is the reason why I have so much to say about Multibrom Plus: it is fun to work with these toners on a paper similar to the one for which they were designed, even though they will work on other papers as well.

The 6-T system consists of three separate bleaches, three separate toners, a sodium chloride solution, plus a gold tone modifier. By mixing and matching the various bleaches and toners, and throwing in the chloride bath and/or the modifier once in a while, a large variety of tones can be achieved from purplish-brown to a bright sunlit sepia. This is a very versatile system. Try it on your own paper, then experiment with Multibrom Plus and get a feel for what it was like to print in the middle of the twentieth century!

Multiple Toning

It is entirely possible to selectively tone areas of a print with different toners. The trick is to cover areas not to be toned with either rubber cement or a frisket material, such as Photo Maskoid or Dr. Ph. Martin's Frisket Mask Liquid, both available from art supply stores.

If you use rubber cement, dilute it 1:1 with rubber cement thinner. If you use Photo Maskoid, use the red variety as it is easier to see the areas you have covered.

Use an appropriately sized soft brush that forms a good point and does not lose its bristles. Apply two or three thin coats of the material to a dry print; use a few brush strokes to smooth out each coat, then coat another area, or wait a few minutes, before applying the next coat.

[2]DuPont bought its paper technology from Defender.

After you have applied the mask, soak the print in water; soak fiber-based prints for approximately 10 minutes, RC papers for no more than 2 minutes. Then immerse the print in the toning solution. The print might buckle or curl; simply keep it immersed as much as possible. If the toner tends to bleed under the mask you may have to skip the presoak.

After the print has been washed according to the toner's instructions you can remove the mask. Remove Photo Maskoid by touching sticky tape to one edge and pulling it off. Remove rubber cement by carefully rubbing your fingers across the print surface while it is in the final stages of the wash. After the print is dry, the previously toned area of the image may be masked and an entirely different area can be toned with a different color toner. There is no limit to the number of colors that can be applied, or the areas that can be toned.

Split-Toning

Split-toning is a process in which the middle to low values respond to the toner with added density and color, while the higher values do not respond at all. This is especially likely to occur with papers that contain a mixture of emulsions, such as variable contrast papers. The results are selectively toned areas often associated with a color shift. Properly managed, a split-toned print has an ethereal, three-dimensional look all its own.

As with other toning processes, almost every part of the process has an affect on the split-toned image (see "Points to Remember for All Toning Processes" above). According to Jonathan Bailey, a split-tone expert working in Maine, any warm-toned paper should work well with the process. Jonathan also says that the choice of fixer can be significant. He claims that the best fixer he has found for this process is made by Sprint (see appendix II, Sources). This is apparently because Sprint Fixer contains buffers that cause prints to accept toners unevenly, facilitating split-tone effects.

There are many processes for obtaining split-tones, and they change as often as manufacturers reformulate their papers. The following are two that have stood the test of time.

Method #1: Kodalk/Selenium
(With thanks to Ryuijie.)

1. After fully fixing the paper, soak the print for 2 to 3 minutes in a bath of 20% Kodalk (20 grams per 100 ml).
2. Drain and transfer the print to a bath of selenium toner 1:7. Do not mix the selenium with HCA.
3. Watch the toning carefully and pull the print *before* the desired degree of toning is reached, as it will continue toning for awhile after removal from the bath. Toning effects take place over a period of approximately 3 to 10 minutes.
4. After toning, the print may be transferred to a separate bath of HCA then washed thoroughly.

NOTE: The use of Kodalk is not entirely necessary. However, it appears to shorten toning times and, with some emulsions, adds to the vibrancy of the color.

Method #2: Selenium/GP-1
(With thanks to Jonathan Bailey)

1. Tone prints in a working solution of selenium toner 1:10 to 1:15 until a split-tone effect occurs (typically plum-reds in the shadows and blue-greens in the highlights).
2. HCA and thoroughly wash the prints. Drying the prints before continuing is optional, and may, or may not, slightly affect the end result.
3. Tone the prints back-to-back in pairs with constant agitation in Kodak GP-1 Gold Protective Solution. The "target" time is 10 minutes, but toning is by inspection; toning times may be as brief as 3 minutes or as long as 30. Tones continue to shift after prints are pulled from the toner. Watch for the first indication of "rouge" appearing between the blue highlights and the greens and/or plum-reds of the shadows, at which point pull the print from the toner.
4. Wash prints for at least 10 minutes.

NOTE: Split-toning may require a slightly higher contrast in the original print.

NOTE: If you wish to learn more about toning, and many more unusual and unique effects that you can use to make your images unique, an excellent book on all aspects of the process is *From Black and White to Creative Color* by Jerry Davidson (see Bibliography).

12 Reduction

Most photographers have, at one time or another, created masterpieces of over- or underexposure, over- or underdevelopment, and sometimes both! Not all negatives can be saved, but the techniques of reduction and intensification (see chapter 13, Intensification) may prove to be just the tonic to reclaim what, undoubtedly, would have been the best photograph ever created. Even if the negative is printable, reduction and intensification techniques can often improve slight miscalculations in exposure or development.

Negative Reduction

Negative reducers are used to subtract density from completely processed film that has been overexposed or overdeveloped. Reduction is not a controlled process and requires experience to achieve the correct negative densities. Nor is it a onetime, all-or-nothing process. Thus, a negative can be reduced slightly, dried, a print made, and then the negative further reduced if necessary. Therefore, always err on the side of not enough reduction.

Reducers are classified into three general types:

1. Cutting, or subtractive, reducers act first on the shadow areas and then on the midrange and highlights. They are used for clearing film fog and for reducing prints. Kodak R-4a Farmer's Cutting Reducer for Overexposed Negatives is the most commonly used and easiest to control.
2. Proportional reducers decrease the image density throughout the film in proportion to the amount of silver already deposited. The effect is similar to giving the film less development. Kodak R-4b Farmer's Proportional Reducer for Overdeveloped Negative is most commonly used.
3. Super proportional reducers have a considerable effect on highlight areas but a negligible effect on shadow densities. They are the most unpredictable and should be used with appropriate caution. Super pro-

portional reducers are used when a greater reduction in contrast is desired than can be achieved with cutting reducers. Kodak R-15 for extreme overdevelopment is an example of a super proportional reducer.

Cutting and Proportional Reducers

Cutting and proportional reducers are the most common types used. While there are about a dozen or so formulas available, the most widely used is Howard Farmer's formula, which dates to 1883. The ingredients are easy to obtain in almost any part of the world, the process is almost foolproof from the chemical angle, and the results are permanent. Most important, it is not usually dangerous to the hands or skin.

There are dozens of published formulas claiming to be Farmer's Reducer. The actual makeup is flexible, with the two main ingredients being potassium ferricyanide and sodium thiosulfate (hypo). The quantity of ferricyanide used determines the strength of the solution, so the amount of hypo is flexible.

Farmer's Reducer may be used as a single- or two-solution formula. The single solution gives cutting reduction, that is, it reduces the shadows first, then the highlights; this method corrects for overexposure. The two-solution method works by treating the negative in a ferricyanide solution first, then in a separate solution of hypo. This method is proportional, giving reduction in the highlights and shadows in proportion to the amount of silver bromide that has been reduced in development; this method corrects for overdevelopment.

NOTE: Before attempting to reduce any negative, you should fix it with an acid-hardening fixer and wash it thoroughly. Also, reduce only one negative, or strip of negatives, at a time. Following reduction the negative should always be washed thoroughly and handled carefully before drying.

Super Proportional Reducers

Super proportional reducers, as noted, have the property of reducing the denser parts of the negative in preference to the middle tones and shadows. Ammonium persulfate is able to do this particularly well. However, ammonium persulfate is notably subject to deterioration and is easily affected by other substances. Therefore, the use of potassium persulfate, as in Kodak R-15, is recommended.

Print Reduction

Many photographers do not realize the value of chemical reduction of prints. It is the greatest all-around "after treatment" and can transform a mediocre print into a great image. *Overall reduction* of prints can add extra brilliance and sparkle to almost any good enlargement. *Local and spot reduction* can take out black pinhole spots and place catch lights in eyes; it can brighten specific areas, put luminosity into shadows, or drastically alter tonal values.

W. Eugene Smith was a master of the ferricyanide technique of reduction. He had to be; for most of his career he did not use, or have access to, a light meter. As a result, it was necessary for him to guess at exposures, often in the heat of action. He was also an adherent of using available light, which, in his

case, could more aptly be referred to as available darkness. Some of his most famous negatives were grossly under- or overexposed. Ferricyanide helped him bring out the subtle highlights that otherwise would have been lost.

Print reduction, commonly known as bleaching, can be used to increase shadow detail. It is different from dodging, which is also used to increase shadow detail. Dodging blocks out proportional amounts of light from all areas that are dodged, while reduction removes equal amounts of *developed* silver. As a result, dodging retains the general contrast of the print within the dodged area, while bleaching increases the contrast within the same area.

With bleaching, highlight areas, which have less silver, will quickly exhibit a dramatic change with bleaching, while removing the same amount of silver from a shadow area may be almost imperceptible. For example, suppose that after development, the highlights held 100 silver grains and the shadows, being denser, held 1000 silver grains. If you were to dodge both areas for 20% of the overall exposure, the highlights would then have 80 silver grains and the shadows would have 800. This is proportional reduction through dodging. Suppose that instead of dodging you were to bleach the print by the overall method (see below) and remove 20 grains of silver from the highlights and 20 from the shadows. You would now have 80 silver grains in the highlights and 980 in the shadows. The highlights would be significantly lighter and the shadows would have hardly changed. In other words, bleaching would have increased the contrast of the print. The same effect holds true in locally bleached areas: contrast is increased within the area.

There are three basic methods for reducing prints:

1. Overall: The print is completely immersed in the reducing solution. This is excellent for overall brightening and increasing general contrast.
2. Local: This is the method for control work on comparatively large areas. Bleaching is done with a small wad of cotton or a brush.
3. Spot: This is the way to eliminate black spots or when precise control is necessary. The bleach is applied with a spotting brush or toothpick.

Prints that have been selenium-toned should only be reduced by the overall method, as the color of the print will change in the area that is bleached. Gold-chloride blue-toned prints should not be bleached at all as the color will usually change to green-blue. For these reasons, it is better to reduce prints before toning.

The action of the bleach is largely paper dependent. Some papers, Agfa, Cachet, and Forte, readily take to bleaching, while others, Kodak and Ilford, are highly resistant. There are dozens of reducers available for overall print reduction and local spotting and bleaching, but, as in negative reduction, the easiest and most versatile is still Farmer's.

Overall Reduction Technique

The action of Farmer's Reducer is more sudden on prints than negatives. It reduces the weakest portions of the silver image first, and in a print, that means the highlights. Then it begins to reduce the midtones, and finally the blacks. If the reducer is too potent, the lighter areas may be wiped out and the print ruined. Therefore, a highly dilute solution of Farmer's is recommended.

A technique for creating delicately separated shadows with more pronounced highlights is to make a print about ⅓ stop darker in the highlights and ½ grade lower to keep the shadows open. Then bleach the print until the highlights are to your satisfaction.

Another technique that creates a unique effect with greatly pronounced tonal separation is to overexpose the print by 1 to 1½ stops, using one full grade less contrast, then bleach it in a fairly dilute solution of Farmer's Reducer. This affects the print on a micro level as it accentuates the graininess of the image. Although the prebleached print will look very dark, holding it up against a light will reveal all the detail waiting to become visible.

NOTE: For both of the above techniques the print should be fixed and thoroughly washed before bleaching.

For overall proportional reduction of the highlights, midtones, and shadows, start with a wet print. For clearing the high values only, start with a dry print.

With either method, wet or dry, the print should be thoroughly washed after fixing and not toned. Have a tray with plain or running water ready to stop the action of the reducer.

NOTE: Always use a non-hardening fixer for any after-process such as reduction, intensification, toning, etc.

You can use either Farmer's Reducer or Kodak R-4a. Dilutions for Farmer's Reducer are given in the Formula section. For print reduction with R-4a mix 1 part A, 1 part B, and 10 to 15 parts water, depending on the desired rate of reduction.

With either reducer, slide the print, face up, quickly and completely into the reducer. Do not agitate, as this will cause reduction to proceed faster on the edges than the center. The print should remain in the solution for 5 to 10 seconds. Pull the print from the solution and submerge it face down under the fresh water. Do not try to judge the print until it has been soaked for a minute in water. If standing water is used, use constant agitation, and change it often.

After all traces of reducer have been removed and the action stopped, remove the print from the water and carefully examine its condition. A good practice is to have an unreduced, wet print available for visual comparison. If the reduction is not enough, repeat the process for 5 seconds, but be careful. It is easy to eliminate all detail and texture from the highlight areas. When you are satisfied with the results, rinse the print well and refix in a fresh, non-hardening fixer, followed by HCA and an additional wash to remove the fixer.

An alternative formula for overall reduction is Ammonium Thiosulfate Reducer.

Local Reduction Technique

Local reduction is an invaluable technique for centralizing the interest, brightening certain areas (e.g., the sky, windows, etc.), adding contrast, and giving the image a three-dimensional effect. Knowing that bleaching increases contrast in an area, you may even want to refrain from dodging in order to both lighten and increase local contrast through bleaching.

You can begin with the same proportions of A/B reducer solution as for overall reduction, above. Increasing the amount of the ferricyanide solution

will increase the rate of reduction. Another method is to dissolve ¼ teaspoon into 200 ml of water. There is no correct dilution, though it is better to start slowly and build up as experience dictates. Also, if you are working on lighter tones you will want a more dilute solution as the bleach works rapidly on light areas; you can always add a little more ferricyanide if needed.

Under full room light, place a freshly washed print on a flat surface, such as the back of a large tray or a piece of ½-inch white Plexiglas. Stand the working surface up in your darkroom sink. Wipe the surface of the print dry with a sponge or squeegee. If available, hold a sink hose with running water directly beneath the area to be reduced. Move it slowly from side to side so that any bleach that runs down the print will be instantly diluted and washed away.

There are several ways in which to apply the bleach. One is to dip a piece of cotton into the bleach and squeeze until it is almost dry. Beginning at the top, so the bleach will run down over the area to be reduced, lightly wipe the cotton over the area to be reduced for 2 or 3 seconds. Do not use friction! Let the chemical action do the work. If you rub too hard you may damage the emulsion. Don't be impatient! It may take several applications to achieve the results you want. However, if the print is exceptionally dense in the area being worked on, you can strengthen the working solution by adding more ferricyanide. Also, if you are working on a large area, don't try to do it all at once.

Instead of a cotton ball there are a number of applicators that you can use. Marshall Noice recommends the use of a #10 Winsor & Newton watercolor brush for large open areas. Jay Dusard (a.k.a. Captain Ferricyanide) uses #5 and #10 brushes or a cotton ball for all of his bleaching. Bruce Barnbaum, a master of the bleaching technique, prefers to use a Japanese calligraphy brush.

To halt the bleach process use the hose, mentioned above, directly on the area being bleached. If a hose is not available, use a water-saturated sponge. After the bleach has been thoroughly rinsed with water, place the print back in the fixer. You may repeat the bleaching process as many times as necessary.

When the process is complete, fix in a fresh, *nonhardening* fixer and wash the print thoroughly.

Spot Reduction Technique

The spot method is useful for the removal of small pinhole spots or other small areas that need to be lightened. The spot method allows the photographer to add pleasing catch lights to eyes and even to remove an occasional unwanted element from the image. In essence, spot reduction is a basic form of print retouching.

I was originally taught to use a wet print by Boyd Wetlauffer of Canada in 1974, and I still make use of it in certain instances. However, I have found that, for me, a dry print allows greater control.

Start with a strong viewing light, at least 75 watts, and either a wet or dry print. Use a strong solution of Farmer's R-4a. One method recommends 1 part A to 2 parts of B, without adding water. Boyd Wetlauffer taught me to use what he referred to as a "supersaturated solution" of straight ferricyanide in water: add ferricyanide to an ounce of water until it stops dissolving and dis-

pense with solution B altogether. Technically, this is not a true supersaturated solution, as any *real* chemist will be quick to point out, but call it what you will, it works. To make Boyd's "supersaturated solution" use distilled water at 125°F/52°C. When no more ferricyanide will go into solution, filter the solution through a chemically untreated coffee filter.

You will also need spotting brushes and blotters. Be certain that the brush you use is only for reducing. For small areas, use brushes as small as #000, or a toothpick; for larger areas, try a #3 brush. Photowipes and Kimwipes, available in camera stores, make good blotters.

Place one blotter on the right side of the print and hold the other in your left hand (reverse if you are left-handed). Dip the brush into the reducer and wipe it on the blotter to the right of the print, drawing it across and turning it to a fine point several times. Hold the brush 90 degrees to the print and carefully touch the area to be reduced with the tip. As with local reduction, do not use pressure; let the chemical action do the work. If you get a bit careless, use the blotter in your left hand to stop the action.

Having deposited a very small amount of ferricyanide on the area to be reduced, watch it for a few seconds. The spot will slowly become lighter. The action will automatically cease because the small amount of reducer will become exhausted. Repeat the procedure as needed. If you are using the A/B solution instead of Boyd's supersaturated solution, and feel the action is too slow, add a little more solution A. If you inadvertently carry the action too far, you can darken it with SpoTone or Touchrite spotting dyes available from darkroom suppliers.

When all black spots have been removed, catch lights added, and satisfaction achieved, follow the same procedure as in overall and local reduction: rinse, fix, and wash. This final procedure must be done for even the smallest spot, otherwise the color of the print will eventually change.

NOTE: An alternative to Farmer's Reducer is medicinal iodine tincture. Use as you would Farmer's for removing dark or black spots. It can be applied with a toothpick and can reduce the intensity of a dark spot, without going all the way to white, depending on the dilution with water.

Black fogging along the border of prints can also be removed by carefully applying undiluted iodine tincture, making sure that it does not touch the image itself. Remove the iodine by immersing the print in hypo, just as you would with Farmer's; fix and wash.

Fixer and the Bleaching Process

Fixer acts as a neutralizer, halting the bleaching action. How quickly it stops the bleach from working depends on how much ferricyanide is in the solution. However, the fixer also acts as a catalyst, even while it is neutralizing the bleach. This means that if the print looks perfect on the board it will probably be too light after it is placed in the fixer. This is another reason it is important to work up slowly to the lightening you want.

Fixer that has been partially exhausted will cause bleached prints to stain more easily. At the same time, ferricyanide bleach rapidly destroys fixer. For fixer, use one that is fairly fresh—not on its last legs—and discard it after the bleaching session, after first neutralizing it by dumping the remaining bleach

solution into it. Plain Hypo is useful for this purpose, as it uses only one ingredient, and must be discarded after use anyway.

When bleaching is complete and neutralized in fixer, rinse the print thoroughly for 5 to 10 minutes in running water and then refix with a *fresh* non-hardening fixer. After fixing, the print must be thoroughly washed. The use of Hypo Clearing Agent (HCA) between the fix and final wash will ensure the elimination of any residual staining. If toning is desired, this would be a good time to do it, although the prints can also be dried and toned later.

13 Intensification

Negative Intensification

Intensification is normally used to increase the density of underexposed, underdeveloped, and, in some cases, overexposed or overdeveloped negatives. It is also an invaluable technique for the control of contrast.

Ansel Adams used intensification to expand roll film negatives by at least one paper grade, or in Zone System parlance, N+1. The intensifier he used was selenium toner diluted with water 1:2. His technique was to first refix the negative in Plain Hypo (1 pound of sodium thiosulfate to 1/2 gallon of water), then soak the negative in selenium toner (1:2) for about 5 minutes.

To dilute the selenium, he recommended using a working strength bath of Hypo Clearing Agent (HCA). He followed the toning bath with a second, full-strength, bath of HCA, without selenium, and then a thorough washing.

The purpose of refixing the negative in plain hypo before intensification is to ensure that there is no residual hardener. Hardener will cause staining in both negatives and paper when it comes in contact with selenium. If you are confident that your negatives have been thoroughly washed, or if you use fixer without hardener, then refixing should not be necessary. But when in doubt, refix.

The list of intensifier formulas includes uranium, silver, copper, selenium, chromium, mercuric chloride, and mercuric iodide. Some of the formulas, such as uranium, create a high degree of intensification but a low degree of stability. Others, such as chromium, do not intensify nearly as well, but the image is reputedly quite stable.

CAUTION: Intensifiers, along with selenium toners, contain the most hazardous and toxic chemicals used in photography. Before using any intensifier, read appendix I, Safety in Handling Photographic Chemicals. IF YOU HAVE ANY DOUBTS, WHATSOEVER, ABOUT YOUR ABILITY TO SAFELY HANDLE TOXIC CHEMICALS, DO NOT USE INTENSIFIERS.

For many years chromium intensification supplanted most other methods for two good reasons. First, Kodak marketed an over-the-counter, easy-to-use, prepackaged chromium intensifier. Second, it was discovered that there were health hazards associated with many of the other substances. This has changed for two good reasons. It has now been discovered that chromium intensification precipitates a heavy metal that is an environmental hazard, and Kodak has ceased selling chromium intensifier!

Chromium Intensifier

Chromium intensifier is a proportional intensifier. The amount of intensification is proportional to the amount of silver present in the negative. Therefore, denser areas of the negative are affected more than thin areas. Chromium intensification is best used for increasing contrast since it has little effect on thin, shadow areas. To be effective, chromium intensification must often be repeated several times, increasing the chance of damage to the negative.

The two main ingredients in chromium intensifier, potassium dichromate and hydrochloric acid, are both toxic substances. Hydrochloric acid can burn a hole in your skin, and dichromate can cause serious skin irritation. Handle chromium intensifier with gloves and respirator, observing all safety precautions (see appendix I, Safety in Handling Photographic Chemicals).

Mercury Intensification

Mercury-based intensifiers are the best to use to strengthen weak shadow areas. For this purpose, Smith-Victor's VMI is a miracle cure for underexposed negatives. It is especially useful in enhancing images made under exceptionally low light. VMI works to intensify the shadow areas, where exposure is the weakest.

One drawback to VMI is that it changes the grain structure of the image, making it more defined. Some users find this pleasing, others do not.

An alternative to VMI is Kodak In-1 Mercury Intensifier. In-1 is a bleach-and-redevelop method with five separate redevelop formulas, each one giving greater levels of intensification.

Mercury intensifiers are based on mercuric-chloride. Mercuric chloride is a deadly poison that can be absorbed through the skin. Of all the chemicals used in *The Darkroom Cookbook*'s formulas, mercuric chloride is perhaps the most toxic.

CAUTION: IF YOU HAVE ANY DOUBTS, WHATSOEVER, ABOUT YOUR DARKROOM VENTILATION SYSTEM, OR YOUR ABILITY TO SAFELY HANDLE TOXIC CHEMICALS, DO NOT USE MERCURIC CHLORIDE. Avoid inhaling any of the powders before or during mixing. Use ample darkroom ventilation and a face mask. Also, use neoprene gloves when handling caustic chemicals such as mercuric chloride, whether in powder or solution. Read the additional cautions found in appendix I.

Silver Intensification

Another method of intensification, Kodak In-5 Silver Intensifier, makes use of silver nitrate. Silver intensification is similar to mercury, having a noticeable effect on low values. It is nearly as effective and less toxic, although it does

have the nasty habit of staining everything black. Wear gloves and try not to get it on your hands or clothes, but if you accidentally stain yourself, use one of the two Silver Nitrate Stain Removers in the formula section.

Sepia Intensification

Possibly the safest, albeit smelliest, method of intensifying negatives is with sepia toner such as Ansco 221 Sepia Toner, or Kodak T-7a Sulfide Sepia Toner. Sepia toner is more effective than chromium intensifier and will provide maximum archival protection for your negatives. The reason for the latter is explained more fully in chapter 11, Toning Prints, under "Protective Toners," though simply put, converting an image from silver metal to silver sulfide makes the image as permanent as it possibly can be.

To intensify negatives using sepia toner use the following procedure.

CAUTION: Sodium sulfide in solution smells like rotten eggs. The smell has been known to cause some people to have headaches. Use in a well-ventilated area; outdoors works just fine. Also, sulfide can damage undeveloped sensitized materials such as films and papers in a darkroom. This is another good reason to use sepia toners outdoors.

1. Refix the negatives in rapid fixer without hardener for 1 minute.
2. Wash the negative for 5 minutes.
3. Move to the A bath and agitate for 30 seconds every minute for 5 minutes.
4. Rewash the negatives until they are completely clear of the yellow bleach.
5. Move to the B bath. The negatives should be fully toned in two minutes.
6. Rinse the negatives for 1 minute, then immerse them in HCA for 2 to 3 minutes, with agitation.
7. Wash for 5 minutes.
8. Rinse in wetting agent, hang to dry.

Notes on Negative Intensification

- When possible, work with one negative or strip of negatives at a time.
- Use a white tray in order to better judge density increases. Experience will enable you to accurately judge increases.
- 35mm and 120 negatives, either singly or in strips, can be placed on reels to minimize damage while wet. However, visual inspection will be more difficult.
- Intensification may take place in room light.
- Negatives should be well washed and wet. If they have been dried, soak them for 5 minutes before intensifying.

Print Intensification

Intensifying a print has two advantages:

1. If the print is weak, it will exhibit greater density and snap.
2. In almost all instances the tonal quality will be improved. The resulting image will exhibit either a rich, warm brown or a finer black than was

originally obtained during development. The degree to which this effect is achieved depends upon the type of developer, the strength of the intensifier, and the paper used.

Intensification is also a good technique for paper negatives as it will strengthen the paper transparency, or paper negative, for contact printing on enlarging papers.

Chromium Intensification for Prints

When warm tones are desired, chromium intensifier is a good method for increasing the strength of a print. The technique is to bleach the print and then redevelop it in a nonstaining developer, just as you would for a negative.

Slow chlorobromide and chloride papers respond best to this technique. Cold-toned and bromide papers don't respond as well to intensification, but changes will occur. If in doubt, give it a try.

Selenium Intensification

Selenium toning causes a slight increase in print density and contrast, a form of intensification that gives most prints a richer appearance. The increased contrast is more noticeable in the shadow areas, whereas the increased density is more noticeable in the highlights. If you want to use selenium toning on prints for longevity without the intensification, you must compensate by reducing the development time of the print by about 10%.

Selenium toning should be done after fixing and bleaching. If a nonhardening fixer, or plain hypo, is used, the prints may be moved directly to the toner. Use Berg Selenium Toner, Kodak Rapid Selenium Toner, or Dassonville T-55 Direct Selenium Toner. Dilution ratios can vary from 1:10 to 1:40, depending on the toner and paper combination. Be experimental. Try each dilution, or one of your own choosing, and see which you prefer. Keep a file of the results. Immerse the prints for 5 minutes, with agitation.

After toning, soak the prints in a second bath of HCA (without the selenium), then wash for the recommended time.

NOTE: Some workers recommend mixing the stock selenium toner with a working solution of Hypo Clearing Agent. Others, such as Bruce Barnbaum, suggest that this will shorten the life of the toner. Bruce reasons that the useful life of HCA is approximately 80 8 x 10" prints or equivalent films, and that the useful life of selenium toner is at least 200 8 x 10" prints or equivalent. When the HCA is exhausted the bath should be replaced, which is a waste of good (expensive) selenium toner, and further results in more selenium being introduced into the environment.

CAUTION: Selenium powder is highly toxic. IF YOU HAVE ANY DOUBTS, WHATSOEVER, ABOUT YOUR DARKROOM VENTILATION SYSTEM OR YOUR ABILITY TO SAFELY HANDLE TOXIC CHEMICALS, DO NOT USE SELENIUM POWDER.

14 Development by Inspection

Although it is apparent that the development of film by time and temperature is here to stay, this was not always the case. Even after the discovery of time and temperature development, development by inspection remained the method of choice for most professionals well into the 1930s. The reason was that many photographers learned their craft on material that was hand-coated, or manufactured under loose tolerances, and its sensitivity varied greatly. In order to ensure usable negatives photographers *had* to develop by inspection. As more sensitive plates and films became available, along with consistent mechanized manufacturing processes, many photographers steadfastly refused to give up the tried-and-true practice of development by inspection, passing it along to their assistants.

It wasn't until the publication of the first edition of *Morgan and Lester's Photo-Lab-Index* in 1936 (now *Morgan and Morgan's Photo-Lab-Index*) that a complete and reliable source of time and temperature tables was generally available. Henceforth, development of film by time and temperature became the industry standard.

Nonetheless, there are still a few valid reasons to develop by inspection. The most important is that it allows complete and total control over every image. A second reason is that it might help save negatives when there is doubt as to the correctness of exposure. A final reason is that when developing films by the water bath method to control contrast, it is often desirable to visibly monitor development.

The technique of development by inspection should be approached in the same way one would approach any new process. Start by creating practice negatives and developing them until you are confident in your ability to judge their quality. Only then should you work with important images.

One final point, development by inspection is really only suited for 4 × 5″ and larger film. This is because development by inspection assumes that each negative will be developed to an ideal density for that particular negative.

Safelight

Development by inspection is traditionally done using a Wratten #3 dark-green safelight. This is not because panchromatic films are not sensitive to green, but because green is the color to which our eyes are the most sensitive. This means that during the brief intervals that the light is on we get the most bang for our buck. The safelight should be fitted with a 10- to 15-watt bulb and placed at least three feet away for inspection by reflection, and at least four feet for inspection by transmission.

Even if a chemical desensitizer has been used, the safelight should not be turned on until at least halfway through the estimated development time. This is because film loses its sensitivity as development proceeds. If a desensitizer has been used, the safelight can be left on when the estimated halfway point has been reached. Without the use of a desensitizer, the safelight should only be turned on for brief intervals (1 or 2 seconds at a time) after the estimated halfway point.

In either case, a footswitch, attached to the safelight, is a good idea in order to avoid early termination of your darkroom career when you reach for the light switch with wet hands. It will also keep you from dripping developer across the room and down the wall.

Judging Densities

Judging the correct density of film is simply a matter of experience, and it doesn't take long to learn. There are two basic methods: transmission and reflectance. With either method, there are two points to remember. The first is to always judge through the *base* of the negative, not through the emulsion side. The second is to always judge the highlights, not the shadow densities. The highlights are the densest areas of the image; the shadows are the thinnest.

Transmission

I was taught, by Frank Rogers, to judge negatives by transmission using the finger method: develop the film for about half the time you estimate it should require (base this on time/temperature charts or use an educated guess). Hold the film, with the base side towards you, up to the safelight, which should be at least four feet away, and then place a finger against the back (emulsion side) of the film. As the film develops, the highlights become denser and your finger harder to see. When your finger is just barely visible, development is complete.

Check the density increase every 1 to 3 minutes, depending on how close you estimate you are to full development. As completion gets closer, you can begin checking every 30 seconds, but remember, the film is still sensitive to light, unless a desensitizer has been used (see "Desensitizers" below). Therefore, only check as often as absolutely necessary. You will find that after developing by inspection a few times you will need to check the density increase less and less.

Reflection

The second method is by reflection. Some photographers who do a lot of development by inspection claim this is a more accurate method. To use this method, hold the film at least three feet from the safelight and look at the base side with the light reflected off of it, not through it. The base will appear to have a milky-white coating through which the densities can be seen. Once again, judge the densest part of the film, the highlights. When the highlights appear strong, but not black, stop development.

Both the transmission and reflection methods work equally well with any panchromatic film. Using either method, as many sheets of film as can be safely handled at one time can be developed, inspecting each one individually as development proceeds. When a film is fully developed it should be moved into a holding acid stop bath where it can be left indefinitely until the other films "catch up," at which time they can all be moved to the fixing bath. A water bath should not be used to hold unfixed negatives, as they will continue to develop until they are placed in the fixer. However, if an alkaline fixer is used, such as Formulary TF-4, the films should be moved from the acid stop bath into a plain water rinse for 1 minute before being placed in the fixer.

Desensitizers

Desensitizing is a process that reduces the light sensitivity of emulsions so that they can be developed in comparatively bright light. Unfortunately, most of the desensitizers once in common use, such as Aurantia, Methylene Blue, Toluylene Red, and Amethyst Violet, don't work well with modern emulsions.

Phenosafranine was the first viable desensitizer and originally appeared on the market as Pinasafrol and Desensitol. Although phenosafranine can be used alone, diluted 1:10,000 with water, a better choice for modern MQ developers is Basic Scarlet N, a combination of phenosafranine and chrysoidine, two commercially available dyes. Basic Scarlet N is more efficient than phenosafranine and has greater keeping properties.

The major drawback to both phenosafranine and Basic Scarlet N is that they stain everything. They can also cause excessive fog when used with pyro developers.

The disadvantage of the strong staining properties of phenosafranine and its allied compounds soon led to the discovery of other desensitizers that do not stain to the same extent. Pinakryptol Green was the first to receive wide application. In solution it has a dark green color and the slight coloration of the film usually disappears with washing.

Pinakryptol Green was introduced in the 1920s by Dr. Köenig of the Hoechst Dye Works in Germany. It was originally available only as a proprietary powder from Agfa-Ansco. At one time Pinakryptol was available in three formulas: the original green, then yellow, and finally white. Green is the least effective, can cause staining with some MQ developers, but can be used as either a forebath or mixed directly into most pyro developers. Yellow is more active for reducing panchromatic sensitivity and more compatible with MQ developers but can only be used as a forebath, as it is destroyed by sulfite.

White was sold in tablet form, and was meant to be used in the developer. White had the advantage of being compatible with both pyro and MQ formulas.

Pinakryptol tends to lengthen development times; Basic Scarlet N shortens them. With Pinakryptol Green, set the initial time at 50% more than the standard development time, with Yellow use 25% more, and with Basic Scarlet N start with 10% less.

Pyro and Development by Inspection

Pyro formulas are especially compatible with development by inspection because they reduce the sensitivity of the emulsion during development through the strong tanning effect that occurs.

Due to the staining properties of pyro, the highlights should not be developed to the same density as with other developers. This is because the contrast of a pyro-developed negative is dependent upon the stain density, not the silver density. Therefore, when using pyro for development by inspection, the highlights should be less dense.

15 Printing-Out Processes

The use of printing-out paper (P.O.P.) is a time-honored method for making inexpensive prints without a darkroom. Indeed, prior to the 1880s, P.O.P. was the only method for obtaining photographic prints on paper. The technique is simple: a sensitizing solution is mixed, applied to paper, and the paper is contact-printed with a negative using the sun for a light source (a UV lamp, available from grocery and hardware stores, can also be used).

There are many P.O.P. methods, including salted paper, gelatinochloride, and albumen, differing largely in the medium used to suspend the light sensitive substance. In salted paper the silver is held by the fibers of the paper; gelatinochloride suspends the silver in a gelatin layer; albumen uses egg whites.

The basic light-sensitive substance used in all P.O.P. is silver nitrate, and the final image is as permanent as any silver process. Indeed, it is as permanent as the paper it is printed on. Once the image has been printed and toned, the rest of the procedure is like handling a silver print. It is washed, dried, and preserved in much the same way.

P.O.P. can only be contact-printed. For this reason a 4 × 5″ or larger negative is usually preferred. A good P.O.P. print requires a dense negative with good shadow detail. The best negatives are slightly overexposed and overdeveloped. The reason for this is that P.O.P. has a self-masking printing-out image. This means that thin areas of the negative quickly darken and block light from reaching the lower layers of emulsion, preventing detail from forming. The result is that the shadow areas lose separation in proportion to the length of time they're exposed. Denser shadow areas with more detail will slow down this tendency to self-mask. The masking effect is negligible in already dense negative areas (the highlights).

Paper Selection

Making a P.O.P. print begins with the selection and preparation of the paper. Strathmore Artist Drawing #500 Plate, Arches Hot Press Watercolor, and Crane's Kid Finish AS 8111 are three good choices.

Before proceeding, identify the front of the paper. This is important as fine papers are made to be used only on one side. Once the paper has been prepared, it is often harder to identify the front. If the paper is in a tablet or pad, the top side is the front. If it is purchased as an individual sheet, the easiest way to identify the front is to hold it up to the light and look for the watermark. If the watermark reads correctly, left to right, the paper is oriented to the front. If there is no watermark, the front surface is often smoother and brighter. Finally, a factory-deckled edge always bevels up to the front surface. Having identified the front, place a mark on the back with a pencil.

Many experienced printers like to use paper one size larger than the negative. For example, with an 8 x 10″ negative they may use a 9 x 12″ or 11 x 14″ piece of paper. The paper should be preshrunk by soaking it for 10 minutes in water at about 100°F, then hanging it to dry. As many sheets as can be dried in your space can be soaked at one time. After preshrinking, the paper needs to be "salted" and dried, before sensitizing.

Salting the Paper

The next step is to coat the paper with a gelatin or starch salting emulsion. The salting formula not only prepares the paper to receive the silver nitrate but also makes it waterproof, a process known as "sizing."

There are a number of different salting formulas. The choice of a particular salting emulsion is one of the creative controls you have over the look and feel of your final image. Formulas using gelatin will produce cooler prints than those using starch. The paper may be immersed in the salting solution for 2 to 3 minutes, or it may be coated by means of a brush (see below), then hung to dry. The immersion method uses more solution, but it is easier to obtain an even coat.

Sensitizing the Paper

After the paper is salted, you will need to sensitize it before printing. Sensitizing may be done by tungsten light, though a bright Kodak OC safelight is preferable. As with salting, the paper may be immersed in the solution for 2 to 3 minutes, or it may be coated by means of a brush (see below) then hung to dry. If a brush is used, sensitizing should be done first lengthwise, then across, for maximum evenness. A second coating is recommended.

The paper, having been coated, is now light-sensitive. It can be heat-dried under a safelight or left to dry in a dark room. For heat drying, use a hair dryer on a low setting for short periods. Do not try to dry the paper quickly as the excess heat will adversely affect its sensitivity and tonal gradation.

If you live in a humid area the paper should be used within a few hours. If not, you should be able to store it for about one week.

CAUTION: Silver nitrate stains skin and clothing. Wear rubber gloves. Should staining result, try removal with one of the Stain Removers under "Miscellaneous" in the Formulas section.

Coating the Paper

The usual technique for brush-coating the paper is to make tick marks with a pencil at the corners where the negative will be positioned. Then, using a good quality artist brush (an inexpensive foam brush works well, but soaks up a lot of solution), coat the emulsion over a slightly larger area. This prevents the paper from curling into a tube as the emulsion is being brushed on and is the reason why many printers prefer an oversized piece of paper.

Brushing on the emulsion is a critical part of the process and the one that gives printers the most difficulty. The problem is compounded because the gelatin and emulsion are usually clear and can't be seen while they're being applied. For best results, pour the solution into the center of the area to be coated and brush with smooth, parallel strokes both vertically and horizontally, covering an area slightly larger than the tick marks (assuming oversized paper is being used).

NOTE: An alternative to coating with a brush is to use a glass coating rod, such as those available from Photographers' Formulary and Bostick and Sullivan. This is a method favored by many platinum printers to obtain a smooth, even coat.

Printing

P.O.P. is printed using a wooden contact-printing frame with a hinged back or held flat with a piece of glass. If the paper is not thoroughly dry, it can cause stains on the negative. If you're concerned about damage to the negative, place a thin piece of clear acetate, available at art stores, between it and the paper.

When exposed to the light source (sunlamp, north light, direct sunlight), the paper will darken quickly at first and then slow down. When using a contact-printing frame, you can check the progress of the print by taking the print frame into the shade or anywhere away from the primary light source and unhinging the short side of the back. Peel back the edge of the print. Be careful not to fog the paper by exposure to bright light or to move the registration. The highlights should be darker than the tone desired in the final print, and the shadows may even have a metallic sheen. With practice you'll learn to judge when the print has reached the proper density.

Contrast Control

P.O.P. tends to be very low in contrast. This is another reason why denser, more contrasty negatives are better. Two methods can be used to control the contrast of the print: the addition of potassium dichromate or the choice of light source.

Chemical Control of Contrast

The addition of potassium dichromate gives the most control and repeatability. Three drops of a 10% solution in 28 ml of salting solution will increase the contrast by approximately one paper grade. For further increases add dichromate in increments of three drops. A further benefit of adding dichromate is that it causes the salting solution to turn slightly yellow. This makes it easier to see when coating the paper. The disadvantage is that it decreases the printing speed by about half for every three drops per 28 ml.

Ultraviolet Light to Control Contrast

Further control can be gained through the choice of light source. The higher the amount of ultraviolet (UV) light, the lower the contrast. Sunlamps and direct sunlight both contain relatively high amounts of UV and give the lowest contrast. While direct sunlight will print the fastest, north light on a sunny day has less UV and will print more slowly with greater contrast.

Fixing, Washing, and Toning

The print should be washed to remove any free silver nitrate. Free silver nitrate will precipitate gold from the toning bath and interfere with fixing. Wash until all milkiness in the water has been removed, but not any longer, as prolonged washing, before fixing, may weaken the image. At this point the paper has lost most of its sensitivity, but it is still sensitive until fixed. If gold toning is intended, trim the darkened edges from around the print so that you don't waste gold solution; also, washing will take less time.

Fix the print in fixer without hardener. After fixing, immerse the print in Hypo Clearing Agent (HCA) and wash as you would any double-weight, fiber-based paper.

After fixing and thoroughly washing, the prints may be toned immediately, or dried to be toned later, or not toned at all. Without toning, the print will tend towards reddish brown. By toning with gold you can create a variety of colors ranging from reddish brown to purple to blue-gray. As a rule, acid toners, such as P.O.P. Borax Toning Bath, act slowly and tend to be warm; alkaline toners, such as P.O.P. Thiocyanate Toning Bath, act more quickly and tend to be cool, or blue.

It is difficult to judge the final tone of P.O.P. paper until it is dry as it tends to change color. It is a good idea to print out several step tablets and place them in the toner at 3-minute intervals. Carefully mark each one and keep them for reference.

Toning also increases the permanence of the print, not unlike silver-gelatin papers. There are a number of formulas for gold toning; two are given in the Formulas section, Borax Toning Bath and Thiocyanate Toning Bath.

That's all there is to making P.O.P. prints. Alternative processes, such as P.O.P., gum printing, platinum/palladium, carbro, and others, can be rewarding avenues of creativity. The level of difficulty is minimal when measured against the great control and freedom of expression available through manipulation of the process.

Safety in Handling Photographic Chemicals

Basic Precautions

Toxic chemicals can enter your body in three ways: breathing them, swallowing them, or absorbing them through your skin. Wearing a good quality, well-fitting dust mask will prevent breathing them in when working with powders. An appropriately rated fume mask will prevent you from breathing in toxic fumes, such as formalin.[1] Wear neoprene gloves[2] when working with poisonous chemical powders or solutions. Putting your unprotected hands in developer trays to shuffle film or paper may seem convenient, but in time this repeated exposure can develop into a sensitivity to common developing agents like metol and hydroquinone.

Basic Safety Procedures[3]

The following list of basic safety procedures is one of the best published. These guidelines are not designed to frighten you but to ensure that you have a long and safe career in photography. Remember that your eyes, lungs, and skin are porous membranes and can absorb chemical vapors, liquids, and powders. Some of the procedures may seem like common sense, but take the time to read the list anyway.

[1] Check with a reputable chemical supplier, such as Tri-Ess Sciences, for a properly rated fume mask (see appendix II, Sources).

[2] Common household latex gloves are not chemical-proof. I recommend the use of either Bench Mark or Bluettes made by Spontex. See "Darkroom Safety Products," appendix II.

[3] This list was originally published in *Photographic Possibilities* by Robert Hirsch (Focal Press, 1991). Used by permission.

1. Read and follow all instructions and safety recommendations provided by the manufacturer before undertaking any process. This includes mixing, handling, disposal, and storage. Request a Material Safety Data Sheet (MSDS) from the manufacturers of photo chemicals. Collect these in a loose-leaf binder and keep it where someone can find it in an emergency.
2. Become familiar with all the inherent dangers associated with any chemicals being used. When acquiring chemicals, ask about proper handling and safety procedures.
3. Know the antidote for the chemicals you are using. Prominently display the telephone numbers for poison control and emergency treatment centers in your working area and near the telephone.
4. Many chemicals are flammable. Keep them away from any source of heat or open flame to avoid a possible explosion or fire. Keep a fire extinguisher that can be used for both chemical and electrical fires in the work area.
5. Work in a well-ventilated space. Hazardous chemicals should be mixed under a vented hood or outside.
6. Protect yourself. Wear thin, disposable plastic gloves, safety glasses, and a plastic apron. Use a disposable face mask or respirator when mixing chemicals or if you have had any previous allergic reaction. If you have any type of reaction, consult a physician immediately and suspend work with all photographic processes.
7. Follow mixing instructions precisely.
8. Keep all chemicals off your skin, out of your mouth, and away from your eyes. If you get any chemicals on your skin, flush the area immediately with cool running water.
9. Do not eat, drink, or smoke while handling chemicals.
10. Always pour acids slowly into water; never pour water into acids. Do not mix or pour any chemicals at eye level, as a splash could be harmful. Wear protective eye wear when mixing acids.
11. Avoid touching any electrical equipment with wet hands. Install shock-proof outlets (ground-fault interrupters) in your darkroom.
12. Follow instructions for proper disposal of all chemicals. Wash yourself and any equipment that has come into contact with any chemicals. Launder darkroom towels after each session. Dispose of gloves and disposable masks to avoid future contamination. Keep your work space clean and uncontaminated.
13. Store all chemicals properly. Use safety caps or lock up chemicals to prevent other people and pets from being exposed to their potential dangers. Store chemicals in a cool, dry area away from any direct sunlight.
14. If you are pregnant or have any preexisting health problem, read the pertinent materials under "Additional Information," at the end of this appendix.
15. Remember, people have varying sensitivities to chemicals. If you have had allergic reactions to any chemicals, pay close attention to the effects that darkroom chemicals have on you, and be extra careful about following safety procedures.

Mixing Dry Powders

While exposure to chemical solutions can be hazardous, and it is strongly advised that one use gloves and other appropriate safety equipment, the single greatest hazard to the darkroom worker is exposure to aerial-borne chemical powder and dust. Once most chemicals are in solution they are so dilute as to be mostly harmless. This does not mean that they are safe with constant exposure, and some, such as mercuric chloride, are never safe with any degree of exposure.

However, fine dust and powder, whether it is mercuric chloride or plain sodium carbonate, an ingredient sometimes found in food, can be damaging to the sensitive membranes in the lungs. For this reason, the minimum precaution for mixing dry chemicals is to use a dust mask universally available in hardware stores and only mix in a room with good ventilation. If a dust mask is not available, mixing the chemicals outside is another option, though even outside a dust mask should still be employed.

A safe method for mixing prepackaged dry chemicals is one proposed by Richard Henry in *Controls in Black-and-White Photography.* Henry suggests cutting the top of the packet completely off with a pair of scissors then immersing the entire packet under water with a gloved hand. It is important to use a mixing container with an opening large enough for one and a half hands at least (I use a one-gallon measuring beaker into which both hands can easily fit). Though it is only necessary to immerse one hand, it is important to have enough room to hold the packet under water and move it around to dissolve the contents. It is also sometimes necessary to insert a stirring rod into the immersed packet to facilitate the removal of all the chemical.

This method can also be used with bulk chemicals which you have weighed out on a scale. Weigh the chemicals in a plastic container, available from chemical supply houses, and hold the entire container under water. A dust mask should still be used while removing the powders from their storage jars.

Storage

Keep all chemicals away from children and pets. If necessary, lock the chemicals up. Label and date all bottles of mixed solutions. Do not use drink or food bottles for darkroom solutions that are not *clearly* relabeled. Be sure storage bottles have a secure cap. Protect all chemicals from air, heat, light, moisture, and contamination from other chemicals.

Disposal and Safety

When working with any chemical, you must assume the responsibility for its safe use and disposal. Follow any special instructions included with each chemical or process being used. Laws concerning disposal of chemicals vary widely. Contact the hazardous materials (HazMat) unit of your local fire department. They will explain in detail exactly what you can and cannot do in terms of disposal in your area.

Some noncorrosive liquids can be poured onto kitty litter and placed in a plastic bag. Often, dry chemicals or contaminated materials can be disposed of by sealing them in a plastic bag. These should be left in a closed, outside dumpster. Do not mix liquid and solid wastes together, as dangerous reactions might occur. Be sure to read and follow all safety recommendations that come with the chemicals.

Additional Information

On the World Wide Web

The Office of Radiation, Chemical and Biological Safety of Michigan State University, (517) 355-0153; http://www.orcbs.msu.edu.

Oxford University's Physical and Theoretical Laboratory, http://physchem.ox.ac.uk/MSDS/

Books

The presence of a book on this list does not necessarily indicate my endorsement.

McCann, Michael. *Artist Beware*. New York: Watson-Guptill, 1979.

Rempel, Siegfried, and Wolfgang. *Health Hazards for Photographers*. Lyons & Burford Publishers, 1992.

Shaw, Susan. *Overexposure: Health Hazards in Photography*. San Francisco: The Friends of Photography, 1983.

Tell, Judy. "Making Darkrooms Saferooms" (1989). Available from National Press Photographers Association, 3200 Croqsdaile Drive, Suite 306, Durham, NC 27705.

Other Sources

Agfa, North America, 24-hour hotline, (800) 424-9300.

Center for Occupational Hazards, 5 Beekman Street, New York, NY 10038; (212) 227-6220.

Ilford, North America, 24-hour hotline, (800) 842-9660.

Kodak, Australia/Asia/Western Pacific, 24-hour hotline, 03-350-1222 ext. 288.

Kodak, North/South America, 24-hour hotline, (716) 722-5151.

Kodak Ltd., United Kingdom/Europe/Africa, 24-hour hotline, 01-427-4380.

New Jersey Poison Control Center, 24-hour hotline, (800) 962-1253.

New York City Poison Control Center, 24-hour hotline, (212) POISONS (212) 764-7667.

Appendix II **Sources**

Not all chemical suppliers will sell directly to photographers. The following is a list of sources for bulk chemicals, photographic kits, labware, and apparatus.

Chemical Suppliers

- Antec (bulk chemicals), 721 Bergman Avenue, Louisville, KY 40203; (502) 636-5176, Fax: (502) 635-2352; E-mail: kyantec@aol.com.
- Artcraft Chemicals (bulk photographic chemicals), P.O. Box 583, Schenectady, NY 12301; (518) 355-8700, (800) 682-1730, Fax: (518) 355-9121; E-mail: jacobson@juno.com. Call 5:30-7:30 P.M. EST or weekends only.
- Berg Color-Tone (dye toners, selenium toner, washing aids), 72 Ward Road, Lancaster, NY 14086; (716) 681-2696, Fax: (716) 684-0511.
- Bostick & Sullivan (alternative process supplies and chemicals, including glass-coating rods), P.O. Box 16639, Santa Fe, NM 87506; (505) 474-0890, Fax: (505) 474-2857; E-mail: *orderinfo@earthlink.net*; http://www.bostick-sullivan.com.
- Bryant Laboratory (bulk chemicals, labware, and apparatus), 1101 Fifth Street, Berkeley, CA 94710; (800) 367-3141, (510) 526-3141, Fax: (510) 528-2948; E-mail: bry_lab@sirrus.com.
- Engelhard Company (precious metal salts), 554 Engelhard Drive, Seneca, SC 29678; (800) 336-8559; http://www.engelhard.com.
- Falcon Safety Products (Edwal proprietary chemicals), 25 Chubb Way, P.O. Box 1299, Sommerville, NJ 08876; (908) 707-4900.
- First Reaction (precious metals, hard-to-find chemicals such as selenium powder), 37 Depot Road, Hampton Falls, NH 03844; (603) 929-3583, Fax: (603) 929-5023; E-mail: firstrxn@aol.com.

- Johnny De Iure (bulk chemicals), 5835 Chambly Road, St. Hubert, PQ J3Y 3R4, Canada; (450) 678-1920, Fax: (450) 678-4411; E-mail: jdeiure@colba.net.
- Photographers' Formulary (bulk photographic chemicals and kits), P.O. Box 950, Condon, MT 59806; (800) 922-5255; E-mail: formulary@montana.com; http://www.photoformulary.com.
- Rayco Chemical Co. Limited (bulk chemicals, prepared chemistry, film, paper and safety equipment), 199 King Street, Hoyland, Barnsley, South Yorkshire S74 9LJ, United Kingdom; Telephone/Fax: (01226) 744594.
- Sprint Systems (Sprint proprietary chemicals), 100 Dexter Street, Pawtucket, RI 02860; (800) 356-5073; http://www.sprintsystems.com.
- Tri-Ess Sciences (chemicals for most black-and-white and nonsilver photographic procedures, lab equipment, books), 1020 West Chestnut Street, Burbank, CA 91506; (818) 848-7838, outside California (800) 274-6910; E-mail: science@tri-esssciences.com; http://www.tri-esssciences.com.

Darkroom Equipment and Photographic Materials

- AccuLab (digital electronic scales), 8 Pheasant Run, Newtown, PA 18940; (215) 579-3170; http://www.acculab.com.
- Albro Engineering (PVC sinks, PVC tanks), 46 Radipole Lane, Weymouth, Dorset DTA 9RW, United Kingdom; (01305) 771528.
- Bergger Products, Inc. (Bergger BPF 200 film, fine art printing papers, alternative process products), 5955 Palo Verde Drive, Rockford, IL 61114; (815) 282-9876, Fax: (815) 282-2982; E-mail: info@bergger.com; http://www.bergger.com.
- Cachet Fine Art Photographic Papers (EcoWasher for film and paper), 11661 Martenes River Circle, Suite D, Fountain Valley, CA 92708; (714) 432-7070, (888) 322-2438, Fax: (714) 432-7102; E-mail: onecachet@aol.com; http://www.onecachet.com.
- Calumet (darkroom equipment supplier), 890 Supreme Drive, Bensenville, IL 60106; (800) 225-8938.
- Charles Beseler Company (enlargers, easels), 1600 Lower Road, Linden, NJ 07036; (908) 862-7999.
- CPM, Inc. (Delta 1 darkroom environmentally sensitive darkroom equipment), 10830 Sanden Drive, Dallas, Texas 75238-1337; (214) 349-6886, (800) 627-0252.
- David Lewis (Private Label soft-emulsion enlarging paper), 457 King Street, P.O. Box 254, Callander, ON P0H 1H0, Canada; (705) 752-3029; E-mail: dlewis@onlink.net.
- Doran Enterprises, Inc. (manufacturers of Premier darkroom equipment accessories including paper safes), 2779 South 34th Street, Milwaukee, WI 53215; (414) 645-0109.
- Edmund Scientific (scales, labware, and apparatus), 101 East Gloucester Pike, Barrington, NJ 08007-1380; (609) 573-6260.
- Freestyle Sales Co. (darkroom equipment and supplies, paper, film), 5124 Sunset Boulevard, Los Angeles, CA 90027; (323) 660-3460,

(800) 292-6137, Fax: (800) 616-3686; E-mail: foto@freestylesalesco.com; http://www.freestylesalesco.com.

- Hass Manufacturing (Intellifaucet water control monitors), 9 Tyler Street, P.O. Box 565, Troy, NY 12181-0565; (518) 274-3908.
- JOBO Fototechnic (darkroom equipment manufacturers, including daylight development tanks for large format film), 4401 Varsity Drive, Suite D, Ann Arbor, MI 48108; (800) 664-0344; E-mail: sales@jobo-usa.com; http://www.jobo-usa.com.
- Omega/Arkay (enlargers, easels, darkroom accessories, King Concept processors), P.O. Box 2078, 191 Shaeffer Avenue, Westminster, MD 21157; (800) 777-6634.
- Paterson Darkroom Equipment (darkroom accessories), 21 Jet View Drive, Rochester, NY 14624-4996; (716) 328-7800.
- Pelouze Scale Company (Pelouze R-47 photographic balance beam, postage scales), 2120 Greenwood Street, Evanston, IL 60204; (708) 430-8330.
- Phillips Morris Scales (Ohaus scales), 20150 SW Avery Court, Tualatin, OR 97062; (503) 691-5949; E-mail: jgaunt@phillipsscale.com; www.phillipsscale.com.
- Redlight Enterprises (MetroLux enlarging timers), 1692 Roseland Drive, Concord, CA 94519; (925) 825-5999.
- Samy's Camera (darkroom equipment and supplies), 431 South Fairfax, Los Angeles, CA 90036; (323) 938-2420, (800) 321-4726.
- The Saunders Group (enlargers, easels, darkroom accessories), 21 Jet View Drive, Rochester, NY 14624-4996; (716) 328-7800.
- Schneider Optics (Componon-S enlarging lenses, black-and-white filters), 400 Crossways Park Drive, Woodbury, NY 11797; (516) 496-8500.
- Summitek (vertical print washers), P.O. Box 520011, Salt Lake City, UT 84152; Telephone/Fax: (801) 972- 8744; http://www.summitek.com.
- Quadro Photographics (easels, paper safes), The Old Courthouse, Norfolk PE32 1AA, United Kingdom; (01485) 600601, Fax: (01485) 600074.
- RH Designs (timers, analyzers), 20 Mark Road, Hemel Hempstead, Herts HP2 7BN United Kingdom; (01442) 258111, Fax: (01442) 258112; E-mail: rhdesigns @nildram.co.uk; http://www.nildram.co.uk/rhdesign.

Darkroom Safety Products

- Karde Air Purifiers, 224 Pine Boulevard, Medford, NJ 08055; (800) 245-8802.
- Spontex (Bluettes and Bench Mark neoprene safety gloves), 1 Spontex Drive, Columbia, TN 38401; (800) 787-6060.
- Photographic Solutions (Photofinish cleaner, The Finishing Touch hand lotion), 7 Granston Way, Buzzards Bay, MA 02532; (508) 759-2322; http://www.photosol.com.

Appendix III **Planning a Darkroom**

There are six requirements for a darkroom to safely and efficiently process, proof, and print negatives:

1. A source of water for washing
2. A lighttight environment
3. Proper ventilation
4. A dust-free environment for film drying
5. Electricity
6. Adequate space

Water

It is not necessary for water to be in the same room, just available. The supply should be as clean and grit-free as possible, especially for film processing. If you are processing in a bathroom or kitchen, obtain a water filter that fits on the end of the tap. These filters are inexpensive and reduce the risk of spots from dust, dirt, rust, and undissolved chemicals contained in tap water.

A water-temperature control (WTC) is a good lifetime investment. A WTC can be purchased alone and water filters added, or it can be purchased as a complete, ready-to-install unit.

If you do invest in a prefabricated WTC, spend a few extra dollars and buy one with two filters. Two filters will increase the life of your valve. Use wound-polypropylene filters. Cellulose filters may come apart with use and contaminate the water.

If you do not have a WTC, use a water-temperature monitor (WTM). A WTM is simply a pipe with a built-in thermometer that attaches below the faucet to monitor temperature.

No Light Is Good Light

Ideally, a darkroom should be absolutely lighttight. Fortunately, the only part of the process in which zero light is absolutely necessary is while loading film, a problem that can be solved by using a changing bag.

From a practical point of view it is not always possible to achieve an absolute lighttight home darkroom. From a personal point of view it is not always desirable. Brett Weston worked in his darkroom after midnight, every night. He lived in the country where there were no neighbors or city lights. When printing he opened all the windows and doors to allow the night air to circulate freely. The only light was that of the stars.

If you don't live in the country, leaving the doors and windows open is probably not an option. However, making a room lighttight enough to print is not that difficult. An easy way to block windows is to place a strip of Velcro around all four sides and attach a piece of blackout cloth, available from most photo suppliers. If your space doesn't have a door you can close, cover the opening in the same manner or purchase an inexpensive hollow-core door from a builder's supply store.

Sealing the light around the door is not difficult either. Spend a few minutes browsing in the weather stripping section of any hardware or building supply outlet, and you will find many self-adhesive products that can be applied to the frame or the door. A two-by-four nailed to the floor along the bottom edge of the door and a good door sweep, attached so it drags the floor, will take care of most of the light leakage along the bottom edge. Or better yet, Delta 1 makes an automatic darkroom door bottom that will even adjust to irregular floor surfaces, see appendix II, Sources.

As a final step, paint the door jambs with flat black paint.

Ventilation

Making the room lighttight is desirable. Making it airtight can be hazardous. All darkrooms should be well ventilated.

Proper ventilation in the darkroom is the first, and possibly most important, expense, even before an enlarger and lens. Make it a priority to build a darkroom that is healthy and comfortable to work in. Add equipment as you can afford it.

If your darkroom work is limited to film development in a daylight tank over the kitchen sink, ventilation is not an issue. If you have a situation like Brett Weston's, where all the doors and windows can be left open, no problem. But as soon as you close off a space, in a closet, bathroom, or a specially built room, proper ventilation is of utmost importance.

Lack of fresh air can cause a buildup of toxic fumes, which, though not usually lethal, can cause drowsiness and headaches. In addition to fumes and stale air, heat from the enlarger lamp, or even from outside if you live in a warm clime, can cause you to leave early and unconsciously avoid working in the darkroom.

Current OSHA and EPA studies indicate that proper ventilation means an active exhaust fan, to remove toxic fumes, and a passive vent, or active fan, to

admit fresh air. Ideally, the exhaust fan, should be placed above the processing sink in order to draw the fumes directly from the processing trays. The passive vent should be low to the ground, usually, though not necessarily, opposite the exhaust fan. Both need to be lighttight.

The best way to ventilate a small darkroom is to purchase a lighttight exhaust fan. This is an investment that is as important as an enlarger, and you should not cut corners. The small, round, passive air vents available from retail outlets may be good to facilitate air flow in a small space, but don't consider them a substitute for real ventilation. A darkroom requires *active* ventilation.

If the darkroom is in a closet, install the fan directly in the door. You could install a fan at the top of the door, drawing air out, and a passive vent at the bottom, allowing fresh air in. If you're renting a house or apartment, remove and store the landlord's door and replace it with a door of your own. When you move, replace the landlord's original door, keeping your ventilator door intact for the next darkroom.

If a window is available, the fan can be installed permanently, or mounted on a removable Masonite board. The Masonite should be attached to a lightweight wooden frame that fits over the window to block light. After a darkroom session, the complete unit—Masonite board and lighttight fan—can be removed and stored.

Dust-Free

While a fresh supply of air is of paramount importance to the health and safety of the darkroom worker, clean, dust-free air is important to the quality of the work. It is an especially important consideration in areas where film is to be dried.

Many photographers dry film by hanging it in a bathroom. This is a perfectly acceptable arrangement with the following precautions.

1. Remove all towels and area rugs. These are dust magnets and static generators.
2. The film needs to be hung inside the bathtub or shower with the door closed.
3. If possible, the bathroom should not be used for the first hour of drying.
4. To rid the bathroom of dust, run hot water for a few minutes to create steam. When the steam clears, the dust will have settled and, if traffic is held to a minimum, will stay settled.

One method for hanging film in a shower is to use a retractable clothesline available from a housewares or variety store. Install the retractable line above the showerhead, and the receiving hook on the opposite wall.

Another solution where traffic is heavy or there is no shower stall is to use a drying bag or cabinet. Drying bags and cabinets are available from many photo suppliers.

Do not make the mistake of hanging your film in a clothes closet unless a drying bag is used. You will have negatives so full of dust they will be unprintable.

Electrical Current

The electrical demands of a darkroom are not great. One outlet with a four-plug adapter or a good power strip with multiple outlets is often sufficient for a closet or temporary darkroom.

If you are building the darkroom from the ground up, take a moment to tally the total wattage of all the electrical equipment you plan to use—enlarger, timer, lights, safelights, drier, dry mount press, slide viewer, and so on. Divide the total wattage by 120 volts (or whatever voltage you will be using). The result is the number of amperes of current that would be drawn if everything were on at the same time. Add 10 to 20% for growth. Then provide one or more circuits sufficient to carry the current demand in amperes. Common circuits are 15 amperes. However, by using larger wiring, you can have 20- or 30-ampere circuits.

Always use reset-type circuit breakers instead of replaceable fuses. If possible, locate the breakers close to the area served by the circuit. It's a smart idea to put the lights on one circuit and everything else on a separate circuit. Then, if a momentary overload trips the circuit breaker, you won't be "left in the dark."

A second circuit dedicated to the enlarger only will help minimize voltage fluctuations. If that's not possible, use a constant-voltage transformer between your enlarger and the outlet.

A small darkroom should have at least four outlets, more if needed. Locate two of them spaced conveniently around the wall, and one each above the sink and enlarger bench. If the darkroom is in a basement, locate the outlets high in case of flooding.

On the wet side, locate the outlet high above the sink and use a ground-fault interrupter (GFI) outlet in case an appliance is dropped into a solution or develops a short. GFIs are available as separate units to plug into a conventional outlet or as easy-to-install replacements for ordinary outlets. If in doubt, consult a licensed electrician.

Space

Establishing a permanent darkroom presupposes the availability of a permanent space. The space does not have to be large. Ideally, there should be enough room to have a dry side for enlarging and a wet side for developing and other chemical processes. The two can be on opposite sides of the room or side by side with a splash wall separating them.

The location of the darkroom is important. An attic, unless it is well-insulated, is likely to be too hot in the summer and too cold in the winter. Also, it is usually difficult and expensive to extend plumbing into an attic.

A dry basement is an ideal location. If the basement is damp, make it dry with a dehumidifier, available from appliance stores. The optimum relative humidity for a darkroom is between 45% and 50%; the ideal temperature is between 70°F/21°C and 75°F/24°C. It is usually easier to maintain this temperature in a basement than in other parts of the house. Also, hot and cold water and electrical connections are generally available in a basement. Another advantage is the ease with which a basement can be made lighttight.

If a basement location is not available, locate space in a garage, second bathroom, utility closet, or unused spare room. Try to find a situation that simulates a dry basement as closely as possible.

Size

Bigger is not always better. A large-format photographer of my acquaintance converted a 20 × 20' room into his version of a dream darkroom. He spends half his time walking from one side to the other.

Another photographer whom I know has a small, walk-in closet. He built shelves, put his enlarger at one end, stacked trays on a tray ladder, and added a paper safe and rotating drafting stool. He turns from his enlarger to his trays and back. When a print is finished, he carries it outside and places it in a washer.

From a practical point of view a permanent darkroom should not be much smaller than 6 × 7'. For safety and comfort the minimum open space to stand and move about should be at least 30" wide.

Figures A3.1 and A3.2 show two possible darkroom configurations. The size of either darkroom can be increased to accommodate a longer sink, drying cabinet, and the addition of a utility bench.

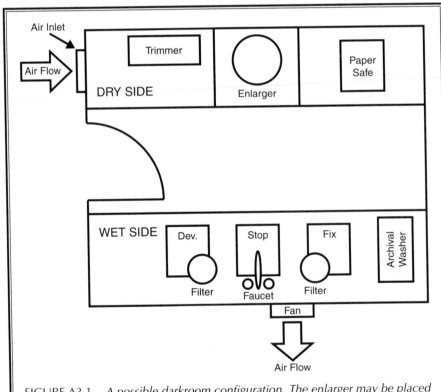

FIGURE A3.1 *A possible darkroom configuration. The enlarger may be placed in the middle or at either end and the trays arranged accordingly. Fresh air should enter from a passive vent either in or above the door. (Thanks to Brian MacNeil of Canada for this diagram.)*

Placement of Equipment and Work Flow

In planning a darkroom, the main objective is to arrange the equipment and materials for efficiency and convenience. The dry side and the wet side should be arranged to facilitate the flow of work, from enlarging to developing and back again, with a minimum of steps.

Study the work pattern in the darkrooms in Figures A3.1 and A3.2. You can see the reasons for the recommended arrangement of the benches and equipment. To make prints, for example, you would take the photographic paper from the paper storage shelf, open it, and place it in a dark drawer (Figure A3.3) or in a paper safe next to the enlarger. After placing the negative in the enlarger and composing the image, you would place a sheet of printing paper in the easel and expose. After the paper is exposed you either turn around or pass it on to the developer and the rest of the processing solutions. Then you turn on the light, inspect the print, and move it to the washer. Finally, you turn around or take the few steps back to the enlarger. Everything is accomplished with a minimum amount of time spent moving from one place to another.

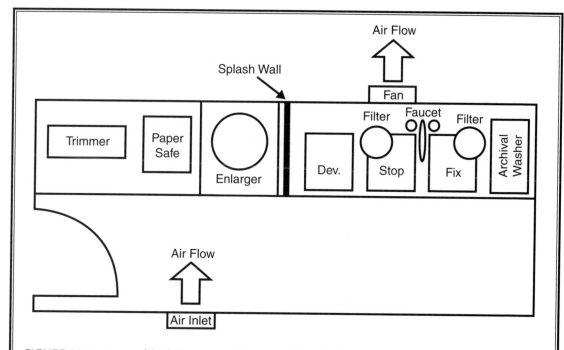

FIGURE A3.2 *A possible darkroom configuration. The enlarger may be placed in the middle or at either end and the trays arranged accordingly. An active slot hood would be well placed above the trays, in which case fresh air should come in from the wall opposite or the door area. (Thanks to Brian MacNeil of Canada for this diagram.)*

Walls and Floor

Darkrooms can have light-colored walls to allow reasonable light in the room. This is safer and causes less eyestrain. Remember that walls can only reflect the light that falls on them; if that light is safe for photographic materials, the light they reflect is also safe.

That being said, I still prefer to paint the wall and ceiling directly behind and above my enlarger black. Many enlargers leak some light, and light can also be scattered off the baseboard. Black walls help to absorb stray light.

The most serviceable color for the remaining walls is light gray, light yellow, or white. The ceiling and the upper part of the walls can be finished in white. This is particularly useful when indirect safelight is used.

The lower part of the walls, especially the area around the wet side, should be finished with a waterproof coat that will allow wiping down and cleaning with a damp cloth.

One useful tip is to paint the corners of tanks, tables, cupboards, and so forth, white. This will make movement in and around the darkroom easier and safer.

Floors call for special consideration. They need to be protected against moisture and chemical action. The best material is asphalt or a special chemical-resistant concrete coating. The next best is a good-quality linoleum, which should be kept clean and well waxed to help prevent the penetration of spilled solutions. This can be underlaid with bitumen paper as an extra precaution against liquids getting through and damaging the subfloor.

An antifatigue, chemical-resistant floor mat is another good idea. An antifatigue mat will help you work longer and more comfortably, especially if your darkroom is in a basement or garage with a concrete or asphalt floor. The mat will also insulate you from the cold.

Safelights

Comfortable handling of negative material in the darkroom is largely dependent upon proper darkroom lighting. The lighting is a compromise between illumination of a color and intensity that does not fog sensitive materials but that still enables the photographer to work with a minimum of inconvenience and eyestrain. It is essential that the correct safelight filter is selected and used in a housing of appropriate design and fitted with a bulb of the correct wattage.

Ordinary printing paper can be handled in a relatively high intensity of dark-brown or red-brown light, corresponding to Kodak OC or OA filters. Panchromatic papers (e.g., Kodak Panalure Select RC) are sensitive to all colors and require the use of a low-intensity Kodak #3 dark-green filter or no filter at all. Orthochromatic or red-blind materials such as Kodalith and other high-contrast line films used in the graphic arts, can be handled using a high-intensity Kodak #2 red filter.

Some sources recommend two safelights, equipped with 15-watt frosted bulbs, suspended no closer than 4' above the work surface. Use one for the dry side, one for the wet. In a small darkroom, aiming one safelight at a white ceiling provides adequate illumination and is safe for sensitized materials. Use a 25-watt bulb.

Cabinets, Benches, and Sinks

Benches for a darkroom can be built by a cabinetmaker, purchased ready-made as modular kitchen units, or built by you. If you choose the last option, *Build Your Own Home Darkroom* by Lista Duren and Will McDonald is an excellent resource.

Sinks can also be purchased or made. I prefer a sink at least 6' long, preferably 8' to 10'. However, many photographers must make do with 4' sinks. A 4' sink will accommodate three 11 x 14" trays. A 6' sink will accommodate four 11 x 14" trays with barely enough room for a vertical print washer. If you don't normally make prints larger than 8 x 10" a 4' sink is adequate. However, a 6' sink is still preferable. If you are limited to a 4' sink and need additional space, use a set of tray ladders.

If your space is minimal you will need to run a galvanized wire or clothesline over the sink to hang film for drying. Since the film won't be able to hang straight (a 36-exposure roll is about 5' long), you will have to attach both ends to the line via clothes pins or film clips.

Storage Space

Whereas counter space for the enlarger and room for the sink is essential, ample storage and shelves are what make small darkrooms efficient.

A lighttight "dark" drawer (see Figure A3.3) located near the enlarger is an added convenience. This will provide quick access to printing paper and eliminate the necessity of opening and closing the package of paper every time you need a sheet. To make a dark drawer, install a sliding lid that fits in

FIGURE A3.3 *To make a dark drawer lighttight, install a sliding lid that fits in a groove around the top perimeter of the drawer. Paint the inside of the drawer and lid flat black. Attach a small block of wood on the top of the lid and another one on the underside of the counter top to push the lid closed when you close the drawer.*

FIGURE A3.4 *Diagram of a small sink. The faucet can be placed on the back wall or on either end. (Courtesy of Camera & Darkroom.)*

a groove around the top perimeter of the drawer. Paint the inside, including the lid, flat black. Attach a small block of wood on the top of the lid and another on the underside of the counter top. The blocks of wood will push the lid closed when you close the drawer.

If you don't have a dark drawer, I strongly recommend the use of a paper safe, even though it occupies valuable counter space.

You can use the sink for mixing chemicals and for all processing operations. Storage space for trays and chemical solutions should be beneath the sink. Shelves mounted 2′ above both the sink and enlarger bench will provide additional storage space for bottles of stock solution, timers, thermometers, and other small equipment. Wooden pegs mounted on the splash wall (see Figure A3.4) provide a place for film hangers and graduates. A towel holder mounted on or near the sink provides a place for a towel to dry your hands.

Temporary Darkrooms

There are many small spaces that can be converted for darkroom use: a kitchen sink; a 12″ wide board extending from the top of the toilet to the edge of the bathroom sink; a board covering the bathtub (bring a stool to sit on); a shelf in a closet; a storage shed in the backyard.

Another option is to use a rollaway utility cart. Large variety stores often have them for less than $100. Buy one that is large enough to place your enlarger on, and use the shelves to store paper, chemicals, and extra equipment.

Equipment

The equipment needed for a darkroom falls into three categories: wet side, dry side, and miscellaneous. The following items are recommended for a well-equipped darkroom.

Wet Side
- 1-liter beaker or graduate
- developing tank and reels
- dial thermometer
- enlarging trays
- film-drying bag, cabinet, or a clothesline in the shower
- film-hanging clips
- film squeegee
- film washer
- ½" white Plexiglas for viewing and "squeegeeing" wet prints
- print-washing device
- print-drying screens
- process timer (e.g., GraLab 300)
- stirring rod
- tongs
- water control valve or WTM

Dry Side
- contact-printing frame
- dark drawer or paper safe
- enlarger
- enlarger alignment tool
- enlarging lens
- grain-focusing device
- multicontrast filters
- negative carriers
- paper easel
- paper trimmer
- repeatable darkroom timer
- soft brush for cleaning negatives

Miscellaneous
- air cleaner or purifier
- antifatigue mat
- film-cassette opener or bottle opener
- light box for judging negatives
- magnifying loupe for negatives
- package of negative file pages
- passive lighttight ventilators
- safelight
- scissors
- tape—drafting, black photographic, and clear
- trash can (extra large)
- ventilator or exhaust fan

Appendix IV **The Anatomy of Film**

The anatomy of a piece of film.

A—Protective coating, dissolved during development.

B—Emulsion, light-sensitive silver bromide crystals suspended in gelatin. The size of the crystals (granules) controls speed, grain, contrast, and resolution. All can be altered to some extent in the development process.

C—Base, usually some form of pliable, clear acetate.

D—Antihalation backing, which absorbs excess light that penetrates the emulsion and base and prevents it from bouncing back and scattering in the emulsion, thereby fogging and degrading the image. Also dissolved during development.

Definitions

- Acutance: the separation of adjoining objects or details in a negative. Also known as sharpness of definition and edge sharpness. When two objects are adjoining in a negative, acutance describes how sharp and clear the line is between them. All the things that cause graininess can lower the acutance of a film. In addition, halation (see *antihalation*

backing described above), irradiation (the spreading of light as it passes through the emulsion), and grain size affect acutance.

Slow, thin emulsion films, such as Kodak Technical Pan or Ilford Pan-F, developed in high-definition developers such as Windisch Extreme Compensating Developer or POTA will produce negatives, even from 35mm, of extremely high acutance with the ability to enlarge to mural size. The trade-off is an extremely low EI.

- Grain or Granularity: the measurable grain size of any undeveloped film. Generally, slower films have smaller grain, faster films have larger grain. Grain size is predetermined by the manufacturer.
- Graininess (grain aggregation): the clumping together of individual grain particles during development. Graininess can also be induced by exposure to excessive heat before or after exposure (graininess does not change after development is complete). The choice of developer can reduce or increase graininess. It does not affect grain size.

 Factors that noticeably increase graininess are overvigorous agitation during development, solutions that vary more than ±2 degrees, and overexposure in the camera.

 Grain and graininess can be emphasized or reduced by the choice of enlarger light source (cold light and diffusion light sources suppress grain; condenser and less commonly found point-light sources increase or emphasize grain).
- Print Graininess: paper has grain and is subject to graininess for many of the same reasons as film. Paper grain is related to the grade of contrast. The higher the grade of contrast, the larger the grain (except for variable contrast papers).

 Surface texture also has an effect. Glossy and matte surfaces emphasize both film and paper grain more than pebble or textured surfaces.
- Resolving Power: the ability of the emulsion to record fine detail. Resolving power is determined by photographing a line graph. Although the quality of the lens does affect the resolving power of the film, most lenses made today have higher resolving power than the film is able to reproduce. Both fineness of grain size and graininess affect the smoothness of tone and the resolving power of the film.

Bibliography

Adams, Ansel. *The Negative*. New York: New York Graphic Society, 1982. Reprint. New York: Morgan & Morgan, 1968.

Adams, Ansel. *The Print*. New York: New York Graphic Society, 1981.

Anderson, Paul L. *Pictorial Photography: Its Principles and Practices*. New York: J.B. Lippincott Company, 1917.

Barnbaum, Bruce. *The Art of Photography*, 2nd ed. Dubuque, IA: Kendall-Hunt, 1999. Available from the author at Box 1791, Granite Falls, WA 98252; (360) 691-4105.

Davidson, Jerry. *From Black and White to Creative Color*. Markham, ON: Pembroke Publishers Limited, 1994.

DeCock, Liliane, ed. *Photo-Lab-Index*, 41st ed. New York: Morgan & Morgan, 1990.

Dignan, Patrick D., ed. *150 Do-It-Yourself Black and White Popular Photographic Formulas*. North Hollywood: Dignan Photographic, 1977.

Duren, Lista, and McDonald, Will. *Build Your Own Home Darkroom*. Amherst, N.Y.: Amherst Media, 1990.

Eastman Kodak Company. *Black-and-White Processing Using Kodak Chemicals*, publication J-1. Rochester, NY: Eastman Kodak Company, 1985.

Eastman Kodak Company. *How to Make Good Pictures*, 24th ed. Rochester, N.Y., n.d.

Eastman Kodak Company. *Toning KODAK Black-and-White Materials*, publication G-23. Rochester, NY: Eastman Kodak Company, 1989.

Graves, Carson. *The Elements of Black-and-White Printing*. Boston: Focal Press, 1993.

Haist, Grant. *Monobath Manual*. New York: Morgan & Morgan, 1966.

Henry, Richard. *Controls in Black-and-White Photography*, 2nd ed. London and Boston: Focal Press, 1986.

Hirsch, Robert. *Photographic Possibilities: The Expressive Use of Ideas, Materials, and Processes.* Boston, MA: Focal Press, 1991.

Hutchings, Gordon. *The Book of Pyro,* 3rd ed. Granite Bay, CA: Bitter Dog Press, 1998. Can be ordered directly from the author, P.O. Box 2324, Granite Bay, CA 95746.

Jacobson, C.I., and Jacobson, R.E. *Developing,* 18th ed. London: Focal Press, 1976.

Jones, Bernard E., ed. *Encyclopedia of Photography.* New York: Arno Press, 1974.

Lester, Henry M. *Photo-Lab-Index,* 7th and 10th eds. New York: Morgan & Lester, 1945 and 1949.

Lewis, David W. *The Art of Bromoil and Transfer.* Callander, ON: David W. Lewis. Available from the author at 457 King Street, Box 254, Callander, ON, POH 1H0, Canada.

Lootens, J. Ghislain. *Lootens on Photographic Enlarging and Print Quality,* 5th ed. New York: Amphoto, 1958.

Stone, John H., and Taylor, Martin L., eds. *Building a Home Darkroom.* Rochester, N.Y.: The Kodak Workshop Series, 1981.

Stroebel, Leslie, and Zakia, Richard D., eds. *Focal Encyclopedia of Photography,* 3rd. ed. Boston: Focal Press, 1993.

Stroebel, Leslie, Compton, John, Current, Ira, and Zakia, Richard. *Photographic Materials and Processes.* Boston: Focal Press, 1986.

World Journal of Post-Factory Photography, The, Issue #3, ed. Judy Seigel. Post Factory Press, 61 Morton Street, New York, NY 10014; E-mail: info@post-factory.org.

Out of print photographic books can often be obtained from the following booksellers:

A Photographer's Place, P.O. Box 274, Prince St. Station, New York, NY 10012-0005; (212) 431-9358.

Photo-Eye, 376 Garcia Street, Santa Fe, NM 87501; (505) 988-5152.

Formulas

Film Developers

With a few exceptions, I have chosen to publish a general range of development times for each film developer formula. For some formulas, such as Kodak D-76, time/temperature data is readily available from Kodak. Others, such as Ansco 47, which has not been manufactured for years, will have to be individually determined for your working methods.

The developing-time ranges given for each developer are for films rated by the manufacturer between ISO 100 and ISO 320. To choose an initial developing time use this rough rule of thumb: For films rated between ISO 100 and ISO 320, use a time in the middle of the range. For films rated from ISO 12 to ISO 80, decrease the development time from the midpoint by one-quarter. For films rated higher than ISO 320, increase the time from the midpoint by one-quarter.

EXAMPLE: Suppose a developing formula recommends using between 10 and 14 minutes. With an ISO 125 film, start by developing a test roll for 12 minutes. With an ISO 64 film, develop for one-quarter less, or 9 minutes. With an ISO 400 film, increase by one-quarter to 15 minutes. This is a rough rule, and you may find that it is too much or too little. That is why an initial test roll or two is recommended.

NOTE: If you routinely overexpose film by rating it at a lower EI (e.g., Tri-X rated at EI 250 instead of the manufacturer's recommended ISO 400), try developing it at the time indicated for the new EI. In the example just given, that would mean developing Tri-X at 12 minutes, as you would for any film rated between ISO 100 and ISO 320. With normal developers a variation of a $\frac{1}{2}$ minute on either side of full development will not seriously affect the results.

Testing

Take some film, walk down the street, and expose it to a range of subjects. Try to include textured whites (painted white buildings) and some deep shadows. Keep careful notes. In the darkroom, cut the test roll into two, three, or four equal strips. Develop each strip for a different time. Give at least a

10% increase or decrease in time from your best guess starting time. Round the time off to the nearest 15 seconds. When in doubt about what time to start with, do what I do—start with 9 minutes for slow films, 12 minutes for medium speed films, and 15 minutes for fast films. These times will probably be too much or too little, but remember, in black and white you can be off as much as 40% in your development time and still have a printable negative (it may not be your best negative, but it will still be printable, and it will help you determine a more accurate development time!).

Proof for Maximum Black

After developing the test roll, proof it for maximum black (see Carson Graves, *The Elements of Black-and-White Printing*, Boston: Focal Press 1993, p. 21), and determine which way to go for a basic developing time. Remember: exposure is for the shadows; development is for the highlights.

- If the shadows are good, but the highlights are gray, more developing time is indicated.
- If the highlights look right, but the shadows are thin and lacking detail, then more exposure is indicated. Use a lower EI (more exposure) and maintain the same developing time.
- If the shadows are too light (gray with detail) and the highlights are also gray, use a lower EI (less exposure) and increase the developing time.

Agitation

Unless otherwise noted, agitation should be varied as follows:

- intermittent for roll film tanks (continuous agitation for the first 30 to 60 seconds; agitation for 10 seconds every minute thereafter)
- continuously rocking and interleaving for trays

If continuous agitation in a tank is used, as with a JOBO processor, reduce developing time by approximately 20%.

Adjusting Developer Formulas

Developer formulas are not carved in stone. They can be adjusted to customize the results by making one or more of the following changes:

Contrast	Density	Modification
Increase	Increase	Increase pH Increase temperature (same developing time)
Increase	No change	Increase hydroquinone
Increase	Decrease	Increase restrainer
Decrease	Increase	Decrease restrainer Increase metol
Decrease	Decrease	Decrease pH Decrease temperature (same developing time) Decrease hydroquinone

To increase the activity of a developer, increase the amount of accelerator or use an accelerator of higher pH (e.g., substitute sodium carbonate for Kodalk or borax). The approximate relative pH of some commonly used alkalies, acids, and reducing agents can be found on the pH scale in chapter 4, Developers.

Processing at Different Temperatures

Film can be processed over a wide range of temperatures. However, optimum results are almost always achieved at or near 68°F/20°C. Development times at temperatures other than 68°F/20°C may be calculated from the chart in Table 1 as follows:

1. Determine a normal development time at 68°F/20°C for a film/developer combination.
2. Find this time on the 68°F/20°C line.
3. Follow the diagonal line for this time to where it crosses the horizontal line for the new temperature.
4. Draw a line straight down from this point and read off the approximate new development time on the base of the chart. For example, if 6 minutes at 68°F/20°C is your standard time, then at 72°F/22°C the adjusted time would be 5 minutes, and at 65°F/18°C the adjusted time would be 7 minutes.

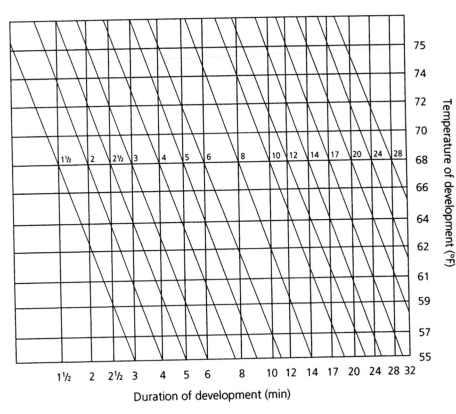

TABLE 1 Time/Temperature Chart.

Divided and Water-Bath Developers

Formula #1

Amidol Water-Bath Developer

Water (68°F/20°C)	24 fl oz	750.0 ml
Sodium sulfite	292 grains	20.0 grams
Amidol	73 grains	5.0 grams
Water to make	32 fl oz	1.0 liter

NOTE: Mix at room temperature below 70°F/21°C as amidol oxidizes quickly at higher temperatures.

The negative is given three soakings in the developer for 40 then 50 and finally 90 seconds, respectively, and after each immersion is allowed to lie in water for 2 minutes without being disturbed. It is possible that amidol water-bath development may cause streaking with some modern emulsions. This could possibly be prevented by using a 3% sodium sulfite solution instead of plain water for the "water" bath. There will be slightly less compensation, but this is preferable to streaked negatives.

Formula #2

D2D Divided Developer

(Thanks to William E. Davis)

Solution A

Water (110°F/43°C)	24 fl oz	750.0 ml
Metol	⅛ oz	3.75 grams
*Sodium sulfite	2¼ oz	67.5 grams
Hydroquinone	¼ oz	7.5 grams
Water to make	32 fl oz	1.0 liter

*Add a pinch of the total sulfite, dissolve the metol completely, then add the remainder of the sulfite.

Solution B

Water (110°F/43°C)	24 fl oz	750.0 ml
Borax	1¼ oz	37.5 grams
Sodium carbonate	1 oz	30.0 grams
Potassium bromide	⅛ oz	3.75 grams
Water to make	32 fl oz	1.0 liter

Solution C (Replenisher)

Water (110°F/43°C)	24 fl oz	750.0 ml
Borax	1¼ oz	37.5 grams
Sodium carbonate	¾ oz	22.5 grams
Potassium bromide	⅛ oz	3.75 grams
Water to make	32 fl oz	1.0 liter

NOTE: It may be possible to improve this formula by reducing the carbonate and bromide. Try using 20 grams of carbonate and 1.5 to 2 grams of bromide in Solution B.

Recommended development times are:

Solution A—4 minutes
Solution B—8 minutes

Agitate in Solution A for an initial 15 to 30 seconds, then for 5 seconds every 30 seconds thereafter. Do the same in Solution B. Other methods of agitation may work equally well; experiment.

After development the film should be rinsed in stop bath or a plain running-water bath, then fixed and washed in the usual manner.

The recommended developing time in Solution B for most two-bath developers is from 2 to 6 minutes. With D2D, density continues to build for up to 8 minutes. This creates maximum shadow detail without excessive blocking in the highlights.

As Solution A is carried over into B, film will gradually become grainier and more contrasty. To prevent this, a new batch of B can be mixed each time, or the old B can be replenished. To replenish, discard $\frac{1}{3}$ of the old B and fill it to the original level with Solution C.

Solution A should be replenished only when it becomes too low, because of carryover to Solution B. Mix a fresh batch of A and use it to bring the working solution back to its original volume.

For softer negatives, use less carbonate in Solution B. For more contrasty negatives, use more carbonate. Using this method, one could have one Solution A and several different B solutions to handle scenes of any brightness range.

In time, both A and B will oxidize, form a precipitate, and turn brown and muddy. This is normal and will not affect the working properties of the formula.

Formula #3

D-23 Divided Developer

This is one of the best divided developer formulas for fine grain and full tonal scale. For the first bath you can use classic D-23 or a modified version, given here. This is because when D-23 was formulated in the 1940s it was felt that a minimum of 7.5 grams of metol were needed for full development. In the 1950s, when Microdol was formulated, it was discovered that less metol could be used with no loss in energy or capacity. As a result, many variations of D-23 have been formulated, some using as little as 3 grams of metol.

Modified D-23 Formula
Water (125°F/52°C)	24 fl oz	750.0 ml
Metol	73 grains	5.0 grams
Sodium sulfite	3 oz 146 grains	100.0 grams
Water to make	32 fl oz	1.0 liter

Method #1, Single Cycle:
For the second bath, use one of the following accelerators in 500 ml of water.

Borax, granular	263 grains	18.0 grams

or		
Sodium metaborate (Kodalk)	¼ oz	7.5 grams
or		
Sodium carbonate, anhydrous	66 grains	4.5 grams

Borax produces the finest grain with the least contrast, metaborate produces medium grain with low contrast, and sodium carbonate has the highest contrast, coarsest grain, and greatest film speed. For minus development, use borax in the second bath.

Development times should be from 2 to 3 minutes in the first bath, with constant agitation, and 3 minutes in the second bath, with 5 seconds of agitation each 30 seconds.

Bob Ingraham of British Columbia states that one inversion every 20 seconds in the first bath, and one inversion every 30 seconds in the second bath, results in even more development. Try both agitation methods and choose the one you prefer.

Extending time in the A bath will increase overall density. Increasing time in the B bath will not appreciably alter the results.

NOTE: This method may have a tendency to raise base and fog levels, but not to an extent that it cannot be printed through. If a problem occurs, the fog level can be contained by adding a 10% potassium bromide solution to the A bath. Use 10 ml to start.

The negative may appear to be soft but will contain fully developed shadow area detail.

Method #2, Multicycle:

This method will produce a more completely developed negative, with additional compensating effects, than the single-cycle method. Develop the film for 30 to 60 seconds in the first bath, then place it into a 1% solution of Balanced Alkali for 1 to 3 minutes with no agitation. The film is put into a weak acid stop bath, then completely rinsed in water. The film is then returned to the first bath for a second cycle. The procedure may be repeated as many as five times to achieve the desired contrast range.

NOTE: When using intermittent development with roll films, using alkali as the second bath, invert the rolls each time they are moved to the alkali to minimize any chemical settling effects.

Formula #4

D-76H Divided Developer

This is David Vestal's Divided D-76 formula, without the hydroquinone (see *The Film Developing Cookbook*).

Solution A

Water (110°F/43°C)	24 fl oz	750.0 ml
Metol	44 grains	3.0 grams
*Sodium sulfite	1 oz 292 grains	50.0 grams
Water to make	32 fl oz	1.0 liter

*Add a pinch of the total sulfite, dissolve the metol completely, then add the remainder of the sulfite.

Solution B

Water (110°F/43°C)	24 fl oz	750.0 ml
Borax	73 grains	5.0 grams
Sodium sulfite	1 oz 292 grains	50.0 grams
Water to make	32 fl oz	1.0 liter

RECOMMENDED DEVELOPMENT TIMES:
Solution A—3 minutes
Solution B—3 to 5 minutes

Agitate continuously in Solution A for the first 60 seconds, then for 5 seconds every 30 seconds thereafter. Agitate continuously in Solution B. Alternately, agitate continuously in both solutions.

After development the film should be fixed and washed in the usual manner.

Formula #5

General Purpose Divided Developer

Solution A

Water (125°F/52°C)	24 fl oz	750.0 ml
Metol	25.6 grains	1.8 grams
Sodium sulfite	1 oz 234 grains	46.0 grams
Sodium bisulfite	134 grains	9.2 grams
Hydroquinone	87.6 grains	6.0 grams
Potassium bromide	12 grains	0.8 grams
Water to make	32 fl oz	1.0 liter

Solution B

Water (90°F/32°C)	24 fl oz	750.0 ml
Sodium sulfite	1 oz 234 grains	46.0 grams
Borax, granular	1 oz	30.0 grams
Water to make	32 fl oz	1.0 liter

Develop all films for 3 minutes in Solution A and 3 minutes in Solution B. Leaving the film longer in Solution A will increase the contrast. Solution A will last indefinitely; Solution B should be discarded after 20 rolls of film.

Formula #6

Reichner's Divided Developer

Solution A

Distilled water (125°F/52°C)	24 fl oz	750.0 ml
Metol	26 grains	1.8 grams
Sodium sulfite	3 oz 146 grains	100.0 grams
Sodium bisulfite	350 grains	24.0 grams

Hydroquinone	73 grains	5.0 grams
Benzotriazole	17.5 grains	1.2 grams
Phenidone	10 grains	0.7 grams
Distilled water to make	32 fl oz	1.0 liter

Solution B

Balanced Alkali	1½ oz 73 grains	50.0 grams
Sodium sulfite	2½ oz 80 grains	80.0 grams
*Potassium iodide, 0.1% solution	146 grains	10.0 ml
Potassium bromide	7.3 grains	0.5 grams
Water to make	32 fl oz	1.0 liter

*A 0.1% solution of potassium iodide can be made by dissolving 1 gram in water to make 1 liter.

Develop conventional films (e.g., Kodak Tri-X) for 3 minutes in each solution; do not rinse in between. Develop T-grain films for 4 minutes in each bath. Use continuous agitation in both baths to avoid uneven development.

CAPACITY: Approximately 25 rolls of 35mm or 120 film, if Solution A is not contaminated by Solution B. Both baths should be filtered if precipitation or cloudiness occurs.

NOTE: This formula may cause dichroic fog on some modern films. Testing is advised.

Formula #7

H. Stoeckler's Fine-Grain Divided Developer

This developer is a hybrid of Kodak D-23 and Kodak D-25.

Solution A

Metol	73 grains	5.0 grams
Sodium sulfite	2 oz 292 grains	80.0 grams
Sodium bisulfite	292 grains	20.0 grams
Water to make	32 fl oz	1.0 liter

Solution B

Borax	146 grains	10.0 grams
Water to make	32 fl oz	1.0 liter

DEVELOPMENT TIMES:

Films rated to ISO 80: 3 minutes in Solution A, 3 minutes in Solution B.

Films rated from ISO 100 to 320: 4 minutes in Solution A, 3 minutes in Solution B.

Films rated higher than ISO 320: 6 minutes in Solution A, 3 minutes in Solution B.

Formula #8

D175 Tanning Developer

Solution A

Pyrogallol	58.4 grains	4.0 grams
Sodium sulfite	73 grains	5.0 grams
Water to make	32 fl oz	1.0 liter

Solution B

Sodium carbonate, anhydrous	409 grains	28.0 grams
Water to make	32 fl oz	1.0 liter

Mix equal parts Solutions A and B immediately before use. Development time is between 5 and 8 minutes.

Formula #9

Maxim Muir's Pyrocatechin Compensating Developer

This developer is primarily used to retain detail in extremely high values—in Zone System parlance, Zone IX and higher.

Solution A

Water	8 fl oz	250.0 ml
Sodium metabisulfite	146 grains	10.0 grams
Pyrocatechin	1 oz 146 grains	40.0 grams
Water to make	16 fl oz	500.0 ml

Solution B

Sodium hydroxide	146 grains	10.0 grams
Cold water to make	3.2 fl oz	100.0 ml

Do not mix too much of Solution B, as it has a short shelf life.

Mix 2 parts A, 1 part B, and 200 parts water (a 500.0 ml working solution equals 5.0 ml A, 2.5 ml B, and 500.0 ml of water).

Presoak the film for 2 to 5 minutes in plain water, water with ½ teaspoon of borax per liter, or water with Edwal's LFN added per directions.

Development time is approximately 6 to 8 minutes at 70°F/21°C, with slow-speed films. Constant agitation is recommended.

CAUTION: Cold water should always be used when dissolving sodium hydroxide because considerable heat is generated. If hot water is used, the solution will boil with explosive violence and may result in serious burns. If the water is not cold enough, the solution may start to steam. If this should occur, add some ice to cool the solution. DO NOT BREATHE THE VAPOR. If it starts to steam and you cannot get it to cool, leave the room until it is cool.

The best method to mix a solution of sodium hydroxide, is to measure out the amount to be used, place it in a dry glass or plastic mixing container, and slowly add cold water.

Wear a dust mask, gloves, and goggles when working with the powder and solutions.

For further contractions (N-2, N-3), Maxim Muir recommends an alternative Solution B.

Water	12 fl oz	375.0 ml
Sodium carbonate, monohydrate	1 oz 292 grains	50.0 grams
Water to make	16 fl oz	500.0 ml

For N-2 contractions, use 1 part A, 4 parts B, 100 parts water (a 500.0 ml solution equals 5 grams of A, 20 grams of B, 500 ml of water). Develop for approximately 8 minutes at 70°F/21°C with slow-speed films.

For N-3 contractions, use 1 part A, 2 parts B, 100 parts water (a 500 ml solution equals 5 grams of A, 10 grams of B, 500.0 ml of water). Develop for approximately 8 minutes at 70°F/21°C with slow-speed films.

This formula is especially effective with slow-speed films, which are hard to contract as development times are usually too short to modify. However, it is also effective with faster films.

NOTE: N-2 and N-3 development will cause a loss of film speed and compress the midtones.

Formula #10

Windisch Extreme Compensating Developer

This developer is primarily used to retain definition in negatives with extreme high values.

Hans Windisch published two dilutions for this formula. They are almost always given as stock solutions. Here they are both given as working solutions—do not dilute for use. Development times should be approximately the same for either dilution. This developer works best with slow and medium speed films.

Dilution A

Distilled water (125°F/52°C)	24 fl oz	750.0 ml
Sodium sulfite	4.4 grains	0.3 grams
Pyrocatechin	29 grains	2.0 grams
Sodium hydroxide, 10% solution	.48 fl oz	15.0 ml
Distilled water to make	32 fl oz	1.0 liter

OR

Dilution B

Distilled water (125°F/52°C)	24 fl oz	750.0 ml
Sodium sulfite	7.3 grains	0.5 grams
Pyrocatechin	47 grains	3.2 grams
Sodium hydroxide, 10% solution	2½ fl drams	10.0 ml
Distilled water to make	32 fl oz	1.0 liter

Use either Dilution A or B undiluted. Develop for 12 to 15 minutes at 68°F/20°C.

NOTE: This formula produces a stain, such as found with pyrogallol developers, which increases the printing contrast. Do not try to evaluate negative densities without printing.

CAUTION: Cold water should always be used when dissolving sodium hydroxide because considerable heat is generated. If hot water is used, the solution will boil with explosive violence and may result in serious burns. If the water is not cold enough, the solution may start to steam. If this should occur, add some ice to cool the solution. DO NOT BREATHE THE VAPOR. If it starts to steam and you cannot get it to cool, leave the room until it is cool.

The best method to mix a solution of sodium hydroxide is to measure out the amount to be used, place it in a dry glass or plastic mixing container, and slowly add cold water.

Wear a dust mask, gloves, and goggles when working with the powder and solutions.

Fine-Grain Developers—Grain Reduction

Formula #11

Kodak D-23

This is a semi-compensating developer that produces fine shadow values while retaining a high emulsion speed.

Water (125°F/52°C)	24 fl oz	750.0 ml
Metol	¼ oz	7.5 grams
Sodium sulfite	3 oz 146 grains	100.0 grams
Water to make	32 fl oz	1.0 liter

STARTING POINTS FOR DEVELOPING TIMES AT 68°F/20°C, UNDILUTED:

ISO 100 Films—5½ minutes

ISO 200 Films—6½ minutes

ISO 400 Films—8 minutes

Diluted 1:3, development times are longer, resulting in full midtones and lower contrast. Try tripling the times previously determined for the full-strength developer.

NOTE: This developer produces negatives of speed and graininess comparable to Kodak D-76, without D-76's tendency to block highlights. Its low alkalinity and high salt content, as well as its low fogging propensity, make it suitable for use up to 85°F/29°C. At temperatures above 75°F/24°C use stop-bath Kodak SB-4 Tropical Hardener Bath between development and fixing.

NOTE: D-23 may be replenished with Balanced Alkali Replenisher.

NOTE: A white scum of calcium sulfite may occur on films processed in high-sulfite, low-alkalinity developers. This scum is soluble in acid stop baths and in fresh acid fixing baths, especially if the film is well agitated. It is slowly

soluble in wash water and may also be wiped or sponged off wet film, although light deposits may not be noticed until the film is dry. The nonswelling acid stop bath, Kodak SB-5 Nonswelling Acid Rinse Bath, is recommended for its removal.

NOTE: D-23 is one of the most versatile developers ever formulated. Having only two ingredients, it is simple to mix and with various modifications can be used over a wide range of situations.

D-23 can also be used as a water bath to manage extreme contrast. Be certain to allow enough exposure to ensure good shadow detail—usually at least one additional stop. The method is as follows:

1 minute: D-23 with constant agitation.

4 minutes: water without agitation.

1 minute: D-23 with constant agitation.

4 minutes: water without agitation.

1 minute: D-23 with constant agitation.

4 minutes: water without agitation.

After the last immersion in water, transfer the film directly to fixer.

Formula #12

Kodak D-25

This is a fine-grain developer with medium to low contrast. The grain is softer than the one produced by Kodak D-23. This formula was originally designed to produce fine grain with small format negatives. As with all fine-grain developers, except Crawley's FX 10, it will cause a loss of emulsion speed of at least one stop.

Water (125°F/52°C)	24 fl oz	750.0 ml
Metol	¼ oz	7.5 grams
Sodium sulfite	3 oz 146 grains	100.0 grams
Sodium bisulfite	½ oz	15.0 grams
Water to make	32 fl oz	1.0 liter

The average development time for roll films is about 13 minutes in a tank at 68°F/20°C.

NOTE: If it is not essential to obtain minimum graininess use half the quantity of sodium bisulfite.

This formula can also be used as a divided developer. To use as a two-solution developer try 4 minutes at 68°F/20°C in the formula just listed, followed by 3 minutes in a 2% borax solution. Use intermittent, gentle agitation in the first solution and gentle but continuous agitation in the second solution. This will prevent uneven development, especially with 120-roll film. For extremely contrasty light, increase exposure and shorten the time in the first solution.

Formula #13

Kodak Balanced Alkali Replenisher for D-23 and D-25

Water (125°F/52°C)	24 fl oz	750.0 ml
Metol	146 grains	10.0 grams
Sodium sulfite	3 oz 146 grains	100.0 grams
Balanced Alkali (Kodalk)	292 grains	20.0 grams
Water to make	32 fl oz	1.0 liter

For Kodak D-23, add 22 ml for each roll of 36-exposure 35mm or 120mm roll film, discarding some developer if necessary to keep the original volume.

For Kodak D-25, 45 ml of replenisher should be added for each roll of 120mm or 36-exposure 35mm roll film, for the first 12 rolls per liter. For the next 12 rolls per liter, add only 22 ml per roll. Loss of speed becomes apparent after 25 rolls. Discard the developer after 24 rolls have been processed.

General-Purpose Developers

Formula #14

Ansco 17

This is a Kodak D-76 variant that uses borax instead of sodium carbonate to obtain soft, slow, fine-grained development. The results are a somewhat coarser grain, but higher sharpness.

Water (125°F/52°C)	24 fl oz	750.0 ml
Metol	22 grains	1.5 grams
Sodium sulfite	2½ oz 80 grains	80.0 grams
Hydroquinone	45 grains	3.0 grams
Borax, granular	45 grains	3.0 grams
Potassium bromide	7½ grains	0.5 grams
Water to make	32 fl oz	1.0 liter

Use the same developing times as you would with Kodak D-76. As with D-76, this developer can be used 1:1 for sharper images with a slight increase in graininess.

Formula #15

Ansco 17a

Replenisher for Ansco 17.

Water (125°F/52°C)	24 fl oz	750.0 ml
Metol	32 grains	2.2 grams
Sodium sulfite	2½ oz 80 grains	80.0 grams

Hydroquinone	65 grains	4.5 grams
Borax, granular	½ oz 44 grains	18.0 grams
Water to make	32 fl oz	1.0 liter

Add ¼ to ½ oz of replenisher to Ansco 17 for each roll of 120mm or 36-exposure 35mm (or equivalent) film developed. Maintain the original volume of the developer, discarding some used developer if necessary. No increase in original developing time is necessary.

Formula #16

Ansco 47

This is a long-lived, clean-working formula. It is ideal for producing brilliant negatives in controlled lighting situations (i.e., studio) or for low-contrast landscapes.

Water (125°F/52°C)	24 fl oz	750.0 ml
Metol	22 grains	1.5 grams
Sodium sulfite	1½ oz	45.0 grams
Sodium bisulfite	15 grains	1.0 gram
Hydroquinone	45 grains	3.0 grams
Sodium carbonate, monohydrate	88 grains	6.0 grams
Potassium bromide	12 grains	0.8 grams
Water to make	32 fl oz	1.0 liter

For tank development, dilute 1:1 with water and develop for 8 to 12 minutes at 68°F/20°C. For tray development, use undiluted for 5 to 7 minutes at 68°F/20°C.

Formula #17

Ansco 47a

Replenisher for Ansco 47.

Water (125°F/52°C)	24 fl oz	750.0 ml
Metol	44 grains	3.0 grams
Sodium sulfite	1½ oz	45.0 grams
Sodium bisulfite	29 grains	2.0 grams
Hydroquinone	88 grains	6.0 grams
Sodium carbonate, monohydrate	¼ oz 65 grains	12.0 grams
Water to make	32 fl oz	1.0 liter

For every 80 square inches of film processed (one 36-exposure roll of 35mm film or one 120 roll) add 15 ml of undiluted replenisher and pour off any excess in order to maintain the initial volume. No increase in original developing time is necessary when replenisher is used.

NOTE: Replenisher is for undiluted Ansco 47 only.

NOTE: If you intend to use replenisher for this formula, follow the instructions for replenishing Kodak D-76, under Kodak D-76R.

Formula #18

Crawley's FX 37 for Tabular-Grain Films

This developer was specially formulated by Geoffrey Crawley for tabular and crystal grain films. However, according to Crawley it can be used for traditional films when "the finest grain is not the prime requirement."

Water (125°F/52°C)	24 fl oz	750.0 ml
Sodium sulfite	2 oz	60.0 grams
Hydroquinone	73 grains	5.0 grams
Sodium carbonate, anhydrous	73 grains	5.0 grams
Phenidone	7.3 grains	0.5 grams
Borax	36.5 grains	2.5 grams
Potassium bromide	7.3 grains	0.5 grams
Benzotriazole, 1% solution	1.6 fl oz	50.0 ml
Water to make	32 fl oz	1.0 liter

Dilute 1:3 to 1:5. The higher dilution will increase film speed.

DEVELOPING TIMES FOR 1:3 DILUTIONS AT 68°F/20°C:
Iford Delta 100—7.5 minutes

Ilford Delta 400—8 minutes

Ilford FP4+—4.5 minutes

Ilford HP5+—6.5 minutes

Kodak T-Max 100—8 minutes

Kodak T-Max 400—9 minutes

Kodak T-Max P3200—8 minutes

Kodak Plus-X—5.5 minutes

Kodak Tri-X—6 minutes

Kodak Verichrome Pan—8 minutes

Formula #19

D-76H

(Thanks to Grant Haist)

This formula is virtually indistinguishable from Kodak D-76 and can be used in exactly the same way, including the same development times. It has the advantage of costing less to make, being more "environmentally friendly," and being more stable than D-76 (see "General-Purpose Developers," chapter 5, Film Developers).

Water (125°F/52°C)	24 fl oz	750.0 ml
Metol	36.5 grains	2.5 grams
Sodium sulfite	3 oz 146 grains	100.0 grams
Borax	29 grains	2.0 grams
Water to make	32 fl oz	1.0 liter

Formula #20

Ilford ID-68

This is a general-purpose, fine-grain developer.

Water (125°F/52°C)	24 fl oz	750.0 ml
Sodium sulfite	2 oz 365 grains	85.0 grams
Hydroquinone	73 grains	5.0 grams
Borax	102 grains	7.0 grams
Boric acid	29 grains	2.0 grams
Potassium bromide	15 grains	1.0 gram
Phenidone	1.9 grains	0.13 grams
Water to make	32 fl oz	1.0 liter

Use undiluted; develop films for 8 to 10 minutes at 68°F/20°C.

Formula #21

Ilford ID-68R

Water (125°F/52°C)	24 fl oz	750.0 ml
Sodium sulfite	2 oz 365 grains	85.0 grams
Hydroquinone	117 grains	8.0 grams
Borax	102 grains	7.0 grams
Phenidone	3.2 grains	0.22 grams
Water to make	32 fl oz	1.0 liter

Add the replenisher to the developer tank so as to maintain the level of solution. Where the tank is in continuous use, a quantity of replenisher equal to that of the original developer may normally be added before the solution is discarded.

Formula #22

Ilford Microphen-type Developer

Microphen is a fine-grain PQ developer that produces an effective increase in film speed without a corresponding increase in graininess. Its high-speed-to-grain ratio permits a ½ stop increase without a change in grain pattern. For example, HP5+, rated by Ilford at ISO 400, can be rated at EI 650.

Water (125°F/52°C)	24 fl oz	750.0 ml
Sodium sulfite	3 oz 146 grains	100.0 grams
Hydroquinone	73 grains	5.0 grams
Borax, granular	44 grains	3.0 grams
Boric acid, granular	51 grains	3.5 grams
Potassium bromide	15 grains	1.0 gram
Phenidone	3 grains	0.2 grams
Water to make	32 fl oz	1.0 liter

Use undiluted and develop for 4½ to 6 minutes at 68°F/20°C. Microphen can also be diluted 1:1 (8 to 11 minutes) or 1:3 (14 to 21 minutes). The greater the dilution, the greater the acutance and tonal scale. Diluted developers work best for retaining shadow and highlight details in subjects possessing a full tonal range.

Microphen is especially good for developing T-Max 100 copy negatives of full-scale black-and-white prints for reproduction. Make initial tests using Microphen 1:2 with a development time of 6 minutes at 72°F/22°C.

Formula #23

Kodak D-76

This developer is good for low contrast and maximum shadow detail. The commercial product, marketed by Kodak, is the world's best-selling black-and-white developer. It contains a number of additional chemicals in order that it may be sold as a single package (so that the metol will not deteriorate in the presence of the sulfite, and so that it will mix easily in all types of hard and soft water, etc.).

Ilford markets a formula in two packages, separating the metol from the sulfite, under the name ID-11. This eliminates some, though not all, of the extra chemicals found in the Kodak variety and makes for a better developer.

Many photographers feel that the original formula, as given here without the "extras," is superior to the commercial product. This means mixing the formula from "scratch," which is easy to do.

Water (125°F/52°C)	24 fl oz	750.0 ml
Metol	29 grains	2.0 grams
Sodium sulfite	3 oz 146 grains	100.0 grams
Hydroquinone	73 grains	5.0 grams
Borax	29 grains	2.0 grams
Water to make	32 fl oz	1.0 liter

Dilute 1:1 and develop for 7 to 12 minutes at 68°F/20°C. Development times using D-76 are available from most film manufacturers.

NOTE: D-76 may be used undiluted, but there is no advantage in doing so. The negatives, while slightly finer grained, do not exhibit the same degree of sharpness or tonal scale.

DEVELOPING TIMES FOR 1:1 DILUTIONS AT 68°F/20°C:
Ilford Delta 100—14 minutes
Ilford Delta 400—9 minutes
Ilford FP4+—7.5 minutes
Ilford HP5+—11 minutes
Kodak T-Max 100—12 minutes
Kodak T-Max 400—12.5 minutes
Kodak Plus-X—7 minutes
Kodak Tri-X—10 minutes
Kodak Verichrome Pan—9 minutes

Formula #24

Kodak D-76R

This can be used as a replenisher for D-76.

Water (125°F/52°C)	24 fl oz	750.0 ml
Metol	44 grains	3.0 grams
Sodium sulfite	3 oz 146 grains	100.0 grams
Hydroquinone	¼ oz	7.5 grams
Borax	292 grains	20.0 grams
Water to make	32 fl oz	1.0 liter

For every 80 square inches of film processed (one 36-exposure roll of 35mm or one 120mm roll), add 30 ml of undiluted replenisher and pour off any excess to maintain the original volume. When the original volume of D-76 has been replaced by an equal volume of D-76R, the developer should be discarded. For example, 1 liter of D-76 should be discarded after it has been replenished with 1 liter of D-76R.

Replenisher is for undiluted D-76 only. Do not replenish D-76 that has been diluted for use.

Formula #25

Paul Lewis' Mytol

A film developer similar to Kodak XTOL. Like XTOL, this is a more "environmentally friendly" developer. Unlike XTOL, this formula uses readily available chemicals.

Water (80°F/27°C)	24 fl oz	750.0 ml
Sodium sulfite	2 oz	60.0 grams
*Sodium metaborate	58.4 grains	4.0 grams
**Sodium ascorbate	175 grains	12.0 grams
Phenidone	2 grains	0.15 grams
Sodium metabisulfite	44 grains	3.0 grams
Water to make	32 fl oz	1.0 liter

*Kodalk can be substituted.
**Sodium Isoascorbate can be substituted.

Use as you would XTOL, or at 1:2 develop medium speed films for 8 to 13 minutes at 68°F/20°C.

Formula #26

Chris Patton's E-76

"Environmentally friendly" film developer similar to Kodak D-76.

Water (125°F/52°C)	24 fl oz	750.0 ml
Phenidone	2.9 grains	0.2 grams
Sodium sulfite	3 oz 146 grains	100.0 grams
Ascorbic acid	117 grains	8.0 grams
Borax	146 grains	10.0 grams
Cold water to make	32 fl oz	1.0 liter

Use as you would D-76.

High-Contrast Developers

Formula #27

Ansco 22

This formula is recommended for tray or tank development of cine title film and positive film to obtain high-contrast results.

Water (125°F/52°C)	24 fl oz	750.0 ml
Metol	11.7 grains	0.8 grams
Sodium sulfite	1 oz 146 grains	40.0 grams
Hydroquinone	117 grains	8.0 grams
Sodium carbonate, monohydrate	1 oz 292 grains	50.0 grams
Potassium bromide	73 grains	5.0 grams
Cold water to make	32 fl oz	1.0 liter

Do not dilute for use. Normal developing times are 5 to 8 minutes at 65°F/18°C.

Formula #28

Ilford ID-13

For line and screen negatives.

Stock Solution A

Water (125°F/52°C)	24 fl oz	750.0 ml
Potassium metabisulfite	365 grains	25.0 grams
Hydroquinone	365 grains	25.0 grams
Potassium bromide	365 grains	25.0 grams

Cold water to make	32 fl oz	1.0 liter

Stock Solution B

Sodium hydroxide	1 oz 292 grains	50.0 grams
Cold water to make	32 fl oz	1.0 liter

Mix equal parts of A and B immediately before use. The mixed solution has very poor keeping qualities and should be discarded immediately after using. With normal exposures, development is complete in 4 to 4½ minutes at 65°F/18°C.

CAUTION: Cold water should always be used when dissolving sodium hydroxide because considerable heat is generated. If hot water is used, the solution will boil with explosive violence and may result in serious burns. If the water is not cold enough, the solution may start to steam. If this should occur, add some ice to cool the solution. DO NOT BREATHE THE VAPOR. If it starts to steam and you cannot get it to cool, leave the room until it is cool.

The best method to mix a solution of sodium hydroxide is to measure out the amount to be used, place it in a dry glass or plastic mixing container, and slowly add cold water.

Wear a dust mask, gloves, and goggles when working with the powder and solutions.

Formula #29

Kodak D-19

This is a high-contrast developer with good keeping properties and high capacity. It is especially recommended for continuous-tone scientific and technical work that requires higher-than-normal contrast.

Water (125°F/52°C)	24 fl oz	750.0 ml
Metol	29 grains	2.0 grams
Sodium sulfite	3 oz	90.0 grams
Hydroquinone	117 grains	8.0 grams
Sodium carbonate, monohydrate	1¾ oz	52.5 grams
Potassium bromide	73 grains	5.0 grams
Water to make	32 fl oz	1.0 liter

Develop about 6 minutes in a tank or 5 minutes in a tray at 68°F/20°C.

Formula #30

Kodak D-19R

Replenisher for Kodak D-19.

Water (125°F/52°C)	24 fl oz	750.0 ml
Metol	65.7 grains	4.5 grams
Sodium sulfite	3 oz	90.0 grams
Hydroquinone	256 grains	17.5 grams
Sodium carbonate	1¾ oz	52.5 grams
Sodium hydroxide	¼ oz	7.5 grams
Cold water to make	32 fl oz	1.0 liter

Use this replenisher undiluted. After each 8 × 10" sheet of film or its equivalent is developed, add to the developer 25 ml of replenisher solution. The total volume of replenisher added should not exceed the original volume of the developer.

CAUTION: Cold water should always be used when dissolving sodium hydroxide because considerable heat is generated. If hot water is used, the solution will boil with explosive violence and may result in serious burns. If the water is not cold enough, the solution may start to steam. If this should occur, add some ice to cool the solution. DO NOT BREATHE THE VAPOR. If it starts to steam and you cannot get it to cool, leave the room until it is cool.

The best method to mix a solution of sodium hydroxide is to measure out the amount to be used, place it in a dry glass or plastic mixing container, and slowly add cold water.

It is a good practice to dissolve sodium hydroxide separately in a small amount of cold water, then add the solution after the developing agent has been dissolved, stirring vigorously.

Wear a dust mask, gloves, and goggles when working with the powder and solutions.

High-Definition Developers—Enhanced Acutance

Formula #31

Beutler's High-Definition Developer 105

Solution A

Water (125°F/52°C)	24 fl oz	750.0 ml
Metol	146 grains	10.0 grams
Sodium sulfite	1 oz 292 grains	50.0 grams
Water to make	32 fl oz	1.0 liter

Solution B

Water (125°F/52°C)	24 fl oz	750.0 ml
Sodium carbonate, anhydrous	1 oz 292 grains	50.0 grams
Water to make	32 fl oz	1.0 liter

Mix 1 part A, 1 part B, and 8 parts water. Develop for approximately 7 to 10 minutes at 68°F/20°C.

Formula #32

Crawley's FX 1

This developer was formulated for maximum acutance with conventional medium- and slow-speed films. It is not recommended for fast films or for tabular grain films.

Water (125°/52°C)	16 fl oz	500.0 ml
Metol	7.3 grains	0.5 grams
Sodium sulfite	73 grains	5.0 grams
Sodium carbonate, anhydrous	36.5 grains	2.5 grams
+Potassium iodide, .001%	1¼ fl drams	5.0 ml
Water to make	32 fl oz	1.0 liter

+To make a 0.001% solution of potassium iodide, add 1 gram to 1 liter of water. Take 100 ml of this solution and dilute to 1 liter. Again take 100 ml of this solution and dilute to 1 liter (this is equal to 1 mg per 100 ml).

Use undiluted. Developing time is between 7 to 14 minutes at 68°F/20°C. This developer may be diluted 1:3 for extremely contrasty scenes. Develop a test roll before committing important subjects.

Formula #33

Crawley's FX 2

This high-definition developer was formulated for a more pleasing pictorial gradation than FX 1 with only slightly less sharpness. Like FX 1, it works best with conventional grain medium- and slow-speed films.

Stock Solution A

Water (125°/52°C)	16 fl oz	500.0 ml
Metol	36.5 grains	2.5 grams
Sodium sulfite	1 oz 73 grains	35.0 grams
Glycin	¼ oz	7.5 grams
Water to make	32 fl oz	1.0 liter

Stock Solution B

Potassium carbonate, crystalline	1 oz 219 grains	75.0 grams
Water to make	32 fl oz	1.0 liter

Stock Solution C

Pinacryptol yellow, 1:2000

Working solution: 100 ml A, 100 ml B, 3.5 ml C, water to make 1 liter. Development time for medium-speed films is 9 to 12 minutes at 68°F/20°C.

Formula #34

Ilford ID-60

Water (125°/52°C)	24 fl oz	750.0 ml
Sodium sulfite	292 grains	20.0 grams
Potassium carbonate	2 oz	60.0 grams
Glycin	½ oz	15.0 grams
Water to make	32 fl oz	1.0 liter

Dilute 1:7 and develop for about 12 minutes in a tray or 15 minutes in a tank at 68°F/20°C.

Formula #35

Rodinal-type Developer

This formula is very similar to the original Agfa Rodinal. Rodinal is the oldest proprietary formula in use today, the original formula dating back to the 1880s. It is considered by some to be the finest all-around film developer, even for modern T-grain films.

Solution A

Water (125°F/52°C)	24 fl oz	750.0 ml
p-Aminophenol hydrochloride	3 oz 146 grains	100.0 grams
*Potassium metabisulfite	10 oz	300.0 grams
Water to make	32 fl oz	1.0 liter

*Although it is usually acceptable to substitute sodium metabisulfite for potassium metabisulfite, it is not recommended in this formula.

Solution B

Sodium hydroxide	6 oz 292 grains	200.0 grams
Cold water	13 fl oz	400.0 ml

Mix solution A and allow to cool before adding Solution B. A precipitate of p-aminophenol hydrochloride will form. Place Solution A in an iced water bath and, with continuous mixing, slowly add 280 ml of Solution B. Then very slowly add additional Solution B until a sudden darkening in color takes place. Finally, add, drop-by-drop, Solution B until only a few crystals remain.

If this is done properly, the remaining crystals will dissolve in the working solution. In time, the developer will turn dark brown. However, the unused stock solution will last for several years.

This formula can be used at dilutions ranging from 1:25 to 1:100. Developing times published for Agfa Rodinal can be used as a starting point.

CAUTION: Cold water should always be used when dissolving sodium hydroxide because considerable heat is generated. If hot water is used, the solution will boil with explosive violence and may result in serious burns. If the water is not cold enough, the solution may start to steam. If this should occur, add some ice to cool the solution. DO NOT BREATHE THE VAPOR. If it starts to steam and you cannot get it to cool, leave the room until it is cool.

The best method to mix a solution of sodium hydroxide is to measure out the amount to be used, place it in a dry glass or plastic mixing container, and slowly add cold water.

Wear a dust mask, gloves, and goggles when working with the powder and solutions.

Low-Contrast Developers—For High-Contrast Films

Formula #36

Burton 195

(Thanks to Björn Burton)

For Kodak Technical Pan film.

Water (125°F/52°C)	24 fl oz	750.0 ml
Metol	15 grains	1.0 gram
Sodium sulfite	146 grains	10.0 grams
Borax	29 grains	2.0 grams
Boric acid	15 grains	1.0 gram
Water to make	32 fl oz	1.0 liter

Use *undiluted. Expose Tech Pan at EI 25 and develop for 6 minutes at (68°F/20°C) with continuous agitation.

*Although not recommended by Mr. Burton, try using this formula 1:1 for 9 to 12 minutes.

This formula was submitted by Bjorn Burton (http://bjornburton.org) along with an explanation of how he came up with it. His method is the classical "cookbook method," which I like to promote and encourage you to use. Some of the greatest formulas have been devised in this way. I feel his full commentary is worth reading.

I came up with this formula empirically in January of 1995. At first I had no idea how to treat this film (Tech Pan) so I started (blindly) with D-76. I had just a bit of a contrast problem so I dropped the hydroquinone, and diluted it quite a bit, and got an improvement. I still didn't have much in the shadows, so I dropped the bromide and reduced the sulfite down to strictly preservative levels; no change. I diluted it even more and added some boric acid to push the pH a little lower (around 8.5, I think). I continued making small adjustments in chemistry and time until I was satisfied. These things remained constant throughout: temperature, agitation (continuous inversion, 1-second cycle), 120 film size, and the 500cc stainless tank.

A friend told me I should come up with a name, so I used my name along with the month and year. I made test exposures with my Speed Graphic (circa 1934) and used a Luna N100 and a little contact printer as a densitometer, but I think my gamma measurement was close.

Formula #37

POTA

This formula was originally designed to record nuclear blasts on conventional films. It is capable of recording light over a 20-stop range. With modern films, the results are low in contrast. However, with films such as Kodak Technical Pan, it produces a full gray tonal scale.

Water (185°F/85°C)	24 fl oz	750.0 ml
Sodium sulfite	1 oz	30.0 grams
Phenidone	22 grains	1.5 grams
Water to make	32 fl oz	1.0 liter

Use undiluted for 11½ to 15 minutes in a tank or 6½ to 8 minutes in a tray at 68°F/20°C.

NOTE: Use this formula as soon as possible as the solution deteriorates quickly.

Formula #38

Special Developer for Kodak 2415 Technical Pan Film

Water (125°F/52°C)	24 fl oz	750.0 ml
Sodium sulfite	365 grains	25.0 grams
Phenidone	22 grains	1.5 grams
Edwal's Liquid Orthazite	½ dram	2.0 ml
Water	32 fl oz	1.0 liter

Develop for 15 minutes at 75°F/24°C. Immediately following development, soak for 3 minutes in a 1% Balanced Alkali solution, then for 30 seconds in a weak stop bath, and, finally, for 2 minutes in a rapid fixer with hardener.

NOTE: Expose Tech Pan at ISO 25 to 32 or ISO 12 with a red filter.

Formula #39

T/O XDR-4

Water (125°F/52°C)	24 fl oz	750.0 ml
Metol	15 grains	1.0 gram
*Potassium sulfite	365 grains	25.0 grams
Hydroquinone	15 grains	1.0 gram
+Potassium bicarbonate	146 grains	10.0 grams
Water to make	32 fl oz	1.0 liter

Use undiluted for 8 to 12 minutes at 68°F/20°C.

*20.0 grams of sodium sulfite can be substituted for potassium sulfite.
+10.0 grams of sodium bicarbonate (baking soda) can be substituted for potassium bicarbonate.

Low-Contrast Developers—For Panchromatic Films

Formula #40

Agfa 14

This is a metol-sulfite soft-working developer.

Water (125°F/52°C)	24 fl oz	750.0 ml
Metol	65.7 grains	4.5 grams
Sodium sulfite	2 oz 365 grains	85.0 grams
Sodium carbonate, monohydrate	17.5 grains	1.2 grams
Potassium bromide	7.3 grains	0.5 grams
Water to make	32 fl oz	1.0 liter

Use undiluted and develop from 10 to 20 minutes at 68°F/20°C.

Formula #41

Ilford ID-3

This formula takes advantage of the soft-working characteristics of metol.

Stock Solution A

Water (125°F/52°C)	24 fl oz	750.0 ml
Metol	175 grains	12.0 grams
Sodium sulfite	1 oz 292 grains	50.0 grams

Stock Solution B

Water (125°F/52°C)	24 fl oz	750.0 ml
Sodium carbonate, monohydrate	2 oz 394 grains	87.0 grams
Potassium bromide	29 grains	2.0 grams
Water to make	32 fl oz	1.0 liter

Mix 1 part A, 1 part B, and 6 parts water. Develop films approximately 1 minute in a tray or 5 minutes in a tank at 68°F/20°C.

Formula #42

Kodak D-8

Water	24 fl oz	750.0 ml
Sodium sulfite	3 oz	90.0 grams
Hydroquinone	1½ oz	45.0 grams
Sodium hydroxide	1¼ oz	37.5 grams
Potassium bromide	1 oz	30.0 grams
Water to make	32 fl oz	1.0 liter

Mix 2 parts of stock solution and 1 part of water.

CAUTION: Cold water should always be used when dissolving sodium hydroxide because considerable heat is generated. If hot water is used, the solution will boil with explosive violence and may result in serious burns. If the water is not cold enough, the solution may start to steam. If this should occur, add some ice to cool the solution. DO NOT BREATHE THE VAPOR. If it starts to steam and you cannot get it to cool, leave the room until it is cool.

The best method to mix a solution of sodium hydroxide is to measure out the amount to be used, place it in a dry glass or plastic mixing container, and slowly add cold water.

It is a good practice to dissolve sodium hydroxide separately in a small amount of cold water, then add the solution after the developing agent has been dissolved, stirring vigorously.

Wear a dust mask, gloves, and goggles when working with the powder and solutions.

Procedures for Processing Film in the +30°F/–1°C to +60°F/16°C Range with D-8.

1. Develop for the times given on the time-temperature development chart in Table 2.
2. Rinse in dilute acetic acid (Kodak SB-1 Nonhardening Stop Bath) about 1 minute.
3. Fix in rapid fixer for 1½ times the time required to clear, which should be approximately 4 minutes at 60°F/15°C or 8 minutes at 40°F/4°C.
4. Wash in running water for 30 minutes, or in four successive changes of water for 2 to 5 minutes each. Where water is scarce, these rinse baths may be saved, discarding the first bath each time, making the second bath the first, the third bath the second, the fourth bath the third, and employing a fresh fourth bath.
5. Air dry, or dry with heat if available. For more rapid drying, bathe in isopropyl alcohol or a good denatured alcohol for 1 to 2 minutes. The

film should then be dried without heat or opalescence will occur. Use of an 85% alcohol solution will eliminate opalescence, but drying will be slower.

6. If the solutions are likely to be subjected to freezing temperatures during storage, 25% of ethylene glycol should be added to the total volume of developer and the processing times doubled. The alcohol bath is imperative when there is danger of freezing during drying.

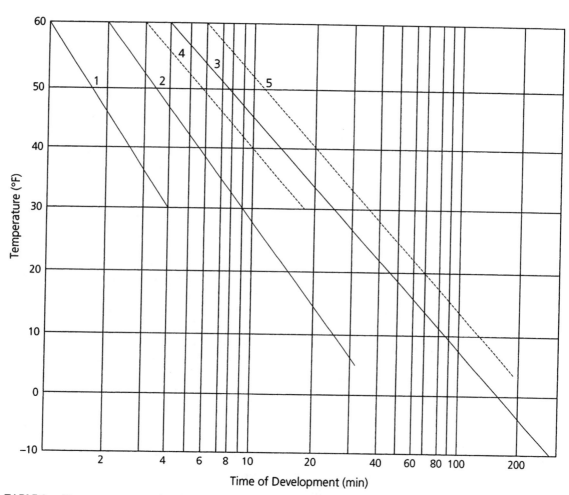

TABLE 2 *Time-temperature development chart for low-temperature developers. This chart shows time-temperature curves for low-temperature developers labeled as follows: (1) Kodak SD-22 Amidol-Pyrocatechin, no glycol; (2) Kodak SD-22, 25% glycol; (3) Kodak SD-22, 50% glycol; (4) Kodak D-8, no glycol; (5) Kodak D-8 + 25% glycol.*

Formula #43

Kodak D-82 + Caustic

This formula is similar to Kodak D-82 (not reproduced in this edition) with an increase in hydroxide and the addition of benzotriazole for low temperature processing.

Water (125°F/52°C)	16 fl oz	500.0 ml
Methyl (wood) alcohol	1½ fl oz	48.0 ml
Metol	204 grains	14.0 grams
Sodium sulfite	1 oz 329 grains	52.5 grams
Hydroquinone	204 grains	14.0 grams
Sodium hydroxide	257 grains	17.6
Potassium bromide	131 grains	9.0
Benzotriazole	3 grains	0.2 grams
Water to make	32 fl oz	1.0 liter

For temperatures down to +30°F/−1°C, use the above formula undiluted. For temperatures down to +5°F/−15°C, use 3 parts stock solution, 1 part ethylene glycol.

NOTE: The ethylene glycol should be added prior to storage at low temperatures.

CAUTION: Cold water should always be used when dissolving sodium hydroxide because considerable heat is generated. If hot water is used, the solution will boil with explosive violence and may result in serious burns. If the water is not cold enough, the solution may start to steam. If this should occur, add some ice to cool the solution. DO NOT BREATHE THE VAPOR. If it starts to steam and you cannot get it to cool, leave the room until it is cool.

The best method to mix a solution of sodium hydroxide is to measure out the amount to be used, place it in a dry glass or plastic mixing container, and slowly add cold water.

It is a good practice to dissolve sodium hydroxide separately in a small amount of cold water, then add the solution after the developing agent has been dissolved, stirring vigorously.

Wear a dust mask, gloves, and goggles when working with the powder and solutions.

Formula #44

Kodak SD-22 Amidol-Pyrocatechin

Solution A

Water (125°F/52°C)	16 fl oz	500.0 ml
Sodium bisulfite	3 oz 146 grains	100.0 grams
Amidol	1 oz 146 grains	40.0 grams
Pyrocatechin	1 oz 146 grains	40.0 grams
Benzotriazole	29 grains	2.0 grams
Water to make	32 fl oz	1.0 liter

Solution B

Water (125°F/52°C)	16 fl oz	500.0 ml
Sodium hydroxide	4 oz	120.0 grams
Potassium bromide	292 grains	20.0 grams
Potassium iodide	58 grains	4.0 grams
Water to make	32 fl oz	1.0 liter

For use down to +30°F/–1°C, mix 1 part Solution A, 1 part Solution B, and 2 parts water.

For use down to +5°F/–15°C, mix 1 part Solution A, 1 part Solution B, 1 part water, and 1 part ethylene glycol.

For use down to –40°F/–40°C, mix 1 part Solution A, 1 part Solution B, and 2 parts ethylene glycol.

NOTE: The glycol may be divided and added to each of these solutions before storing at low temperatures. Combine Solutions A and B immediately before use, since the mixed developer oxidizes rapidly. Solution A may also deteriorate on keeping and should be kept well-stoppered and as cool as possible.

CAUTION: Cold water should always be used when dissolving sodium hydroxide because considerable heat is generated. If hot water is used, the solution will boil with explosive violence and may result in serious burns. If the water is not cold enough, the solution may start to steam. If this should occur, add some ice to cool the solution. DO NOT BREATHE THE VAPOR. If it starts to steam and you cannot get it to cool, leave the room until it is cool.

The best method to mix a solution of sodium hydroxide is to measure out the amount to be used, place it in a dry glass or plastic mixing container, and slowly add cold water.

Wear a dust mask, gloves, and goggles when working with the powder and solutions.

Monobath Formulas

Formula #45

G.W. Crawley

Water	24 fl oz	750.0 ml
Sodium sulfite	1 oz 292 grains	50.0 grams
Phenidone	14.6 grains	1.0 grams
Hydroquinone	175 grains	12.0 grams
Sodium thiosulfate, pentahydrate	2¼-4 oz	70-125.0 grams
Sodium hydroxide	146 grains	10.0 grams
Water to make	32 fl oz	1.0 liter

To mix, add the Phenidone to the water, do not mix. Add a pinch of hydroquinone and place the rest aside. Add the remaining ingredients in the order given. Mix well to dissolve the Phenidone. Finally, add the remainder of the hydroquinone.

CAUTION: Cold water should always be used when dissolving sodium hydroxide because considerable heat is generated. If hot water is used, the solution will boil with explosive violence and may result in serious burns. If the water is not cold enough, the solution may start to steam. If this should occur, add some ice to cool the solution. DO NOT BREATHE THE VAPOR. If it starts to steam and you cannot get it to cool, leave the room until it is cool.

The best method to mix a solution of sodium hydroxide is to measure out the amount to be used, place it in a dry glass or plastic mixing container, and slowly add cold water.

It is a good practice to dissolve sodium hydroxide separately in a small amount of cold water, then add the solution after the developing agent has been dissolved, stirring vigorously.

Wear a dust mask, gloves, and goggles when working with the powder and solutions.

Formula #46

H.S. Keelan

Water	24 fl oz	750.0 ml
Sodium sulfite	1 oz 292 grains	50.0 grams
Phenidone	146 grains	10.0 grams
Hydroquinone	½ oz	15.0 grams
Sodium thiosulfate, pentahydrate	3 oz 292 grains	110.0 grams
Sodium hydroxide	263 grains	18.0 grams
Potassium alum	263 grains	18.0 grams
Water to make	32 fl oz	1.0 liter

To mix, add the Phenidone to the water, do not mix. Add a pinch of hydroquinone and place the rest aside. Add the remaining ingredients in the order given. Mix well to dissolve the Phenidone. Finally, add the remainder of the hydroquinone.

CAUTION: Cold water should always be used when dissolving sodium hydroxide because considerable heat is generated. If hot water is used, the solution will boil with explosive violence and may result in serious burns. If the water is not cold enough, the solution may start to steam. If this should occur, add some ice to cool the solution. DO NOT BREATHE THE VAPOR. If it starts to steam and you cannot get it to cool, leave the room until it is cool.

The best method to mix a solution of sodium hydroxide is to measure out the amount to be used, place it in a dry glass or plastic mixing container, and slowly add cold water.

It is a good practice to dissolve sodium hydroxide separately in a small amount of cold water, then add the solution after the developing agent has been dissolved, stirring vigorously.

Wear a dust mask, gloves, and goggles when working with the powder and solutions.

Formula #47

Kodak Research Lab

Water	24 fl oz	750.0 ml
Sodium sulfite	1 oz 292 grains	50.0 grams
Phenidone	58 grains	4.0 grams
Hydroquinone	175 grains	12.0 grams
Sodium thiosulfate, pentahydrate	3 oz 292 grains	110.0 grams
Sodium hydroxide	58 grains	4.0 grams
Water to make	32 fl oz	1.0 liter

To mix, add the Phenidone to the water, do not mix. Add a pinch of hydroquinone and place the rest aside. Add the remaining ingredients in the order given. Mix well to dissolve the Phenidone. Finally, add the remainder of the hydroquinone.

CAUTION: Cold water should always be used when dissolving sodium hydroxide because considerable heat is generated. If hot water is used, the solution will boil with explosive violence and may result in serious burns. If the water is not cold enough, the solution may start to steam. If this should occur, add some ice to cool the solution. DO NOT BREATHE THE VAPOR. If it starts to steam and you cannot get it to cool, leave the room until it is cool.

The best method to mix a solution of sodium hydroxide is to measure out the amount to be used, place it in a dry glass or plastic mixing container, and slowly add cold water.

It is a good practice to dissolve sodium hydroxide separately in a small amount of cold water, then add the solution after the developing agent has been dissolved, stirring vigorously.

Wear a dust mask, gloves, and goggles when working with the powder and solutions.

Formula #48

C. Orlando

Water	24 fl oz	750.0 ml
Metol	188 grains	12.9 grams
Sodium sulfite	2 oz 159 grains	70.9 grams
Hydroquinone	375 grains	25.7 grams
Sodium thiosulfate, pentahydrate	6 oz	180.0 grams
Sodium hydroxide	375 grains	25.7 grams
Benzotriazole	146 grains	10.0 grams
Water to make	32 fl oz	1.0 liter

CAUTION: Cold water should always be used when dissolving sodium hydroxide because considerable heat is generated. If hot water is used, the solution will boil with explosive violence and may result in serious burns. If the water is not cold enough, the solution may start to steam. If this should occur, add some ice to cool the solution. DO NOT BREATHE THE VAPOR. If it starts to steam and you cannot get it to cool, leave the room until it is cool.

The best method to mix a solution of sodium hydroxide is to measure out the amount to be used, place it in a dry glass or plastic mixing container, and slowly add cold water.

It is a good practice to dissolve sodium hydroxide separately in a small amount of cold water, then add the solution after the developing agent has been dissolved, stirring vigorously.

Wear a dust mask, gloves, and goggles when working with the powder and solutions.

Push-Processing Formulas

Formula #49

Crawley's FX 11

This formula produces at least a one-stop true speed increase with grain and sharpness similar to Kodak D-76.

Water (125°F/52°C)	20 fl oz	700.0 ml
Phenidone	3.7 grains	0.25 grams
Hydroquinone	73 grains	5.0 grams
Glycin	22 grains	1.5 grams
Sodium sulfite	4 oz 73 grains	125.0 grams
Borax	37 grains	2.5 grams
Potassium bromide	7.3 grains	0.5 grams
Water to make	32 fl oz	1.0 liter

The development times at 68°F/20°C are as follows:

Plus-X	7 minutes
Tri-X 35mm	7 minutes
Tri-X 120	8 minutes

Formula #50

Diafine-type

This formula gives a one-stop true speed increase, with grain and sharpness equivalent to Kodak D-76. This developer is panthermic, meaning it can be used at any temperature between 68°F/20°C and 80°F/28°C without altering the time.

Solution A

Water (125°F/52°C)	24 fl oz	750.0 ml
Sodium sulfite	1 oz 73 grains	35.0 grams
Hydroquinone	88 grains	6.0 grams
Phenidone	3 grains	0.2 grams
Sodium bisulfite	88 grains	6.0 grams
Water to make	32 fl oz	1.0 liter

Solution B

Water (125°F/52°C)	24 fl oz	750.0 ml
Sodium sulfite	2 oz 73 grains	65.0 grams
Borax	292 grains	20.0 grams
Water to make	32 fl oz	1.0 liter

Soak in the A bath for 3 minutes, then move to the B bath for 3 minutes without rinsing in between. Do not use a presoak.

NOTE: Do not use an acid stop bath. Use a water rinse for 30 seconds to 1 minute. A good fixer to use with this formula is Photographers' Formulary TF-4. See "Divided Development," chapter 5, Film Development.

Pyro Developers

Unless otherwise specified, mixing and development with pyro formulas should be carried out between 65°F/18°C and 70°F/21°C.

Formula #51

Bürki's Two-Solution Pyro Developer

(Thanks to Lawrence Cooper)

Solution A

Pyrogallol	½ oz	15.0 grams
Sodium bisulfite	½ oz	15.0 grams
Water to make	8 fl oz	250.0 ml

Solution B

Sodium carbonate, monohydrate	3 oz 146 grains	100.0 grams
Water to make	1.0 gallons	4.0 liters

Mix 1 part of Solution A to 19 parts of B, or as a percentage solution, use 5% A to 95% B to make the total volume (e.g., to make 1 liter of working solution, add 50 ml of A to 950 ml of B).

	Time	Agitation
T-Max 400 (EI 320)	6 minutes	5 inversions every 30 seconds
T-Max 100 (EI 100)	7 minutes	5 inversions every 30 seconds
Tri-X (EI 400)	7 minutes	5 inversions every 60 seconds

Formula #52

Focal Two-Solution Pyro Developer

This developer (from *Developing*, Jacobson and Jacobson, London: Focal Press, 1976) produces negatives with delicate gradation and good detail.

Solution A

Pyrogallol	1 oz 292 grains	50.0 grams
Potassium metabisulfite	73 grains	5.0 grams
Sodium sulfite	4 oz 73 grains	125.0 grams
Water to make	32 fl oz	1.0 liter

Solution B

Sodium carbonate, anhydrous	2 oz 219 grains	75.0 grams
Water to make	32 fl oz	1.0 liter

Mix 1 part A, 1 part B, and 4 parts water. Development time is 6 to 7 minutes at 68°F/20°C.

NOTE: Because the sulfite has been added to Solution A, this formula should be used within 30 days of mixing. Alternatively, the sulfite can be left out and approximately ½ gram per liter added just prior to mixing Solutions A and B.

Formula #53

Gordon Hutchings' PMK Formula

This is possibly the best pyro formula for modern emulsions. Formulated by Gordon Hutchings after many years of careful testing and research, PMK Formula is fully documented in *The Book of Pyro*. If you are interested in pyro, this book is a must read (see Bibliography).

Solution A

Water	24 fl oz	750.0 ml
Metol	146 grains	10.0 grams
Sodium bisulfite	292 grains	20.0 grams
Pyrogallol	3 oz 146 grains	100.0 grams
EDTA-disodium (optional)	73 grains	5.0 grams
Water to make	32 fl oz	1.0 liter

Solution B

Water	45 fl oz	1400.0 ml
Sodium metaborate	20 oz	600.0 grams
Water	64 fl oz	2.0 liters

Mix 1 part A to 2 parts B to 100 parts water (e.g., 10 ml of A to 20 ml of B to 1000 ml of water). Measure the water and then add the A and B solutions. Development times are between 9 and 15 minutes at 70°F/21°C.

NOTE: To help preserve the developing agents in Solution A, measure out the sodium bisulfite first and add a "pinch" to the water before the metol. Set the remainder of the bisulfite aside and add it in proper sequence.

NOTE: Sodium metaborate may be difficult to dissolve completely at room temperature, but any residual amount will dissolve by itself over a 24-hour period. The small amount of residual chemical is not enough to affect the solution activity even if it is used immediately.

NOTE: The addition of a "pinch" of amidol (approximately 0.5 grams), immediately prior to development, will increase the activity of the developer and create an apparent speed gain of ⅓ to ½ stop without altering development times. Gordon Hutchings calls this PMK+.

NOTE: PMK, unlike most other pyro developers, can be used at temperatures between 65°F/18°C and 80°F/26°C.

Formula #54

Kodak D-1, ABC Pyro

The classic pyro formula is known as "ABC" because it uses three stock solutions. There are several variations on ABC Pyro formulas and different opinions as to the ratio of the three ingredients.

ABC is one of the most difficult and fickle pyro formulas to use. It is usually recommended for large-format negatives, due to graininess. Used properly, the results obtained are unequaled, even by most other pyro formulas, in tonal gradation and subtle highlight separation.

Solution A

Water	24 fl oz	750.0 ml
Sodium bisulfite	140 grains	9.8 grams
Pyrogallic acid (pyro)	2 oz	60.0 grams
Potassium bromide	16 grains	1.1 grams
Water to make	32 fl oz	1.0 liter

Solution B

Water	32 fl oz	1.0 liter
Sodium sulfite	3½ oz	105.0 grams

NOTE: Sodium sulfite, in solution, will slowly change to sodium sulfate. The result, in an ABC Pyro formula, is decreased protection from aerial and auto-oxidation, leading to increased image and fog staining. This change is one of the leading reasons pyro developers have a reputation for being hard to control and unpredictable.

Gordon Hutchings recommends that Solution B not be mixed at all. Instead he suggests adding ⅓ to ½ gram of dry sulfite powder to each liter of the working solution, just before use. According to Hutchings, this will give a more consistent and predictable stain.

If you do mix Solution B in advance, use it within 30 days.

Solution C

Water	32 fl oz	1.0 liter
Sodium carbonate, monohydrate	3 oz	90.0 grams

NOTE: When mixing, do not use water over 80°F/27°C because that will cause oxidation of the pyro.

For tray development, the standard ABC formula calls for a dilution of 1 part each A, B, and C to 7 parts water (1:1:1:7). The resulting development time would then be between 5 and 7 minutes at 68°F/20°C.

Prepare everything in advance, combining the water and Solutions B and C in a tray. Then measure out the correct amount of Solution A and leave it where it can be easily found, without spilling, in the dark. Presoak the film in a separate tray of water in order to achieve more uniform development. (While not completely necessary, a drop or two of Edwal's LFN, or ¼ teaspoon of sodium metaborate dissolved in a liter of presoak water, will prevent the individual sheets of film from sticking together in the developer.) After 1 minute the film is lifted to drain. While it is draining, carefully pour the A solution into the waiting tray.

The standard dilution for tank development is different from that for tray development. The ratio is 1 part each of A, B, and C to 11 parts of water. Agitate every 30 seconds for 8 to 12 minutes at 65°F/18°C.

NOTE: Because of pyro's rapid rate of oxidation and tendency to stain, the three solutions should be combined at each developing session. Once combined, the formula should be used within a few minutes, as the developer rapidly loses activity. An alternative method is to mix the working solution fresh each time. The amounts for various dilutions of the working solution are given in *The Film Developing Cookbook.*

Before placing the film into the formula, all three solutions should be thoroughly mixed. Do not place the film in Solutions B and C and then pour A on top! A streak will appear across every sheet of film where the potent A solution first comes in contact.

Because of its tanning properties, pyro is self-hardening. It is not necessary to use fixers with hardener. If you wish to use an acid stop bath after the water rinse, a good fixer to use is Kodak F-24 Nonhardening Acid Fixer, otherwise, use plain running water and Photographer's Formulary TF-4 Fixer.

Film developed in ABC Pyro is subject to aerial oxidation, which is manifested as brown stains on the surface of the film. They are usually caused by oxidized developer, although excess silver sulfide in the developer or fixing bath can also be a cause. Oxidation occurs when the film is lifted from certain developers (i.e., pyro nearing exhaustion) and exposed to air during the shuffling process used to agitate films in tray development. Aerial stains can be removed with Kodak S-6 Stain Remover.

To avoid aerial staining during tray development, it is best to develop only one sheet at a time. While the developer is fresh, flip the negative two or three times to dislodge air bubbles, after which agitation should be continuous by rocking the tray only. Do not lift the negative from the developer until it is time to move it to a water rinse.

Aerial oxidation is not a problem with tank development for two reasons. The first is because of the volume of developer used. Deep tanks made for sheet film use either 1 or 3½ gallons of developer. Second, the surface-to-

volume ratio of developer exposed to air is proportionately small compared to that exposed in a tray. Development will be complete before the developer is either oxidized or exhausted to a point where it may cause aerial staining.

Ansel Adams' Variation
Ansel Adams had a slight variation to the traditional D-1 formula. While his solution A is identical to D-1, his B solution calls for 75 grams of sodium sulfite instead of 105 grams. His C solution calls for 87.75 grams of sodium carbonate monohydrate instead of 90 grams. The variation between 87.75 and 90 in the C solution is hardly important. The 30-gram variation in Solution B, the preservative, could possibly make a difference, in the life of the working solution and the overall sharpness to grain characteristics of the negative. It would probably not affect tonality.

Edward Weston's Variation
The main difference between standard ABC Pyro and Edward Weston's variation is the dilution ratio. Weston diluted the formula with 30 parts of water. The result was a softer working developer with an even fuller than usual tonal scale.

In order to keep the developing time within workable limits and to prevent complete exhaustion of the developing agent before development was complete, he increased the developer to 3 parts instead of one. His resulting dilution was 3:1:1:30, with a developing time of 15 to 20 minutes at 70°F with constant agitation in a tray.

Although aerial oxidation is still a problem, it does not appear to be as serious with Edward Weston's dilution since the amount of Solution A has been increased three times, allowing the process to be complete before the pyro reaches a point of exhaustion conducive to aerial staining.

Alternate Dilutions
Although ABC Pyro is not suitable for Zone System-style expansions or contractions, contrast can be controlled by altering the amount of stock Solution C (carbonate) used. Increasing the carbonate will increase contrast; decreasing will have the opposite effect. Popular dilutions to lower or raise contrast are either 1:1:½:7 or 1:1:1½:7, respectively (or 1:1:½:11 or 1:1:1½:11 for tanks). The carbonate can be increased or decreased even more. Some testing is recommended before developing important negatives.

NOTE: Increasing or decreasing carbonate to control contrast is accepted practice with many photographers. Photo chemist Bill Troop disagrees. He strongly recommends altering the developer concentration, Solution A, to achieve changes in contrast.

NOTE: As can be seen, raising and lowering carbonate (Solution C) or raising the developer (Solution A) are ways to control the results. However, do not lower the amount of developer (Solution A). A minimum of 1 part is needed to maintain the working strength of the formula throughout the development process.

Formula #55

Kodak SD-1 Pyro Stain Developer

This developer will produce an overall stain image. If more stain is desired, soak the negatives in the used developer for 2 to 3 minutes after fixing and before washing.

Water (68°F/20°C)	24 fl oz	750.0 ml
Sodium sulfite	20 grains	1.4 grams
Pyrogallol	40 grains	2.8 grams
Sodium carbonate, monohydrate	88 grains	6.2 grams
Water to make	32 fl oz	1.0 liter

Use undiluted. Develop medium speed films for about 6 minutes at 68°F/20°C, then rinse and fix in a plain hypo bath. (For more information on this formula, see "Paul Van Gelder on Pyro," chapter 8, Pyro Developers.)

Formula #56

Rollo Pyro (AB C+ Pyro)

(Thanks to Harald Leban)

Pyrogallol/Metol/Vitamin C/Kodalk film developer for rotary drum processing.

Part A

Distilled water	24 fl oz	750.0 ml
Sodium bisulfite	292 grains	20.0 grams
Metol	292 grains	20.0 grams
Pyrogallic acid	5 oz	150.0 grams
Ascorbic acid (Vitamin C)	146 grains	10.0 grams
Potassium bromide	22 grains	1.5 grams
EDTA tetrasodium	29–73 grains	2.0–5.0 grams
Distilled water to make	32 fl oz	1.0 liter

Part B

Distilled water	28 fl oz	900.0 ml
Sodium metaborate	10 oz	300.0 grams
EDTA tetrasodium	73 grains	5.0 grams
Distilled water	32 fl oz	1.0 liter

Working solution for 4 8 × 10" films:

10 ml Part A
20 ml Part B
500 ml Water

Normal developing times with continuous rotation in a JOBO Expert Drum at 68°F/20°C:

Film	EI	Time
FP4+	100	6.0
HP5+	400	6.5
BPF 200	200	6.0
T-Max 100	100	6.5

For more information on using this developer contact Harald Leban at hleban@1012surfnet.at

Superfine-Grain Developers—Extreme Grain Reduction

Formula #57

Crawley's FX 10

This is the only true superfine-grain developer known not to cause a loss of emulsion speed. It is very sensitive to overexposure and overdevelopment. This developer may very well prove useful with tabular grain films. Try diluting it 1:3.

Sodium sulfite	3 oz 146 grains	100.0 grams
*Kodak CD-2	¼ oz	7.5 grams
Hydroquinone	88 grains	6.0 grams
Borax	58 grains	4.0 grams
Boric acid, crystalline	58 grains	4.0 grams
Water to make	32 fl oz	1.0 liter

*Kodak CD-2 is N,N-diethyl-2-methyl-p-phenylenediamine, monohydrochloride; this is a p-phenylenediamine derivative used in color developers.

Develop films for approximately 5 to 11 minutes at 68°F/20°C.

If the fine-grain effect is found to be too great and dichroic fog results, the sulfite content can be lowered. Alternatively, the boric acid could be reduced, the borax increased, or both. Development times would be shorter.

If an even finer-grained effect is desired, with an inevitable loss in film speed, increase the boric acid and extend the development time. This would also increase the chance of dichroic fog.

NOTE: This formula was meant to be reused without replenishment to develop 6 to 7 rolls per liter. However, development time should be extended by about 5% each time it is used.

Formula #58

Edwal No. 12 Fine-Grain Developer

Water	24 fl oz	750.0 ml
Metol	90 grains	6.2 grams
Sodium sulfite	3 oz	90.0 grams
p-Phenylenediamine, base	150 grains	10.4 grams
Glycin	75 grains	5.1 grams
Water to make	32 fl oz	1.0 liter

Develop fine grain films for approximately 10 minutes at 68°F/20°C, fast films for 15 minutes.

Formula #59

Sease No. 3 Superfine-Grain Developer

This formula is reputed to give the finest possible grain. It reduces emulsion speeds somewhat, necessitating about a 3X increase in exposure.

Water (125°F/52°C)	24 fl oz	750.0 ml
Sodium sulfite	3 oz	90.0 grams
p-Phenylenediamine, base	146 grains	10.0 grams
Glycin	117 grains	8.0 grams
Water to make	32 fl oz	1.0 liter

Dissolve the chemicals separately, then mix. The glycin will dissolve after mixing. Filter the solution through a damp linen cloth. Development time, undiluted, is between 12 to 18 minutes at 68°F/20°C.

The glycin may be eliminated altogether or increased to 12 grams. The more glycin, the less speed loss, but the fine-grain effect decreases.

NOTE: Any grey coating remaining on the film after development can be removed by a 3% solution of Glacial Acetic Acid.

Formula #60

Windisch Superfine-Grain Developer

Water (125°F/52°C)	24 fl oz	750.0 ml
o-Phenylenediamine	175 grains	12.0 grams
Metol	175 grains	12.0 grams
Sodium sulfite	3 oz	90.0 grams
*Sodium metabisulfite	146 grains	10.0 grams
Water to make	32 fl oz	1.0 liter

*The formula as originally published by Hans Windisch calls for 10 grams of potassium metabisulfite, crystal.

Develop film for 12 to 13 minutes at 68°F/20°C.

Tropical Developers—High-Temperature Processing

For more information on tropical developers, especially development time tables for sulfated developers, Kodak D-76, and Kodak D-72, see "Tropical Developers," chapter 5, Film Development.

Formula #61

Agfa 16

Water (125°F/52°C)	24 fl oz	750.0 ml
Metol	88 grains	6.0 grams
Sodium sulfite	3 oz 146 grains	100.0 grams
Sodium carbonate, anhydrous	176 grains	12.0 grams
Potassium bromide	44 grains	3.0 grams
ADD SLOWLY TO AVOID CAKING:		
Sodium sulfate, anhydrous	1 oz 146 grains	40.0 grams
Water to make	32 fl oz	1.0 liter
DEVELOPING TIMES:		
65°F/18°C		9 to 11 minutes
75°F/24°C		6 minutes
85°F/29°C		3 minutes

Formula #62

Kodak DK-15

This is a nonblistering tropical developer.

Water (125°F/52°C)	24 fl oz	750.0 ml
Metol	80 grains	5.5 grams
Sodium sulfite	3 oz	90.0 grams
Balanced Alkali	¾ oz	22.5 grams
Potassium bromide	29 grains	2.0 grams
ADD SLOWLY TO AVOID CAKING:		
*Sodium sulfate, anhydrous	1½ oz	45.0 grams
Water to make	32 fl oz	1.0 liter

*If crystalline sodium sulfate is used, then 105 grams per liter should be used.

DEVELOPING TIMES:

Temperature	Tank Development (Intermittent Agitation)	Tray Development (Constant Agitation)
65°F/18°C	12½ minutes	10 minutes
70°F/21°C	10 minutes	8 minutes
75°F/24°C	8¼ minutes	6½ minutes
80°F/27°C	6¼ minutes	5 minutes
85°F/29°C	4¾ minutes	3¾ minutes
90°F/32°C	3¼ minutes	2½ minutes

Greater or lesser contrast may be obtained by developing for longer or shorter times than those specified.

NOTE: When development is completed, rinse the film in water for 1 or 2 seconds only and then immerse in Kodak SB-4 Tropical Hardener Bath for 3 minutes (omit the water rinse if the film tends to soften). Then fix for at least 10 minutes in an acid-hardening fixing bath, such as Kodak F-5 Hardening Fixer, and wash for 10 minutes in water (not over 95°F/35°C).

NOTE: When working below 75°/24°C, you may omit the sulfate for faster developing. Development time without the sulfate is 6 minutes at 68°F/20°C. Develop about 20% less for tray use.

NOTE: When working above 95°F/35°C use Kodak SH-5 Prehardener.

Formula #63

Kodak DK-15a

This is a low-contrast version of DK-15.

Water (125°F/52°C)	24 fl oz	750.0 ml
Metol	80 grains	5.5 grams
Sodium sulfite	3 oz	90.0 grams
Balanced Alkali	73 grains	5.0 grams
Potassium bromide	29 grains	2.0 grams
Add slowly to avoid caking:		
*Sodium sulfate, anhydrous	1½ oz	45.0 grams
Water to make	32 fl oz	1.0 liter

*If crystalline sodium sulfate is used, then 105 grams per liter should be used.

Developing time and procedures are identical to those given for DK-15.
NOTE: When working above 95°F/35°C use Kodak SH-5 Prehardener.

Paper Developers

As noted in the Preface, *The Darkroom Cookbook* is not meant to teach darkroom technique (i.e., printing controls). I highly recommend the use of *The Elements of Black-and-White Printing* by Carson Graves. Graves outlines procedures for testing papers and print developers, determining print tones,

additional methods for creating a print developer, and procedures for creating maximum black proof sheets and standard black-and-white reference patches. The latter is important for determining the existence, and level, of paper fog.

In addition, there are many other fundamental and advanced techniques for creating fine prints carefully considered in Graves' book.

Paper-Developing Agents

The primary developing agents often have a major effect on print color and gradation. Pyrocatechin is often used for warm tones. Glycin is favored for neutral tones and subtle gradations. Amidol is often used in cold-tone formulas.

However, as can be seen from the following formulas, there are no hard and fast rules. Agfa 108 is compounded with pyrocatechin, yet the addition of bromide, usually for warmer tones, causes it to become neutral to cold. Amidol is found in many neutral-tone formulas, and glycin is often used for warm tones.

Development Time

Paper may be developed over a wide range of times with varying results. Up to a point, the longer paper is developed, the richer the gradation and overall print quality. Exposure and dilution can be adjusted to allow development from 1 to 7 minutes. Less than 1 minute can result in stains, streaks, and uneven development. However, the changes that take place after 3 minutes are often slight, even though they can at times make a difference.

I recommend that you standardize on a $1\frac{1}{2}$ minute developing time for RC papers, and a 3 minute developing time for fiber-based papers; adjusting print exposure accordingly, for all developers. Once you have become familiar with the results, you can extend or shorten the time to suit individual images. One useful technique is to slightly underexpose the print and then extend development time about $\frac{1}{2}$ again more than you would normally use.

Unless otherwise specified, standard development time for all the paper developers can be considered to be $1\frac{1}{2}$ minutes for RC (i.e., 1 minute 20 seconds with a 10 second drain) and 3 minutes for fiber-based (2 minutes 50 seconds with a 10 second drain).

Methods of Manipulating Print Developers

None of the paper developers in this section is written in stone. Many of them were created by photographers, not unlike you, who were experimenting with various proportions of developing agents and alkali. Feel free to play with, and alter, any of the formulas. If your new brew gives you the tone/color, look, and feel you're after, great. If not, you may lose a few sheets of paper.

In chapter 4, Developers, and chapter 9, Paper Development, a number of methods for manipulating print developers to alter or enhance their characteristics are explained. One suggestion for anyone wishing to become a "chef" and alter or create new formulas is to break existing formulas down into proportionate amounts. This will give a clearer picture of the overall composition

and allow you to make considered changes. Be certain to always compare and modify working solutions, not stock solutions.

The following is a brief synopsis of some of the methods outlined in chapters 4 and 9.

Cold Tones

With MQ Developers
- Reduce the amount of bromide.
- Reduce the amount of bromide and add benzotriazole.

NOTE: Eliminating the bromide entirely, without replacing it by an antifoggant, may cause paper fog. To maintain an equivalent amount of fog reduction, substitute 0.2 grams of benzotriazole for every 1.0 gram of bromide. Because of the small amount of benzotriazole, the easiest way to accomplish this is by converting both amounts into percentage solutions. That is, mix a 2% solution of benzotriazole (2 grams per 100 ml) and a 10% solution of bromide (10 grams per 100 ml). Then, substituting 10.0 ml of 2% benzotriazole will give the same results as 1.0 ml of 10% bromide.

With PQ Developers
- Eliminate the bromide and replace it entirely with a 1% benzotriazole solution.
- Increase the benzotriazole content up to 15 ml of 1% solution per liter.
- Substitute Phenidone and benzotriazole for metol and bromide.

NOTE: The more benzotriazole used, the bluer the tone is likely to be. However, if there is too much benzotriazole paper development will be entirely suppressed.

Neutral Tones

- Eliminate or reduce the amount of bromide and/or substitute benzotriazole or Edwal's Liquid Orthazite.

Warm Tones

- Reduce the amount of sodium carbonate.
 NOTE: Too little carbonate will result in a flat, muddy print.

- Substitute potassium carbonate for sodium carbonate.
- Increase the amount of potassium bromide. Use a 10% bromide solution. Start with 1 to 4 ounces. After that, increase by 1 ounce until the tones suit you or fogging occurs.
- With the right paper and developer combination, increasing exposure and using shorter development times will enhance warm tones.
- Dilute fresh developer with up to 50% used developer. If you like warm tones in your images, keep a bottle of used developer on the shelf.

Cold-Tone Developers

Formula #64

Bürki and Jenny Cold-Tone Developer

Similar to Kodak D-72 and Defender 54-D, this formula produces a more pronounced blue-black on most papers.

Stock Solution A

Water (110°F/43°C)	24 fl oz	750.0 ml
Metol	44 grains	3.0 grams
Sodium sulfite	1 oz 146 grains	40.0 grams
Hydroquinone	175 grains	12.0 grams
Sodium carbonate, monohydrate	2½ oz	75.0 grams
Potassium bromide	12 grains	0.8 grams
Water to make	32 fl oz	1.0 liter

Stock Solution B

Benzotriazole, 1% solution

Dilute 1:2 and add between 6.0 ml and 15.0 ml of Stock Solution B per each liter of Stock Solution A used. The more benzotriazole, the greater the blue density. Develop for 2 minutes at 68°F/20°C.

Formula #65

Defender 54-D

The effects of this formula on paper color are subtle with most modern emulsions.

Water (110°F/43°C)	24 fl oz	750.0 ml
Metol	40 grains	2.7 grams
Sodium sulfite	1 oz 146 grains	40.0 grams
Hydroquinone	155 grains	10.6 grams
*Sodium carbonate, anhydrous	2½ oz	75.0 grams
Potassium bromide	12 grains	0.8 grams
Water to make	32 fl oz	1.0 liter

*If you use monohydrate carbonate, increase the quantity to 88.0 grams.

Dilute 1:2 to make a working solution with a normal development time of 2 minutes.

Formula #66

Kodak D-73

For blue-black tones on Kodak Azo paper.

Water (125°F/52°C)	16 fl oz	500.0 ml
Metol	40 grains	2.7 grams
Sodium sulfite	1 oz 140 grains	40.0 grams
Hydroquinone	155 grains	10.5 grams
Sodium carbonate, anhydrous	2½ oz	75.0 grams
Potassium bromide	12 grains	0.8 grams
Water to make	32 fl oz	1.0 liter

Dilute 1:2 and develop for 45 seconds or longer at 70°F/21°C.

Formula #67

Maxim Muir's Blue-Black Developer

This formula gives either blue-blacks or rich, neutral tones, depending upon the paper. It works best with bromide papers.

Water (125°F/52°C)	24 fl oz	750.0 ml
Sodium sulfite	6 oz	180.0 grams
Hydroquinone	1 oz 336 grains	53.0 grams
Phenidone	32 grains	2.2 grams
Benzotriazole	22 grains	1.5 grams

A white precipitate will form when the above ingredients are dissolved in the order shown. This is normal. Allow to cool to about 75°F/24°C, then, slowly and while stirring, gently add the following:

Sodium hydroxide	1 oz 73 grains	35.0 grams

This will clear or almost clear the solution. Then add:

Water to make	32 fl oz	1.0 liter

Dilute stock 1:5 with water. For less dramatic cool tones, dilute 1:10 or 1:15. The image will appear almost immediately after the print is put into the tray. Do not prematurely pull the print; develop for the full 2 minutes.

NOTE: The sodium hydroxide is not buffered, and, therefore, the solution loses activity after about 10 prints. However, the stock solution will keep for a month or more in a well-stoppered, amber glass bottle. A good way to make use of this formula is to mix up 1 liter, then dilute 250 ml of the stock with 1250 ml of water, make 10 prints, mix a fresh batch, and so on. Forty or more prints can be made in one session in this way.

NOTE: Altering the amount of benzotriazole will affect the level of fog and print tone.

CAUTION: Cold water should always be used when dissolving sodium hydroxide because considerable heat is generated. If hot water is used, the solution will boil with explosive violence and may result in serious burns. If the water is not cold enough, the solution may start to steam. If this should occur, add some ice to cool the solution. DO NOT BREATHE THE VAPOR. If it starts to steam and you cannot get it to cool, leave the room until it is cool.

The best method to mix a solution of sodium hydroxide is to measure out the amount to be used, place it in a dry glass or plastic mixing container, and slowly add cold water.

Wear a dust mask, gloves, and goggles when working with the powder and solutions.

High-Contrast Developers

Formula #68

Agfa 108

Water (125°F/52°C)	16 fl oz	500.0 ml
Metol	75 grains	5.0 grams
Sodium sulfite	1 oz 145 grains	40.0 grams
Hydroquinone	88 grains	6.0 grams
Sodium carbonate, monohydrate	1 oz 145 grains	40.0 grams
Potassium bromide	29 grains	2.0 grams
Water to make	32 fl oz	1.0 liter

Undiluted use a normal development time of 2 minutes. Longer development will increase the contrast even more.

NOTE: Potassium bromide, in this formula, will cause a slight green cast with some papers. 20.0 ml of Edwal's Liquid Orthazite can be substituted for the bromide.

Formula #69

Edwal 120

Solution A

Water (125°F/52°C)	16 fl oz	500.0 ml
Pyrocatechol	292 grains	20.0 grams
Sodium sulfite	1 oz 146 grains	40.0 grams
Water to make	32 fl oz	1.0 liter

Solution B

Water (125°F/52°C)	24 fl oz	750.0 ml
*Potassium carbonate, anhydrous	4 oz	120.0 grams
+Potassium bromide	15 to 44 grains	1.0 to 3 grams
Water to make	32 fl oz	1.0 liter

*134 grams of sodium carbonate monohydrate, can be substituted for a less warm tone.

+Potassium bromide is optional in this formula. Adding the minimum amount will yield a print of neutral tone; adding more will create an increasingly colder tone.

Mix 1 part of Solution A and 2 parts of Solution B with 1 part water.

Low-Contrast Developers

Formula #70

Agfa 105

Water (125°F/52°C)	24 fl oz	750.0 ml
Metol	44 grains	3.0 grams
Sodium sulfite	½ oz	15.0 grams
Potassium carbonate	½ oz	15.0 grams
Potassium bromide	6 grains	0.4 grams
Water to make	32 fl oz	1.0 liter

Use undiluted, with a normal development time of 1½ minutes.

Formula #71

Ansco 120 Soft-Working Paper Developer

This formula is similar to the commercially prepared Kodak Selectol-Soft.

Water (125°F/52°C)	24 fl oz	750.0 ml
Metol	¼ oz 70 grains	12.3 grams
Sodium sulfite	1 oz 88 grains	36.0 grams
Sodium carbonate, monohydrate	1 oz 88 grains	36.0 grams
Potassium bromide	27 grains	1.8 grams
Water to make	32 fl oz	1.0 liter

For normal use, dilute 1:1 to 1:2; normal development time is 2 minutes.
NOTE: This is an excellent formula for use in two-tray development, where the first tray is a soft developer and the second is either normal or high-contrast. For this application dilute as much as 1:4.

Formula #72

Defender 59-D Soft-Working Developer

This developer is for prints from contrasty negatives.

Water (125°F/52°C)	16 fl oz	500.0 ml
Metol	44 grains	3.0 grams
Sodium sulfite	1 oz 88 grains	36.0 grams

Sodium carbonate, monohydrate	307 grains	21.0 grams
Potassium bromide	58 grains	4.0 grams
Water to make	32 fl oz	1.0 liter

Use 1 part of stock solution to 3 parts water. Develop for 3 to 4 minutes at 68°F/20°C.

Formula #73

Gevaert G.253 Soft-Portrait Paper Developer

This is a warm-tone paper developer, similar to Kodak Selectol and D-52, tending to produce softer gradation than normal paper developers. It is useful for two-tray print development.

Water (125°F/52°C)	24 fl oz	750.0 ml
Metol	44 grains	3.0 grams
Sodium sulfite	292 grains	20.0 grams
Sodium carbonate, monohydrate	336 grains	23.0 grams
Potassium bromide	14.6 grains	1.0 gram
Water to make	32 fl oz	1.0 liter

This solution may be diluted with 1 part of water for increased time of development. Warmer tones may be obtained with the addition of potassium bromide, up to 4 grams.
Develop for 1 to 3 minutes at 68°F/20°C.

Neutral-Tone Developers

Formula #74

Agfa 100

For normal contrast with projection and contact printing papers. The formula, as given here, is in concentrated form. This is an economical formula to use.

Water (125°F/52°C)	24 fl oz	750.0 ml
Metol	44 grains	3.0 grams
Sodium sulfite	1 oz 131 grains	39.0 grams
Hydroquinone	131 grains	9.0 grams
Sodium carbonate, monohydrate	3 oz	90.0 grams
*Potassium bromide	44 grains	3.0 grams
Water to make	32 fl oz	1.0 liter

Dilute 1:2. Develop 1 to 2 minutes.

*Increase potassium bromide to 4.5 grams for improved luminosity.

Formula #75

Agfa 125

Water	16 fl oz	500.0 ml
Metol	44 grains	3.0 grams
Sodium sulfite	1½ oz	44.0 grams
Hydroquinone	175 grains	12.0 grams
Sodium carbonate, monohydrate	2 oz 73 grains	65.0 grams
Potassium bromide	29 grains	2.0 grams
Water to make	32 fl oz	1.0 liter

Dilute 1:2. Develop prints for 2 minutes.

Author's note: I used this formula for many years with the addition of 11 grams of glycin without realizing I had accidentally confused it with the Ansco 130 formula (below), which actually calls for glycin in that amount. In fact, I even published an article that mistakenly gave the formula with glycin. However, since I like the print tones, I continue to use it this way. Although this began as a "happy" accident, it is an example of the advantages of mixing your own.

Formula #76

Ansco 130

This is a versatile developer that is capable of beautiful gradation and print color. The tone will vary, depending upon the paper and adjustments made to the chemistry.

Water (125°F/52°C)	24 fl oz	750.0 ml
Metol	32 grains	2.2 grams
Sodium sulfite	1 oz 292 grains	50.0 grams
Hydroquinone	¼ oz 50 grains	11.0 grams
Sodium carbonate, monohydrate	2½ oz	78.0 grams
Potassium bromide	80 grains	5.5 grams
Glycin	¼ oz 50 grains	11.0 grams
Water to make	32 fl oz	1.0 liter

Normal dilution is 1:1 with water. For high contrast, use full strength; for low contrast, use 1:2 with water. The useful development range with bromide papers is 2 to 6 minutes. With chlorobromide papers it is 1½ to 3 minutes.

NOTE: The prepared stock solution is clear but slightly colored. The coloration does not indicate the developer has deteriorated.

Formula #77

Ansel 130, Ansel Adams' Variation

Ansel Adams created his own version of Ansco 130 by eliminating the hydroquinone and bromide and reducing the amount of sulfite. He would then add bromide as needed to prevent fog. If the contrast was too low, he added, as required, a solution of hydroquinone (given below). In addition to increasing the contrast, the hydroquinone would cause a cooling of the image tone. If a cooler image is desired, try adding a small amount of benzotriazole instead of, or in addition to, the bromide.

Stock Solution

Water (125°F/52°C)	24 fl oz	750.0 ml
Metol	32 grains	2.2 grams
Sodium sulfite	1 oz 73 grains	35.0 grams
Sodium carbonate, monohydrate	2 oz 263 grains	78.0 grams
Glycin	¼ oz 50 grains	11.0 grams
Water to make	32 fl oz	1.0 liter

Hydroquinone Solution

Water (125°F/52°C)	24 fl oz	750.0 ml
Sodium sulfite	365 grains	25.0 grams
*Sodium bisulfite	73 grains	5.0 grams
Hydroquinone	146 grains	10.0 grams
Water to make	32 fl oz	1.0 liter

*The sodium bisulfite is not in Adams' original formula. This is a recommendation made by Maxim Muir to buffer the hydroquinone solution.

To use, add as needed to the stock solution.

Formula #78

Dassonville D-1 Charcoal Black Paper Developer

Water	16 fl oz	500.0 ml
Metol	45 grains	3.0 grams
Sodium sulfite	1½ oz	43.0 grams
Hydroquinone	165 grains	11.0 grams
Sodium carbonate, monohydrate	1 oz 73 grains	35.0 grams
Potassium bromide	30 grains	2.0 grams
Add water to make	32 fl oz	1.0 liter

Dilute 1:1. Develop prints for 2 minutes.

Formula #79

Ilford ID-20

For neutral blacks with bromide paper.

Water	16 fl oz	500.0 ml
Metol	22 grains	1.5 grams
Sodium sulfite	365 grains	25.0 grams
Hydroquinone	88 grains	6.0 grams
Sodium carbonate, monohydrate	1 oz 73 grains	35.0 grams
Potassium bromide	29 grains	2.0 grams
Add water to make	32 fl oz	1.0 liter

Dilute 1:1. Develop prints for 2 minutes.

Formula #80

Kodak D-72

This developer is similar to Kodak Dektol.

Water (125°F/52°C)	24 fl oz	750.0 ml
Metol	45 grains	3.0 grams
Sodium sulfite	1½ oz	45.0 grams
Hydroquinone	175 grains	12.0 grams
Sodium carbonate, monohydrate	2 oz 290 grains	80.0 grams
Potassium bromide	30 grains	2.0 grams
Water to make	32 fl oz	1.0 liter

Dilution may vary from 1:1 to 1:4 depending upon the contrast and image tone desired. Normal dilution with chlorobromide papers is 1:2. For warmer tones, dilute 1:3 or 1:4 and add approximately 8 ml of 10% potassium bromide per liter. For higher contrast with bromide papers, dilute 1:1 and add 1 ml of 10% bromide per liter.

Useful development times are from 1½ to 3 minutes.

Formula #81

Chris Patton's E-72

"Environmentally friendly" Dektol-type developer substituting ascorbic acid for hydroquinone and Phenidone for metol.

Water (125°F/52°C)	24 fl oz	750.0 ml
*Phenidone	4.4 grains	0.3 grams
Sodium sulfite, anhydrous	1½ oz	45.0 grams
Ascorbic acid	277 grains	19.0 grams
Sodium carbonate, monohydrate	3 oz	90.0 grams

| Potassium bromide | 27.7 grains | 1.9 grams |
| Water to make | 32 fl oz | 1.0 liter |

Dilute 1:1 with water for high-contrast prints, 1:2 for less contrast, or 1:3 for normal contrast. 1:4 will give a low contrast print.

*3.0 grams of metol may be substituted for the Phenidone.

Toning Developers

Formula #82

Bürki and Jenny Toning Developer

This formula was compounded in 1943. It produces tones varying from brown to red-chalk on chlorobromide papers by direct development.

Solution A
Water (70°F/21°C)	24 fl oz	750.0 ml
Pyrocatechol	292 grains	20.0 grams
Sodium sulfite	3 oz 146 grains	100.0 grams
Potassium carbonate	3 oz 146 grains	100.0 grams
Potassium bromide	29 grains	2.0 grams
Water to make	32 fl oz	1.0 liter

Solution B
Ammonium sulfate, 2% solution
Normal Working Solution
Solution A	6.4 fl oz	200.0 ml
Solution B	8 fl oz	250.0 ml
Water	8 fl oz	250.0 ml

Expose the print so the desired density is reached in $2\frac{1}{2}$ minutes at 68°F/20°C.
To increase red-brown tones take equal parts of A and B. To increase cold brown tones decrease B, and for reddish tones increase B.

Formula #83

Dassonville D-3 Autotoning Developer

This formula is the same as Edwal 106 and Ansco 115.

Water (125°F/52°C)	16 fl oz	500.0 ml
Sodium sulfite	$2\frac{3}{4}$ oz	82.5 grams
Sodium carbonate, monohydrate	4 oz 263 grains	138.0 grams
Glycin	387 grains	26.5 grams
Hydroquinone	124 grains	8.5 grams
Potassium bromide	55 grains	3.7 grams
Water to make	32 fl oz	1.0 liter

For warm black tones, dilute with 3 parts water with bromide papers. For brown blacks, dilute with 7 parts of water and develop for 2 to 3 minutes with bromide and fast chlorobromide papers, and 4 to 6 minutes with slow chlorobromide papers.

At a dilution of 1:15, Dassonville D-3 produces tones known as "gravure-brown" on enlarging papers. At this dilution, develop for 3 to 5 minutes. The image should not begin to show for at least 1½ minutes.

With slow chlorobromide and contact papers, D-3 produces tones that vary from greenish brown to sepia and brick red and are beautiful in high-key work, where the predominate tones are lighter than middle gray. With fast chlorobromide papers, it produces delicate tones that are also exceptional for high-key images.

Formula #84

Gevaert G.262 Special Warm-Tone Paper Developer

Water (125°F/52°C)	24 fl oz	750.0 ml
Sodium sulfite	2 oz 146 grains	70.0 grams
Hydroquinone	365 grains	25.0 grams
*Potassium carbonate	3 oz	90.0 grams
Potassium bromide	30 grains	2.0 grams
Water to make	32 fl oz	1.0 liter

*For slightly less warm tones, 81.0 grams of sodium carbonate monohydrate, can be substituted for the potassium salt.

This is a special warm-color paper developer. The image color tends toward red as the dilution is increased or as development time is extended. Development times are between 1½ and 6 minutes. The relationship between image color and solution strength is as follows:

- Undiluted, the image will be brown-black.
- Diluted 1:2, the image will be brown.
- Diluted 1:4, the image will be brown-red.
- Diluted 1:6, the image will be red.

NOTE: A few papers will react in unusual and inconsistent ways to this developer.

Variable Contrast Developer

Formula #85

Beers Two-Solution Variable Contrast Developer

Solution A

Water (125°F/52°C)	24 fl oz	750.0 grams
Metol	117 grains	8.0 grams

Sodium sulfite	336 grains	23.0 grams
*Potassium carbonate	307 grains	21.0 grams
Potassium bromide, 10%	.35 fl oz	11.0 ml
Water to make	32 fl oz	1.0 liter

Solution B

Water (125°F/52°C)	24 fl oz	750.0 grams
Hydroquinone	117 grains	8.0 grams
Sodium sulfite	336 grains	23.0 grams
*Potassium carbonate	414 grains	28.4 grams
Potassium bromide, 10%	.7 fl oz	22.0 ml
Water to make	32 fl oz	1.0 liter

*Substituting sodium carbonate will give a more neutral print tone, and a more pleasing color with some papers. Use 23.4 grams and 31.5 grams, respectively, of monohydrate in place of the potassium salt.

Mix the stock solutions in the following proportions to give a progressive range of contrasts.

Contrast	Low		Normal			High	
Solution No.	1	2	3	4	5	6	7
Parts of A	8	7	6	5	4	3	2
Parts of B	0	1	2	3	4	5	14
Parts water	8	8	8	8	8	8	0

The lower contrast solutions can be diluted with water for even softer contrast. Use normal development times, 2 to 3 minutes, but agitate less.

Warm-Tone Developers

Formula #86

Agfa 120 Brown-Tone Paper Developer

Water (125°F/52°C)	24 fl oz	750.0 grams
Sodium sulfite	2 oz	60.0 grams
Hydroquinone	350 grains	24.0 grams
Potassium carbonate	2 oz 292 grains	80.0 grams
Water to make	32 fl oz	1.0 liter

This developer will produce a variety of brown to warm black tones on various papers, depending on dilution and exposure time.

Tone Desired	Exposure Time	Dilution	Development Time at 68°F/20°C
Warm-black	Normal	1:5	4-5 minutes
Brown-black	$1\frac{1}{2} \times$ longer than normal	1:4	3 minutes

Formula #87

Agfa 123 Brown-Tone Paper Developer

This is essentially the same as Agfa 120 Brown-Tone Developer with the addition of potassium bromide. It works well with slow chlorobromide and chloride papers.

Stock Solution

Water (125°F/52°C)	24 fl oz	750.0 ml
Sodium sulfite	2 oz	60.0 grams
Hydroquinone	350 grains	24.0 grams
Potassium carbonate	2 oz 292 grains	80.0 grams
Potassium bromide	365 grains	25.0 grams
Water to make	32 fl oz	1.0 liter

This developer produces tones ranging from brown-black to olive brown on Portriga Rapid paper, depending on dilution and exposure. The table below gives the typical development conditions for various tones with warm-tone chlorobromide papers.

Tone Desired	Exposure Time	Dilution	Development Time at 68°F/20°C
Brown-black	$2\frac{1}{2}$ × longer than normal	1:1	2 minutes
Neutral to Sepia	2 × longer than normal	1:4	5-6 minutes

Formula #88

Ansco 110 Direct Brown-Black Paper Developer

This developer can be used for either contact printing papers or chlorobromide papers.

Water (125°F/52°C)	24 fl oz	750.0 grams
Sodium sulfite	$1\frac{3}{4}$ oz 50 grains	57.0 grams
Hydroquinone	$\frac{3}{4}$ oz	22.5 grams
Sodium carbonate, monohydrate	$2\frac{1}{2}$ oz	75.0 grams
Potassium bromide	40 grains	2.75 grams
Water to make	32 fl oz	1.0 liter

Dilute 1:5. Give prints 3 to 4 times normal exposure and develop for 5 to 7 minutes at 68°F/20°C.

Formula #89

Ansco 135 Warm-Tone Paper Developer

This developer is recommended for rich, warm-black tones with contact printing papers.

Water (125°F/52°C)	24 fl oz	750.0 ml
Metol	24 grains	1.6 grams
Sodium sulfite	¾ oz 20 grains	24.0 grams
Hydroquinone	96 grains	6.6 grams
Sodium carbonate, monohydrate	¾ oz 20 grains	24.0 grams
Potassium bromide	40 grains	2.8 grams
Water to make	32 fl oz	1.0 liter

Use 1:1 and develop between 1½ and 2 minutes at 70°F/21°C.

For greater softness, dilute the above 1:1 dilution with an equal amount of water.

To increase the warmth, add bromide up to double the amount in the formula.

Formula #90

Catechol Copper-Tone Developer

Water (110°F/43°C)	24 fl oz	750.0 ml
Pyrocatechin	1 oz 292 grains	50.0 grams
Sodium sulfite	292 grains	20.0 grams
Potassium carbonate	1½ oz	45.0 grams
Potassium bromide	10 grains	0.7 grams
Water to make	32 fl oz	1.0 liter

Use 1:1 and develop between 1 and 2 minutes at 70°F/21°C. As mentioned earlier, the shorter the development time, the warmer the tone.

WARNING: Use gloves and other necessary precautions with all catechol paper developers.

Formula #91

Catechol Warm-Tone Developer

Water (110°F/43°C)	22 fl oz	700.0 ml
Pyrocatechin	58 grains	4.0 grams
Potassium carbonate	1½ oz	45.0 grams
Potassium bromide	6 grains	0.4 grams
Water to make	32 fl oz	1.0 liter

The developer should be used full strength at 100°F/38°C with exposure times greatly reduced from those used with normal developers. After development, the print is cooled in a water bath and then processed following normal procedures. This process works particularly well with Photographers' Formulary Fixer TF-4, which does not use an acid stop bath.

WARNING: Use gloves and other necessary precautions with all catechol paper developers.

Formula #92

Defender 55-D Professional Portrait Developer

Defender 55-D is a good choice for producing subtle, warm blacks. It also creates a beautiful tonal scale, with gentle gradations.

Water (125°F/52°C)	16 fl oz	500.0 ml
Metol	37 grains	2.5 grams
Sodium sulfite	1¼ oz	37.5 grams
Hydroquinone	146 grains	10.0 grams
*Sodium carbonate, anhydrous	1¼ oz	37.5 grams
+Potassium bromide	190 grains	13.0 grams
Water to make	32 fl oz	1.0 liter

*If sodium carbonate monohydrate is used, the quantity must be increased to 45.0 grams.
+The liberal use of potassium bromide is recommended, even in excess of the quantity indicated in the formula.

To use, take 1 part of stock solution and add 2 parts of water. For normal use, exposure should be adjusted to produce the desired contrast and tone when developed from 1½ to 2 minutes at 68°F/20°C.

Formula #93

DuPont 51-D

For warm black tones on slow chlorobromide and chloride papers. Neutral tones on bromide papers.

Water (125°F/52°C)	16 fl oz	500.0 ml
Metol	22 grains	1.5 grams
Sodium sulfite	¾ oz	22.5 grams
Hydroquinone	92 grains	6.3 grams
Sodium carbonate, monohydrate	256 grains	17.5 grams
Potassium bromide	22 grains	1.5 grams
Water to make	32 fl oz	1.0 liter

To use, dilute 1:1. For normal use, exposure should be adjusted to produce the desired contrast and tone when developed from 1½ to 2 minutes at 68°F/20°C.

Formula #94

Gevaert G.261 Brown-Black Paper Developer

Water (125°F/52°C)	24 fl oz	750.0 ml
Sodium sulfite	1 oz 146 grains	40.0 grams

Glycin	88 grains	6.0 grams
Hydroquinone	88 grains	6.0 grams
Sodium carbonate, monohydrate	1 oz 73 grains	35.0 grams
Potassium bromide	29 grains	2.0 grams
Water to make	32 fl oz	1.0 liter

Without dilution this developer will produce brown-black tones on papers in about 2 minutes at 68°F/20°C. Diluted 1:2, this developer produces brown tones in 4-8 minutes. Diluting 1:4, and developing 8 to 15 minutes, produces a red-brown tone. Diluting 1:6, and developing from 15 to 25 minutes, will produce a red tone. For still warmer tones, add 10 grams of sodium bicarbonate to each liter of the diluted developer.

Formula #95

Glycin Warm-Tone Developer

This formula is designed to give warm tones on bromide papers.

Water	20 fl oz	650.0 ml
Metol	12 grains	0.8 grams
Sodium sulfite	$2\frac{1}{2}$ oz	90.0 grams
Hydroquinone	115 grains	7.9 grams
Glycin	120 grains	8.2 grams
Sodium carbonate, monohydrate	$2\frac{1}{2}$ oz	90.0 grams
Potassium bromide	18 grains	1.25 grams

Dilute 1 part stock to 4 parts of water. Develop for $1\frac{1}{2}$ to 3 minutes. For warmer tones increase exposure and use shorter developing times. Increasing developing times gives colder tones.

Formula #96

Ilford ID-24

For Sepia to Bright Red Tones.

Water (125°F/52°C)	16 fl oz	500.0 ml
Sodium sulfite	1 oz 19 grains	31.3 grams
Hydroquinone	49.6 grains	3.4 grams
Sodium carbonate, monohydrate	1 oz 194 grains	43.3 grams
Potassium bromide	4.4 grains	0.3 grams
Glycin	49.6 grains	3.4 grams
Water to make	16 fl oz	500.0 ml

With increased exposure, greater dilution of developer, and more potassium bromide, the color produced ranges from sepia to bright red, as indicated in the following table. Development can be up to 30 minutes,

depending on the color desired. Using the solution at 80°F/27°C can speed up development.

Color	Exposure	Dilution of Developer	*Additional 10% Potassium Bromide	Approximate Development Time
Warm-black	Normal	Full strength	None	1½ minutes
Sepia	2× normal	5×	1.0 ml	5 minutes
Brown sepia	3× normal	10×	3.0 ml	10 minutes
Red-brown	4× normal	15×	5.0 ml	15 minutes
Red	5× normal	20×	6.0 ml	20 minutes

*Per 25 ml of stock solution used to make the working solution.

Normal exposure should be determined by first using Ilford ID-25 (next formula).

The quality of the negative plays an important part in the creation of warm tones by direct development. The best results are obtained from negatives of good contrast and printing density.

Formula #97

Ilford ID-25

MQ developer for warm-black tones.

Water (125°F/52°C)	24 fl oz	750.0 ml
Metol	15 grains	1.0 gram
Sodium sulfite	183 grains	12.5 grams
Hydroquinone	44 grains	3.0 grams
Sodium carbonate, monohydrate	157 grains	10.8 grams
Potassium bromide	44 grains	3.0 grams
Water to make	32 fl oz	1.0 liter

Dilute 1:1 and develop for 1½ to 2 minutes at 68°F/20°C. Colder or warmer tones can be obtained by considerably reducing or increasing the potassium bromide, up to ½ or double.

Formula #98

Kodak D-52 Selectol-type Developer

This formula is the same, or similar to, Kodak Selectol.

Water (125°F/52°C)	16 fl oz	500.0 ml
Metol	22 grains	1.5 grams
Sodium sulfite	¾ oz	22.5 grams
Hydroquinone	90 grains	6.0 grams

Sodium carbonate, monohydrate	248 grains	17.0 grams
Potassium bromide	22 grains	1.5 grams
Water to make	32 fl oz	1.0 liter

Dilute 1:1 and develop for about 2 minutes. More bromide may be added if warmer tones are desired. For a softer print, dilute 1:3. To increase the warmth, add bromide up to double the amount in the formula (this may cause a slight green cast with some papers).

Formula #99

Kodak D-74 Olive-Brown Tone Developer

For contact printing papers such as Kodak Azo.

Water	16 fl oz	500.0 ml
Metol	11.7 grains	0.8 grams
Sodium sulfite	350 grains	24.0 grams
Hydroquinone	64 grains	4.4 grams
Glycin	93 grains	6.4 grams
Sodium carbonate, anhydrous	175 grains	12.0 grams
Potassium bromide	32 grains	2.2 grams
Water to make	32 fl oz	1.0 liter

Dilute 1:1. Normal development time is $1\frac{1}{2}$ minutes at 70°F/21°C. As soon as development is complete, remove the print from the developer and rinse thoroughly in Kodak SB-1 Nonhardening Stop Bath before fixing. Glycin is slow in its action, and the time of development determines the tone of the print. Short development produces warm tones; longer development produces colder tones.

Formula #100

Kodak D-155 Very Warm Paper Developer

Water (125°F/52°C)	24 fl oz	750.0 ml
Metol	5.8 grains	0.4 grams
Sodium sulfite	321 grains	22.0 grams
Hydroquinone	58.4 grains	4.0 grams
Sodium carbonate, anhydrous	263 grains	18.0 grams
Potassium bromide	58.4 grains	4.0 grams
Glycin	38 grains	2.6 grams
Water to make	32 fl oz	1.0 liter

Dilute 1:1 to 1:4 for use. Brown-black to red-brown image tones.

Formula #101

Kodak D-166 Red-Brown Paper Developer

Water (125°F/52°C)	24 fl oz	750.0 ml
Metol	8.8 grains	0.6 grams
Sodium sulfite	183 grains	12.5 grams
Hydroquinone	61 grains	4.2 grams
Sodium carbonate, anhydrous	183 grains	12.5 grams
Potassium bromide	91 grains	6.2 grams
Water to make	32 fl oz	1.0 liter

Dilute 1:1 for use. Develop until the desired image tone is reached.

Formula #102

Pyro Warm-Tone Developer

Water at room temperature	10 fl oz	300.0 ml
Potassium metabisulfite	22 grains	1.5 grams
Sodium sulfite	1 oz	30.0 grams
Pyro	65 grains	4.4 grams
Sodium carbonate, monohydrate	1 oz.	30.0 grams
Potassium bromide	65 grains	4.4 grams
Water to make	24 fl oz	750.0 ml

Use full strength. Develop paper for not less than $1\frac{1}{2}$ minutes. Warmer tones are possible with longer exposure and shorter development (see "Image Color: Warm, Neutral, and Cold Tones," in chapter 9, Paper Development). This developer oxidizes rapidly and has a short tray life.

Formula #103

Sepia-Toned Paper Developer

(Thanks to Jim Carbone)

Water (125°F/52°C)	24 fl oz	750.0 ml
Sodium sulfite	2 oz	60.0 grams
Sodium carbonate, monohydrate	3 oz	90.0 grams
Glycin	365 grains	25.0 grams
Hydroquinone	117 grains	8.0 grams
Potassium bromide	30 grains	2.0 grams
Water to make	32 fl oz	1.0 liter

Dilute 1 part stock to 2 parts of water. Develop for a full 2 minutes. For warmer tones increase dilution.

Amidol Paper Developers

Notes on Amidol:

- Amidol works without an accelerator, or alkali.
- Varying the quantity of amidol affects the development time. As a rule, use a 3 minute standard development time for amidol developers, instead of the 2 minutes usually recommended with MQ and PQ developers.
- Varying the amount of sodium sulfite affects the keeping qualities of the solution.
- Amidol is not very sensitive to bromide, so the amount of bromide may be adjusted to ensure clear highlights without fogging.
- As a rule, amidol solutions do not keep well, so they should be mixed just before use.
- Blue-black tones can be increased by adding benzotriazole or Edwal's Liquid Orthazite. Bromide may be reduced or eliminated.
- Amidol, before mixing in solution, works best when it is fresh. Fresh amidol has a green cast. Old, oxidized amidol is gray or black. Old amidol will often be usable, but the results will be different from those obtained with a fresh batch, including longer development times. Old amidol also tends to stain prints more readily.
- To prevent staining of the borders and highlights of prints, use Kodak SB-8 Citric Acid Stop Bath or a plain running water bath. The Citric Acid Stop Bath exhausts quickly, so discard after about 10 to 12 8 × 10" prints.
- When mixing amidol formulas, use a mask, as the fine powder is easy to inhale.

Formula #104

Ansco 113

Water at room temperature	24 fl oz	750.0 ml
Sodium sulfite	1½ oz	44.0 grams
Amidol	96 grains	6.6 grams
Potassium bromide, 10%	.19 fl oz	6.0 ml
Water to make	32 fl oz	1.0 liter

Do not dilute. Develop for 1½ to 7 minutes, followed by a 30-second plain water rinse or a Citric Acid Stop Bath.

NOTE: The sulfite and bromide can be mixed as a stock solution and the amidol added just before use.

Formula #105

Amidol Paper Developer

Sodium sulfite	3 oz 146 grains	100.0 grams
Amidol	96 grains	6.6 grams
Potassium bromide	146 grains	10.0 grams
Water to make	32 fl oz	1.0 liter

This developer may be used in dilutions ranging from undiluted to 1:15, depending on the contrast desired. Developing times are from 1½ to 6 minutes, followed by a 30-second plain water rinse or a Citric Acid Stop Bath.

NOTE: This formula is similar to one suggested by David Lewis, a leading expert on amidol and bromoil. David recommends the use of 2.2 grams of amidol and a working dilution between undiluted and 1:3.

NOTE: The sulfite and bromide can be mixed as a stock solution and the amidol added just before use.

Formula #106

Amidol Teaspoon Formula

This famous "teaspoon" formula first appeared in *Practical Photography* No. 5 in 1935. It is a good developer for bromide and chloride papers and is often recommended for bromide enlargements that are intended for the bromoil process.

Water at room temperature	14 fl oz	500.0 ml
Sodium sulfite, 1 tablespoon	100 grains	6.8 grams
Amidol, 1 teaspoon	25 grains	1.7 grams
*Potassium bromide, ⅛ teaspoon	10 grains	0.7 grams

*Use more potassium bromide as needed.

Use undiluted or 1:1. Develop for 1½ to 2 minutes at 68°F/20°C.

Formula #107

Below's Amidol Paper Developer

This formula is claimed to have better keeping qualities in solution than other amidol formulas.

Water at room temperature	32 fl oz	1.0 liter
Metol	14.6 grains	1.0 gram
Sodium sulfite	1 oz	30.0 grams
Amidol	88 grains	6.0 grams
Potassium bromide	5.8 grains	0.4 grams

Dilute as needed to manipulate contrast. Development time, 2-4 minutes, followed by a 30-second plain water rinse or a Citric Acid Stop Bath.

Formula #108

Dassonville D-2

Water at room temperature	24 fl oz	750.0 ml
Sodium sulfite	467 grains	32.0 grams

Amidol	77 grains	5.3 grams
Potassium bromide	7 grains	0.5 grams
Water to make	32 fl oz	1.0 liter

Use at full strength. Develop for 2 minutes, followed by running water or a Citric Acid Stop Bath.

Formula #109

Defender 61-D

Water at room temperature	16 fl oz	500.0 ml
Sodium sulfite	225 grains	15.4 grams
Amidol	50 grains	3.8 grams
Potassium bromide	35 grains	2.5 grams
Water to make	32 fl oz	1.0 liter

Use at full strength. Develop for 2 minutes, followed by running water or a Citric Acid Stop Bath.

Formula #110

Ilford ID-22

For bromide papers.

Water at room temperature	32 fl oz	1.0 liter
Sodium sulfite	365 grains	25.0 grams
Amidol	88 grains	6.0 grams
Potassium bromide, 10% solution	.256 fl oz	8.0 ml

Use full strength. Develop about 2 minutes.
Reduce the bromide to $\frac{1}{4}$ of the amount given (2.0 ml) if this developer is to be used with a contact printing paper such as Kodak Azo. This variation is known as ID-30.

Formula #111

Lootens' Amidol Black Developer

Water at room temperature	24 fl oz	750.0 ml
Sodium sulfite	358 grains	24.5 grams
Citric acid	9 grains	0.6 grams
Amidol	118 grains	8.1 grams
Potassium bromide	9 grains	0.6 grams
*Potassium thiocyanate	4.4 grains	0.3 grams
Water to make	32 fl oz	1.0 liter

*Potassium thiocyanate is optional in this formula but highly recommended for truer black tones. If the potassium salt is not available, the sodium salt may be substituted.

Use at full strength. Develop for 1½ to 4 minutes, followed by running water or a Citric Acid Stop Bath.

The Westons' Amidol Developers

All three of the famous Westons—Edward, Brett, and Cole—used amidol paper developers for much, if not all, of their photographic careers. Each had his own variation. All three formulas are used undiluted and should be followed by running water or a Citric Acid Stop Bath.

Formula #112

Edward Weston's Amidol Paper Developer

Water at room temperature	40 fl oz	1140.0 ml
Sodium sulfite	1¼ oz	37.5 grams
Amidol	153 grains	10.5 grams
Potassium bromide, 10%	0.22 fl oz	7.0 ml
*"BB" solution (optional)	2 fl oz	60.0 ml

*BB solution was a proprietary formula that is no longer manufactured. It is believed to have been a 1% solution of benzotriazole.

Formula #113

Brett Weston's Amidol Paper Developer

Water at room temperature	3½ quarts	3.5 liters
Sodium sulfite	3 oz	90.0 grams
Amidol	1 oz 146 grains	40.0 grams
*Citric Acid		
10% potassium bromide	1 fl dram	4.0 ml

*Brett's formula calls for "a pinch"; the citric acid acts as an organic antifoggant, similar to benzotriazole. Use as needed.

Formula #114

Cole Weston's Amidol Paper Developer

Water at room temperature	60 fl oz	2.0 liters
Sodium sulfite	1 oz 350 grains	54.0 grams
Amidol	234 grains	16.0 grams
10% potassium bromide	3 fl drams	12.0 ml
10% citric acid	3 fl drams	12.0 ml

Universal Developers

Formula #115

Ilford ID-36

This is a "universal" developing formula for film or paper. It is also recommended as a redeveloper for bleached negatives or prints.

Water (125°F/52°C)	24 fl oz	750.0 ml
Metol	22 grains	1.5 grams
Sodium sulfite	365 grains	25.0 grams
Hydroquinone	92 grains	6.3 grams
Sodium carbonate, monohydrate	1 oz 153 grains	40.5 grams
Potassium bromide	5.8 grains	0.4 grams
Water to make	32 fl oz	1.0 liter

For contact papers, use full strength; develop 45 to 60 seconds.

For enlarging papers, use 1:1 with water and develop for $1\frac{1}{2}$ to 2 minutes.

For tray development of film, use 1:1 with water and develop for 3 to 5 minutes.

For tank development of film, use 1:3 with water and develop for 6 to 10 minutes.

Formula #116

Kodak DK-93

This formula can be used to develop film and paper. The use of this developer is especially recommended for people subject to skin irritation.

Water (125°F/52°C)	16 fl oz	500.0 ml
*Kodelon	73 grains	5.0 grams
Sodium sulfite	1 oz	30.0 grams
Hydroquinone	36.5 grains	2.5 grams
Balanced Alkali	292 grains	20.0 grams
Potassium bromide	7.3 grains	0.5 grams
Water to make	32 fl oz	1.0 liter

*para-Aminophenol hydrochloride.

FILM: Use without dilution. Develop roll film about 9 minutes in a tank of fresh developer at 68°F/20°C. Develop sheet films for about 6 minutes at 68°F/20°C. More or less contrast may be obtained by developing longer or shorter than specified.

PAPER: For warm tones on papers, use without dilution and develop for about 2 minutes at 68°F/20°C. For colder tones, double the quantity of Balanced Alkali; use without dilution and develop 1 to 2 minutes at 68°F/20°C.

In either case, the tones given by this developer are slightly warmer than the normal tones given with Kodak D-52 and Kodak D-72.

Stop and Hardening Baths

Formula #117

Bisulfite Stop Bath

This stop bath is inexpensive and very gentle acting. It may be used in place of an acetic acid stop bath.

Water	24 fl oz	750.0 ml
Sodium bisulfite	146 grains	10.0 grams
Water to make	32 fl oz	1.0 liter

Formula #118

Indicator for Stop Baths

Bromcresol purple, 10% solution	2½ fl drams	9.25 grams
Sodium hydroxide	15 grains	1.0 gram
Distilled water to make	8 oz	250.0 ml

Add a sufficient amount of this solution to any amount of fresh 28% acetic acid to cause it to be clearly visible as yellow. When the pH of the acid becomes higher than 6.8, the bath will turn purple. Discard at the first signs of changing to purple, or sooner.

An alternate method is to place 24 ml of stop bath into a vial. Add 2 drops of the testing solution. If the stop bath remains yellow, it is still good. If it turns purple, time to deep six.

CAUTION: Cold water should always be used when dissolving sodium hydroxide because considerable heat is generated. If hot water is used, the solution will boil with explosive violence and may result in serious burns. If the water is not cold enough, the solution may start to steam. If this should occur, add some ice to cool the solution. DO NOT BREATHE THE VAPOR. If it starts to steam and you cannot get it to cool, leave the room until it is cool.

The best method to mix a solution of sodium hydroxide is to measure out the amount to be used, place it in a dry glass or plastic mixing container, and slowly add cold water.

Wear a dust mask, gloves, and goggles when working with the powder and solutions.

Formula #119

Kodak SB-1 Nonhardening Stop Bath

Water	32 fl oz	1.0 liter
*Acetic acid, 28%	1½ fl oz	48.0 ml

*To make 28% acetic acid from glacial acetic acid, dilute 3 parts of glacial acetic acid with 8 parts of water.

Rinse prints for at least 15 seconds. Capacity is approximately 20 8 × 10" prints per 1 liter.

Formula #120

Kodak SB-4 Tropical Hardener Bath

This solution is recommended for use in conjunction with tropical developers when working above 75°F/24°C.

Water	32 fl oz	1.0 liter
Potassium alum	1 oz	30.0 grams
Sodium sulfate, anhydrous	2 oz	60.0 grams

After development, rinse the film in water for not more than 1 second, then immerse in the SB-4 bath for 3 minutes. Omit the water rinse above 85°F/29°C, transferring the film directly to the hardener. Agitate for 30 to 45 seconds immediately after immersing in the hardener, or streakiness will result.

The hardening bath is a violet blue color by tungsten light when freshly mixed, but it ultimately turns to yellow-green with use; it then ceases to harden and should be replaced with a fresh bath. The hardening bath should never be overworked.

An unused bath will keep indefinitely, but a partially used bath will deteriorate rapidly within a few days.

Formula #121

Kodak SB-5 Nonswelling Acid Rinse Bath

Water	16 fl oz	500.0 ml
Acetic acid, 28%	1 fl oz	32.0 ml
Sodium sulfate, anhydrous	1½ oz	45.0 ml
Water to make	32 fl oz	1.0 liter

This bath is satisfactory up to 80°F/27°C. It should be replaced after processing about 12 rolls per liter. The bath should not be revived with acid.

When working at temperatures below 75°F/24°C, the life of the acid rinse bath may be extended by giving films a few seconds rinse in running water prior to immersion in the acid rinse.

Formula #122

Kodak SB-8 Citric Acid Stop Bath

Water	24 fl oz	750.0 ml
Citric acid	½ oz	15.0 grams
Water to make	32 fl oz	1.0 liter

Fixers

Crystalline hypo, when mixed with water, produces a noticeable lowering of temperature. Always begin with water of at least 90°F/32°C when mixing the crystalline form.

Use 64% of the anhydrous salt as a substitute for the crystalline form. With either crystalline or anhydrous, mix the hypo first, then add the remaining ingredients.

Dissolve the acid ingredients separately (e.g., boric acid) in a small volume of hot water, especially when a mixture of sodium sulfite and acetic acid is used. When possible, crystalline boric acid should be used. Powdered boric acid dissolves with great difficulty.

Removing the hardener from fixer will improve the gloss on paper.

As a general guideline, most fixing baths, rapid or standard, have a capacity of 20 8 × 10" prints or films per liter. If no capacity is specified, use this as your guide for archival processing of film and paper.

Formula #123

Agfa 304 Rapid Fixer

This simple fixer makes use of sodium thiosulfate and ammonium chloride to form ammonium thiosulfate in solution.

Water (125°F/52°C)	24 fl oz	750.0 ml
Sodium thiosulfate	6 oz 292 grains	200.0 grams
Ammonium chloride	1 oz 292 grains	50.0 grams
Potassium metabisulfite	292 grains	20.0 grams
Water to make	32 fl oz	1.0 liter

Use undiluted. Fix paper for 3 to 5 minutes. Film should be fixed for three times the clearing time.

Formula #124

ATF-1 Nonhardening Rapid Fixer

Use this formula for film or paper to reduce fixing times. The hardener is optional.

Stock Solution

Ammonium thiosulfate, 60% solution	24 fl oz	750.0 ml
Sodium sulfite	1 oz 256 grains	48.0 grams
Acetic acid, glacial	1.15 fl oz	36.0 ml
Boric acid, granular	1 oz	30.0 grams

Add the acetic acid slowly with stirring. Dissolve the boric acid separately in a little hot water and add this last.

Optional Hardener

Aluminum chloride, hexahydrate	1 oz 292 grains	50.0 grams
Water to make	3.2 fl oz	100.0 ml

This formula is to make 1 liter of concentrate.

For film, dilute 1:3 with water. If hardening is desired, add 25 ml to each liter of working solution. The hardener should be added slowly with stirring after the fixer has been diluted. Films should be fully fixed in approximately 5 minutes, with clearing times from 1 to 3 minutes in the fresh bath.

For paper, dilute 1:3, then take 2 parts of this fixer dilution and add 1 part of water. Prints will be fixed in 3 minutes. Do not leave prints in this fixer for more than 10 minutes.

Formula #125

ATF-5 Acid Hardening Rapid Fixer

Use this formula for film or paper (when hardening is desired) to reduce fixing times.

Water (125°F/52°C)	20 fl oz	600.0 ml
*Ammonium thiosulfate, 60% solution	11 fl oz	333.0 ml
Sodium sulfite	½ oz	15.0 grams
Acetic acid, 28%	1 oz 365 grains	55.0 ml
+Boric acid	¼ oz	7.5 grams
Potassium alum	½ oz	15.0 grams
Add Water to make	32 fl oz	1.0 liter

*200.0 grams (27 oz) of ammonium thiosulfate, crystalline can be used.
+Dissolve the boric acid separately in a little hot water and add this last.

For film, use undiluted. With a fresh bath, clearing time should be approximately 1 to 2 minutes. Film should be completely fixed in 4 to 5 minutes. The bath can be used until clearing time exceeds 7 minutes.

For paper, dilute 1 part ATF-5 with 1 part water. Immerse fiber-based paper for 3 minutes. Resin-coated paper should receive 1½ minutes. If 2 baths are used, give 3-and-3, or 1½-and-1½ minutes in each bath for fiber-based and resin coated papers, respectively.

This amount of ATF-5 can be used to fix 20 8 × 10" sheets of paper.

NOTE: Substituting 22 grams of citric acid for the bisulfite will eliminate much of the odor associated with fixers.

Formula #126

Defender 9-F Rapid Thiocyanate Fixer

Use this fixer when fixing has to be completed in a matter of seconds or when fixing must take place in very low temperatures.

Water (125°F/52°C)	20 fl oz	600.0 ml
Potassium thiocyanate	3 oz 146 grains	100.0 grams
Potassium alum	1 oz 292 grains	50.0 grams
Add Water to make	32 fl oz	1.0 liter

When the above is thoroughly dissolved, ADD:

Acetic acid, glacial	.8-1.12 fl oz	25.0-35.0 ml

At room temperatures of 65°F/18°C or higher, fixing will take place in 20 seconds. At −23°F/−7°C fixing will take place in 4 minutes (1 hour with ordinary fixers). This fixer will not freeze at temperatures above −28°F/−18°C.

Use 25 ml of acetic acid for rapid fixing and 35 for low temperatures.

CAUTION: Potassium thiocyanate is a mild skin irritant. Wear gloves and wash off any that splashes onto your skin.

Formula #127

Kodak F-1a Acid Hardener

Water (125°F/52°C)	14 fl oz	425.0 ml
Sodium sulfite	2 oz	60.0 grams
Acetic acid, 28%	6 fl oz	190.0 ml
Potassium alum	2 oz	60.0 grams
Water to make	32 fl oz	1.0 liter

NOTE: The sodium sulfite should be dissolved completely before adding the acetic acid. After the sulfite-acid solution has been mixed thoroughly, add the potassium alum with constant stirring.

To use, make an acid-hardening fixing bath by adding 250 ml of this hardener to 1.0 liter of cool hypo solution. If the hypo is not thoroughly dissolved before adding the hardener, a precipitate of sulfur is likely to form.

To make a plain hardening bath, without fixer, dilute 250 ml of the stock hardener solution in 1 liter of water. Harden film or paper for 1 minute before fixing.

Formula #128

Kodak F-5 Hardening Fixer

F-5 is the standard sodium-thiosulfate-based formula. Many commercially marketed fixers are essentially unaltered versions of this formula. Use this formula for film and paper when hardening is desired.

Water (125°F/52°C)	20 fl oz	600.0 ml
Sodium thiosulfate (hypo)	8 oz	240.0 grams
Sodium sulfite	½ oz	15.0 grams
Acetic acid, 28%	1½ fl oz	48.0 ml
*Boric acid, crystals	¼ oz	7.5 grams
Potassium alum, dodecahydrate	½ oz	15.0 grams
Add Water to make	32 fl oz	1.0 liter

*Crystalline boric acid should be used as specified. Powdered boric acid dissolves only with great difficulty, and its use should be avoided.

For paper, use the two-bath method, 5 minutes in each bath. Do not use this fixer for the second bath if you intend to tone the print. Use Kodak F-24 Nonhardening Acid Fixer instead.

F-5 can fix about 20 to 25 8 × 10″ prints per liter.

In a fresh bath, film should be clear in 5 minutes and fully fixed in 10. Discard when the clearing time is close to 10 minutes.

The hardener can be mixed separately as a stock solution (see the following formula).

Formula #129

Kodak F-5a Hardener

Water (125°F/52°C)	16 fl oz	500.0 ml
Sodium sulfite	2 oz 219 grains	75.0 grams
Acetic acid, 28%	7.5 fl oz	235.0 ml
*Boric acid, crystals	1 oz 110 grains	37.5 grams
Potassium alum, dodecahydrate	2 oz 219 grains	75.0 grams
Water to make	32 fl oz	1.0 liter

*Crystalline boric acid should be used as specified. Powdered boric acid dissolves only with great difficulty, and its use should be avoided.

The sodium sulfite should be dissolved completely before adding the acetic acid. After the sulfite-acid solution has been mixed thoroughly, add the boric acid and then the potassium alum with constant stirring.

To make an acid-hardening fixing bath, add 250 ml of this hardener to 1 liter of cool hypo solution. If the hypo is not thoroughly dissolved before adding the hardener, a precipitate of sulfur is likely to form.

To make a plain hardening bath, without fixer, dilute 250 ml of the stock hardener solution in 1 liter of water. Harden film or paper for 1 minute before fixing.

Formula #130

Kodak F-6 Odorless Acid-Hardening Fixer

Most fixing formulas have strong odors caused by sulphur dioxide emanating from the fixing process. The substitution of Balanced Alkali for boric acid in the F-6 formula eliminates the odor almost entirely.

Water (125°F/52°C)	20 fl oz	600.0 ml
Sodium thiosulfate	8 oz	240.0 grams
Sodium sulfite	½ oz	15.0 grams
Acetic acid, 28%	1½ fl oz	48.0 ml
Balanced Alkali	½ oz	15.0 grams
Potassium alum	½ oz	15.0 grams
Water to make	32 fl oz	1.0 liter

To prevent sulfurization, mix the potassium alum separately in a small amount of hot water, then add this last, stirring rapidly.

For paper, use the divided fixing method detailed under Kodak F-5 Acid Hardening Fixer above. Film should be fixed for at least 10 minutes.

Formula #131

Kodak F-24 Nonhardening Acid Fixer

Fixer without hardener is preferred for prints that are to be toned. Prints without hardener are also easier to wash and retouch with spotting fluid.

F-24 works well with pyro negatives, though care must be taken to avoid scratching while wet. The reason F-24 is a good choice for pyro is that it is less acidic, using sodium bisulfite instead of the stronger 28% glacial acetic acid found in many formulas. Fixers that are too acid tend to remove highly desirable pyro stains. Hardener is not necessary with pyro since the developer creates its own hardening effect.

Water (125°F/52°C)	16 fl oz	500.0 ml
Sodium thiosulfate	8 oz	240.0 grams
Sodium sulfite	146 grains	10.0 grams
*Sodium bisulfite	365 grains	25.0 grams
Water to make	32 fl oz	1.0 liter

*Substituting 22 grams of citric acid for the bisulfite will eliminate much of the odor associated with fixers.

For fiber-based prints, use the two-bath method, 5 minutes in each bath; for resin-coated papers, $1\frac{1}{2}$ to 2 minutes in each bath.

For film, fix for twice the time it takes to clear. The bath should be discarded when clearing nears 10 minutes.

Formula #132

Looten's Acid Hypo

Water (125°F/52°C)	64 fl oz	2.0 liters
Sodium thiosulfate	16 fl oz	480.0 grams
Sodium bisulfite	$1\frac{1}{2}$ oz	45.0 grams

Use undiluted. Unlike Plain Hypo this fixer can be saved and reused. It allows easy toning with direct toners, such as selenium.

Formula #133

Plain Hypo

Water (125°F/52°C)	64 fl oz	2.0 liters
Sodium thiosulfate	16 fl oz	480.0 grams

Use fresh and undiluted. The best use of a plain hypo bath is in the place of the second fixing bath immediately before toning. As it contains no sulfite it will produce the maximum image stain possible on pyro negatives.

A plain hypo bath can be used to fix a print in 30 seconds. However, it has poor keeping qualities and must be used with an acid stop bath or staining will occur. Do not keep a used plain hypo bath overnight.

Formula #134

TF-2 Alkaline Fixer

(Thanks to Bill Troop and *The Film Developing Cookbook*)

Due to its alkalinity, this fixer will wash out of negative and print materials more rapidly than will an acid fixer. This fixer should be odorless.

Water	24 fl oz	750.0 ml
Sodium thiosulfate	8 oz 146 grains	250.0 grams
Sodium sulfite	½ oz	15.0 grams
Sodium metaborate	146 grains	10.0 grams
Water to make	32 fl oz	1.0 liter

Use undiluted for either film or paper. Follow development by a 60-second plain water rinse or a minimum of 5 full changes of water. Fix films for 3 times the clearing time, or a minimum of 5 minutes, agitating for a full 30 seconds during each minute. Fix paper for 10 full minutes with occasional agitation.

The capacity of TF-2 is 20 8 × 10" prints or films per liter.

NOTE: To obtain maximum image stain with pyro developers, reduce the sulfite in the fixer or eliminate it altogether. The life of the working solution will be no more than one day, the same as Plain Hypo, but you will achieve the maximum image stain possible.

Overfixing, a problem often associated with acid fixers, is not a problem with alkali fixers.

Formula #135

TF-3 Alkaline Rapid Fixer

(Thanks to Bill Troop and *The Film Developing Cookbook*)

As with TF-2, this fixer will wash out of negative and print materials more rapidly than will an acid fixer. It has the added advantage of fixing films and papers in less than half the time of TF-2 Alkaline Fixer.

(This formula is similar to Photographers' Formulary TF-4. However, TF-4 is more concentrated and slightly less alkaline. The greater concentration of Formulary TF-4 increases the fixing capacity to 50 8 × 10" prints or films per liter; the slightly lower alkalinity of TF-4 decreases the ammonium odor.)

Ammonium thiosulfate, 57-60%	26 fl oz	800.0 ml
Sodium sulfite	2 oz	60.0 grams
Sodium metaborate	73 grains	5.0 grams
Water to make	32 fl oz	1.0 liter

Dilute 1:4 for either film or paper. Follow development by a 60-second plain water rinse or a minimum of 5 full changes of water. Fix films for 3 minutes, agitating for a full 30 seconds during each minute. Fix paper for 1 full minute with continuous agitation.

The capacity of this fixer is 20 8 × 10" prints or films per liter.

NOTE: To obtain maximum image stain with pyro developers, reduce the sulfite in the fixer or eliminate it altogether. The life of the working solution will be no more than one day, the same as Plain Hypo, but you will achieve the maximum image stain possible.

Overfixing, a problem often associated with acid fixers, is not a problem with alkali fixers.

Toners

Different papers, even different paper grades of the same paper, react differently to toners. Paper developers also affect a toner's color. Test each paper/developer/toner combination before committing valuable work to the process. Keep a book of the results.

Consult Carson Graves, *The Elements of Black-and-White Printing*, for a good toner-testing procedure (see Bibliography).

Be certain the print is completely and correctly fixed. Incorrectly fixed prints will often stain. Papers intended for toning should be even more thoroughly washed than average prints.

Use a nonhardening fixer. If a print has been previously hardened, use Dehardener.

Unless otherwise specified, a print should always be washed after toning and air-dried, as heat-drying can produce noticeable color shifts.

Safety Precautions

The chemicals used for toning are among the most toxic in photography. If proper safety procedures are adhered to (see appendix I, Safety in Handling Photographic Chemicals), there should be no more danger than in any other process. Here are some additional precautions:

- Be sure to use gloves for all toner processes.
- Be certain there is adequate ventilation and that ventilator fans are turned on. Toning takes place under normal working lights, so there is no reason not to open the door, if necessary.
- Sulfide toning should not be carried on in a room where film or paper is stored, as the fumes of the sulfide will cause fogging of sensitized materials. When in doubt, have no other photographic materials in the toning area.
- It is also wise to use the sulfide bath in a well-ventilated room since the fumes are somewhat poisonous and will cause headaches and illness if inhaled too much.

Formula #136

Ansco 241 Iron Blue Toner

This formula is suitable for bromide and fast chlorobromide papers.

Water (125°F/52°C)	16 fl oz	500.0 ml
Ferric ammonium citrate	¼ oz	8.0 grams
Potassium ferricyanide	¼ oz	8.0 grams
Acetic acid, 28%	9 oz	265.0 ml
Water to make	32 fl oz	1.0 liter

NOTE: The solution should be prepared with distilled water. If enameled iron trays are used, no chips or cracks should be present, or spots and streaks may appear in the print.

Prints for toning should be fixed in plain, nonhardening hypo at a temperature of 68°F/20°C or less to prevent excessive swelling. When prints have been fully toned, they will be greenish in color, but they will change to clear blue when placed in running water.

The depth of the blue toning will vary with the quality of the prints toned, with light-toned prints generally toning to lighter blue. Some intensification of the print usually occurs in toning; consequently, prints should be slightly lighter than the density desired in the final toned print.

Wash water should be acidified slightly with acetic acid, since the blue tone is quite soluble in alkaline solutions and is considerably weakened when the wash water is alkaline. Pleasing variations in the tone can be obtained by bathing the washed prints in a 0.5% solution (5 g/L) of borax, which produces softer, blue-gray tones, the extent of which depends on the length of treatment.

Formula #137

Blue Gold Toner

This formula is one of the fastest and easiest to use. It is capable of creating a deep blue color on warm-tone chlorobromide papers.

Distilled water (125°F/52°C)	24 fl oz	750.0 ml
*Ammonium thiocyanate	3 oz 219 grains	105.0 grams
Gold chloride, 1% solution	2 oz	60.0 ml
Water to make	32 fl oz	1.0 liter

*110 grams of sodium thiocyanate or 135 grams of potassium thiocyanate may be substituted.

After fixing and thorough washing tone prints for 10 to 20 minutes with occasional agitation, the prints should then be thoroughly washed and dried.

Dassonville T-6 Gold Chloride

(For gray-blue tones)

Solution A

Thiocarbamide	240 grains	16.0 grams
Water to make	32 fl oz	1.0 liter

Solution B

Gold chloride	60 grains	4.0 grams
Water, distilled	32 fl oz	1.0 liter

For use, take:

Water	12 fl oz	360.0 ml
Solution A	3 oz	90.0 ml
Solution B	3 oz	90.0 ml
Sulfuric acid, concentrate	16 drops	16 drops

Use the bath at 75°F/24°C. Prints should be toned two at a time, back-to-back and well covered with the toning solution. Agitate occasionally. Toning will take from 5 to 20 minutes. The bath may be used until exhausted. The stock solutions will keep indefinitely, but the mixed toner will not keep for more than a few days. The toned print is permanent and will not fade or change color.

If a lighter shade of blue is desired, remove the prints from the toning bath before the maximum effect is reached. After toning, treat the prints in a washing aid and wash for ½ hour; dry as usual.

NOTE: Prints to be blue-toned should be developed in Dassonville D-3 Autotoning Developer. (Other warm-toned developers can be used, but they will probably not give as deep a blue tone. A warm-toned print will give a deeper blue than a cool-toned print; D-3 will give very warm-toned results and correspondingly deep blues.)

Prints should be slightly softer and lighter than normal and should be developed for 5 minutes. This long development is important. If the print is too dark, decrease exposure; do not reduce development time.

After development, the prints should be fixed in a nonhardening fixer and thoroughly washed. Two-bath fixing is recommended, the second being a plain hypo bath without hardener.

NOTE: Stains are caused by incomplete washing between fixing and toning.

NOTE: The surface of the print will be quite soft after washing since no hardener is used in the fixing bath. It is recommended that the prints be dried between washing and toning. This will tend to harden the emulsion slightly and help to prevent frilling in later baths (in frilling, the emulsion separates from the paper; this also can occur when solutions or wash water are excessively hot). Care should also be used in handling the prints after toning.

NOTE: The stock solutions will keep indefinitely, but the mixed toner will not keep for more than a few days.

Gold Chloride Blue Toner

This gives a soft, grayish purple rather than a vivid blue, suggesting a "blue" atmosphere. A subdued bluish tone will appear on chloride papers, and a more green-blue on chlorobromide papers.

Solution A

Water	8 fl oz	250.0 ml
*Thiocarbamide	50 grains	3.5 grams

*If thiocyanate is substituted for thiocarbamide, more purplish tones will appear.

Solution B

Water	8 fl oz	250.0 ml
Citric acid	50 grains	3.5 grams

Solution C

Water	8 fl oz	250.0 ml
Gold chloride	15 grains	1.0 gram

Take 30 ml of each stock solution and add 300 ml of water. Tone the well fixed (in a plain hypo bath) and washed print for 10 to 30 minutes. The average print will be toned in about 15 minutes. Dark prints take longer. Agitate the prints during toning. Treat with a washing aid and wash for about 1 hour.

Slight intensification will take place with some papers, particularly chloride and chlorobromide emulsions.

This quantity of toner can be used for 2 to 4 11 × 14" prints. The mixed solution will keep for several hours.

Formula #140

Kodak T-12 Iron-Toning Bath

This toner produces blue tones on paper prints.

Ferric ammonium citrate, green	58 grains	4.0 grams
Oxalic acid, crystals	58 grains	4.0 grams
Potassium ferricyanide	58 grains	4.0 grams
Water to make	32 fl oz	1.0 liter

NOTE: Dissolve each chemical separately and filter before mixing together.

To use, immerse the well-washed print in the toning bath for 10 to 15 minutes until the desired tone is obtained. Then wash until the highlights are clear.

Formula #141

Kodak T-26 Blue Toner

For solid deep blue tones on warm-tone papers, and soft blue-black tones on neutral-tone papers.

Gold chloride, 1% solution	1¼ fl oz.	40.0 ml

Add to 937 ml of water at 125°F/52°C.
Stirring, add:

Thiourea	15 grains	1.0 gram
Tartaric acid	15 grains	1.0 gram
Sodium sulfate, anhydrous	½ oz.	15.0 grams

Continue to stir until all the chemicals are totally dissolved.

The range of toning times is 8 to 45 minutes at 68°F/20°C. Increasing the temperature to between 100°F/38°C and 105°F/40°C decreases the toning time from 2 to 15 minutes. Since toning is slow, only occasional agitation is needed to avoid streaking.

NOTE: T-26 increases the contrast and density of the print. Compensate by reducing the normal exposure time (start with 10% less). Toning starts in the highlights and slowly moves into the shadows. Careful observation is necessary to avoid a partially toned print with blue highlights and untoned shadows.

T-26 exhausts rapidly. It has a capacity of only 5 to 15 8 × 10″ prints per quart.

Brown Toners

Formula #142

Ansco 221 Sepia Toner

For warm-brown tones.

Bleach, Solution A

Water (125°F/52°C)	24 fl oz	750.0 ml
Potassium ferricyanide	1½ oz 73 grains	50.0 grams
Potassium bromide	146 grains	10.0 grams
Sodium carbonate, monohydrate	½ oz 70 grains	20.0 grams
Water to make	32 fl oz	1.0 liter

This solution should be stored in the dark as ferricyanide solutions are light-sensitive. Should the solution turn blue, the bleach should be discarded.

Redeveloper, Solution B

Water	10 fl oz	300.0 ml
*Sodium sulfide, anhydrous	1½ oz	45.0 grams
Water to make	16 fl oz	500.0 ml

*Be sure to use sodium sulfide, not sodium sulfite.

Use plastic trays, especially with the bleaching bath. Otherwise, blue spots may form on the print.

To use, dilute 1 part of the redeveloper (Solution B) with 8 parts water. Prints should be washed thoroughly and then bleached in Solution A until the black image is converted to a very light brown color, about 1 minute. Prints should then be washed for 10 to 15 minutes and redeveloped.

Redevelopment should be complete in about 1 minute, with constant agitation. After redevelopment the prints should be washed for about 30 minutes and then dried. If the toner leaves sediment, which could result in streaks or finger marks on the surface of the paper, immerse it for a few seconds in a 3% solution of acetic acid, after which a 10-minute washing is necessary.

Formula #143

Ansco 222 Hypo-Alum Toner

For reddish-brown tones.

Solution A

Water	80 fl oz	2350.0 ml
Sodium thiosulfate	15 oz	450.0 grams

Solution B

Water	1 fl oz	30.0 ml
Silver nitrate	20 grains	1.3 grams

Solution C

Water	1 fl oz	30.0 ml
Potassium iodide	40 grains	2.7 grams

Add Solution B to Solution A, then add Solution C to the mixture. Finally add 105 grams of potassium alum and heat the entire bath to the boiling point, or until sulfurization takes place (indicated by a milky appearance of the solution). Tone prints 20 to 60 minutes at 110°F/43°C to 125°F/52°C. Agitate prints occasionally until toning is complete.

Care should be taken to see that the blacks are fully converted before removing the prints from the toning bath, otherwise double tones may result.

Formula #144

Dassonville T-5 Copper Toner

For purple-brown to chalk-red tones.

Solution A

Copper sulfate	96 grains	6.5 grams
Potassium citrate, neutral	¾ oz 33 grains	24.8 grams
Water to make	32 fl oz	1.0 liter

Solution B

Potassium ferricyanide	80 grains	5.5 grams
Potassium citrate, neutral	¾ oz 33 grains	24.8 grams
Water to make	32 fl oz	1.0 liter

Take equal parts of A and B. Immerse the thoroughly washed prints one at a time, and tone until the desired color is reached. The prints will progress from black to deep brown and finally to red chalk. Toning may be stopped by removing the print and washing well. A washed and dried print may be returned to the toner at any time. As it is important to remove prints at the exact moment that the desired color is obtained, a guide print should be toned first.

Wash prints for $\frac{1}{2}$ hour after toning.

If pinkish tints show up in toning, add more potassium citrate to Solution B.

For maximum permanence, prints should be toned as deeply as possible, given a bath in weak hypo, treated with a washing aid, and washed. However, any print toned to less than red chalk should not be treated with hypo.

The mixed solution will not keep well and should be discarded after use.

Prints that appear weak after toning can be strengthened by immersing in a bath composed of the following:

Copper sulfate	1 oz 263 grains	48.0 grams
Potassium bromide	350 grains	24.0 grams
Acetic acid, 28%	1 oz 5 fl drams	50.0 ml
Water to make	32 fl oz	1.0 liter

Prints should be washed another $\frac{1}{2}$ hour after using this solution. Fresh solution should always be used.

Formula #145

Formulary Thiourea Toner

(Thanks to William M. Wilson of The Photographers' Formulary)

(For brown tones)

This formula is similar to Ansco 221 Sepia Toner, without the rotten egg smell associated with sulfide toners.

*Bleach

Water (125°F/52°C)	24 fl oz	750.0 ml
Potassium ferricyanide	1½ oz 73 grains	50.0 grams
Potassium bromide	146 grains	10.0 grams
Sodium carbonate, monohydrate	½ oz 70 grains	20.0 grams
Water to make	32 fl oz	1.0 liter

*This is the same bleach formula used in Ansco 221 Sepia Toner.

This solution should be stored in the dark as ferricyanide solutions are light-sensitive. Should the solution turn blue the bleach should be discarded.

Redeveloper

Solution A

Sodium hydroxide	146 grains	10.0 grams
Cold water to make	3.2 fl oz	100.0 ml

This solution should be prepared in a plastic or glass container, and in a well-ventilated area. Measure out the amount of hydroxide to be used, place it in a dry glass or plastic mixing container, and slowly add cold water. Stir with a plastic spoon or glass rod until the solid has gone into solution. Stir gently and avoid splashing.

CAUTION: Cold water should always be used when dissolving sodium hydroxide because considerable heat is generated. If hot water is used, the solution will boil with explosive violence and may result in serious burns. If the water is not cold enough, the solution may start to steam. If this should occur, add some ice to cool the solution. DO NOT BREATHE THE VAPOR. If it starts to steam and you cannot get it to cool, leave the room until it is cool.

The best method to mix a solution of sodium hydroxide is to measure out the amount to be used, place it in a dry glass or plastic mixing container, and slowly add cold water.

Wear a dust mask, gloves, and goggles when working with the powder and solutions.

Solution B

Thiourea	73 grains	5.0 grams
Water	3.2 fl oz	100.0 ml

Add the thiourea to the water and stir until the entire solid goes into solution. Pour into a container for storage.

To use the Redeveloper, mix 1 part A and 1 part B with 16 parts water.

To make:	250.0 ml	500.0 ml	1000.0 ml
Solution A	14.0 ml	28.0 ml	56.0 ml
Solution B	14.0 ml	28.0 ml	56.0 ml
Add water to make	250.0 ml	500.0 ml	1.0 liter

Once mixed, the Redeveloper is good for a working session but cannot be saved. Dispose of the spent solution down the drain using excess amounts of water.

Using the Toner

Use plastic trays, especially with the bleaching bath. Otherwise, blue spots may form on the print.

Prints should be washed thoroughly and then bleached while wet (if they have previously been dried, rewet before bleaching). Bleach until the black image is converted to a very light brown color, about 1 minute. Wash the bleached prints for 10 to 15 minutes in running water. The bleach can be reused.

Immerse the well-washed, bleached prints in the redeveloper. Redevelopment should be complete in about 1 minute, with constant agitation. After redevelopment the prints should be washed for about 30 minutes and then dried. If the toner leaves sediment, which could result in streaks or finger marks on the surface of the paper, immerse it for a few seconds in a 3% solution of acetic acid, after which a 10-minute washing is necessary.

Ilford IT-2 Hypo-Alum Sepia Toner

This is a versatile toner that generally gives relatively cool tones. Adding a solution of potassium iodide can cause it to yield warmer tones.

Toner

Water (125°F/52°C)	24 fl oz	750.0 ml
Sodium thiosulfate, pentahydrate	5 oz	150.0 grams

Place the hot water in a mixing bowl and add the hypo. Stir until the solid goes into solution. Then add a little at a time:

Potassium alum	365 grains	25.0 grams

Ripening the Toner

A solution containing only thiosulfate and alum will act as a reducer and bleach a print by removal of the silver. When the silver concentration in the bath is high enough the solution will act as a toner. In order to convert a fresh hypo-alum solution to a toning bath, silver must be added. This can be done by adding silver nitrate and then immersing spoiled prints in the bath until the desired toning result is reached. If silver nitrate is not available, the bath can be ripened by immersing a series of spoiled prints alone.

Chemical Ripener for Ilford IT-2

Water	1¼ fl drams	5.0 ml
Silver nitrate	1.7 grains	.12 grams

Add the water to the silver nitrate and mix well. Add the nitrate solution to the toner. If a precipitate should form simply ignore it. Stir the solution to ensure it is homogeneous.

IT-2 tends to give cold tones. If warmer tones are desired add the following solution:

IT-2 Iodide Warming Solution

Water (68°F/20°C)	1.6 fl oz	50.0 ml
Potassium iodide	14.6 grains	1.0 gram

Pour the iodide solution into the toner. It is normal for a precipitate to form.

Once the toner is mixed, the ripening solution added, and the optional warming solution, add cold water to bring the total volume to 1 liter.

Prints to be toned should be developed more than usual. RC papers will tend to gray due to the loss of their brighteners in this bath. The bath should be used undiluted at (120°F/50°C) to minimize the toning time. Rock the tray to keep precipitate off the surface of the print, and tone for approximately 10 minutes. After toning wash the print for 10 to 20 minutes and use a wet cotton ball to wipe any scum off the print surface.

Formula #147

Kodak T-1a Hypo-Alum Toner

For sepia tones on warm-tone papers.

This formula is particularly suitable for warm-toned slow chlorobromide and chloride papers.

Prepare this formula carefully following these instructions:

Distilled water	90 fl oz	2800.0 ml
Sodium thiosulfate	16 oz	480.0 grams

Dissolve thoroughly, and add the following solution:

Distilled water (160°F/70°C)	20 fl oz	640.0 ml
Potassium alum	4 oz	120.0 grams

Then add the following solution (including precipitate) slowly to the hypo-alum solution while stirring the latter rapidly:

Distilled water	2 fl oz	64.0 ml
*Silver nitrate, crystals	60 grains	4.0 grams
Sodium chloride	60 grains	4.0 grams

After combining the solutions, continue as follows:

Add water to make	1 gallon	4.0 liters

*The silver nitrate should be dissolved completely before adding the sodium chloride, and immediately afterward, add the solution containing the milky white precipitate to the hypo-alum solution. The formation of a black precipitate in no way impairs the toning action of the bath if adequate agitation is used.

To use, pour into a tray supported by a water bath heated to 120°F/50°C. Bring the toner to this temperature. At this temperature prints will tone in 12 to 15 minutes, depending on the type of paper. Never use the solution above 120°F/50°C because blisters and stains may result. Toning should not be continued longer than 20 minutes at 120°F/50°C.

NOTE: Toning may be speeded up by placing the prints in a bath of 10% sulfuric acid for 1 minute and then transferring them directly to the toning bath.

In order to produce good sepia tones, the prints should be exposed so that the print is slightly darker than normal when developed normally (1½ to 2 minutes).

The prints to be toned should be fixed thoroughly and washed for a few minutes before being placed in the toning bath. Dry prints should be soaked in water. To ensure even toning, the prints should be immersed completely and separated occasionally, especially during the first few minutes.

After the prints are toned, they should be wiped with a soft sponge and warm water to remove any sediment, and then washed for 1 hour in running water.

NOTE: When the toner is first mixed, it has too great a reducing action. This can be avoided by toning a few waste prints before the toner is used on good prints.

Formula #148

Kodak T-7a Sulfide Sepia Toner

(For cold-tone papers)

Stock Bleaching Solution A

Potassium ferricyanide	2½ oz	75.0 grams
Potassium bromide	2½ oz	75.0 grams
Potassium oxalate	6½ oz	195.0 grams
Acetic acid, 28%	1¼ fl oz	40.0 ml
Water	64 fl oz	2.0 liters

Stock Toning Solution B

*Sodium sulfide	1½ oz	45.0 grams
Water to make	16 fl oz	500.0 ml

*Be sure to use sodium sulfide, not sodium sulfite.

Prepare the bleaching bath as follows:

Stock Solution A	16 fl oz	500.0 ml
Water	16 fl oz	500.0 ml

Prepare toner as follows:

Stock Solution B	4 oz	125.0 ml
Water to make	32 fl oz	1.0 liter

The print should be washed thoroughly. Place it in the bleach until only faint traces of the middle densities are left and the black of the shadows has disappeared. This will take about 1 minute.

NOTE: Care should be taken not to use trays with exposed iron, otherwise blue spots may result.

Rinse thoroughly in clean cold water. Place in the toner until original detail returns—about 30 seconds. Give the print an immediate and thorough water rinse; then immerse it for 2 to 5 minutes in a hardening bath composed of 1 part of hardener (Kodak F-5a Hardener) and 13 parts of water. Wash the prints for 4 minutes in running water at 65°F/18°C to 75°F/24°C.

Formula #149

Kodak T-8 Polysulfide Toner

(For sepia tones)

This toner creates slightly darker brown tones than Kodak T-7a on warm-tone papers. It has the further advantage, over hypo-alum formulas, of not requiring heating, although raising the temperature to 100°F/38°C will reduce the toning time.

Water	24 fl oz	750.0 ml
*Polysulfide	¼ oz	7.5 grams

| Sodium carbonate, monohydrate | 35 grains | 2.4 grams |
| Water to make | 32 fl oz | 1.0 liter |

*Also known as sulfurated potash, liver of sulfur, and potassa sulfurated.

Immerse the well-washed print in the bath and agitate for 15 to 20 minutes at 68°F/20°C or for 3 or 4 minutes at 100°F/38°C.

After toning, rinse the print for a few seconds in running water and place for about 1 minute in a sodium bisulfite solution containing 1 ounce per quart (30 grams per liter) of water. Then immerse the print for about 2 minutes in a hardening bath prepared by adding 1 part Kodak Liquid Hardener or 2 parts of Kodak F-5a Hardener to 16 parts of water.

After toning, if any sediment appears on the print, the surface should be wiped with a soft sponge. The print should be treated in a washing aid, then washed for at least 30 minutes.

Approximate life of the toning bath is 35 8 × 10″ prints per liter.

Formula #150

Nelson Gold Toner

Using Nelson Gold Toner, three-dimensional brown tones can be obtained that vary from a hint of warmth to rich brown sepia browns. The depth of tone depends upon the duration of time the print remains in the toning bath, from 5 to 20 minutes.

Solution A, Part 1
Distilled water (125°F/52°C)	16 fl oz	500.0 ml
Sodium thiosulfate	8 oz	240.0 grams
Ammonium persulfate	1 oz	30.0 grams
Water to make	32 fl oz	1.0 liter

Dissolve the hypo completely, then add the persulfate while stirring vigorously. If the solution does not turn milky, increase the temperature until it does. Then add the cold water.

Solution A, Part 2
Distilled water (room temperature)	½ oz	15.0 ml
Silver nitrate	19 grains	1.3 grams
Sodium chloride	19 grains	1.3 grams

Part 2 should be mixed in a container that is different from that of Part 1; the two solutions will be mixed in a subsequent step. The silver nitrate should be thoroughly dissolved before adding the sodium chloride, otherwise the nitrate will be trapped in the solid that forms. A white precipitate will form; stir vigorously.

Combining Part 1 and Part 2:
Both solutions must be at room temperature (68°F/20°C) before they are combined to make Stock Solution A. Stir Part 2 vigorously to disperse the solid throughout the solution, then pour all of Part 2 into Part 1. Stir the combined

solution to ensure thorough mixing. A precipitate may or may not be present in the final solution. Transfer the combined solution along with any precipitate (if present) to the storage container.

Solution B

*Gold chloride, 1% solution	1¾ fl oz	52.0 ml

*To make a 1% solution, mix 1 gram of gold chloride with 100 ml of distilled water. Gold chloride is deliquescent and rapidly absorbs atmospheric moisture. The solid may have liquefied by the time you wish to use it. Since you will be transferring it to a water solution, prior liquefaction is not detrimental. However, when gold chloride liquefies, some of the liquid clings to the cap of its container. Because of the small amount used, it is important that all of the residual gold chloride in the container be transferred when you prepare Stock Solution B.

NOTE: Due to the cost of obtaining gold chloride, the best method for obtaining a 1% solution is to purchase it premixed from Photographer's Formulary.

Mixing the Working Solution:
Add one half of Stock Solution B to Stock Solution A (the balance of Stock Solution B will be used to replenish the bath). Stir the mixture to ensure it is homogeneous. The bath should not be used until after it has cooled and formed sediment, preferably overnight.

Using the Toner:
Prints for toning should be wet. They should be fully fixed, but only a brief washing is necessary. Very carefully pour off the clear liquid for use, being careful to avoid the sediment.

Heat the toner to about 110°F/43°C for use. Maintain the temperature between 110°F/38°C and 110°F/43°C while toning. If necessary, place a smaller tray containing the toner inside a larger tray of running water at 110°F/43°C. Toning takes from 5 to 20 minutes depending on the desired hue.

After all the prints have been toned, refix for 5 minutes, then wash for one hour in running water.

The bath should be revived at intervals by the addition of further quantities of Solution B. The quantity to be added will depend on the number of prints toned and the time of toning. For example, when toning to a warm brown, add 4 ml of gold solution after each 50 8 × 10" prints or their equivalent have been toned.

Dye Toners

Formula #151

Single-Solution Dye Toner

Dye (see below for quantity)

Wood (methyl) alcohol	3½ fl oz	100.0 ml
Potassium ferricyanide	15 grains	1.0 grams

*Glacial acetic acid	1½ drams	5.0 ml
Water to make	32 fl oz	1.0 liter

*18 ml of 28% acetic acid may be substituted.

The quantity of dye varies according to the dye used:

Auramine O (yellow)	6 grains	0.4 grams
Bismark brown	3 grains	0.2 grams
Fuchsin (red)	3 grains	0.2 grams
Methyl violet	1¼ grains	0.1 grams
Methylene blue BB	3 grains	0.2 grams
Rhodamine B (red)	6 grains	0.4 grams
Safranin O (red)	3 grains	0.2 grams
Victoria green	6 grains	0.4 grams

The nature of the tone varies with the time of toning, and eventually a point is reached beyond which it is unsafe to continue, as the gradation of the toned image becomes affected. Average toning time at 68°F/20°C is from 3 to 9 minutes.

Formula #152

Two-Solution Dye Toner

Toning Bath (mordant)
Iodine	½ oz	15.0 grams
Potassium iodide	1 oz 292 grains	50.0 grams
*Glacial acetic acid	¾ fl oz	25.0 ml
Distilled water to make	32 fl oz	1.0 liter

*90 ml of 28% acetic acid may be substituted.

Dye Toner
*Dye	3 grains	0.2 grams
+Acetic acid, 10%	1¼ drams	5.0 ml
Distilled water to make	32 fl oz	1.0 liter

*Thoroughly dissolve the dye in hot water, filter, add the acid and dilute to 1 liter with water. For methyl violet dye, use 0.05 grams.
+1 part glacial acetic acid slowly added to 9 parts water.

Place the print in the mordant for 1 to 5 minutes. The image will turn a brownish gray. The longer the image is in the bleach, the more silver is mordant and the deeper the dye tone. Wash for 5 minutes or until all of the bleach is removed from the print. Place in the dye toner for 2 to 5 minutes. Rinse, use stain remover if necessary, and wash.

The dye can be cleared from the highlights by submerging in a clearing bath made of 60 ml of glacial acetic acid in 1 liter of water. An alternate method is to use 10 ml of household bleach to 1 liter of water.

Formula #153

Ansco 251 Green Toner

This formula produces rich green tones by combining the effects of iron blue toning and sulfide sepia toning. It must be carefully used with attention both to the directions and to cleanliness in handling prints throughout the process. The formula is not adaptable to all types of papers and surfaces, and it is suggested that tests be run before committing important prints.

Solution A

Potassium ferricyanide	1¼ oz 146 grains	40.0 grams
Water	32 fl oz	1.0 liter
Ammonia (25% to 29%)	3.8 fl drams	15.0 ml

Solution B

Ferric ammonium citrate	½ oz 29 grains	17.0 grams
Water	32 fl oz	1.0 liter
Hydrochloric acid, concentrate	1¼ oz	40.0 ml

Solution C

Sodium sulfide	30 grains	2.0 grams
Water	32 fl oz	1.0 liter
*Hydrochloric acid, concentrate	2½ fl drams	10.0 ml

CAUTION: Mix the ingredients in the exact order given. Always add the acid to the water to avoid a dangerous chemical reaction.

*Do not add hydrochloric acid to Solution C until immediately before use. Prints to be toned should be darker and softer than normal prints, produced by using approximately 25% overexposure on the next softer grade of paper. Development of the print should be carried out in a standard developer, such as Kodak D-72, with particular attention given to avoid underdevelopment or forcing the print with overdevelopment. Prints should be fixed as usual, thoroughly washed, and completely dried before toning.

Prints to be toned should be first soaked in cold water until limp, and then placed in Solution A until bleached. This should take about 60 seconds or less. The bleached prints should be immediately transferred to running water for at least 30 minutes.

Bleached prints are placed in Solution B for 45 seconds to 1 minute, toning being continued until the deepest shadows are completely toned. Prints should then be washed for 4 to 6 minutes, excessive washing being undesirable because of the solubility of the blue image. If wash water is slightly alkaline, it should be acidified somewhat with acetic acid to prevent degradation of the blue tone during washing.

The blue-toned prints are next immersed in Solution C for about 30 seconds, or until the green tone is sufficiently strong. Toned prints should then

receive a final washing of 20 to 30 minutes in neutral or slightly acidified wash water and should be dried. Avoid belt and heat-drying machines for drying.

NOTE: All solutions should be prepared within 24 hours before use. Care should be taken to avoid crosscontamination of Solutions A and B. Even slight traces of Solution A carried over on hands or prints into Solution B can cause blue stains.

CAUTION: Solution C should be used in a well-ventilated room, preferably near an open window or exhaust fan to lessen the chance of inhaling hydrogen sulfide formed in the solution.

Formula #154

GT-16 Indirect Green Toner

This formula is most effective on warm-tone papers. Give 10 to 25% more exposure than usual.

Solution A

Oxalic acid	114 grains	7.8 grams
Ferric chloride	15 grains	1.0 gram
Ferric oxalate	15 grains	1.0 gram
Water to make	9½ fl oz	285.0 ml

Solution B

Potassium ferricyanide	30 grains	2.0 grams
Water to make	9½ fl oz	285.0 ml

Solution C

*Hydrochloric acid, concentrate	1 oz	30.0 ml
+Vanadium chloride	30 grains	2.0 grams
Water to make	9¼ fl oz	285.0 grams

*Add the acid to the water, never add the water to the acid.
+Heat the solution to the boiling point, then add the vanadium chloride.

To use, mix Solution B with Solution A. Stir vigorously while adding Solution C.

Tone in the mixed solution until the print appears deep blue. Then remove and wash until the tone changes to green. After the green tone appears, continue to wash for an additional 10 minutes. Treat the print with Hypo Clearing Agent (HCA) and give a final wash of at least 1 hour.

If a yellowish stain appears, you can remove it by placing the print in the following solution:

Ammonium sulfocyanide	23 grains	1.6 grams
Water (68°F/20°C) to make	9¼ fl oz	285.0 ml

This should be done before treating the print with a washing aid and giving the final wash.

Formula #155

Variable Green Toner

Bleach

Potassium bichromate	5 grains	0.3 grams
Potassium ferricyanide	25 grains	1.6 grams

Bleach the print for 3 to 5 minutes. Wash free from the bichromate stain and tone in one of the following:

*Light Green Toner

Cobalt chloride	20 grains	1.3 grams
Ferrous sulfate	5 grains	0.3 grams
Hydrochloric acid	20 minims	1.2 ml
Water	2 minims	60.0 ml

*The longer the bleaching, the lighter the green.

Emerald Green Toner

Cobalt chloride	20 grains	1.3 grams
Ferrous sulfate	5 grains	0.3 grams
Glacial acetic acid	30 minims	1.8 ml
Water	2 minims	60.0 ml

*Olive Green Toner

Vanadium chloride (in 1 oz of water)	1 grain	.07 grams
Ferric chloride	1 grain	.07 grams
Nitric acid	10 minims	0.6 ml
Water	2 minims	60.0 ml

*The depth of olive green depends on the extent to which the print has been bleached. If olive green toning is allowed to continue, the print may become light green again.

Toning is slow. After toning wash the print for 5 to 10 minutes then refix. The resulting print is very permanent.

Protective Toners

Formula #156

Dassonville T-55 Direct Selenium Toner

(Thanks to Judy Seigel and *The World Journal of Post Factory Photography*)

This toner produces rich plum-purple to brown tones.

*Sodium sulfite	365 grains	25.0 grams
+Selenium powder	14.6 grains	1.0 gram

*Sulfite not sulfide.
+Selenium powder is available from First Reaction (see appendix II, Sources).

Dissolve the sodium sulfite in 100 ml of warm water. Add the selenium powder and slowly heat until dissolved. Allow to cool. Add:

Ammonium chloride	1 oz 15 grains	31.0 grams
Water	2.1 fl oz	67.0 ml

For use, dilute 1:5 to 1:9. Tone the prints for 2 to 3 minutes with continuous agitation. Wash the prints thoroughly before drying. This formula deteriorates rapidly once diluted; dilute only enough for immediate use.

A small amount of thiourea can be added to vary the tone, or this toner can be used after a light thiourea toning.

CAUTION: The preparation of this toner involves heating a solution containing selenium powder. Selenium is highly poisonous, both in powder and vapor form. Care should be taken not to inhale either the unmixed fine powder or the fumes of the heated liquid. Work in a well-ventilated room and wear an appropriate fume mask and protective gloves when mixing and using.

Formula #157

Dassonville T-56 Bleach and Redevelop Selenium Toner

(Thanks to Judy Seigel and *The World Journal of Post Factory Photography*)

This toner produces rich plum-purple to brown tones. Although this toner contains sodium sulfide the odor is minimal.

Bleaching solution

Potassium ferricyanide	3 oz 145 grains	100.0 grams
Potassium bromide	3 oz 145 grains	100.0 grams
Water to make	32 fl oz	1.0 liter

For use dilute 1 part with 9 parts of water. Bleach prints before immersing in the selenium-sulfide stock solution.

Selenium-Sulfide Stock Solution

Sodium sulfide	365 grains	25.0 grams
+Selenium powder	73 grains	5.0 grams

+Selenium powder is available from First Reaction (see appendix II, Sources).

Dissolve the sodium sulfide in 100 ml of warm water. Add the selenium powder and slowly heat until dissolved. Allow to cool.

For use, dilute 1:20. Tone the prints for 3 to 5 minutes with continuous agitation. Rinse the prints for 5 minutes in Berg Bath and wash for 30 minutes.

To vary the color the print can be soaked for 1 to 2 minutes in the selenium-sulfide stock solution prior to bleaching. A small amount of thiourea can also be added to vary the tone.

If the whites stain, add a few drops of ammonia in the working solution. If this does not help, try passing the prints through one or more baths of 1% sodium sulfite.

This formula deteriorates rapidly once diluted; dilute only enough for immediate use.

CAUTION: The preparation of this toner involves heating a solution containing selenium powder. Selenium is highly poisonous, both in powder and vapor form. Care should be taken not to inhale either the unmixed fine powder or the fumes of the heated liquid. Work in a well-ventilated room and wear an appropriate fume mask and protective gloves when mixing and using.

Formula #158

Flemish Toner

Although this toner is similar to Dassonville T-56, it produces a more subtle change in tone. Flemish toner was a very popular commercial formula until it was discontinued in the 1970s.

Bleaching Solution

Potassium ferricyanide	1.0 ounce	30.0 grams
Potassium bromide	1.0 ounce	30.0 grams
Water to make	32 fl oz	1.0 liter

Use full strength. Prints must be thoroughly washed before bleaching or loss of highlight detail will result. Bleach the print completely, wash, and tone in:

Selenium-Sulfide Stock Solution

Sodium sulfide	1 oz 146 grains	40.0 grams
*Selenium powder	15 grains	1.0 gram
Water to make	32 fl oz	1.0 liter

*Selenium powder is available from First Reaction (see appendix II, Sources).

Dissolve the sulfide and warm the solution before adding the selenium; continue to heat until the selenium is completely dissolved.

For use dilute 1 part 10 parts of water. Immerse the bleached print in the selenium-sulfide solution and tone to the desired depth. Rinse the prints for 5 minutes in Berg Bath and wash for 30 minutes.

For best tones, the prints must be fully developed. Overexposed and underdeveloped prints will give inferior tones.

CAUTION: The preparation of this toner involves heating a solution of sodium sulfide and dissolving the selenium powder in it. Selenium is highly poisonous, both in powder and vapor form. Care should be taken not to inhale either the unmixed fine powder or the fumes of the heated liquid. Work in a well-ventilated room and wear a fume mask and protective gloves when mixing and using.

Formula #159

Kodak GP-1 Gold Protective Solution

Water	24 fl oz	750.0 ml
*Gold chloride, 1% solution	2½ fl drams	10.0 ml
+Sodium thiocyanate	146 grains	10.0 grams
Water to make	32 fl oz	1.0 liter

*A 1% solution may be prepared by dissolving 1 gram of gold chloride in 100 ml of water.

+An equal weight of potassium thiocyanate may be substituted.

Add the gold chloride 1% stock solution to 750 ml of water. Dissolve the thiocyanate separately in 125 ml of water. Then add the thiocyanate solution slowly to the gold chloride solution while stirring rapidly.

To use, immerse the well-washed print for 10 minutes at 68°F/20°C or until just a perceptible change in tone (slightly blue-black) takes place. Then immerse in a washing aid and wash for 1 hour.

NOTE: Toning time can be increased up to 20 minutes for increased blue-black tone.

Approximately 30 8 × 10" prints can be toned per gallon. For best results, mix immediately before use.

CAUTION: Work in a well-ventilated room and wear protective gloves when mixing and using.

Red-Tone Formulas

Formula #160

Bartolozzi Red

For rich red tones.

*Ammonium carbonate, saturated solution	1 fl oz	30.0 ml
Copper sulfate	10 grains	0.6 grams
Potassium ferricyanide	25 grains	1.5 grams

*Make up a saturated solution of ammonium carbonate by adding 90.0 grams of the crushed salt to 300 ml of cold water; shake as often as possible for several days.

Any precipitate that forms when the copper is added will be redissolved. The solution should be perfectly clear, but should be used immediately. Toning should be continued until the deepest shadow is converted, and then for 1 minute longer. The print should be refixed then washed.

Any pink stains in the whites can be removed by treating with a 1% solution of ammonia water.

Formula #161

Crimson Toner

For crimson tones on hypo-alum toned prints.

A print toned in hot hypo-alum may be further toned to a rich crimson by gold toning. After the print has been toned and thoroughly washed, it should be put through a bath made by dissolving 30 grams of sodium chloride in 1 liter of water. Rinse then tone in:

Solution A

Gold chloride	15 grains	1.0 gram
Water	15 fl oz	450.0 ml

Solution B

Potassium thiocyanate (sulfocyanide)	90 grains	6.0 grams
Water	15 fl oz	450.0 ml

Add either one to the other, stirring slowly, so as not to precipitate the gold. Prints tone in about 10 minutes and should then be fixed and rewashed. The working solution of 900 ml will tone about 18 8 × 10" prints.

Formula #162

GT-15 Red Toner

Solution A

Potassium citrate, neutral	3 oz 146 grains	100.0 grams
Water (68°F/20°C) to make	16 fl oz	500.0 ml

Solution B

Copper sulfate	¼ oz	7.5 grams
Water to make	8 fl oz	250.0 ml

Solution C

Potassium ferricyanide	95 grains	6.5 grams
Water to make	8 fl oz	250.0 ml

Mix Solution B with Solution A. While stirring, slowly add stock Solution C.

NOTE: GT-15 bleaches the print. Compensate by extending the printing time as much as 50% more.

Formula #163

DuPont 6-T Toning System

This system of bleaches and toners can be mixed and matched to provide a variety of tones from purplish sepia to brilliant yellow (see "DuPont 6-T Toning System" in chapter 11, Toning Prints).

Varigam Toning Bleach 6B-1

Water	24 fl oz	750.0 ml
Potassium ferricyanide	320 grains	22.0 grams
Potassium bromide	365 grains	25.0 grams
Water to make	32 fl oz	1.0 liter

Varigam Toning Bleach 6B-2

Water	24 fl oz	750.0 ml
Potassium ferricyanide	320 grains	22.0 grams
Potassium iodide	146 grains	10.0 grams
Water to make	32 fl oz	1.0 liter

Varigam Toning Bleach 6B-3

Water	24 fl oz	750.0 ml
Potassium ferricyanide	320 grains	22.0 grams
Sodium chloride	1 oz 75 grains	35.0 grams
Nitric acid	½ oz	15.0 ml
Water to make	32 fl oz	1.0 liter

Prints should be developed for 1½ minutes and fixed in a nonhardening fixing bath. Try using DuPont 55-D with Cachet Multibrom, as originally recommended by DuPont. Thoroughly wash the prints, then bleach in one of the above bleaching baths for twice the time necessary to completely convert the black image. Then wash again through at least three changes of water until the image is free from the yellow bleach color.

The bleached print is then placed in one of the following toning baths and left until toning is complete.

Varigam Toner 6T-1

Water	24 fl oz	750.0 ml
Thiourea (thiocarbamide)	44 grains	3.0 grams
Sodium hydroxide	88 grains	6.0 grams
Water to make	32 fl oz	1.0 liter

CAUTION: Cold water should always be used when dissolving sodium hydroxide because considerable heat is generated. If hot water is used, the solution will boil with explosive violence and may result in serious burns. If the water is not cold enough, the solution may start to steam. If this should occur, add some ice to cool the solution. DO NOT BREATHE THE VAPOR. If it starts to steam and you cannot get it to cool, leave the room until it is cool.

The best method to mix a solution of sodium hydroxide is to measure out the amount to be used, place it in a dry glass or plastic mixing container, and slowly add cold water.

Wear a dust mask, gloves, and goggles when working with the powder and solutions.

Varigam Toner 6T-2

Water	24 fl oz	750.0 ml
Thiourea (thiocarbamide)	44 grains	3.0 grams
Sodium carbonate	1½ oz	45.0 grams
Water to make	32 fl oz	1.0 liter

Varigam Toner 6T-3

Water	24 fl oz	750.0 ml
Thiourea (thiocarbamide)	44 grains	3.0 grams
Potassium carbonate	1 oz 262 grains	48.0 grams
Water to make	32 fl oz	1.0 liter

Various combinations of bleach and toner will give different tones as shown by the following table:

Bleach in	Tone in	Type of Tone Resulting
6B-3	6T-1	Deep brown, slight purplish tint.
6B-1	6T-1	Deep brown tint.
6B-2	6T-3	Increasing warmth with a golden tinge until a bright
6B-1	6T-3	sunlit type of sepia is produced with the B-3—T-3
6B-3	6T-3	combination.

6T-2 can be used instead of 6T-3 but it gives a colder color.

Gold Tone Modifier

Gold Chloride	14 grains	1.0 gram
Potassium thiocyanate	90 grains	6.0 grams
Water to make	32 fl oz	1.0 liter

This bath can be used directly on a print to produce a blue-black tone. It may also be used on prints that have been toned in any of the preceding methods. The toned print is first immersed in a 3% sodium chloride solution.

Sodium Chloride Solution

Water	24 fl oz	750.0 ml
Sodium chloride	1 oz	30.0 grams
Water to make	32 fl oz	1.0 liter

After treatment in the above chloride bath, the prints are rinsed briefly and placed in the gold solution. In general, the effect of this bath is to replace the golden tint with a reddish one. Toning may be continued for from 2 to 16 minutes, the color becoming more purple as the toning proceeds. A short wash should be done before drying.

If a slight yellowish stain appears on the gold-toned print, it may be cleared with a second treatment in any nonhardening fixing bath. Thorough washing should follow.

The following table indicates the effect obtained by gold modification after toning in the various bleach-toner combinations.

Bleach in	Tone in	Tone Resulting after Gold Modification
6B-1	6T-1	From purplish-brown to rich purple colors.
6B-2	6T-1	More crimson-like tone.
6B-1	*6T-3	Rich-reddish brown.
6B-3	*6T-3	Brilliant light reddish-brown, darkening as toning progresses.

*When modified, the 6T-3 toners produce less purple colors than the 6T-1 toners.

All gold tone modified prints change color somewhat on drying, and this cannot be avoided. The color descriptions given above apply to the dried prints.

Negative Reducer Formulas

Formula #164

Ammonium Thiosulfate Reducer

This reducer can be used to remove silver stains and dichroic fog from negatives, and for the reduction of both prints and fine-grain negative materials. It is easily prepared by adding citric acid to an ammonium thiosulfate rapid fixing bath, such as ATF-5 Acid Hardening Rapid Fixer.

Normal Ammonium Thiosulfate Reducer

Dilute 1 part of rapid fixer, containing hardener, with 2 parts of water. To each liter of the diluted fixer add 15 grams of *citric acid, anhydrous.

Removal of Silver Stains and Dichroic Fog:

Immerse the negative or print in the solution and swab the surface with absorbent cotton to hasten the removal of surface scum. The action is usually complete in 2 to 5 minutes. Remove the negative or print from the solution immediately if any reduction of low-density image detail is noted.

Reduction of Prints and Fine-Grain Negative Materials:

This solution is useful for correcting slight overexposure or overdevelopment of fine-grain negatives (see "Negative Reduction" in chapter 12, Reduction).

It can also be used as an alternative to Farmer's Reducer for overall reduction of prints (see "Print Reduction" in chapter 12).

Strong Ammonium Thiosulfate Reducer

For the reduction of high-speed negative materials.

Dilute 1 part of rapid fixer, containing hardener, with 2 parts of water. To each liter of the diluted fixer add 30 grams of *citric acid, anhydrous.

The time of treatment will depend on the type of material and the degree of reduction desired. The reaction is very slow with high-speed materials.

*Possible sulfurization of the fixer can be avoided by dissolving the citric acid in a portion of the water used for dilution.

Before reducing the negative or print, clean it thoroughly with Film Cleaner to remove any surface grease left from handling. To promote uniform reduction, prewet the material in a wetting agent such as Kodak Photo-Flo or Edwal's LFN.

CAUTION: This reducer gives off a strong odor of sulfur dioxide and should be used in a well-ventilated room. Do not use near sensitized photographic products.

Formula #165

DuPont 4-R Eder's Harmonizing Reducer

This reducer acts in a unique fashion, intensifying lighter densities and reducing the heavier densities. It is useful for correcting excessive contrast.

Bleach Solution

Water	24 fl oz	750.0 ml
Hydrochloric acid, concentrate	1 fl oz	30.0 ml
Potassium bichromate	146 grains	10.0 grams
Alum	1 oz 292 grains	50.0 grams
Water to make	32 fl oz	1.0 liter

To use, bleach to completion. Wash thoroughly until all the yellow stain has disappeared. The removal of yellow stain is accelerated if, after a 2- to 3-minute wash, the negative is immersed in a 2% solution of sodium bisulfite for a few minutes and then returned to the wash. Redevelop in a slow-acting developer, such as D-23, highly diluted (1:5), then fix and wash in the usual manner.

Formula #166

Flattening Reducer for Heavy Negatives

This reducer is useful for lessening the density and contrast of dense negatives.

Potassium ferricyanide	1 oz 73 grains	35.0 grams
Potassium bromide	146 grains	10.0 grams
Water to make	32 fl oz	1.0 liter

To use, bleach in this solution, and after thorough washing, redevelop to desired density in negative developer Ansco 47. (Developers containing a

high sulfite and low alkali concentration, such as Kodak D-76 and ID-11, should not be used for redevelopment because the sulfite tends to dissolve the silver image before the developing agents have had time to act upon it.) Then fix and wash in the usual manner. Conduct the operation in subdued light.

Formula #167

Kodak R-4a Farmer's Cutting Reducer for Overexposed Negatives

Stock Solution A

Potassium ferricyanide	1¼ oz	37.5 grams
Water to make	16 fl oz	500.0 ml

Stock Solution B

Sodium thiosulfate	16 oz	480.0 grams
Water to make	64 fl oz	2.0 liters

Immediately before use, take 30 ml of A, add 120 ml of B, and add water to make 1 liter. Add A to B; add water, and immediately pour the mixed solution over the negative, which should be in a white tray. Watch the reducing action carefully. When the negative has been reduced sufficiently, wash the negative for at least 5 minutes, and dry. Any residue left on the film can be removed during the final wash with a cotton ball.

For less rapid reducing action, and more control, use one-half the amount of Stock Solution A.

The stock solutions keep indefinitely; the combined A/B solution will exhaust in a matter of minutes. The process can be repeated, but a fresh solution should be used each time.

Formula #168

Kodak R-4b Farmer's Proportional Reducer for Overdeveloped Negatives

Stock Solution A

Potassium ferricyanide	¼ oz	7.5 grams
Water to make	32 fl oz	1.0 liter

Stock Solution B

Sodium thiosulfate	6¾ oz	200.0 grams
Water to make	32 fl oz	1.0 liter

These are working solutions. The ferricyanide will keep indefinitely if shielded from strong daylight.

Place the dry film in Solution A for 1 to 4 minutes at 68°F/20°C. As with Kodak R-4a, watch the reduction carefully. Transfer the film to Solution B for 5 minutes, then wash.

You may repeat this process if necessary. If hypo contaminates Solution A through repeated treatments, the life of the ferricyanide will be shortened. Therefore, be sure to thoroughly wash the film before repeating. After the desired reduction has been achieved, wash the film thoroughly, since it has just been treated with fixer in Solution B.

NOTE: This formula also may be used to reduce general fog. In this case, mix 1 part of Solution A with 1 part water before using.

CAPACITY: Approximately 15 sheets of 8 × 10″ film, which equates to 60 sheets of 4 × 5″, 30 sheets of 5 × 7″, and about 480 individual 35mm frames!

Formula #169

Kodak R-15 Super Proportional Reducer for Extreme Overdevelopment

Stock Solution A

Potassium persulfate	1 oz	30.0 grams
Water to make	32 fl oz	1.0 liter

Stock Solution B

Water	8 fl oz	250.0 ml
*Sulfuric acid, 10% solution	½ oz	15.0 ml
Water to make	16 fl oz	500.0 ml

*To prepare a 10% solution of sulfuric acid, take 1 part sulfuric acid and, with caution to avoid contact with the skin, add it slowly to 9 parts of water with stirring. Never add the water to the acid. The solution may boil and spatter the acid on the hands or face, causing serious burns. Because of the presence of sulfuric acid, only glass, hard rubber, or impervious and unchipped enamelware should be used to contain the reducer solution during mixing and use.

To use, take 2 parts of Solution A and 1 part of Solution B. Fix with an acid-hardening fixer and wash the negative thoroughly. Immerse in the reducer with frequent agitation and inspection until the required amount of reduction is attained. Remove the negative, immerse in an acid fixing bath for a few minutes, and wash thoroughly before drying.

The used solution does not keep and should be discarded. In storage, stock Solution A should be kept away from excessive heat and light. The life of stock Solution A is about 2 months.

CAUTION: Be sure to use gloves when mixing and during use. Observe all other cautions.

NOTE: 4.25 grams of sodium bisulfate may be substituted for the sulfuric acid.

Print Reducers

Formula #170

Farmer's Reducer

See chapter 12, Reduction, for the technique of print reduction.

Stock Solution A

Potassium ferricyanide	2 oz	60.0 grams
Potassium bromide	1 oz	30.0 grams
Water to make	8 fl oz	250.0 ml

Stock Solution B

Hypo	4 oz	120.0 grams
Water to make	16 fl oz	500.0 ml

For overall reduction, mix 7.5 ml of Solution A with 180 ml of Solution B, and add 1500 ml of water. The amount of Solution A may be increased or decreased to control the time of reduction.

For local reduction, mix the same proportions as for overall reduction, adding more of Solution A if reduction is too slow.

For spot reduction, mix 1 part A to 2 parts B without adding water.

Solution A will keep at least 6 months in a well-stoppered brown or green bottle. However, when A and B are mixed for use, they become unstable. The mixture may deteriorate within a few minutes or may work for as long as $\frac{1}{2}$ hour. The weaker the working solution, the longer it will keep. You can tell when it is exhausted by its loss of color. It's a good idea to renew the mixture every 10 minutes.

Formula #171

Kodak R-14 Nonstaining Reducer

Farmer's reducer can cause a brownish stain with certain papers. This problem can sometimes be avoided by adding a small quantity of potassium iodide to the final print fixing bath. If the brownish residual stain still persists, a nonstaining reducer should be used instead of Farmer's.

Solution A

Water	16 fl oz	500.0 ml
Thiourea	$\frac{1}{2}$ oz	15.0 grams
Sodium thiosulfate, crystal	25 oz	700.0 grams
Water to make	32 fl oz	1.0 liter

Solution B

Water	6 fl oz	200.0 ml
Potassium ferricyanide	$2\frac{1}{2}$ oz	75.0 grams
Water to make	8 fl oz	250.0 ml

Add 14 parts water to 5 parts of Solution A, and then add 1 part of Solution B. The resulting solution can be diluted again (1:1) to produce a convenient working concentration.

Formula #172

Print Rehalogenating Bleach

Use this bleach to convert all silver metal to silver bromide in a print prior to using the redevelopment method of toning (see "Redevelopment Method" in chapter 9, Paper Development). After rehalogenating, any toning developer, warm or cold, can be used to give the purest tones possible.

Potassium ferricyanide	117 grains	8.0 grams
Potassium bromide	175 grains	12.0 grams
Water to make	32 fl oz	1.0 liter

1. Develop, fix, and wash a print in the usual manner. Use a neutral tone developer such as Kodak D-72.
2. Immerse the print in the rehalogenating bleach until only a faint brown image remains.
3. Rinse the print for 5 minutes in running water.
4. Redevelop the print in any warm or cold toning developer.
5. If not otherwise specified, wash RC prints for 5 to 15 minutes, fiber-based prints for 30 minutes.

Negative Intensifiers

Formula #173

Chromium Intensifier #1

Potassium dichromate, 10% solution	.4 fl oz	12.5 ml
Hydrochloric acid, concentrated	5 minims	0.3 ml
Water to make	3.2 fl oz	100.0 ml

See Chromium Intensifier #2 for instructions for use.
CAUTION: Always add the hydrochloric acid to the water slowly, stirring constantly, and never add the water to the acid; otherwise, the solution may boil and spatter the acid on the hands or face, causing serious burns.

Formula #174

Chromium Intensifier #2

Potassium dichromate, 10% solution	.4 fl oz	12.5 ml
Hydrochloric acid, concentrated	.038 fl oz	1.2 ml
Water to make	3.2 fl oz	100.0 ml

Immerse the negatives in the bath until completely bleached; this converts the silver image into a combination of chloride and chromium compound. The negative is then washed until completely free from yellow stain, about 5 minutes, and redeveloped, after exposure to daylight, with a normal developer (not fine-grain) until the image has blackened completely. A good developer to use for redevelopment is Kodak D-72 (1:3). After redevelopment, fix the negative for 3 to 5 minutes, and then wash thoroughly and dry. One advantage of these formulas is that if sufficient intensification is not achieved, the process may be repeated.

Intensifier #1 gives more intensification than #2. Negatives to be intensified should first be hardened either in the fixer or as an after-treatment. Failure to do so may cause the gelatin to reticulate and ruin the negative.

CAUTION: Always add the hydrochloric acid to the water slowly, stirring constantly, and never add the water to the acid; otherwise, the solution may boil and spatter the acid on the hands or face, causing serious burns.

Formula #175

Ilford In-3 Chromium Intensifier

Bichromate Stock Solution

Potassium bichromate	3 oz 146 grains	100.0 grams
Distilled water to make	32 fl oz	1.0 liter

The Bichromate Stock Solution keeps indefinitely.

Bleaching Solution A

Bichromate Stock Solution	3.2 fl oz	100.0 ml
Hydrochloric acid, concentrated	.08 fl oz	2.4 ml
Distilled water to make	32 fl oz	1.0 liter

Bleaching Solution B

Bichromate Stock Solution	3.2 fl oz	100.0 ml
Hydrochloric acid, concentrated	.38 fl oz	12.0 ml
Distilled water to make	32 fl oz	1.0 liter

The bleaching solution should be made fresh each time. Immerse the washed negative into either of these solutions until it is entirely bleached, wash until the yellow stain is completely removed, and redevelop in strong artificial or subdued daylight with a negative developer such as Ilford ID-36. Wash thoroughly.

Solution A gives more intensification than Solution B.

CAUTION: Always add the hydrochloric acid to the water slowly, stirring constantly, and never add the water to the acid; otherwise, the solution may boil and spatter the acid on the hands or face, causing serious burns.

Formula #176

Kodak In-1 Mercury Intensifier

Bleach the negative in the following solution until it is white. Then wash it thoroughly.

Potassium bromide, anhydrous	¾ oz	22.5 grams
Mercuric chloride	¾ oz	22.5 grams
Water to make	32 fl oz	1.0 liter

Following the bleach and wash, the negative can be intensified in any of the following solutions. Each solution, in order, gives greater density than the one preceding it.

1. A 10% sulfite solution.
2. A developing solution, such as Kodak D-72 diluted 1:2.
3. Dilute ammonia—1 part of concentrated ammonia (28%) to 9 parts of water.
4. For greatly increased contrast use Monckhoven's Intensifier.

CAUTION: Mercuric chloride is possibly the single most toxic substance in this book. Use all necessary precautions, including a face mask, when handling the dry powder. This formula is included solely because of its effectiveness at intensification.

Mercuric chloride must not be allowed to contact the skin. Use impervious rubber gloves, such as Bench Mark or Bluettes, while handling these chemicals or their solutions. The outer surface of the gloves and the hands should be washed thoroughly after each use.

Containers of mercury intensifier solutions should be adequately labeled as poisonous. If they are used in the home, they should be stored in a locked cabinet out of the reach of children. Read carefully any directions on the manufacturer's label for these substances. Follow regulations of local health authorities regarding disposal of waste solutions.

IF YOU HAVE ANY DOUBTS, WHATSOEVER, ABOUT YOUR ABILITY TO SAFELY HANDLE TOXIC CHEMICALS, DO NOT USE MERCURIC CHLORIDE.

Formula #177

Kodak In-5 Silver Intensifier

This formula gives proportional intensification (increased density in equal percentages in each area of the image) and is easily controlled by varying the time of treatment. In-5 acts more rapidly on fine-grain materials and produces greater intensification than on coarse-grain materials. The formula is equally suited for positive and negative film. It is the only intensifier

known that will not change the color of the image on positive film during projection.

***Stock Solution #1**

Silver Nitrate	½ oz	15.0 grams
Distilled water to make	8 fl oz	250.0 ml

*Store in a brown glass bottle.

Stock Solution #2

Sodium sulfite	½ oz	15.0 grams
Water to make	8 fl oz	250.0 ml

Stock Solution #3

Sodium thiosulfate	¾ oz 54 grains	26.0 grams
Water to make	8 fl oz	250.0 ml

Stock Solution #4

Metol	⅛ oz	4.0 grams
Sodium sulfite	91 grains	6.0 grams
Water to make	24 fl oz	750.0 ml

NOTE: When mixing Stock Solution #4, add a pinch of the sodium sulfite first, stir in the metol until well dissolved, and then add the balance of the sulfite.

To use, prepare the intensifier solution as follows: add 1 part of Solution #2 to 1 part of Solution #1, stir well. A white precipitate will form but will dissolve with the addition of 1 part of Solution #3. Allow the mixture to stand for a few minutes until clear.

Add, while stirring, 3 parts of Solution #4. The intensifier is ready for use, and the film should be treated immediately. The mixed solution is stable for approximately 30 minutes at 68°F/20°C.

After intensification, immerse the film for 2 minutes in a 30% plain hypo bath (30 grams of sodium thiosulfate to 100 ml of water).

I recommend not intensifying with silver beyond 10 minutes, even though Kodak claims it can be used up to 25. If you do over intensify, simply use two-solution Farmer's Reducer R-4b to reduce or eliminate the silver.

Formula #178

Kodak In-6 Intensifier

This intensifier produces the greatest degree of intensification of any known single-solution formula when used with high-speed negative materials. The intensified image is of a brownish hue, and is not completely permanent. However, it will remain in satisfactory condition for several years if stored properly. The intensified image is destroyed by acid hypo; under no circumstances should the intensified negatives be placed either in fixing baths or in wash water contaminated with fixing bath.

Kodak In-6 Intensifier is not suitable for fine-grain materials or for use when only moderate intensification is desired.

Solution A

Distilled water at (68°F/20°C)	24 fl oz	750.0 ml
Sulfuric acid, concentrated	.96 fl oz	30.0 ml
Potassium dichromate, anhydrous	¾ oz	22.5 grams
Water to make	32 fl oz	1.0 liter

Solution B

Distilled water at (68°F/20°C)	24 fl oz	750.0 ml
Sodium bisulfite, anhydrous		3.8 grams
Hydroquinone	½ oz	15.0 grams
Kodak Photo-Flo 200, undiluted	.12 fl oz	3.8 ml
Water to make	32 fl oz	1.0 liter

Solution C

Distilled water at (68°F/20°C)	24 fl oz	750.0 ml
Sodium thiosulfate, pentahydrate	¾ oz	22.5 grams
Water to make	32 fl oz	1.0 liter

The order of mixing is important and should be followed. To 1 part of Solution A, add with constant stirring, 2 parts of Solution B. Still stirring, add 2 parts of Solution C, and finally 1 part of Solution A.

To intensify negatives, first wash the negatives to be treated for 5 to 10 minutes. Harden them for 5 minutes in Kodak SH-1 Formalin Supplementary Hardener and wash them again for 5 minutes.

The greatest possible degree of intensification is achieved by treating the negatives for approximately 10 minutes at 68°F/20°C. If a lesser degree of intensification is desired, treat the negatives for shorter times. Agitate them frequently during treatment to prevent streaking. Treat only one negative at a time when processing in a tray.

When a satisfactory degree of intensification is reached, wash the negative for 10 to 20 minutes and dry as usual.

NOTE: The stock solutions will keep in stoppered bottles for several months; the mixed intensifier is stable for 2 or 3 hours without use. After using it once, discard the working solution, or it may leave a silvery scum on subsequent negatives.

CAUTION: Always add the sulfuric acid to the water slowly, stirring constantly, and never add the water to the acid; otherwise, the solution may boil and spatter the acid on the hands or face, causing serious burns.

Formula #179

Monckhoven's Intensifier

Solution A

Distilled water	16 fl oz	500.0 ml
Sodium cyanide	½ oz	15.0 grams

Solution B

Distilled water	16 fl oz	500.0 ml
Silver nitrate, crystals	¾ oz	22.5 grams

To prepare this formula, dissolve the cyanide and the nitrate separately and add the nitrate, Solution B, to the cyanide, Solution A, until a permanent precipitate is produced. Allow the mixture to stand a short time, then filter. This is kept in a brown bottle.

Redevelopment cannot be controlled as with Smith-Victor's VMI, but must go to completion.

CAUTION: Sodium cyanide is poisonous and may be fatal if swallowed. Sodium cyanide reacts with acids (e.g., acetic acid) to form the poisonous gas, hydrogen cyanide. Cyanide salts and solutions must never be used except in adequately ventilated areas.

Sodium cyanide must not be allowed to contact the skin. Use impervious rubber gloves, such as Bench Mark or Bluettes, while handling these chemicals or their solutions. The outer surface of the gloves and the hands should be washed thoroughly after each use.

IF YOU HAVE ANY DOUBTS, WHATSOEVER, ABOUT YOUR ABILITY TO SAFELY HANDLE TOXIC CHEMICALS, DO NOT USE SODIUM CYANIDE.

Formula #180

Smith-Victor's VMI

Mercuric chloride	190 grains	13.0 grams
Magnesium sulfate	2 oz	60.0 grams
Potassium iodide	1 oz	30.0 grams
Sodium sulfite	½ oz	15.0 grams
Water to make	32 fl oz	1.0 liter

A sediment will form at the bottom of the bottle. You may filter it if you wish, but in any case pour as little as possible into the tray. If sediment does settle on the negative, remove by carefully brushing with a wet piece of cotton.

Place the wet negative, emulsion side up, in a white tray. VMI is very strong. Although most negatives will take from 15 seconds to 2 minutes, VMI can be used up to 10 minutes, for a wide range of intensification. From 1 to 3 minutes will intensify negatives approximately two to three times; after that the process continues at a slower rate. After 10 minutes, no noticeable change will take place. Start with 15 seconds, as you can always repeat the process.

After intensification, wash the negative for 10 minutes. Soak in wetting agent, and hang to dry. The negative will turn orange while it is washing. Too much intensification and the orange stain will mottle and streak. If this happens while the negative is still wet, hold it in a tray of water and wipe off any uneven areas with a cotton ball. Check the negative carefully before hanging it to dry; unevenness can easily be seen.

If after the negative is dry, you notice unevenness or it is overintensified, resoak it in plain hypo. The VMI will entirely dissolve, and you can start the process over.

The advantage of VMI is that, unlike chromium intensifiers, it works on the thin, weak areas of the negative. It effectively strengthens detail especially in the shadow areas, creates greater separation of tone, and increases contrast.

VMI works well with pyro-developed negatives. However, do not try to remove the VMI once it is dry, as immersion in hypo will also remove the pyro stain. Make certain that any orange mottling or streaking is removed with cotton while the negative is wet.

CAUTION: Mercuric chloride is possibly the single most toxic substance in this book. Use all necessary precautions, including a facemask, when handling the dry powder. This formula is included solely because of its effectiveness at intensification.

Mercuric chloride must not be allowed to contact the skin. Use impervious rubber gloves, such as Bench Mark or Bluettes, while handling these chemicals or their solutions. The outer surface of the gloves and the hands should be washed thoroughly after each use.

Containers of mercury intensifier solutions should be adequately labeled as poisonous. If they are used in the home, they should be stored in a locked cabinet out of the reach of children. Read carefully any directions on the manufacturer's label for these substances. Follow regulations of local health authorities regarding disposal of waste solutions.

IF YOU HAVE ANY DOUBTS, WHATSOEVER, ABOUT YOUR ABILITY TO SAFELY HANDLE TOXIC CHEMICALS, DO NOT USE MERCURIC CHLORIDE.

Paper Intensifier Formula

Formula #181

Chromium Intensifier for Prints

Solution A

Potassium bichromate	1 oz	30.0 grams
Water to make	16 fl oz	500.0 ml

Solution B

Hydrochloric acid, concentrated	1¾ fl oz	55.0 ml
Water to make	16 fl oz	500.0 ml

The stock solutions will keep well in brown glass bottles.

NOTE: Prints for intensification should not be hardened in the fixer. If they have been, use Dehardener.

Add 30 ml of Solution B to 30 ml of Solution A, plus 180 ml of water (1:1:6). Soak the dry print for 10 minutes in plain water. Transfer the print to the bleach mixture, and continuously agitate for a minimum of 2 minutes or until most of the image either has disappeared or at least become faded brown.

Bleaching can take place in normal, artificial light. However, redevelopment should be done under safelight conditions to prevent solarization.

If at the end of 2 minutes the print has not changed much, continue the bleaching action for a few minutes. If the print still does not react, or if spots or streaks appear, strengthen the bleach by using as much as 240 ml of A, 60 ml of B, and 180 ml of water. If, after strengthening the bleach or extending the time, spots or streaks remain, they will probably disappear with redevelopment.

Rewash the bleached print until the water is perfectly clear. This may take as long as 1 hour in running water at about 70°F/21°C. This is the most critical step, as any residual bichromate will stain the print during redevelopment. The washing time can be shortened by at least half by placing the print for 10 to 20 seconds in a 3% solution of sodium carbonate. If this method is used, handle the prints carefully. This is because carbonate considerably softens the emulsion.

Redevelop the image with any nonstaining developer (e.g., Lootens' Amidol Black Developer or Kodak D-72) for 2 to 5 minutes. The print should be washed for about ½ hour. Always use a fresh developer for print intensification.

After redevelopment, do not refix the print, as it will become reduced instead of intensified. Wash the print thoroughly, and then hang it to dry to avoid the emulsion sticking to the drying surface.

Inspection Formulas

Formula #182

Basic Scarlet N (for use with MQ developers)

Chrysoidine	15 grains	1.0 gram
*Phenosafranine	15 grains	1.0 gram
Distilled water	6½ fl oz	200.0 ml

Add:

Alcohol, isopropyl	1½ drams	5.0 ml

*Safranine-O, a derivative of phenosafranine, may be substituted in the same amount. Safranine-O is considerably less expensive and more active.

To use, mix 1 part of the stock solution with 50 parts water. Soak the film for 2 minutes, and then transfer to the developer without rinsing. After 2 minutes in the developer, a yellow-green safelight (Kodak #3) can be turned on. Some workers leave the safelight on; others prefer to inspect the film for 10 to 15 seconds at 1-minute intervals.

NOTE: A variation of Basic scarlet N, called De-Tec, developed by Dr. Kevin Pernicano, is available from Antec (see appendix II, Sources).

Pinakryptol Green

At one time Pinakryptol was supplied only in powder form, from which the photographer mixed a stock solution. Photographers' Formulary (see appendix II) sells it already in solution, in 100 ml quantities. If you purchase the solution from the Formulary, do not dilute any further. Follow their directions and use as is, directly out of the bottle. Use at least 500 ml.

Stock Solution

Pinakryptol green	15 grains	1.0 gram
*Water to make	16 fl oz	500.0 ml

*A 50/50 mixture of water and alcohol will improve the keeping qualities of the stock solution.

To use as a forebath, dilute 1 part of the stock solution with 10 parts water. The film is immersed in the desensitizer for 2 minutes with the room in total darkness, then rinsed (note that there is no rinsing with Basic Scarlet N). Finally, it is transferred to the developing solution. Inspection should be carried on by either of the two methods detailed for Basic Scarlet N.

Pinakryptol green can also be used directly in some developers, particularly Rodinal or a diluted glycin developer. To use in the developer, dilute 1 part of the stock solution with 30 parts developer. After 2 minutes in the developer, the safelight can be turned on. This procedure should not be used in developers that contain more than 1 gram per liter of hydroquinone.

NOTE: Any developer with more than 1 gram of hydroquinone per liter is not suitable for the addition of a sensitizing dye.

Miscellaneous

Formula #184

Dehardener

This solution should be used prior to toning prints that have been hardened during fixing. The formula will soften the emulsion so that the print will tone and spot more easily and washing will be more effective.

Water	24 fl oz	750.0 ml
Sodium carbonate, monohydrate	1 oz	30.0 grams
Water to make	32 fl oz	1.0 liter

To use, soak the print for up to 10 minutes in the solution, agitating occasionally. Handle the prints very carefully. The emulsion is soft and no longer protected by hardener.

Formula #185

Developer Stain Remover for Clothing

Dampen the stains with: 5% Solution of potassium permanganate.

Allow to set for a few minutes and then apply: 10% solution of sodium bisulfite

NOTE: Care must be taken with colored fabrics, as the area may become bleached. Make a test on an out-of-the-way area, such as a shirttail.

Formula #186

Developer Stain Remover for Hands #1

This formula is similar to the one above but with a slightly different dilution. It is generally considered to be safe for removing silver stains from hands.

Solution 1

Potassium permanganate	106 grains	7.3 grams
Water	32 fl oz	1.0 liter

Keep the hands in Solution 1 for a few minutes then rinse in:

Solution 2

Sodium bisulfite	3 oz	90.0 grams
Water	32 fl oz	1.0 liter

Wash thoroughly with soap and water.

Formula #187

Developer Stain Remover for Hands #2

This formula is generally considered to be safe for removing silver stains from hands.

Solution 1

Potassium ferricyanide	1 oz	30.0 grams
Potassium bromide	1 oz	30.0 grams
Water	32 fl oz	1.0 liter

Keep the hands in Solution 1 for a few minutes then rinse in:

Solution 2

Sodium bisulfite	1 oz	30.0 grams
Water	24 fl oz	750.0 ml

Wash thoroughly with soap and water.

Formula #188

Film Cleaner

This formula is especially good for removing water spots from the film base.

Ammonia, 28%, concentrated	0.16 oz	5.0 ml
Distilled water	3 fl oz	95.0 ml
Alcohol, isopropyl to make	32 fl oz	1.0 liter

Apply by wiping film base gently with cotton, Photowipes, or soft microfiber photo cloth.

Formula #189

Fixer Test Solution

(Thanks to Manuel A. Garcia Maceda of Mexico City)

Water	2½ fl oz	80.0 ml
Potassium iodide	73 grains	5.0 grams
Water to make	3 fl oz	100.0 ml

Add 3 to 4 drops of Fixer Test Solution to approximately 15 ml of used fixer. If nothing happens, or if a clear cloudiness appears, the fixer is okay. If a white, or yellow-white, precipitate is formed, the fixer should be thrown out, as the buildup of by-products is reaching a critical stage.

Formula #190

Hypo Clearing Agent (HCA)

Water (125°F/52°C)	24 fl oz	750.0 ml
Sodium sulfite	7 oz	200.0 grams
*Sodium bisulfite	1 oz 292 grains	50.0 grams
Water to make	32 fl oz	1.0 liter

*The sodium bisulfite lowers the pH in order to prevent softening of the emulsion of film. If paper is to be used, the bisulfite may be left out in order to improve the paper's gloss.

To make a working-strength bath, dilute 1 part washing aid to 9 parts water. After normal fixing, transfer the prints or film to the washing aid with or without a water rinse. The water rinse increases the capacity of the washing aid.

Papers	Water Rinse After Fixer (optional)	HCA (with agitiation)	Final Running Water Wash
SW	1 minute	2 minutes	10 minutes
DW	1 minute	3 minutes	20 minutes
Film	30 seconds	1 to 2 minutes	5 minutes

Without the optional water rinse, 1 liter can be used for 20 8 × 10″ prints or 15 8 × 10″ films, or the equivalent.

With optional water rinse, 1 liter can be used for 50 8 × 10″ prints or 40 8 × 10″ films, or the equivalent.

Formula #191

Kodak Amidol Redeveloper

Water at room temperature	24 fl oz	750.0 ml
Sodium sulfite	¾ oz 56 grains	25.0 grams
Amidol	95 grains	6.5 grams
Water to make	32 fl oz	1.0 liter

This developer, being nonstaining, can be used for redevelopment following the use of Kodak S-6 Stain Remover.

Formula #192

Kodak HT-1a Residual Hypo Test

Small traces of hypo in films or prints accelerate the rate of deterioration. It is difficult to test for small quantities of hypo, but the following test will indicate when the film or prints may be considered reasonably free from hypo.

Distilled water	6 fl oz	180.0 ml
Potassium permanganate	4 grains	0.3 grams
Sodium hydroxide	8 grains	0.6 grams
Distilled water to make	8 fl oz	250.0 ml

To test film: Take 250 ml of pure water in a clear glass and add 1 ml of the solution. Then take the equivalent of 10 35mm frames (3 frames of 120 or a single 4 × 5″ sheet of film) from the wash water and allow the water to drip for 30 seconds into the glass of test solution. If a small percentage of hypo is present, the violet color will turn orange in about 30 seconds, and with a larger concentration the orange color will turn to yellow. In either case, the film should be returned to the wash until further tests produce no change in the violet color.

To test prints: Take 125 ml of pure water in a clear glass and add 1 ml of the test solution. Pour 15 ml of the diluted solution into a clear 30-ml glass container.

Take 6 prints, size 4 × 5″ or equivalent, from the wash water and allow water from them to drip for 30 seconds into the 15 ml of the dilute test solution. If a small quantity of hypo is present, the violet color will turn orange in about 30 seconds and become colorless in 1 minute. The prints should be returned to the wash and allowed to remain until further tests produce no change in the violet color.

NOTE: Oxidizable organic matter reacts with the test solution and changes its color in the same manner as hypo. The wash water should therefore be tested as follows: Prepare two samples of the test solution, using distilled water. Add a volume of tap water to one sample equal to that of the wash water drained with the film or prints into the second sample. If the sample to which tap water has been added remains a violet color, organic matter is not present. However, if the color is changed slightly by the tap water, the presence of hypo in the film or prints will be shown by the relative color change of the two samples. For example, if the tap water sample turned pink and the wash water sample became yellow, hypo is present. If both turned the same color, this would indicate the absence of hypo.

CAUTION: Cold water should always be used when dissolving sodium hydroxide because considerable heat is generated. If hot water is used, the solution will boil with explosive violence and may result in serious burns. If the water is not cold enough, the solution may start to steam. If this should occur, add some ice to cool the solution. DO NOT BREATHE THE VAPOR. If it starts to steam and you cannot get it to cool, leave the room until it is cool.

The best method to mix a solution of sodium hydroxide is to measure out the amount to be used, place it in a dry glass or plastic mixing container, and slowly add cold water.

Wear a dust mask, gloves, and goggles when working with the powder and solutions.

Formula #193

Kodak HT-2 Hypo Test Solution

This formula reacts with fixer to cause a yellow-brown stain. The darker the stain, the more fixer remaining in the emulsion.

Water	24 fl oz	750.0 ml
Acetic acid, 28%	4 fl oz	125.0 ml
*Silver nitrate	¼ oz	7.5 grams
Water to make	32 fl oz	1.0 liter

*Silver nitrate requires 24 hours to completely dissolve.

To use, place a drop on the center of a blank piece of white print paper that has been washed along with ordinary prints. After 2 minutes in subdued light, flush the print with a mild saltwater solution. The presence of anything more than a slight yellow stain indicates that excessive fixer remains in the print and the prints need more washing.

Store the solution in a dark glass bottle away from strong light. A convenient way to dispense it is to fill a small brown eyedropper bottle, available at most drug stores.

A stain comparison chart is available from Kodak, publication N-405, *Hypo Estimator*, (800) 242-2424, ext. 12.

Formula #194

Kodak S-6 Stain Remover

This formula is used for developer or oxidation stains. It is also effective in removing water spots on negatives if they have not been allowed to set too long.

Stock Solution A

*Potassium permanganate	75 grains	5.2 grams
Water to make	32 fl oz	1.0 liter

*Dissolve the permanganate completely, otherwise spots may appear on the negative.

Stock Solution B

Cold water	16 fl oz	500.0 ml
Sodium chloride	2½ oz	75.0 grams
Sulfuric acid, concentrate	½ fl oz	16.0 ml
Water to make	32 fl oz	1.0 liter

CAUTION: Always add the sulfuric acid to the water slowly while stirring, and never add the water to the acid; otherwise, the solution may boil and spatter the acid on the hands or face, causing serious burns.

Stock Solution C

Sodium bisulfite, 1% solution	15 grains	1.0 gram
Water	3 fl oz	100.0 ml

Harden the film for 2 to 3 minutes in Kodak SH-1 Formalin Supplementary Hardener. After hardening, wash for 5 minutes. Bleach the negative for 3 to 4 minutes using equal parts A and B (the solutions should not be mixed until ready for immediate use, since they do not keep long after mixing).

When bleaching is complete, immerse the negative in Solution C to remove any brown stains. Rinse the negative well, and redevelop in a strong light (not direct sunlight). Use a nonstaining developer such as Kodak D-72, diluted 1:2; Lootens' Amidol Black Developer; or Kodak Amidol Redeveloper.

NOTE: Developers containing high sulfite and low alkali concentrations (e.g., Kodak D-76) should not be used for redevelopment. The sulfite tends to dissolve the silver image before the developing agents have had time to act on it.

Formula #195

Kodak SH-1 Formalin Supplementary Hardener

This formula is recommended for the treatment of negatives that would normally be softened considerably by chemical treatment during the removal of several types of stains, or by intensification or reduction techniques.

Water	16 fl oz	500.0 ml
Formaldehyde, 37% (formalin)	2½ drams	10.0 ml
Sodium carbonate, monohydrate	88 grains	6.0 grams
Water to make	32 fl oz	1.0 liter

After hardening for 3 minutes, negatives should be rinsed and immersed for 5 minutes in a fresh acid fixing bath and well washed before further treatment.

CAUTION: Formaldehyde is highly toxic. Use in a well-ventilated area and exercise all handling precautions. Unless your mixing area has an effective fume hood it is highly recommended that you mix formaldehyde outdoors, and even then an appropriately rated fume mask should be used.

Formula #196

Kodak SH-5 Prehardener

For high-temperature processing.

Water	28 fl oz	900.0 ml
*Kodak Anti-Fog No. 2, 0.5% solution	1½ oz	40.0 ml
Sodium sulfite	1 oz 290 grains	50.0 grams
Sodium carbonate, monohydrate	175 grains	12.0 grams
Water to make	32 fl oz	1.0 liter

Just before use, add:

Formaldehyde, 37% (formalin)	1¼ drams	5.0 ml

*Kodak Anti-Fog #2 is 6-nitrobenzimidazole nitrate. To make a 0.5% solution, dissolve 1 gram in 200 ml of distilled water.

NOTE: The entire bath, with the exception of the formalin, may be kept as a stock solution. Just before use, add 5 ml of the formalin to each liter and mix thoroughly.

To use, soak the exposed film in the prehardener for 10 minutes with moderate agitation. Then drain the film for a few seconds, immerse in water for 30 seconds, drain thoroughly, and immerse in the developer. In general, developers such as Kodak D-76 may be used up to 95°F/35°C. Above 95°F/35°C it may be better to use developers specifically formulated for tropical developing. (See formulas under "Tropical Developers—High-Temperature Processing up to 105°F/40°C.")

The following are developing time adjustments for use with a prehardener at temperatures between 75°F/24°C and 95°F/35°C:

75°F/24°C: Use normal developing time recommended for processing without prehardener at 68°F/20°C.

80°F/27°C: Develop for 85% of time at 68°F/20°C.

85°F/29°C: Develop for 70% of time at 68°F/20°C.

90°F/32°C: Develop for 60% of time at 68°F/20°C.

95°F/35°C: Develop for 50% of time at 68°F/20°C.

After the development rinse, fix in an acid-hardening fixing bath such as Kodak F-5. Wash and dry as usual.

At temperatures above 95°F/35°C, increase the 6-nitrobenzimidazole content of the prehardener up to double the normal formula concentration, if necessary, to control fog. Process as just described, using a low-activity developer to avoid excessively short processing times. The average development time at 110°F/43°C, after prehardening, is 25% of the normal time at 68°F/20°C.

Formula #197

Kodak ST-1 Residual Silver Test Solution

An overworked fixing bath contains complex silver thiosulfate compounds that can be retained by negatives or prints and cannot be removed completely by washing.

This formula detects the presence of undissolved silver compounds in either negatives or prints. These can be the result of inadequate fixing or overfixing in which previously dissolved silver is absorbed into the material.

| Water | 3.2 fl oz | 100.0 ml |
| *Sodium sulfide, anhydrous | 29 grains | 2.0 grams |

*Be sure to use sodium sulfide, not sodium sulfite.

Mix in a well-ventilated area and store in a small stoppered bottle for not more than 3 months.

Dilute 1 part of the stock solution with 9 parts of water. The diluted solution keeps for a limited time and should be replaced weekly.

Place a drop of the solution on a clear area of the negative or print, such as the border (an unexposed negative or print that has been processed in the fixer being tested). Wait 2 or 3 minutes, then remove any excess solution with a clean white blotter.

Any yellowing, other than a barely visible cream tint, or noticeable brown stain indicates excess silver in the emulsion. If the test is positive, residual silver can be removed by refixing in fresh hypo and rewashing for the recommended time. The yellow stain is permanent.

Prints already toned in sulfide or selenium toner will not respond to this test because the residual silver has been toned together with the image.

Alternative Residual Silver Test Solution

An alternative residual test solution can be made from a 10% solution of selenium toner concentrate. Use this solution in the same way as ST-1. Residual silver is indicated by a red stain.

Formula #198

Kodak TC-1 Tray Cleaner

Water	32 fl oz	1.0 liter
*Potassium dichromate, anhydrous	3 oz	90.0 grams
*Sulfuric acid, concentrated	3 fl oz	96.0 ml

*CAUTION: Corrosive, causes burns. Avoid contact with eyes, skin, and clothing. In case of contact, flush eyes and skin with water. Potassium dichromate can also cause allergic skin reactions; the dust can cause irritation. Mixing should be performed in a well-ventilated area using gloves, goggles, and aprons.

Always add the sulfuric acid to the water slowly while stirring, and never add the water to the acid; otherwise, the solution may boil and spatter the acid on the hands or face, causing serious burns.

NOTE: Store the solution in a stoppered glass bottle away from light.

Pour a small volume of TC-1 into the tray or vessel to be cleaned. Slosh it around so that the solution has access to all parts of the tray; then pour the solution out and wash the tray thoroughly with water until all traces of the cleaner disappear. This solution will remove stains caused by oxidation products of developers as well as some silver and dye stains. It should not be used to clean hands.

Formula #199

Kodak TC-3 Stain Remover for Trays

Solution A

Water	24 fl oz	750.0 ml
Potassium permanganate	29 grains	2.0 grams
Sulfuric acid, concentrated	1 dram	4.0 ml
Water to make	32 fl oz	1.0 liter

CAUTION: Always add the sulfuric acid to the water slowly while stirring, and never add the water to the acid; otherwise, the solution may boil and spatter the acid on the hands or face, causing serious burns.

NOTE: Store the solution in a stoppered glass bottle away from light.

Solution B

Water	24 fl oz	750.0 ml
Sodium bisulfite, anhydrous	1 oz	30.0 grams

| Sodium sulfite | 1 oz | 30.0 grams |
| Water to make | 32 fl oz | 1.0 liter |

To remove stains in trays from silver, silver sulfide, and many dyes, pour a small quantity of Solution A into the tray and allow to remain for a few minutes; rinse well and then replace with a similar volume of Solution B. Agitate to clear the brown stain completely, then wash thoroughly.

Solutions A and B can be used for cleaning several trays but should be discarded after use.

An acid-fixing bath may be used in place of Solution B, but it is important to wash thoroughly to eliminate hypo from the tray and the hands.

Formula #200

Print Flattener

| Glycerin | 2 fl oz | 60.0 ml |
| Water to make | 32 fl oz | 1.0 liter |

Immerse prints in this solution for not less than 5 minutes following washing and before drying the prints.

Dampening the back of dried prints with a solution of 1 part glycerin to 3 parts of water before placing them under pressure will also ensure flatness and substantially eliminate their tendency to curl.

Formula #201

Rapid Film Dryer

(Thanks to Paul Lewis)

This formula will reduce the drying time of film without the risk of alcohol clouding the film.

| Isopropyl alcohol | 1 fl oz | 30.0 ml |
| Distilled water | 31 fl oz | 970.0 ml |

Add:

Edwal's LFN (12 drops)

Soak the film for 3 to 4 minutes in the rapid drying solution. It will dry in less than half the normal drying time after removal from the solution. Do not wipe the excess solution off. The emulsion will be very delicate, so handle the film carefully. Exposure to a stream of flowing air (i.e., a fan or air conditioner) will shorten the drying time, though it will increase the risk of dust in the emulsion.

Sticky Easel

The following formula is useful for coating any size piece of plywood to use as an easel for making large blowups, as well as for holding prints flat and in place for copying.

Cold water	16 fl oz	500.0 ml
Gelatin	2 oz	60.0 grams
*Corn syrup	2 oz	60.0 grams
Glycerin	2 oz	60.0 grams
Chrome alum	16 grains	1.1 grams
Water to make	32 fl oz	1.0 liter

*Karo syrup, available in most grocery stores.

Mix the syrup and the glycerin in water, and soak the gelatin in this mixture for 10 minutes. Then warm it up to 120°F/52°C, and let it set for 15 to 30 minutes with occasional stirring.

Dissolve the alum in 60 ml of water. Add this to the mixture, and bring the total to 1 liter with water. Strain through cheesecloth. Each ounce of this mixture will cover 100 square inches (a 10 × 10″ easel).

Build a simple easel, leaving at least an extra $\frac{1}{2}$ to 1 inch more than the maximum paper size to be used, by gluing strips of molding around the edge of an appropriately sized piece of plywood or Masonite and painting the base black. Level the easel on a horizontal surface, and coat the surface by pouring the mixture evenly across it. Let the surface dry for an hour, then add another coat—several thin layers work better than one thick one. Keep the unused solution heated until the easel has been satisfactorily coated, as it cannot be remelted. The easel should be ready for use in about 6 hours after the last coat.

Paper or film will adhere firmly to the surface with slight pressure and can easily be removed without residue.

NOTE: The stickiness of the surface will be preserved if it is covered with a piece of wax paper, celluloid, or plastic wrap. The easel can be recoated as often as necessary.

Printing-Out Paper Formulas

Formula #203

Gelatinochloride P.O.P.

See chapter 15, Printing-Out Processes, for instructions for use.

Sizing and Salting Solution

Water	10 fl oz	300.0 ml
Gelatin	30 grains	2.0 grams

| Sodium citrate | 100 grains | 6.5 grams |
| Ammonium chloride | 100 grains | 6.5 grams |

Combine the gelatin with the water and let stand for 10 minutes. Heat slowly until the gelatin is completely dissolved. Add the ammonium chloride and sodium citrate; mix until dissolved. Pour the solution into a tray. While the solution is still warm, float the paper for 3 to 5 minutes. Hang to dry.

Sensitizing Solution
Distilled water	2 fl oz	60.0 ml
Silver nitrate	139 grains	9.0 grams
Citric acid	100 grains	6.5 grams

Dissolve the silver nitrate in the water. Add the citric acid and stir until dissolved. Float the dry, salted paper in the solution for 2 to 3 minutes. Allow the paper to dry in the dark.

Formula #204

Warm-Tone Printing-Out Paper

See chapter 15, Printing-Out Processes, for instructions for use.

Gelatin Sizing
| Cold water | 32 fl oz | 1.0 liter |
| Knox Gelatin | 409 grains | 28.0 grams |

Allow the gelatin to swell for about 10 minutes, then heat gently until the gelatin is completely dissolved, pour into a tray, and soak each sheet of paper for 1 minute. Hang the paper to dry. Do not touch the surface of the printing paper once it has been sized.

Sensitizing Formula
Ferric ammonium citrate, green	2 oz 367 grains	85.0 grams
Tartaric acid	204 grains	14.0 grams
Silver nitrate	1 oz 75 grains	35.0 grams
Water to make	32 fl oz	1.0 liter

Dissolve the ingredients separately in water. Mix the ferric ammonium citrate solution and the tartaric acid solution, then add the silver nitrate solution while stirring with a nonmetal rod. Add water to make up the complete quantity. Keep in a brown glass bottle, away from light.

After the print is fixed, immerse in hypo clearing agent, then wash for at least 15 minutes, after which the print may be toned.

Formula #205

P.O.P. Borax Toning Bath

For warm tones.

Water (100°F/38°C)	14 fl oz	400.0 ml
Borax	44 grains	3.0 grams
Gold chloride (1% solution)	.2 fl oz	6.0 ml

Dissolve the borax in hot water first, then add the gold chloride. Prepare the bath at least 1 hour in advance and allow it to cool before using. Toning can be done from 6 to 12 minutes, depending on the tone desired. The longer the toning, the colder the tone. Be aware that when the prints are dry, the tone becomes slightly cooler.

After toning is complete, wash the print for 10 minutes.

This bath can be reused, but more gold must be added after each use. Let the bath sit for at least an hour before adding more gold.

Formula #206

P.O.P. Thiocyanate Toning Bath

For cold tones.

Water (100°F/38°C)	14 fl oz	400.0 ml
Ammonium thiocyanate	183 grains	12.5 grams
Tartaric acid	14.6 grains	1.0 gram
Gold chloride (1% solution)	2½ fl drams	10.0 ml
Water to make	16 fl oz	500.0 ml

Tone for 5 to 10 minutes for blue-gray tones.

After toning wash prints for 10 minutes.

This bath will not keep; mix it only when you plan to use it.

Conversion Tables

Direct Equivalents

For direct conversions between metric and U.S. customary units, use the following tables. However, if you intend to convert an entire U.S. customary formula using 32 ounces of liquid to a metric formula using 1 liter, or vice versa, use the compound equivalents following these tables. To convert an individual measure, use the direct equivalents.

Direct Conversions

Ounces × 28.35 = grams
Grams × 0.0353 = ounces
Pounds × 453.6 = grams

U.S. Customary Solid Measures

1 pound = 16 ounces
1 pound = 7000 grains
1 pound = 453.6 grams
1 ounce = 0.0625 pounds
1 ounce = 437.5 grains
1 ounce = 28.35 grams
1 grain = 0.0648 grams

U.S. Customary Liquid Measures

1 gallon = 4 quarts
1 gallon = 128 fl oz
1 gallon = 1024 fl drams
1 gallon = 3785 ml
1 gallon = 3.785 liters
1 quart = 0.25 gallons
1 quart = 32 fl oz
1 quart = 256 fl drams
1 quart = 946.3 ml
1 quart = 0.9463 liters

1 fl oz = 8 fl drams
1 fl oz = 29.57 ml
1 fl oz = 0.02957 liters
1 fl dram = 0.000975 gallons
1 fl dram = 0.0039 quarts
1 fl dram = 0.125 fl oz
1 fl dram = 3.697 ml
1 fl dram = 0.003697 liters

Metric Solid Measures

1000 grams = 2.205 pounds
1 gram = 0.03527 ounces
1 gram = 15.43 grains

Metric Liquid Measures

1 liter = 1000 ml
1 liter = 270.5 fl drams
1 liter = 33.81 fl oz
1 liter = 1.057 quarts
1 liter = 0.2642 gallons
1 ml = 0.001 liters
1 ml = 0.2705 fl drams
1 ml = 0.03381 fl oz

TABLE 3 Direct Conversions from U.S. Customary to Metric Units

DIRECT EQUIVALENTS							
Fluid ounces to Milliliters		Fluid ounces to Milliliters		Fluid ounces to Milliliters		Fluid ounces to Milliliters	
fl oz	ml	fl oz	ml	fl oz	ml	fl oz	ml
1	30	1.69	50	11	325	13.52	400
2	59	2.54	75	12	355	15.21	450
3	89	3.38	100	13	384	16.91	500
4	118	5.07	150	14	414	25.36	750
5	148	5.92	175	15	444	30.43	900
6	177	6.76	200	16	473	33.81	1000
7	207	7.61	225	24	710	67.63	2000
8	237	8.45	250	32	946	101.44	3000
9	266	10.14	300	64	1892	135.26	4000
10	296	11.83	350	128	3785	169.07	5000

DIRECT EQUIVALENTS (Continued)

GRAMS to GRAINS		GRAINS to GRAMS		GRAINS to OUNCES		OUNCES to GRAINS	
grams	grains	grains	grams	grains	ounces	ounces	grains
1	15	1	0.06	30	.07	0.1	44
2	31	2	0.13	50	.11	0.2	88
3	46	3	0.19	60	.14	0.3	131
4	62	4	0.26	80	.18	0.4	175
5	77	5	0.32	90	.21	0.5	219
6	93	6	0.39	100	.23	0.6	262
7	108	7	0.45	150	.34	0.7	306
8	123	8	0.52	200	.46	0.8	350
9	139	9	0.58	250	.57	0.9	394
10	154	10	0.65	300	.69	1.0	438
15	231	15	0.97	400	.92	2.0	875
20	309	20	1.30	500	1.15	3.0	1313
25	386	25	1.62	750	1.72	4.0	1750
30	463	30	1.94	1000	2.29	5.0	2185
35	540	35	2.27	2000	4.58	6.0	2625
40	617	40	2.59	3000	6.88	7.0	3060
45	694	45	2.92	4000	9.16	8.0	3500
50	772	50	3.24	5000	11.45	9.0	3940
75	1157	75	4.86	6000	13.75	10.0	4375
100	1543	100	6.48	7000	16.00	16.0	7000
500	7716	500	32.40				
1000	15432	1000	64.80				

GRAMS to OUNCES		OUNCES to GRAMS		FEET to METERS		METERS to FEET	
grams	ounces	ounces	grams	feet	meters	meters	feet in. (approx.)
5	.18	1	28.3	3	.91	1	3 – 3
10	.35	2	56.7	3½	1.07	1.25	4 – 1
15	.53	3	85.0	5	1.52	1.5	4 – 11
20	.71	4	113.4	6	1.83	1.75	5 – 9
25	.88	5	141.7	7	2.13	2	6 – 7
50	1.76	6	170.1	8	2.44	2.5	8 – 2
100	3.53	7	198.4	9	2.74	3	9 – 10
150	5.29	8	226.8	10	3.05	4	13 – 1
200	7.05	9	255.1	12	3.66	5	16 – 5
250	8.81	10	283.5	15	4.57	6	19 – 8
300	10.58	11	311.8	20	6.10	7	23 – 0
350	12.34	12	340.2	25	7.62	8	26 – 3
400	14.10	13	368.5	30	9.14	9	29 – 6
450	15.87	14	396.9	40	12.19	10	32 – 10
500	17.63	15	425.2	50	15.24	15	49 – 3
600	21.16	16	453.6	75	22.86	20	65 – 7
800	28.21	24	680.4	100	30.48	30	98 – 5
1000	35.27	32	907.2	150	45.72	50	164 – 0

Compound Conversions

The conversion between grams and grains in formulas is not an exact equivalent. The reason is that the two columns do not represent equal quantities of liquid solution. The U.S. customary column makes up to 32 ounces, whereas the metric column makes up to 1 liter. A liter is actually slightly more than 33 ounces. Therefore, the conversion between the two columns must be "compounded" in order that the percentage of dry chemical remains the same in both versions of the formula. For example, 1 ounce equals 28.35 grams. However, 30 g/L is required to give the same working solution strength as 1 ounce per quart.

Any amount not listed can be converted quite easily. The following compound conversion formulas can be used to convert from grams/liter to U.S. customary units:

Grams/liter × 14.6 = grains/32 ounces
Grams/liter × 0.03338 = ounces/32 ounces
Grams/liter × 0.002086 = pounds/32 ounces

The following compound conversion formulas can be used to convert from U.S. customary to grams/liter:

Grains/32 ounces × 0.06847 = grams/liter
Ounces/32 ounces × 29.96 = grams/liter
Pounds/32 ounces × 479.3 = grams/liter

The following compound conversion formula can be used to convert liquid measures from metric to U.S. customary:

ml × 0.032 = fl ounces

The following compound conversion formula can be used to convert liquid measures from U.S. customary to metric:

fl ounces × 31.25 = ml

The smaller the amount, the more critical it is to be accurate. For example, the difference between 100 grams of sodium sulfite and 101 grams is an error of 1%. The difference between 1 gram of sodium sulfite and 1.1 grams is a 10% error.

Dry Measure Compound Equivalents

The tables in this section, one for dry measures and the other for liquids, show the conversions for many of the most commonly used amounts, from metric on the left to U.S. customary on the right.

Grams = Grains
0.1 = 1.5
0.2 = 2.9
0.25 = 3.7
0.3 = 4.4
0.4 = 5.8
0.5 = 7.3
0.55 = 8
0.6 = 8.8
0.7 = 10
0.8 = 11.7
0.9 = 13
1.0 = 14.6
1.1 = 16
1.2 = 17.5
1.25 = 18
1.3 = 19
1.4 = 20
1.5 = 22
1.6 = 23
1.7 = 24.8
1.75 = 25.6
1.8 = 26
1.9 = 27.7
2.0 = 29
2.1 = 30.7
2.2 = 32
2.3 = 33.6
2.4 = 35
2.5 = 36.5
2.6 = 38
2.7 = 39.4
2.75 = 40
2.8 = 41
2.9 = 42
3.0 = 44
3.1 = 45
3.2 = 47
3.3 = 48
3.4 = 49.6
3.5 = 51
3.6 = 52.6
3.7 = 54
3.75 = 54.8 ($\frac{1}{8}$ oz)
3.8 = 55.5
3.9 = 57
4.0 = 58.4

4.1 = 60
4.2 = 61
4.3 = 62.8
4.4 = 64
4.5 = 65.7
4.6 = 67
4.7 = 68.6
4.75 = 69
4.8 = 70
4.9 = 71.5
5.0 = 73
5.1 = 74
5.2 = 76
5.3 = 77
5.4 = 79
5.5 = 80
5.6 = 81
5.7 = 83
5.75 = 84
5.8 = 85
5.9 = 86
6.0 = 88
6.1 = 89
6.2 = 91
6.3 = 92
6.4 = 93
6.5 = 95
6.6 = 96
6.7 = 98
6.75 = 98.6
6.8 = 99
6.9 = 101
7.0 = 102
7.1 = 103.7
7.2 = 105
7.3 = 106.6
7.4 = 108
7.5 = 109.5 ($\frac{1}{4}$ oz)
7.6 = 111
7.7 = 112
7.75 = 113
7.8 = 114
7.9 = 115
8.0 = 117
8.1 = 118
8.2 = 120
8.3 = 121

8.4 = 123
8.5 = 124
8.6 = 126
8.7 = 127
8.75 = 127.8
8.8 = 129
8.9 = 130
9.0 = 131
9.1 = 133
9.2 = 134
9.3 = 136
9.4 = 137
9.5 = 139
9.6 = 140
9.7 = 142
9.75 = 142.4
9.8 = 143
9.9 = 145
10.0 = 146
10.5 = 153
11.0 = 161
11.5 = 168
12.0 = 175
12.5 = 183
13.0 = 190
13.5 = 197
14.0 = 204
14.5 = 212
15.0 = 219 ($\frac{1}{2}$ oz)
15.5 = 226
16.0 = 234
16.5 = 241
17.0 = 248
17.5 = 256
18.0 = 263
18.5 = 270
19.0 = 277
20.0 = 292
21.0 = 307
22.0 = 321
22.5 = 329 ($\frac{3}{4}$ oz)
23.0 = 336
24.0 = 350
25.0 = 365
26.0 = 380
27.0 = 394
28.0 = 409

29.0 = 423	175 = 5 oz 365 grains	570 = 19 oz
30.0 = 438 (1 oz)	180 = 6 oz	575 = 19 oz 73 grains
35.0 = 1 oz 73 grains	185 = 6 oz 73 grains	600 = 20 oz
40.0 = 1 oz 146 grains	190 = 6 oz 146 grains	625 = 20 oz 365 grains
45.0 = 1 oz 219 grains (1½ oz)	195 = 6 oz 219 grains	630 = 21 oz
50.0 = 1 oz 292 grains	200 = 6 oz 292 grains	650 = 21 oz 292 grains
55.0 = 1 oz 365 grains	210 = 7 oz	660 = 22 oz
60.0 = 2 oz	225 = 7 oz 219 grains	675 = 22 oz 219 grains
65.0 = 2 oz 73 grains	240 = 8 oz	690 = 23 oz
70.0 = 2 oz 146 grains	250 = 8 oz 146 grains	700 = 23 oz 146 grains
75.0 = 2 oz 219 grains	270 = 9 oz	720 = 24 oz
80.0 = 2 oz 292 grains	275 = 9 oz 73 grains	725 = 24 oz 73 grains
85.0 = 2 oz 365 grains	300 = 10 oz	750 = 25 oz
90.0 = 3 oz	325 = 10 oz 365 grains	775 = 25 oz 365 grains
95.0 = 3 oz 73 grains	330 = 11 oz	780 = 26 oz
100 = 3 oz 146 grains	350 = 11 oz 292 grains	800 = 26 oz 292 grains
105 = 3 oz 219 grains	360 = 12 oz	810 = 27 oz
110 = 3 oz 292 grains	375 = 12 oz 219 grains	825 = 27 oz 219 grains
115 = 3 oz 365 grains	390 = 13 oz	840 = 28 oz
120 = 4 oz	400 = 13 oz 146 grains	850 = 28 oz 146 grains
125 = 4 oz 73 grains	420 = 14 oz	870 = 29 oz
130 = 4 oz 146 grains	425 = 14 oz 73 grains	875 = 29 oz 73 grains
135 = 4 oz 219 grains	450 = 15 oz	900 = 30 oz
140 = 4 oz 292 grains	475 = 15 oz 365 grains	925 = 30 oz 365 grains
145 = 4 oz 365 grains	480 = 16 oz	930 = 31 oz
150 = 5 oz	500 = 16 oz 292 grains	950 = 31 oz 292 grains
155 = 5 oz 73 grains	510 = 17 oz	960 = 32 oz
160 = 5 oz 146 grains	525 = 17 oz 219 grains	975 = 32 oz 219 grains
165 = 5 oz 219 grains	540 = 18 oz	990 = 33 oz
170 = 5 oz 292 grains	550 = 18 oz 146 grains	1000 = 330 oz 146 grains

Liquid Measure Compound Equivalents

Milliliters = Ounces	3 ml = .096 fl. oz	9.5 ml = .3 fl oz
0.3 ml = 5 minims	3.5 ml = .11 fl oz	10 ml = .32 fl oz (2½ fl drams)
1 ml = .032 fl oz (¼ fl dram)	3.75 ml = .12 fl oz	11 ml = .35 fl oz
1.1 ml = .035 fl oz	3.9 ml = ⅛ fl oz (1 fl dram)	11.7 ml = ⅜ fl oz (3 fl drams)
1.2 ml = .038 fl oz	4 ml = .128 fl oz	12 ml = .38 fl oz
1.3 ml = .042 fl oz	4.25 ml = .136 fl oz	13 ml = .416 fl oz
1.4 ml = .045 fl oz	4.5 ml = .144 fl oz	14 ml = .448 fl oz
1.5 ml = .048 fl oz	5 ml = .16 fl oz (1¼ fl drams)	15 ml = .48 fl oz
1.6 ml = .051 fl oz	5.5 ml = .176 fl oz	15.6 ml = ½ fl oz (4 fl drams)
1.7 ml = .054 fl oz	6 ml = .19 fl oz	16 ml = .51 fl oz
1.8 ml = .058 fl oz	6.5 ml = .2 fl oz	17 ml = .54 fl oz
1.9 ml = .06 (½ fl dram)	7 ml = .22 fl oz	18 ml = .576 fl oz
2 ml = .064 fl oz.	7.5 ml = .24 fl oz	19 ml = .608 fl. oz.
2.25 ml = .072 fl oz	7.8 ml = ¼ fl oz (2 fl drams)	19.5 ml = ⅝ fl oz (5 fl drams)
2.5 ml = .08 fl oz	8 ml = .256 fl oz	20 ml = .64 fl oz
2.75 ml = .088 fl oz	8.5 ml = .27 fl oz	23.5 ml = ¾ fl oz (6 fl drams)
2.8 ml = .09 (¾ fl dram)	9 ml = .288 fl oz	25 ml = .8 fl oz

27.3 ml = $\frac{7}{8}$ fl oz (7 fl drams)
30 ml = .96 fl oz
31.3 ml = 1 fl oz (8 fl drams)
35 ml = 1.12 oz
39 ml = $1\frac{1}{4}$ oz
40 ml = 1.28 fl oz
45 ml = 1.44 fl oz
46.9 ml = $1\frac{1}{2}$ fl oz
50 ml = 1.6 fl oz
55 ml = $1\frac{3}{4}$ fl oz
60 ml = 1.9 fl oz
62.5 ml = 2 fl oz
65 ml = 2.08 fl oz
70 ml = 2.2 fl oz
75 ml = 2.4 fl oz
78.2 ml = $2\frac{1}{2}$ fl oz
80 ml = 2.56 fl oz
85 ml = 2.7 fl oz
90 ml = 2.88 fl oz
93.8 = 3 fl oz
100 ml = 3.2 fl oz
110 ml = $3\frac{1}{2}$ fl oz
125 ml = 4 fl oz
150 ml = 4.8 fl oz
156.3 ml = 5 fl oz

175 ml = 5.6 fl oz
87.5 ml = 6 fl oz
200 ml = 6.4 fl oz
203 ml = $6\frac{1}{2}$ fl oz
218.8 ml = 7 fl oz
225 ml = 7.2 fl oz
250 ml = 8 fl oz
275 ml = 8.8 fl oz
281.3 ml = 9 fl oz
300 ml = 9.6 fl oz
312.5 = 10 fl oz
325 ml = 10.4 fl oz
344 ml = 11 fl oz
350 ml = 11.2 fl oz
375 ml = 12 fl oz
400 ml = 12.8 fl oz
407 ml = 13 fl oz
425 ml = 13.6 fl oz
438 ml = 14 fl oz
450 ml = 14.4 fl oz
470 ml = 15 fl oz
475 ml = 15.2 fl oz
500 ml = 16 fl oz
532 ml = 17 fl oz
550 ml = 17.6 fl oz

563 ml = 18 fl oz
595 ml = 19 fl oz
600 ml = 19.2 fl oz
626 ml = 20 fl oz
650 ml = 20.8 fl oz
657 ml = 21 fl oz
689 ml = 22 fl oz
700 ml = 22.4 fl oz
720 ml = 23 fl oz
750 ml = 24 fl oz
775 ml = 24.8 fl oz
782.5 ml = 25 fl oz
800 ml = 25.6 fl oz
814 ml = 26 fl oz
845 ml = 27 fl oz
850 ml = 27.2 fl oz
876 ml = 28 fl oz
900 ml = 28.8 fl oz
908 ml = 29 fl oz
939 ml = 30 fl oz
950 ML = 30.4 fl oz
950 ml = 30.4 fl oz
970 ml = 31 fl oz
975 ml = 31.2 fl oz
1 L = 32 fl oz

Chemical Substitutions

Alkali Substitutions

Alkalies can sometimes be substituted one for another, but only within a particular family. The three families are mild, alkali, and caustic. Even within a family there may be limitations on substitutions. The only way to be sure is to test.

The formula specifies:	You have:	Multiply by:
Borax, decahydrate	Borax, pentahydrate	0.76
Borax, pentahydrate	Borax, decahydrate	1.32
Potassium carbonate, anhydrous	Sodium carbonate, monohydrate	0.90
Sodium carbonate, monohydrate	Potassium carbonate, anhydrous	1.12
Potassium hydroxide	Sodium hydroxide	1.40
Sodium hydroxide	Potassium hydroxide	0.72
Sodium carbonate, monohydrate	Balanced Alkali or Sodium metaborate, octahydrate	1.70
Balanced Alkali or sodium metaborate, octahydrate	Sodium carbonate, monohydrate	0.59

Other Substitutions

The formula specifies:	You have:	Multiply by:
Acetic acid, glacial	Acetic acid, 28%	3.54
Acetic acid, 28%	Acetic acid, glacial	0.28
Aluminum alum	Ammonium alum	1.5
Ammonium alum	Aluminum alum	0.67
Ascorbic acid	Sodium ascorbate	1.125
Ascorbic acid	Sodium isoascorbate	1.125
Concentrated HCL (35% to 37%)	Muriatic acid	1.17
Muriatic acid	Concentrated HCL (35% to 37%)	0.855
Potassium metabisulfite	Sodium metabisulfite	1.17
Sodium metabisulfite	Potassium metabisulfite	0.855
Sodium ascorbate	Ascorbic acid	0.889
Sodium ascorbate	Sodium isoascorbate	1.0
Sodium isoascorbate	Ascorbic acid	0.889
Sodium isoascorbate	Sodium ascorbate	1.0
Sodium thiosulfate, anhydrous	Sodium thiosulfate, crystalline	1.57
Sodium thiosulfate, crystalline	Sodium thiosulfate, anhydrous	0.64
Sodium bromide	Potassium bromide	1.16
Potassium bromide	Sodium bromide	0.86
Sodium sulfate, crystalline	Sodium sulfate, anhydrous	0.44
Sodium sulfate, anhydrous	Sodium sulfate, crystalline	2.27

Sodium Sulfite Conversion

Crystalline sodium sulfite is not as common as it once was. Photographic chemical suppliers will usually provide the anhydrous salt unless otherwise specified. If you happen to obtain the crystal or decahydrate form you can use the following conversion factors:

The formula specifies:	You have:	Multiply by:
Sodium sulfite, anhydrous	Sodium sulfite, crystalline	2.0
Sodium sulfite, crystalline	Sodium sulfite, anhydrous	0.5

Sodium Carbonate Conversion

Sodium carbonate is one of the most commonly used ingredients in photographic chemistry. It is commercially available in three forms, differing by the amount of water molecules each contains. The three forms are anhydrous (also known as desiccated), monohydrate, and crystal. Crystal is rarely seen today in photographic practice.

Of the three, the monohydrate form is the most stable and the best to use for photographic purposes. The crystalline form is the least stable. However, as is often the case, a formula may call for anhydrous and you may have monohydrate, or a chemical supplier may sell you the anhydrous variety, and so on. In any case, the following table makes for easy conversion from one to the other.

Today, most formulas specify sodium carbonate, monohydrate. If a formula requires one of the other two forms, anhydrous or crystal, or if only one of the others is available, use the following table for conversion:

The formula specifies:	You have:	Multiply by:
Sodium carbonate, mono.	Sodium carbonate, anhyd.	0.855
Sodium carbonate, mono.	Sodium carbonate, cryst.	2.31
Sodium carbonate, anhyd.	Sodium carbonate, mono.	1.17
Sodium carbonate, anhyd.	Sodium carbonate, cryst.	2.7
Sodium carbonate, cryst.	Sodium carbonate, mono.	0.433
Sodium carbonate, cryst.	Sodium carbonate, anhyd.	0.37

Sodium Carbonate Conversion Table

The following tables provide a listing of conversions for anhydrous to mono-hydrated form, then for crystal to monohydrated form.

Anhydrous to Monohydrated

METRIC		U.S. CUSTOMARY			
Anhyd.	Mono.	Anhyd.		Mono.	
Grams ⟷	Grams	Oz ⟷	Grains	Oz ⟷	Grains
0.5	0.58	$\frac{1}{4}$	128
1.0	1.17	...	145	...	170
1.5	1.73	...	165	...	193
2.0	2.34	...	175	...	205
3.0	3.51	$\frac{1}{2}$	256
4.0	4.68	...	265	...	310
5.0	5.85	...	300	...	351
6.0	7.02	$\frac{3}{4}$	384
7.0	8.19	...	350	...	410
8.0	9.36	...	360	...	421
9.0	10.53	...	365	...	427
10.0	11.70	...	385	1	13
15.0	17.55	1	...	1	74
20.0	23.40	$1\frac{1}{4}$...	1	202
25.0	29.25	$1\frac{1}{2}$...	1	330
30.0	35.10	1	260	1	378
35.0	40.95	$1\frac{3}{4}$...	2	20
40.0	46.80	2	...	2	149
45.0	52.65	$2\frac{1}{4}$...	2	278
50.0	58.50	$2\frac{1}{2}$...	2	406
55.0	64.35	$2\frac{3}{4}$...	3	95
60.0	70.20	3	...	3	223
70.0	81.90	$3\frac{1}{4}$...	3	351
80.0	93.60	$3\frac{1}{2}$...	4	42
90.0	105.30	4	...	4	298
100.0	117.00	5	...	5	372
110.0	128.70	6	...	7	9
120.0	140.40	7	...	8	83
130.0	152.10	8	...	9	193
140.0	163.80	9	...	10	228
150.0	175.50	10	...	11	306

Crystal to Monohydrated

| METRIC | | U.S. CUSTOMARY | | | |
| Cryst. | Mono. | Cryst. | | Mono. | |
Grams ⟷	Grams	Oz ⟷	Grains	Oz ⟷	Grains
1.0	.43	¼	47
2.0	.87	...	165	...	71
3.0	1.29	...	175	...	76
4.0	1.73	½	95
5.0	2.17	...	265	¼	6
6.0	2.60	...	300	¼	20
7.0	3.03	¾	...	¼	32
8.0	3.47	...	350	¼	41
9.0	3.89	...	360	¼	46
10.0	4.33	...	365	¼	49
15.0	6.40	...	385	¼	58
20.0	8.67	1	...	¼	79
25.0	10.83	1¼	...	¼	16
30.0	12.90	1½	...	¼	64
35.0	15.07	1	260	¼	82
40.0	17.34	1¾	...	¾	...
45.0	19.55	2	...	¾	47
50.0	21.67	2¼	...	¾	95
60.0	25.99	2½	...	1	33
70.0	30.34	3	...	1¼	18
80.0	34.67	3¼	...	1¼	65
90.0	38.90	3½	...	1½	4
100.0	43.34	4	...	1½	100
110.0	47.67	5	...	2	74
120.0	52.01	6	...	2½	43
130.0	56.24	7	...	3	13
140.0	60.67	8	...	3¼	96
150.0	65.01	9	...	3¼	61
160.0	69.33	10	...	4¼	36
175.0	75.84	15	...	6¼	66
200.0	86.68	20	...	8½	73

Teaspoon Conversions

For those who wish to use teaspoon measurements, the following table of commonly used photographic chemicals shows the metric equivalents for various amounts of dry measures.

The length of time the chemicals sit on a supplier's shelf and the storage conditions are important to take into account, as many chemicals will absorb water with storage, but it is not always possible to obtain this information. Therefore, you may wish to consider the following as "standards" and maintain a consistent work habit.

	Dry Weight in Metric Grams	Teaspoon Amount
*Amidol	1.6 grams	1 teaspoon
*Balanced Alkali	4.3 grams	1 teaspoon
*Benzotriazole	0.2 grams	⅛ teaspoon
*Borax	3.8 grams	1 teaspoon
Boric acid	4.1 grams	1 teaspoon
Chlorhydroquinone	3.4 grams	1 teaspoon
*Chrome alum	1.2 grams	¼ teaspoon
*Citric acid	4.9 grams	1 teaspoon
*Glycin	1.8 grams	1 teaspoon
*Hydroquinone	3.3 grams	1 teaspoon
*Metol	3.0 grams	1 teaspoon
*Phenidone	0.5 grams	¼ teaspoon
o-Phenylenediamine	3.5 grams	1 teaspoon
*p-Aminophenol hydrochloride	2.6 grams	1 teaspoon
p-Phenylenediamine	3.5 grams	1 teaspoon
Potassium alum	1.5 grams	¼ teaspoon
*Potassium bromide	1.9 grams	¼ teaspoon
*Potassium carbonate	6.4 grams	1 teaspoon
*Potassium dichromate	6.4 grams	1 teaspoon
*Potassium ferricyanide	4.7 grams	1 teaspoon
*Potassium permanganate	7.2 grams	1 teaspoon
*Potassium persulfate	6.4 grams	1 teaspoon
*Pyrocatechol	3.3 grams	1 teaspoon
*Pyrogallol	2.3 grams	1 teaspoon
*Silver nitrate	1.7 grams	⅛ teaspoon
*Sodium bisulfite, anhyd.	5.5 grams	1 teaspoon
*Sodium carbonate, anhyd.	4.8 grams	1 teaspoon
*Sodium carbonate, mono.	6.3 grams	1 teaspoon
*Sodium chloride	6.1 grams	1 teaspoon
*Sodium hydroxide	4.0 grams	1 teaspoon
*Sodium metaborate	4.6 grams	1 teaspoon
*Sodium sulfate	6.4 grams	1 teaspoon
*Sodium sulfite, anhyd.	7.9 grams	1 teaspoon
*Sodium thiocyanate	3.6 grams	1 teaspoon
*Sodium thiosulfate	21.0 grams	1 Tablespoon
*Thiourea	3.0 grams	1 teaspoon
Tri-sodium phosphate	4.5 grams	1 teaspoon

*Spoon measurements may differ slightly in weight each time. These were measured and weighed on an Acculab VI-400 electronic scale, four times each, and averaged by the author, using the very best teaspoon-leveling techniques taught to him by Ms. Abernathy in High School Home Ec.

TABLE 4 Comparison of Thermometer Scales

BASIC CONVERSION FACTORS

To convert Fahrenheit into Centigrade:
Subtract 32; multiply by 5 and divide by 9.
Example: 125°F − 32 = 93 × 5 = 465 ÷ 9 = 51.67°C

To convert Centigrade into Fahrenheit:
Multiply by 9; divide by 5; add 32 to result.
Example: 18°C × 9 = 162 ÷ 5 = 32.4 + 32 = 64.4°F.

°C	°F	°C	°F	°C	°F	°C	°F	°C	°F	°C	°F
+100	+212										
99.44	211	74.44	166	49.44	121	24.44	76	−0.55	31	−25.55	−14
98.89	210	73.89	165	48.89	120	23.89	75	−1.11	30	−26.11	−15
98.33	209	73.33	164	48.33	119	23.33	74	−1.67	29	−26.67	−16
97.78	208	72.78	163	47.78	118	22.78	73	−2.22	28	−27.22	−17
97.22	207	72.22	162	47.22	117	22.22	72	−2.73	27	−27.78	−18
96.67	206	71.67	161	46.67	116	21.67	71	−3.33	26	−28.33	−19
96.11	205	71.11	160	46.11	115	21.11	70	−3.89	25	−28.89	−20
95.55	204	70.55	159	45.55	114	20.55	69	−4.44	24	−29.44	−21
95	203	70	158	45	113	20	68	−5	23	−30	−22
94.44	202	69.44	157	44.44	112	19.44	67	−5.55	22	−30.55	−23
93.89	201	68.89	156	43.89	111	18.89	66	−6.11	21	−31.11	−24
93.33	200	68.33	155	43.33	110	18.33	65	−6.67	20	−31.67	−25
92.78	199	67.78	154	42.78	109	17.78	64	−7.22	19	−32.22	−26
92.22	198	67.22	153	42.22	108	17.22	63	−7.78	18	−32.78	−27
91.67	197	66.67	152	41.67	107	16.67	62	−8.33	17	−33.33	−28
91.11	196	66.11	151	41.11	106	16.11	61	−8.89	16	−33.89	−29
90.55	195	65.56	150	40.55	105	15.55	60	−9.44	15	−34.44	−30
90	194	65	149	40	104	15	59	−10	14	−35	−31
89.44	193	64.44	148	39.44	103	14.44	58	−10.55	13	−35.55	−32
88.89	192	63.89	147	38.89	102	13.89	57	−11.11	12	−36.11	−33
88.33	191	63.33	146	38.33	101	13.33	56	−11.67	11	−36.67	−34
87.78	190	62.78	145	37.78	100	12.78	55	−12.22	10	−37.22	−35
87.22	189	62.22	144	37.22	99	12.22	54	−12.78	9	−37.78	−36
86.67	188	61.67	143	36.67	98	11.67	53	−13.33	8	−38.33	−37
86.11	187	61.11	142	36.11	97	11.11	52	−13.89	7	−38.89	−38
85.55	186	60.55	141	35.55	96	10.55	51	−14.44	6	−39.44	−39
85	185	60	140	35	95	10	50	−15	5	−40	−40
84.44	184	59.44	139	34.44	94	9.44	49	−15.55	4		
83.89	183	58.89	138	33.89	93	8.89	48	−16.11	3		
83.33	182	58.33	137	33.33	92	8.33	47	−16.67	2		
82.78	181	57.78	136	32.78	91	7.78	46	−17.22	1		
82.22	180	57.22	135	32.22	90	7.22	45	−17.78	0		
81.67	179	56.67	134	31.67	89	6.67	44	−18.33	−1		
81.11	178	56.11	133	31.11	88	6.11	43	−18.89	−2		
80.55	177	55.55	132	30.55	87	5.55	42	−19.44	−3		
80	176	55	131	30	86	5	41	−20	−4		
79.44	175	54.44	130	29.44	85	4.44	40	−20.55	−5		
78.89	174	53.89	129	28.89	84	3.89	39	−21.11	−6		
78.33	173	53.33	128	28.33	83	3.33	38	−21.67	−7		
77.78	172	52.78	127	27.78	82	2.78	37	−22.22	−8		
77.22	171	52.22	126	27.22	81	2.22	36	−22.78	−9		
76.67	170	51.67	125	26.67	80	1.67	35	−23.33	−10		
76.11	169	51.11	124	26.11	79	1.11	34	−23.39	−11		
75.55	168	50.55	123	25.55	78	0.55	33	−24.44	−12		
75	167	50	122	25	77	0	32	−25	−13		

TABLE 5 Film Development Temperature Conversion Chart

64°F	66°F	68°F	70°F	72°F	75°F	77°F	80°F
5.0	4.5	**4.0**	3.5	3.25	2.5	*	*
5.5	5.0	**4.5**	4.0	3.75	3.0	*	*
6.0	5.5	**5.0**	4.5	4.0	3.25	*	*
6.5	6.0	**5.5**	5.0	4.5	3.5	*	*
7.25	6.5	**6.0**	5.5	5.0	4.0	3.75	*
8.0	7.25	**6.5**	6.0	5.25	4.5	4.0	3.5
8.75	7.75	**7.0**	6.5	5.75	5.0	4.5	3.75
9.25	8.25	**7.5**	6.75	6.0	5.25	4.75	4.0
9.75	8.75	**8.0**	7.25	6.5	5.5	5.0	4.25
10.5	9.5	**8.5**	7.75	7.0	6.0	5.5	4.75
11.25	10.0	**9.0**	8.0	7.25	6.25	5.75	5.0
11.75	10.5	**9.5**	8.5	7.75	6.5	6.0	5.25
12.5	11.25	**10.0**	9.0	8.0	7.0	6.25	5.5
13.0	11.75	**10.5**	9.5	8.5	7.25	6.5	5.75
13.75	12.25	**11.0**	10.0	9.0	7.5	6.75	6.0
14.25	12.75	**11.5**	10.5	9.25	8.0	7.25	6.25
14.75	13.25	**12.0**	10.75	9.75	8.25	7.5	6.5
15.25	13.75	**12.5**	11.25	10.0	8.75	8.0	7.0
16.0	14.5	**13.0**	11.75	10.5	9.0	8.25	7.0
16.75	15.0	**13.5**	12.0	11.0	9.25	8.5	7.25
17.25	15.5	**14.0**	12.5	11.25	9.75	9.0	7.5
17.75	16.0	**14.5**	13.0	11.75	10.0	9.25	7.75
18.5	16.75	**15.0**	13.5	12.25	10.5	9.5	8.0
19.25	17.25	**15.5**	14.0	12.75	10.75	9.75	8.25
19.75	17.75	**16.0**	14.5	13.0	11.0	10.0	8.5
20.5	18.5	**16.5**	14.75	13.5	11.5	10.25	8.75
21.0	19.0	**17.0**	15.25	13.75	11.75	10.5	9.0
21.75	19.5	**17.5**	15.75	14.25	12.0	10.75	9.25
22.25	20.0	**18.0**	16.25	14.5	12.5	11.25	9.5
22.75	20.5	**18.5**	16.75	15.0	12.75	11.5	9.75
23.5	21.0	**19.0**	17.25	15.5	13.25	12.0	10.25
24.25	21.75	**19.5**	17.5	16.0	13.5	12.25	10.5
24.75	22.25	**20.0**	18.0	16.25	13.75	12.5	10.75
25.25	22.75	**20.5**	18.5	16.75	14.25	12.75	11.0
26.0	23.5	**21.0**	19.0	17.0	14.5	13.0	11.25
26.5	23.75	**21.5**	19.5	17.5	15.0	13.5	11.5
27.25	24.5	**22.0**	19.75	17.75	15.25	13.75	11.75
27.75	25.0	**22.5**	20.25	18.25	15.5	14.0	12.0
28.25	25.5	**23.0**	20.75	18.75	16.0	14.5	12.5
28.75	26.0	**23.5**	21.0	19.0	16.25	14.75	12.75
29.75	26.75	**24.0**	21.75	19.5	16.75	15.0	13.0
30.25	27.25	**24.5**	22.0	19.75	17.0	15.25	13.25
30.75	27.75	**25.0**	22.5	20.25	17.25	15.5	13.5

(Courtesy of John Placko, Ilford)

This conversion chart can be used to easily determine changes in development time at different temperatures. Find the recommended time/temperature then use the time to the left or right for changes in temperature.

Index